EVERYTHING
YOU EVER WANTED
TO KNOW ABOUT
WATERCOLOR

EVERYTHING YOU EVER WANTED TO KNOW ABOUT WATERCOLOR

Edited by
Marian E. Appellof

Watson-Guptill Publications / New York

I thank each of the artists included in this book for their willingness to contribute their work to it, and for their dedication to the arts of painting and teaching.

I am grateful, too, to my colleagues Mary Suffudy, who conceived the book; Ellen Greene; Sue Shefts; and especially Jay Anning.

Marian Appellof

Cover illustration by Charles Reid.

Copyright © 1992 by Watson-Guptill Publications

First published in 1992 in the United States by Watson-Guptill Publications, a division of BPI Communications, Inc., 1515 Broadway, New York, N.Y. 10036.

Library of Congress Cataloging-in-Publication Data

Everything you ever wanted to know about watercolor / edited by Marian E. Appellof.
 p. cm.
 Includes index.
 ISBN 0-8230-5649-X (pbk.)
 1. Watercolor painting—Technique. I. Appellof, Marian E.

ND2420.E85 1992
751.42'2—dc20
 92-137
 CIP

Manufactured in Malaysia

First printing, 1992

6 7 8 9 10 11/99 98 97 96 95

Text set in Goudy Oldstyle
Edited by Marian Appellof
Designed by Jay Anning
Graphic production by Ellen Greene

CONTENTS

Collaging & Other Unusual Techniques

Artistic Principles

Perspective

Landscape Painting

Figure Painting

Flowers

Index 396

INTRODUCTION

The ability to paint well in watercolor or in any other medium—to make art that sings with purpose and confidence—is never simply a matter of inborn talent or desire, but of diligence and hard work. Seeking the guidance of a teacher whose own painting inspires you is a first, and perhaps the most important, step toward attaining that goal.

But can you learn all there is to know about painting, about watercolor, from any one teacher? Or from any one book? Maybe. Yet the more styles and approaches you are exposed to, the more you enrich your technical knowledge and visual experience—all to the good of mastering the medium and developing your own, confident style.

Everything You Ever Wanted to Know About Watercolor was conceived with just that idea in mind: to provide variety. Gathered between its covers is the collected expertise, advice, and inspired artwork of nearly twenty different watercolor artists, culled from some of the best art instruction books Watson-Guptill has ever published, by some of its best-loved authors.

In any library a single-volume encyclopedia is a convenient and indispensable reference for a wide range of information distilled from longer works. In a library of watercolor instruction books, *Everything You Ever Wanted to Know About Watercolor* is just such a reference. There is something for everyone here, from straightforward advice about paper, pigments, and how to lay a simple wash, to lessons in creating specific textures, understanding principles of composition and design, painting the landscape, and the ins and outs of working with live models. Unconventional approaches to watercolor, like painting with sand, are here, too, to pique the interest of artists at all skill levels.

The book can be used to suit different needs. You can follow it in sequence, using it as a progressive painting course, or refer to one section or page at a time to learn about a specific technique, term, or artistic principle. If you want to learn about different approaches to landscape painting, you can delve into the chapter devoted to that subject, as well as glance through any of the other chapters to find landscape subjects that are used to teach particular watercolor techniques.

The artists and works I have chosen for each chapter are those who, alone or in combination, I felt would provide the fullest coverage of the subject area. But this should not be taken to mean that I recommend one artist's method or philosophy over another's, or that any single artist has the last word on a given topic. Obviously there are as many approaches to watercolor as there are artists who work in the medium, and in a book that includes so many of both, you are likely to find the occasional contradiction: One artist may advocate a particular pigment color or technique that another would avoid. So obviously, too, the only "right" way to do something is to try the various options presented until you discover what works for you. That's what any good teacher—like the ones in this book—would tell you. Each of the contributing authors, whatever his or her unique strengths, has a passion for showing you how to do one and the same thing: make good art.

Marian Appellof

CONTRIBUTORS

Excerpts have been taken from the following books, listed here alphabetically by author.

Don Andrews, *Interpreting the Figure in Watercolor.*

A resident of Fairhope, Alabama, Don Andrews has taught watercolor and figure painting, and has conducted numerous figure workshops throughout the United States.

Gerald Brommer, *Watercolor & Collage Workshop.*

Gerald Brommer, a California native, has written numerous articles for art education journals and is the author of several books, as well as the editor of many others. He teaches workshops throughout the United States and abroad.

Jeanne Dobie, *Making Color Sing.*

Known for her fresh approach to color and design, Jeanne Dobie has conducted workshops throughout the United States and in Europe. She lives in Pennsylvania.

Howard Etter and **Margit Malmstrom,** *Perspective for Painters.*

An architectural delineator and design consultant as well as a painter, Howard Etter has taught various forms of drawing and painting, including demonstrations in watercolor landscape painting. He resides in Camden, Maine. Margit Malmstrom, a resident of Lincolnville, Maine, has been an editor, writer, and sculptor, contributing articles to *American Artist* magazine and working on numerous art books.

Philip Jamison, *Capturing Nature in Watercolor.*

Philip Jamison lives in West Chester, Pennsylvania, whose surroundings are the source of his inspiration.

Richard Karwoski, *Watercolor Bright and Beautiful.*

A native of Brooklyn, New York, Richard Karwoski has taught painting, drawing, design, and printmaking, as well as a number of watercolor workshops throughout the United States.

John Koser, *Watercolor Red Yellow Blue.*

In addition to being an artist, John Koser holds a degree in dental science. He teaches watercolor workshops in Southern California, where he makes his home.

Maxine Masterfield, *In Harmony with Nature.*

Maxine Masterfield, a resident of Sarasota, Florida, teaches her abstract naturalism painting methods throughout the United States and Canada, as well as abroad. She is also the author of *Painting the Spirit of Nature*, published by Watson-Guptill.

David Millard, *The Joy of Watercolor.*

Dividing his painting time between homes in Needham, Massachusetts, and St. Thomas, U.S. Virgin Islands, David Millard has taught, demonstrated, and given critiques in numerous workshops across the United States as well as in France and Italy.

Alex Powers, *Painting People in Watercolor.*

Alex Powers lives in Myrtle Beach, South Carolina, and divides his time between painting and traveling in the United States and Canada teaching workshops. As well as teaching art, he has served as a juror for national shows and state watercolor society exhibitions.

Stephen Quiller and **Barbara Whipple,** *Water Media Techniques* and *Water Media: Processes and Possibilities.*

Stephen Quiller, *Color Choices.*

A landscape painter with a special affinity for Colorado and New Mexico, Stephen Quiller teaches workshops, juries shows, and lectures on color and water media to art associations and watercolor societies throughout the United States. He also teaches color theory, painting, and printmaking. Barbara Whipple, who collaborated with Quiller on his first two books, was a writer, a teacher, and an artist whose specialty was printmaking.

Don Rankin, *Painting from Sketches, Photographs, and the Imagination; Mastering Glazing Techniques in Watercolor;* and *Answers to 50 of the Most Often Asked Questions About Watercolor Glazing Techniques.*

Don Rankin has made watercolor glazing his specialty. A teacher of painting, he lives in Alabama.

Charles Reid, *Painting What You Want to See; Pulling Your Paintings Together;* and *Painting by Design.*

Charles Reid's popularity as an artist and workshop teacher is well known in the United States and abroad. He is also a best-selling author. His other books published by Watson-Guptill are *Figure Painting in Watercolor; Portrait Painting in Watercolor; Portraits and Figures in Watercolor* (in The Artist's Painting Library series); and *Flower Painting in Watercolor.* Reid lives in Connecticut.

Graham Scholes, *Watercolor and How.*

Graham Scholes has been teaching a popular workshop program to eager audiences throughout his native Canada for more than ten years. He lives in Sidney, British Columbia.

Irving Shapiro, *How to Make a Painting.*

A native Chicagoan, Irving Shapiro spent his early career as a layout artist and illustrator, and began teaching watercolor in 1945. He is the author of several articles on painting and drawing that have appeared in *American Artist* magazine, and his paintings have been featured in many other publications.

Valfred Thëlin with **Patricia Burlin,** *Watercolor: Let the Medium Do It.*

Valfred Thëlin, who lived in Ogunquit, Maine, and once studied with Hans Hofmann and Georgia O'Keeffe, enjoyed wide popularity as a workshop teacher. His work has been featured in major art publications, museums, and galleries in the United States and abroad. Patricia Burlin, a writer and an artist, studied with Valfred Thëlin for some ten years. She lives in Florida, where she teaches painting and writes for magazines.

Edward Norton Ward, *First Impressions: Sketching Nature in Watercolor.*

Edward Norton Ward has pursued dual careers as an artist and a computer software developer. He spends most of his painting time in the American West, from Alaska to his native state of California, where he has taught workshops.

MATERIALS & PREPARATION

Having the right materials at your disposal can make painting a real pleasure. But art-supply stores stock a bewildering array of papers, brushes, and paints. How do you choose? Irving Shapiro and Graham Scholes offer a few recommendations.

Irving Shapiro
Choosing Paper

Watercolor paper comes in a broad range of weights and textures. What will affect the flavor of your painting is not so much the paper's weight (or thickness) as its texture. A rough surface—the "toothiest" paper—is especially well suited for developing graded washes, uniform values (especially within large areas), and textured brushwork. Although the smoother, hot-pressed papers are less adaptable to these techniques, they will let you use "runs" of liquid color more aggressively and experimentally. In addition, their smooth surface encourages the display of brushwork. For an intermediate texture, try a cold-pressed paper, sometimes called "not" paper (meaning that it's not rough).

As with all materials, each brand of paper offers its own distinguishing characteristics. In fact, there seems to be little standardization in paper textures. For example, a rough paper from one paper mill will be comparable to the cold-pressed surface from another mill. Confusing? Possibly at first, but you'll become familiar with the differences as you use a variety of papers.

Machine-made or Handmade

Papers are described as being either machine-made (mold-made) or handmade. The quality of the paper is not affected by either designation, though many watercolorists prefer handmade paper because it's less uniform in overall texture. The slight variations are attractive to these painters just as handcrafted goods of other sorts are considered distinctive.

Watercolor Board

One of Irving Shapiro's favorite painting surfaces is watercolor board, a rag watercolor paper bonded to heavy rag cardboard with noncontaminating adhesive. It's available in rough, cold-pressed, and hot-pressed surfaces. Many artists especially like its absolute stability, since it won't wrinkle when wet. Also, it's unnecessary to stretch it; in effect, watercolor board can be thought of as prestretched paper. Perhaps the only drawback is that watercolor board can be painted on only one side, whereas conventional paper can be painted on either side.

Rice Paper

Still another kind of surface that can provide you with fascinating painting experiences is rice paper. It's really more accurate to describe it as a cereal or grain paper, since rice paper is derived from a wide selection of grains. You can thus choose from a variety of "rice" papers, but keep in mind that almost all are unsized (meaning that brushwork on them will feather) and they are quite fragile (meaning that they cannot be stretched). The shrinking that accompanies paper stretching would make these papers split.

Weight

Watercolor papers are milled in a considerable range of thicknesses, or weights. Most artists recommend using a weight no lighter than 140-lb. paper. If you want a more substantial weight, a 200- or 300-lb. paper can be used.

What do these measures mean? Obviously, the single sheet of paper doesn't weigh 140 pounds! What this refers to is the weight of a ream (500 sheets of paper) that measures the standard 22 × 30" (55.9 × 76.2 cm). Therefore, if 500 sheets of 22 × 30" paper weighs, in total, 140 pounds, a single sheet will be identified as 140-lb. paper.

Acidity

Pure rag papers can be depended on to retain their whiteness, but papers with a cellulose content will yellow, sometimes acquiring an ochre cast. The rate of discoloration can be determined by the degree of the paper's acidity. Fortunately, this acidity can be neutralized, so that you can find reliable blends of rag and cellulose—described as pH-neutral—that retain their whiteness.

Moreover, this neutralizing process has been extended to mat boards to make them colorfast, noncontaminating surfaces. If your mat is not 100 percent rag or neutralized, you must place a piece of rag paper as a barrier between the acid-active mat and the watercolor paper. What is often overlooked is that the *back* of the watercolor paper must also be protected from acid-active surfaces. One of the most frequently used backings for watercolors is corrugated cardboard—which also happens to be extremely acid. Although an acid-free corrugated board has been developed, it is not yet in common use. If a noncontaminating surface is not placed between the back of the watercolor and the corrugated backing, the acid of the backing will gradually penetrate the watercolor paper and affect the front surface, even to the degree that the lines of corrugation will appear as lines on the face of the painting. The weight of the paper you paint on will determine how long it takes for the discoloration to become apparent.

Stretching and Preparing Paper

Stretching paper means saturating the paper with water and then securing it to a surface that won't bend or warp. Although 300-lb. paper is heavy enough not to require stretching, other lighter-weight papers will wrinkle badly when you paint on them unless you stretch them, or unless you saturate them (making them wet enough to cling to the board) and then paint on them while they're this wet. Painting wet-in-wet in this way, of course, eliminates the possibility of a controlled-edge painting. You may wish to stretch even 300-lb. paper to insure absolute flatness when you paint, as this weight can bow with a wet handling—especially if it's a full-size sheet.

Trimming the Edge First
It helps to begin by trimming the deckle edge off the sheet of watercolor paper so the paper will lie flat when it's soaked.

The original edge has a tendency to wrinkle when it becomes saturated. To trim the edge, use either a sharp mat knife or a single-edge razor blade.

Soaking
Soak the paper in a tub of cold or room-temperature water for several minutes. (Don't use hot water, or you'll find yourself with unpalatable gruel on your hands.) Be careful not to crease the paper in any way, since the creases will weaken the paper fibers and the paper may split at the creases as it stretches.

Transferring to the Stretching Surface
Place the limp, saturated sheet of paper on a piece of plywood ½" or ⅓" thick, or on a pine or basswood drawing board. A piece of Masonite can also be used. With the side of your hand (which is almost oil-free), carefully press the paper from its center toward its outer edges. This helps to flatten the paper while at the same time squeezing the excess water from it. Blot the excess water that collects at the paper's edges and then secure the paper to the board with brown paper tape, staples, or long-pinned thumbtacks. If you use Masonite as your stretching surface, you'll have to use tape, since staples or tacks won't penetrate the Masonite.

Taping
The tape must be the type that will stick only if moistened. It's commonly called kraft tape. Test the adhesion with a scrap of the tape first, though, since some tapes will stick only if they're quite wet, while others need to be only dampened. Making the latter too wet will simply rinse the glue off the paper tape.

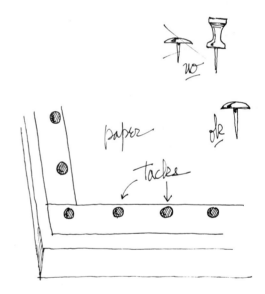

Using Tacks
If you use tacks to reinforce the stretching, use the type with a lightly rounded head and a pin ½" long. The standard tack has a ¼" pin. Stay away from tacks with tall glass or plastic heads; they get in the way as you sweep your hand across the paper.

Drying
Once the stretching has been completed, allow the paper to dry as it lies flat. As the paper dries, it shrinks and becomes taut, providing the watercolorist with a marvelously flat surface that won't buckle or wrinkle. When the paper is completely dry—and the drying can take anywhere from an hour or so to overnight, depending on the weight of the

paper, the degree of saturation, and the humidity conditions—it can then be sketched on with pencil in preparation for painting.

It's a good idea to have two drawing boards so that on one of them you can always have a sheet of watercolor paper stretched and waiting. It's frustrating to plan a painting, build up steam, raring to go—and then have your enthusiasm squelched by discovering that you have to stretch a sheet of paper and wait several hours for it to dry.

Removing the Sizing

To complete the preparation of the watercolor paper or board for painting, it's advisable to remove some of the sizing (also called binder or starch), which is added to the paper as it's being made. Some of this sizing is necessary to insure that edges will be controllable when you paint. Without the sizing, the brushstroke will feather—even if the paper is dry. On the other hand, with too much sizing, the surface will resist the wet brushstroke, much as when you try to paint on a surface that has a waxy or oily content. Under these conditions, you have to keep repeating your brushstroke just to cover the paper with color. Given the importance in the medium of watercolor of direct and immediate statement, paper with too much sizing is a definite deterrent to a vigorous painting message.

Some of the sizing will be lifted from the paper when you soak it in preparation for stretching. To insure a properly receptive surface, try sponging the paper gently but thoroughly after it has dried from stretching, using a soft sponge that's sopping wet, with the water anywhere from cold to room temperature. Again, never use hot water. If the paper is soft or fairly fibrous, making it inadvisable to sponge it, just liberally brush clear, cold water on the paper. In either case, let the paper dry completely before drawing on it with pencil.

Mounting Rice Paper

Rice paper cannot be stretched, but it can be mounted. Mix a thin, but not watery, wheat paste—the same kind that's used to apply wallpaper. Make certain that the paste is free of lumps by mixing it thoroughly, preferably with an electric mixer or blender. Choose an acid-free board for mounting the paper. Foam core is excellent, since it is lightweight and offers stability. Gently roll up the sheet of paper, making absolutely certain that it does not wrinkle or crease as you roll it. Place the rolled-up paper at one end of the board, brush paste on the board, and carefully unroll about 2–3" at a time, until the entire sheet of paper is mounted to the board. Now put a heavy, flat surface on the entire piece of paper. A sheet of plate glass is ideal, since it lies uniformly flat. Finally, place weights evenly on the glass to equalize the pressure. Books and magazines make fine weights. When the paste has dried—allow several hours for this—remove the glass, and you have a mounted piece of a rather exotic paper waiting for you.

As an additional, though not always necessary, step, you can mount a piece of brown wrapping paper to the back of the board on which the rice paper has been mounted. This will provide added stability, making it unlikely that the board will curl or warp from the moisture used in either the mounting or the painting process.

Now that the paper has been mounted, you can also, if you wish, size the surface. Use a large, soft brush and apply a generous amount of a thin gelatin solution, using no more than about ¼ ounce of gelatin to one-half or one gallon of cold or room-temperature water.

Applying Acrylic Gesso

There is another painting surface worth considering. Acrylic gesso, if applied to a surface, can present you with a whole new experience in watercolor. The gesso can be applied in almost any imagined fashion. You can brush it on liberally, with uneven brushstrokes, leaving all sorts of irregular contours on which to paint. Or, for a uniform surface, you can thin the gesso and brush it on evenly. When it's dry, you can sand the surface with a fine sandpaper; then apply another thin coat and again sand it smooth when it's dry.

The possibilities for creating different surfaces with gesso are vast. Try using a pocket comb to striate the gesso before it has dried. Or raggedly notch the edge of a plastic credit card so that "combing" the gessoed surface will provide you with irregular asymmetrical striations. For still another texture, drop a piece of clean window screen onto gesso that's still tacky and then lift the screen quickly and carefully. No matter how you apply the gesso, after you paint on it, you can use sharp points and blades to lift out highlights and to create other "reversed" statements—much like the handling of a scratchboard.

Storing Paper

If possible, store your papers flat and in large drawers or boxes. This will keep your paper flat and clean. Also avoid excessive handling of your watercolor papers to prevent the oils from your fingers from leaving traces that may later act as resist spots.

Irving Shapiro

Selecting and Maintaining Brushes

Watercolor brushes come in all sorts of shapes, and you can choose from natural or synthetic bristles, sable or squirrel ones. There's even a watercolor brush that is a combination of natural and artificial fibers, appropriately called a blend. Although the selection of brushes depends on personal preference, it is strongly recommended that you acquire the best you can afford. In evaluating the quality of a brush, ask yourself:

• Does the brush snap back into its ideal shape when wet and "flicked"? To flick the brush, wet it and, with a quick wrist action, remove the excess water.

• Does the brush hold a generous amount of liquid so that you won't have to replenish it with wet color too often? A well-charged brush can cover an astonishing amount of paper.

• With a round brush, is it supple enough to allow a variety of brushstroke gestures?

Irving Shapiro likes to experiment with all sorts of brushes and has a collection of fifty or more, but finds himself relying on three or four trusty friends: a #12 round kolinsky sable, a #5 or #6 round red sable, and a 1" flat ox-hair brush.

Good brushes should be given the proper care to insure a long period of service. Here are some essential steps:

1. When not using your brushes, lay them aside so that the bristles are not resting against anything. Do not let your brushes stand in water for extended periods. Not only will the shape of the brush be adversely affected, but constant soaking will loosen the metal ferrule from the wood or plastic handle.

2. After rinsing your brushes, wipe them on a paint rag or damp sponge. If you choose a sponge, make sure it's the kind that absorbs liquid readily. (Old-fashioned cloth diapers make perfect paint rags; they're certainly absorbent, and they're a pretty good size. T-shirts are good, too.) Use a wiping action that follows the contour of the bristle.

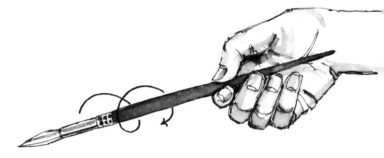

A round brush should be wiped with a spinning action as the brush is dragged off the paint rag or sponge, so that the brush comes away properly pointed.

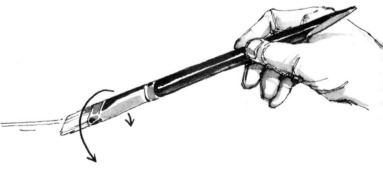

A flat brush should also be wiped to follow its shape. Wipe it flat side to the rag or sponge, and then flop it over to wipe the other flat side.

3. Do not touch the bristles of your watercolor brushes with your fingers unless absolutely necessary. Frequent handling transfers oils from your skin to the brush; the oils collect at the base of the bristles where they meet the ferrule, gradually causing the brush to swell and lose its proper shape.

4. To clean your brushes at the end of a painting session, just rinse them thoroughly in cold or room-temperature water. *Never* use hot water! Shapiro also recommends that you not use soap; he has always cleaned his fine brushes by rinsing them in water only, and has found that they've stayed in prime form for many, many years.

5. Moths find some bristles a gourmet's delight. If you don't use your brushes daily—or at least with some frequency—put them in a container with a few moth crystals, making certain that the container is large enough for your brushes to either stand up straight or lie flat without having the bristles rest against anything. When traveling, place your brushes in a flat box and put a strip of masking tape across the handles so that they're completely separated from each other. Another handy brush carrier is a rattan placemat with elastic ribbons toward each end. Tuck the brush handles into the elastic at 2–3" intervals and roll up the placemat.

6. If your brush does happen to dry misshapen, you can probably reshape it by dipping the bristles into a solution of household starch. With your fingers (one of the few times that you're advised to handle the brush in this way), coax the brush into its proper shape and let it dry. Then, once it's dry, rinse off the starch. You may need to repeat this process a few times.

Irving Shapiro

Matting and Framing Your Work

Classically, watercolors are presented with a mat. Aside from aesthetics (which can be argued), there is a practical need for a mat: It separates the surface of the glass from the surface of the painting. Not only may direct contact disturb the surface of the painting, but also condensation can sometimes form under the glass, and this will ruin the watercolor if the glass rests against it. If the watercolor is to be framed without a mat, or if the paper is mounted on a board with the board's outer margins serving as a mat, you can separate the painting surface from the glass by putting a thin bead of wood (usually balsa wood) under the rabbet of the frame. This bead, which is not visible from the front, will provide the necessary separation. Another way to separate the surfaces is to use a metal frame that has one channel for the artwork and another channel for the glass.

Mats should be neutral enough in color, value, breadth, and texture not to detract from the painting. The same is true of the frame. Your choices are subjective, of course, but in choosing mats and frames, consider the virtues of simplicity. Keep the personality of your painting in mind and evaluate the setting that will best complement it. An inappropriate mat or frame can easily undo the effectiveness of a painting.

Irving Shapiro prefers double mats, with the inner mat (called a fillet) 1/8" or 1/4" wide and of a value that contrasts with to the edges of the painting. The outer mat—usually 3–4" wide—should be white, off-white, or a judiciously selected darker value. Be sure the mat does not compete with or impose on your painting. Iridescent or vibrant colors, fancy silks, velvets, exaggerated textures, and dazzling metallic surfaces are out! Incidentally, a double white treatment in your two mats can be a striking foil for a painting. In any event, use rag mat boards or separate the mat from the painting with rag barrier paper to insure noncontamination of your watercolor paper. (Wood pulp yellows with age.)

As already mentioned, keep your frames simple and choose a neutral material that doesn't interfere with your work. Metal frames are convenient, relatively inexpensive, and usually unimposing. In fact, some museums and group exhibits prefer them because of the sense of uniformity they provide within the exhibit area and the absence of busy, overwhelming moldings.

Finally, don't use nonglare glass. It can alter the color and clarity of your painting. Use either regular glass or the plastic glazing that looks like regular glass. If you're disturbed by the prospect of distracting light reflections, place the picture wire just above the midpoint of the frame. This will tip the painting forward from the wall, making for a slight angle that will reduce the amount of reflection. The higher the wire, the flatter the painting will rest against the wall, and the more reflection you'll have. If your budget allows it, you might consider some of the recently developed glasses that reduce (or even eliminate) glare without affecting the appearance of the painting.

Graham Scholes

Selecting Paints

Your first priority when you choose pigments should be that they have a high degree of permanency. Many artists prefer the kind sold in tubes; you can squeeze whatever amount you need onto a palette and work with large brushes. The dried pan pigments have a place in the compact box you carry with you for small sketches when space and weight are factors. Other criteria to consider when deciding which paints will best suit your needs are these:

• **Transparency.** Pigment allows light to show through; for more luminous paintings.

• **Staining.** Traces of pigment remain on the paper after lift-offs; for creating highlights.

• **Nonstaining.** Pigment can be removed easily to achieve white highlights.

• **Texture.** Pigment's smoothness or graininess; important in achieving mood and atmosphere.

• **Cost.** Look for best value.

All hues in the chart shown opposite are Winsor & Newton Artists' Water Colours. No standardization of pigment names, quality, or colors exists among different paint manufacturers, so results will vary from brand to brand. In the chart, each pigment has been rated for transparent and staining qualities using a scale of 1 to 10. "S" means the pigment has a smooth texture; "G" means it is granular.

Transparency is determined by applying a brushful of strong pigment over a black waterproof marker line. If the black line shows through clearly, the pigment is transparent, like Antwerp blue, which is rated 1 on the scale. If the pigment only partially covers the black line, it is less transparent, like new gamboge, rated 4. If the black line is covered completely, the pigment is opaque, like cerulean blue, rated 9.

Transparency has a great deal of influence on achieving luminosity in your painting. Poor-quality pigments are made with fillers, which diminish transparency and increase the chances of muddy or chalky-looking paintings. With care,

you can use discreet amounts of one opaque pigment in combination with transparent ones. Mixing two opaques in a medium or dark wash will cause loss of luminosity, especially when you apply several washes one over another.

Staining is determined when you remove color that has dried. Gently scrub an area with a damp, hog-hair bristle bright brush (a square brush with bristles shorter than a flat) to lift the pigment. (Note: The watercolor paper must have good wet strength for this test.) The amount of color that remains on the paper determines the staining factor; sap green, for example, leaves a dark stain and rates a 10, while manganese, a nonstaining pigment, rates a 0.

Texture, determined by the ingredients used in a paint's manufacture, is revealed when you apply the pigment on a wetted area (here, below the black line) and allow it to spread and settle on its own. You'll best be able to see the texture of a pigment when you put it down as a juicy wash without manipulating it, letting the color settle at will on the paper's surface. Texture or lack of it can be used to create mood and atmosphere. For example, if you want to achieve a textural quality in a cloud study, you might choose granular pigments like burnt sienna, ultramarine blue, cerulean blue, and raw sienna. If you desire serenity in the cloud study, smooth pigments like Antwerp blue or Winsor blue with brown madder and raw sienna will create this effect. Using one granular pigment moderately will not overstate its texture.

Cost varies according to quality and specific pigment. First, look for artist-quality paints. Student-grade pigments are not recommended because they are less pure and, to reduce the selling price, are made with fillers that can cause a painting to look chalky. Buying watercolors is like buying housepaint. With the inexpensive kind, you'll need two coats to cover, while a good-quality paint does it in one. So in the long run, better paints are more economical. Artist-quality pigments range in price because some, such as the cadmiums, are made from expensive and precious materials. However, in many cases it's possible to approximate some of these costlier pigments with mixtures of others.

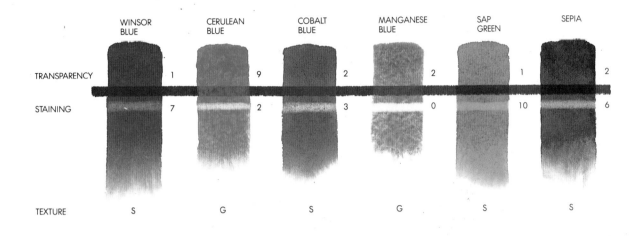

	WINSOR BLUE	CERULEAN BLUE	COBALT BLUE	MANGANESE BLUE	SAP GREEN	SEPIA
TRANSPARENCY	1	9	2	2	1	2
STAINING	7	2	3	0	10	6
TEXTURE	S	G	S	G	S	S

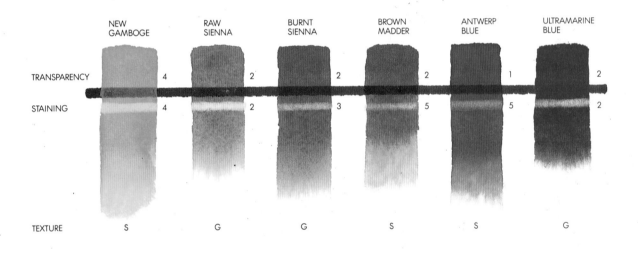

	NEW GAMBOGE	RAW SIENNA	BURNT SIENNA	BROWN MADDER	ANTWERP BLUE	ULTRAMARINE BLUE
TRANSPARENCY	4	2	2	2	1	2
STAINING	4	2	3	5	5	2
TEXTURE	S	G	G	S	S	G

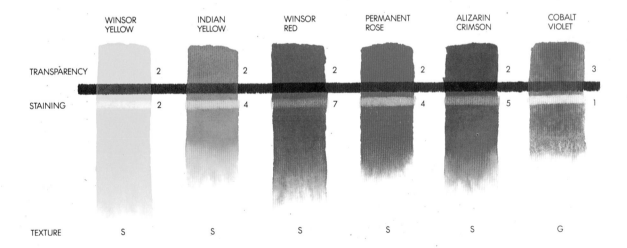

	WINSOR YELLOW	INDIAN YELLOW	WINSOR RED	PERMANENT ROSE	ALIZARIN CRIMSON	COBALT VIOLET
TRANSPARENCY	2	2	2	2	2	3
STAINING	2	4	7	4	5	1
TEXTURE	S	S	S	S	S	G

COLOR

Color is irresistible, a feast or, perhaps, a challenge for the eye of the beholder, depending on how the artist has used it. Color is also confusing, and learning to use it well is important if you hope to find its expressive potential. Here, Stephen Quiller explains the basics of color theory, its terminology, and color inter-relationships; David Millard offers advice on setting up a working palette and mixing color; and Jeanne Dobie shows how to attain luminous color, particularly greens, grays, and darks that glow with life.

Stephen Quiller

Understanding Basic Color Terms

When Stephen Quiller talks about color, he does so as an artist, not as a scientist or theoretician. From this perspective, he has painted a color wheel that illustrates not only hue (color), but also value (light and dark) and intensity (brightness or dullness).

Around the perimeter of the wheel, he has arranged pure colors at their most intense, just as they come from the tube. The primary colors are red, yellow, and blue; the secondary colors, orange, green, and violet. There are also intermediate, or tertiary, colors: yellow-orange, yellow-green, blue-green, blue-violet, red-violet, and red-orange. Complementary colors are those that are located directly opposite each other on the color wheel, for example, blue and orange, red-violet and yellow-green.

By mixing complements, you can create dull greens, warm browns, and earth colors, as can be seen inside the color wheel. Each primary, secondary, and intermediate (tertiary) color has its complement, and when these complements are evenly mixed, they produce a totally neutral color, one in which neither color can be distinguished. This "gray" color is of low intensity. The lowest intensity of any color is in the middle of the color wheel, in the area labeled neutral.

When Quiller is painting with any one color, he is always thinking of its complement. He likes to compare the relationship between complementary colors to the relationship in a marriage: The way the colors work together can make or break a painting. A painting generally has a dominant color, which is set off by its complement, used in a subordinate way. A painting of a winter evening, for example, might be predominantly shades of blue. Such a painting could be accented by a flicker of orange light in a window, with warm reflections on the snow. If, however, complements are used in equal amounts, they will compete with each other. The op art of the late 1960s made explicit use of the optical vibration of intense complementary colors.

In addition to intensity, every color has a value, which describes its lightness or darkness. Transparent watercolor can be diluted with water to lighten it; other water media can be mixed with opaque white to produce a tint. Both a high-intensity color, such as red-orange, and a low-intensity color, such as a dull brown, can be made lighter in value by adding either water or white paint. Both can be made darker by adding either more pigment or black.

Shown on the color wheel is a value scale from black to white of two complementary colors, blue-green and red-orange. For purposes of simplification, only seven basic shades of each color between black and white are shown. Actually there are an infinite number of values of each color.

When we speak of contrasting values, we mean values that are far apart on the value scale. Because contrasting values attract the eye, they are very important when you are developing a composition. Analogous values are those that are close to one another—for example, the high light, light, and low light in the diagram. The effect of analogous values in a painting is one of subtlety.

It is difficult to work with both value and color at the same time. For this reason, the old masters would first do a monochromatic underpainting (called *grisaille*, from the French word for gray), followed by transparent glazes of color. Today, an artist might turn a painting upside down to lose sight of the image and to see how it holds together in terms of lights and darks. Or you might try concentrating on value by using only one color or a limited palette of complementary colors, such as orange and blue.

Another character of color to take into consideration is its temperature, its warmth or coolness. On the color wheel, imagine a diagonal line that extends from yellow-green to red-violet, dividing the circle in half. The colors to the left of the line are warm, and those to the right are cool. Red-violet and yellow-green can be either warm or cool, depending on the colors surrounding them. (Color temperature is actually a relative term; there are reds that can be described as "cool" and blues that can be described as "warm," depending on context.) In terms of painting, warm colors advance and cool colors recede, meaning that it's possible to create the illusion of depth by the organization of color.

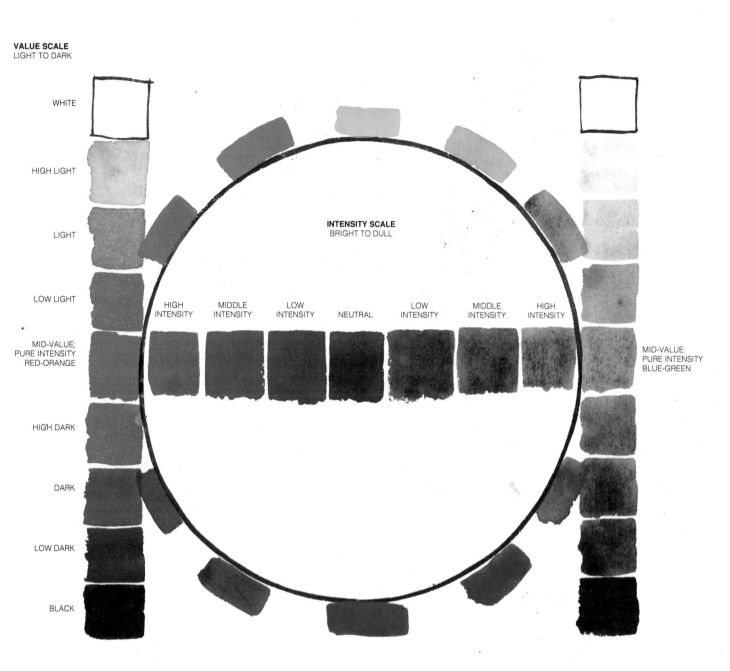

David Millard

Setting Up a Working Palette

To become familiar with how various hues work together, David Millard recommends that you start with a basic palette of primary hues and add colors gradually.

Millard uses a tin folding palette. The inside is painted in white enamel, with twenty-four small spaces for colors, plus five large wells in which to mix paints and washes, and a thumb hole so he can hold the palette easily as he paints.

Use the charts here as a guide for the placement of hues for your specific palette. Squeeze about a quarter teaspoon of tube color into each of the wells you will be using. Let your colors rest for half a day to harden slightly, then dip your fingertip into a bowl of clean water and make a dent in each color, cleaning your finger each time. From now on, your colors are to get a drop of distilled water in this dent every night and each morning, so the pigments are always gooey. This will insure thick, intense color when you mix your hues.

Always arrange your colors the same way on the palette so you can find them quickly without hesitation.

Novice Palette

No matter what your level, you will benefit from working with a limited palette for a while. To start, work with a cool and a warm version of each of the primaries. By mixing all your cool colors with each other and then with the warm hues, you will get two sets of secondaries, one warm and one cool, for a total of twelve secondary hues. For example, mix warm yellow and warm red for a warm orange; cool yellow and cool red for cool orange—and continue the process for mixtures of yellow and blue (green) and red and blue (purple). Then mix warm yellow with cool red, and cool yellow with warm red, and so on. (Detailed advice on mixing follows.) Numbers next to colors listed here indicate their position in the full palette.

Winsor Yellow (1): cool yellow
Cadmium Yellow Deep (3): warm yellow
Alizarin Crimson (10): cool red
Cadmium Scarlet (6): warm red
Cerulean Blue (23): cool blue
Ultramarine Blue (21): warm blue

Intermediate Palette

When you have become completely familiar with using the basic primaries and secondaries, you are ready to add several more colors to your palette—another red, another blue, an orange, four earth tones, and two greens.

Permanent Rose (9)
Cobalt Blue (21)
Cadmium Orange (5)
Raw Sienna (12)
Raw Umber (13)
Burnt Sienna (14)
Burnt Umber (15)
Viridian (17)
Sap Green (16)

The novice palette consists of one warm and one cool version of the three primary colors, red, yellow, and blue, with which you will practice mixing numerous warm and cool variations of secondary and tertiary hues.

The intermediate palette contains all the colors of the novice palette, plus another red, another blue, an orange, four earth hues, and two greens.

Advanced Palette

When you have mastered the novice and intermediate palettes, you are ready to work with the entire range of twenty-four colors. For most of the year, when he is working in cooler climates such as northern California and New England, under more frequent gray skies, Millard uses the palette shown at right for his landscapes, seascapes, still lifes, and portraits. When painting under the brighter skies of tropical climates, and when painting florals, where intense and vivid hues are essential, Millard substitutes the colors listed in brackets for their less vivid relatives.

Naples Yellow (1): creamy, warm, opaque, unusual mixer
[Winsor Yellow (1)]: cool, clear, brilliant mixer
New Gamboge (2): cool, clean, yellow, good basic mixer
Cadmium Yellow Deep (3): warm, hearty, semiopaque
Indian Yellow (4): very warm, clear
Cadmium Orange (5): handsome, brilliant, opaque
Cadmium Red (6): basic mixer, heavy, not clear
[Cadmium Scarlet (6)]: brilliant, opaque; use care in mixes
Light Red (7): least opaque of the earth reds, good mixer
Cobalt Violet (8): unusual mixer, granular
Permanent Rose (9): hot and sharp
Alizarin Crimson (10): cool red, clear, excellent mixer
Raw Sienna (11): warm, heavily pigmented earth color
Raw Umber (12): cool, neutral earth tone
Burnt Sienna (13): hot, clear, medium granular, good mixer
Burnt Umber (14): cool, deep, very granular; use sparingly
Hooker's Green Dark (15): clean, deep, great summer color
[Emerald Green (15)]: opaque, unusual mixer
Cobalt Green (16): delicate, semiclear, pale mixer
Sap Green (17): very clear, warm, stains nicely
Viridian (18): cool, brilliant, mixes well, stays clean
Mauve (19): semiclear, reddish purple, unusual
[Winsor Violet (19)]: brilliant, saves mixing red with blue
Phthalo Blue (20): clear, very deep, cool; use with care
Ultramarine Blue (21): very warm, very granular
Cobalt Blue (22): clean, neutral, key to mixing many grays
Cerulean Blue (23): cool, rather opaque
Manganese Blue (24): very cool, granular, unusual mixer

This is Millard's typical twenty-four-color palette.

This is the palette Millard prefers for florals and tropical subjects. He substitutes Winsor yellow, cadmium scarlet, Venetian red, emerald green, and Winsor violet for their less vivid cousins.

David Millard

Getting to Know Your Colors: Mixing "Chickens"

Each of the palettes discussed on the previous pages involves its own set of mixing exercises designed to help familiarize you with the various colors.

The standard way to make color mixtures is to make a vertical stripe of every color on your palette, then cross them horizontally with the same combination of stripes so that every color mixes at some point with every other one, creating a little square where the stripes cross. But this method can be a bit dull and scientific; also, because the first set of stripes is always dry by the time the second set crosses it, you never get the exciting qualities that result from working wet-in-wet. Thus, Millard recommends mixing color "chickens" instead.

To mix color chickens, work on dry paper. Use two brushes, one in each hand; pointed bamboo brushes 1/2" (13 mm) in diameter are ideal, but any two medium-size (#9) round sable brushes, such as Winsor & Newton's Series 7, or nylon round brushes, will work. Wet both brushes and dip each one into a different color. Working from the head or tail of the chicken toward the center, let the two colors meet in the "body" area. For example, with the brush in your left hand, pick up some cobalt blue and apply it to the dry paper, working from the chicken "head" to the center, then pick up a rich glob of cobalt violet with your right-hand brush and, with a quick stroke, work from the "tail" into the center—and watch the colors explode!

Water and Pigment

Work near a sink so you can wash brushes and water bowl clean after each chicken. Or work with two water containers—a large bucket of tap water for rinsing your dirty brushes, and a smaller bowl of distilled water to mix with your colors. Never mix anything but distilled water with your paints; tap water has additives and rainwater contaminants that can affect your pigments' performance.

Mixing Area

You can mix your colors in one of the large wells on your palette, on a butcher's tray, or on a large, plain white dinner plate 6–8" (150–200 mm) in diameter with a flat rim. Squeeze your cool and warm colors on either side of the rim (such as a blue on the left and an earth hue on the right), or around the rim if there are several hues involved. You can either mix colors one with another directly on the paper as described above, or, for a different effect, premix them on your palette or in the center of the plate.

If you are mixing two colors together on a plate or palette, be careful not to over mix them. Pick up a color on each brush and mix them together in the center well of the plate or palette. Then clean your brushes and pick up a big slurp of the mixture and make a chicken. Finally, rinse your brushes in the bucket of water, wipe them on a clean rag, and wet them again in the smaller bowl of distilled water.

Make a Color Mix File

Create a file that will serve as a ready reference when you want to see in an instant how each of your colors mixes with the others. You will need a standard 8½ x 11" three-ring looseleaf notebook. The looseleaf format will permit you to remove specific pages for reference to solve a problem or to compare colors. It will also let you lay your pages flat, pull out a page or two to carry with you when sketching outdoors, or bring some blank pages for new mixtures when you're out in the field. Keep the notebook in a clear plastic bag to protect it when you travel.

Paper. For your mixtures, you can either purchase a good-quality watercolor paper or use the backs of unsuccessful paintings done on 140-lb. or heavier paper. Choose a paper with some rag content in it, as you'll want it to last several years. If you're using the back of an old painting, wipe off as much color from the image as you can with a damp cloth, then turn it over and use the clean side. Cut the paper into pieces that measure 8½ x 11" or smaller to fit your notebook, and, with a hole-puncher, make holes along one side to accommodate the ring binder.

Filing the Mixtures. Shown here are several examples of how to mix colors and combine them on a sheet. Do three rows of two-color mixtures—three across and three down—for a total of nine per sheet. You may prefer to keep separate pages for blue mixtures, for yellows, for reds, and so forth, and file them accordingly. But you can also group your mixtures like the examples shown here—into primaries, grays, darks, and general color mixtures.

Experimental Mixtures

Don't stop with the mixtures illustrated here. Try oranges and yellows mixed with blues and greens when you're out painting foliage. Mix the local color you see, then try some unusual combinations—colors you don't see—as a way of extending your color capabilities. For example, try cadmium orange and cobalt violet for that strange fall grass color that seems so elusive; or try cadmium orange with cadmium red, then cadmium orange with burnt sienna, for the effect of leaves turning from sunlight into shadow. Also try some oddball combinations, like Naples yellow with permanent rose, or manganese blue with viridian, or alizarin crimson with Davy's gray. Different brands of paint have their own distinctive color qualities and consistency, and perform variously in mixtures; thus, experiment with several brands of the same color for a range of effects.

When you know how two colors work together, try mixtures of three and four colors. Mixing color is great fun, and when you expand your color range, it is like moving from the subtle tones of a string quartet to a full orchestra playing a twenty-four-color Beethoven symphony.

Mixing Grays

Grays form an important part of your color repertoire. Bright colors appear more brilliant when surrounded by gray tones. Grays will also tone down some of your brighter mixtures when added to them. Keep your paper on a slant so your colors remain clean, and don't poke back into these wet-in-wet mixtures or they'll get muddy.

The set of gray mixtures shown on the next page, of three blues and three earths, will start you on your collection of grays. As you progress, you will be making color-file pages of more grays from new colors and adding them to your palette. But learn these first.

Mixing Darks

How often do you hear painters ask, "How do you get really dark colors?" or "How do you keep dark colors clear?" Well, here are some really dark colors for your color-file pages. As long as you keep your paper at a slant as you apply them, dark colors will remain both clear and deep.

These colors are all very heavily pigmented (that is, loaded with paint). You might experiment with lesser amounts of pigment to find out just how deep a tone is required in a painting, because these darks are very intense; seeing them out of context, you cannot really judge how they would look in relation to the values in a particular painting. Whenever you add an accent to a watercolor, be careful that your color-values work in relation to the other hues. Too strong a dark will punch a hole in your painting. Test the mixture first on the side of your painting or on a piece of scrap paper before you commit yourself.

Combining Strong and Weak Hues

As you mix one color with another, you will note that there is sometimes a chemical reaction between them. You might want to make a note as to which of the two colors in a mixture is the more aggressive or overpowering, or observe what happens when colors of equal strength are mixed.

When two aggressive colors mix wet-in-wet, the result is an almost violent reaction, like an explosion. Combine strong colors in your more emotional compositions, or wherever you want more vitality, more exciting brushwork. Your viewer will pick up this quality.

MIXING PRIMARIES

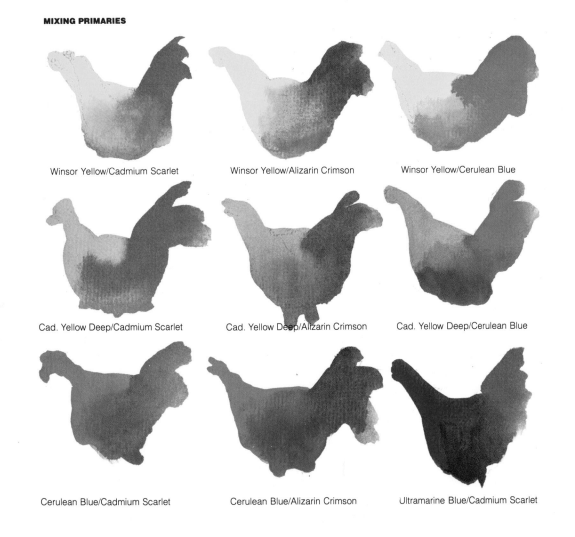

Winsor Yellow/Cadmium Scarlet

Winsor Yellow/Alizarin Crimson

Winsor Yellow/Cerulean Blue

Cad. Yellow Deep/Cadmium Scarlet

Cad. Yellow Deep/Alizarin Crimson

Cad. Yellow Deep/Cerulean Blue

Cerulean Blue/Cadmium Scarlet

Cerulean Blue/Alizarin Crimson

Ultramarine Blue/Cadmium Scarlet

MIXING GRAYS

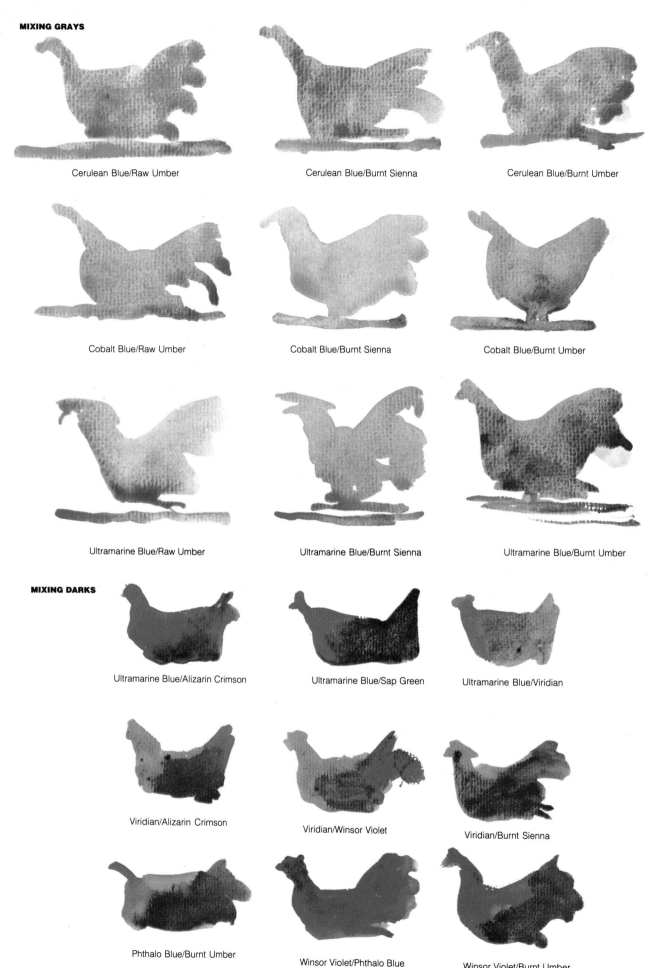

Cerulean Blue/Raw Umber

Cerulean Blue/Burnt Sienna

Cerulean Blue/Burnt Umber

Cobalt Blue/Raw Umber

Cobalt Blue/Burnt Sienna

Cobalt Blue/Burnt Umber

Ultramarine Blue/Raw Umber

Ultramarine Blue/Burnt Sienna

Ultramarine Blue/Burnt Umber

MIXING DARKS

Ultramarine Blue/Alizarin Crimson

Ultramarine Blue/Sap Green

Ultramarine Blue/Viridian

Viridian/Alizarin Crimson

Viridian/Winsor Violet

Viridian/Burnt Sienna

Phthalo Blue/Burnt Umber

Winsor Violet/Phthalo Blue

Winsor Violet/Burnt Umber

30

COMBINING STRONG AND WEAK HUES

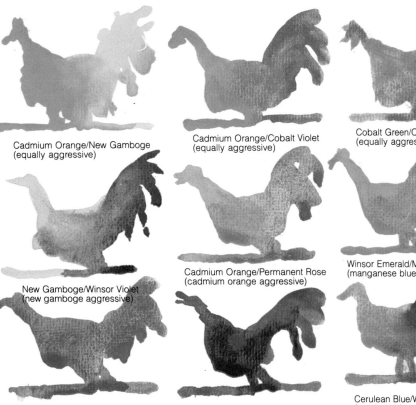

Cadmium Orange/New Gamboge
(equally aggressive)

Cadmium Orange/Cobalt Violet
(equally aggressive)

Cobalt Green/Cobalt Violet
(equally aggressive)

New Gamboge/Winsor Violet
(new gamboge aggressive)

Cadmium Orange/Permanent Rose
(cadmium orange aggressive)

Winsor Emerald/Manganese Blue
(manganese blue aggressive)

Cobalt Blue/Cobalt Violet
(cobalt violet very aggressive)

Ultramarine Blue/Burnt Sienna
(burnt sienna very aggressive)

Cerulean Blue/Winsor Violet
(cerulean blue very aggressive)

EXPERIMENTAL MIXTURES

Cerulean Blue/Cadmium Scarlet

Cerulean Blue/Alizarin Crimson (tint)

Cobalt Blue/Winsor Violet (tint)

Cerulean Blue/Winsor Emerald

Manganese Blue/Sap Green

Ultramarine Blue/Venetian Red (tint)

Naples yellow/Permanent Rose

Raw Sienna/Cobalt Violet

Cadmium Orange/Sap Green (tint)

31

Jeanne Dobie

The Pure Pigment Palette

Getting to know as much as possible about pigments and their "personalities" is important to any artist, and even more so to a watercolorist. Pigments, like people, have different idiosyncrasies. Some perform well in certain jobs and not at all in others. Take the time to become acquainted with your pigments. They can be your friends or enemies, depending on how well you know their characteristics.

Surprisingly, the following remark was made by an experienced artist: "I ran out of cadmium red. Oh, well, I'll use alizarin crimson. One red is as good as another." Wrong! Cadmium red is semiopaque, while alizarin crimson is transparent. Alizarin crimson is also a staining pigment—if you make a mistake, it is there forever.

Color involves much more than the name on the tube. Learn to distinguish the behavioral differences of pigments. Not all pigments are transparent, not all are equal in intensity, not all have "carrying power," not all are permanent, and not all can be corrected. Most important, not all pigments mix well.

Pure Colors

Liquid, fresh color that does not become opaque or "muddy" is the transparent watercolorist's goal. Contrary to common belief, this result does not depend wholly on the use of transparent pigments. Jeanne Dobie's secret is the use of pure color pigments, meaning pigments without any color additives and as close to the raw state as possible. The illustrations opposite and on the next page show her personal color choices, selected for the greatest mixing possibilities.

A pure pigment palette gives you more control over your color mixtures. You have at your command raw, potent pigments that will mix into any color imaginable. Gone is the frustration of struggling with a premixed commercial color that you can't seem to make vibrant enough. With a knowledge of mixing, you no longer need to purchase a large assortment of tube paints. Because of their mixing versatility, you can take pure pigments with you anywhere in the world and capture the unique lighting of any location.

Freedom from Formulas

Jeanne Dobie's palette is uncomplicated. The colors are simply divided into two categories: basic and occasional use. There are no formulas, no limitation to specific color schemes like triads. Without becoming confused or restricted by rules about which color belongs with which, you can begin immediately with the "basic" colors and paint all the way through to darks.

Transparent or Opaque?

As you explore the personalities of your pigments, you'll discover why some colors are more helpful than others in achieving your goals. Are you, for example, interested in

capturing the effect of light, which is an inherent potential of watercolor? This illusion is best expressed through transparent pigments. Because transparent colors permit the greatest amount of light to pass through to the paper, reflecting back to the viewer, they impart luminosity. Moreover, they remain transparent when mixed together—so there's no mud. This is why it's best to use the transparent pigments in the "basic" column as much as possible, especially in beginning a watercolor.

If you begin a watercolor with opaque pigments, you'll lose the effect of light. Opaque pigments are denser and heavier, which greatly reduces the amount of light transmitted through to the paper. Due to this "thickness," an opaque pigment does not mix well with another opaque color; it only becomes thicker. If you mix two opaque pigments together, you are flirting with a muddy mixture. Should you mix three opaque pigments together, the result may be too lifeless to call a watercolor.

With so many disadvantages, why include opaque pigments in your palette at all? They are listed in the "occasional use" column with the hope that they will be considered separately from the basic palette. Although inadequate for many jobs, they can be indispensable in mixing certain colors, chiefly the green mixtures. When Dobie uses an opaque pigment for mixing, however, she combines it with a transparent pigment whenever possible, aiming to avoid the thick blanket built up by two opaques. Occasionally she may use an opaque pigment alone.

Staining Pigments

Staining is a characteristic of the stronger transparent pigments: alizarin crimson, Winsor blue, and Winsor green. Although transparent, these pigments are tenacious—they stain and remain in the paper. They are also powerful—almost twice as powerful as other pigments.

To counteract this power when mixing the staining transparents with other colors, the secret is to generously dilute them. Try to start with the weaker pigment and add the stain a little at a time rather than vice versa. If you blend in reverse, you waste a lot of paint, for the staining pigment continues to dominate the mixture. On the other hand, undiluted, the enormous strength of these colors makes them an excellent choice for darks that are both rich and transparent. And if you need a special brilliant effect, a staining pigment will do the job.

Aim for Carrying Power

Just because a pigment is transparent, don't assume it will mix cleanly or look glowing and vibrant. Find out about its personality first. At the bottom of the "occasional use" column are two tertiary pigments: raw sienna and burnt sienna. Because tertiaries (the umbers and siennas) are not pure pigments, they do not mix well. They lean "optically"

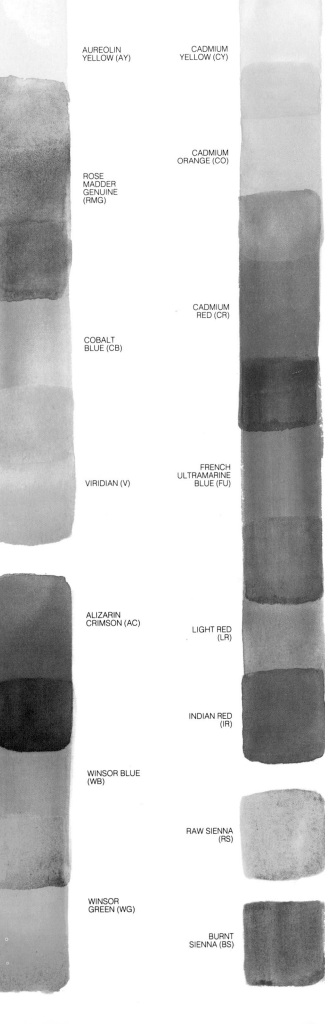

Basic (transparent)
This column contains the pure pigments that Jeanne Dobie uses predominantly. All are transparent, and they mix beautifully—as you can see where they overlap. With pure pigments, you don't need to purchase a large selection of tube paints.

AUREOLIN YELLOW (AY)

ROSE MADDER GENUINE (RMG)

COBALT BLUE (CB)

VIRIDIAN (V)

Vivid, staining transparents

Use these pigments full force for rich darks. Dilute them for light values or for mixtures with the basic transparent pigments.

ALIZARIN CRIMSON (AC)

WINSOR BLUE (WB)

WINSOR GREEN (WG)

CADMIUM YELLOW (CY)

CADMIUM ORANGE (CO)

CADMIUM RED (CR)

FRENCH ULTRAMARINE BLUE (FU)

LIGHT RED (LR)

INDIAN RED (IR)

RAW SIENNA (RS)

BURNT SIENNA (BS)

Occasional use (semiopaque)
These pigments can be added to a transparent pigment to obtain a particular desired color. Beware of mixing two of these pigments together, however, for the result is a heavy, opaque buildup—as you can see where the colors overlap here.

Very opaque
Indian red is in a class by itself. Because of its housepaint consistency, Dobie uses it only sparingly in mixtures.

Tertiaries
These pigments are optional. Although transparent, they are not high-chroma pure pigments. They lean optically toward their complements, so they do not mix well and are best used alone.

BURNT SIENNA

RAW SIENNA

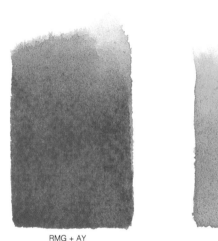

RMG + AY AY + RMG

Alternatives for Tertiaries

For glowing color, mix the pure pigments rose madder genuine and aureolin yellow to approximate burnt sienna and raw sienna. Because the pigments burnt sienna and raw sienna lean heavily toward their complements, the color dulls, resulting in a loss of carrying power.

toward their complements and, as a result, are muted. Therefore, any color you add to a tertiary pigment will only increase the effect of the complement. Mixing two complements together produces a gray. Thus, any time you add another color to a tertiary pigment, you obtain a grayed mixture.

Also, since a tertiary color is not a bright pure pigment, it loses its strength at a distance, dulling in brilliance beyond ten feet. For the greatest glow or carrying power, select a pure pigment mixture of rose madder genuine and aureolin yellow. This combination approximates burnt sienna, but glows at a distance. In fact, because she gets more satisfactory results by substituting these two colors with alterative mixtures, Jeanne Dobie no longer includes raw sienna and burnt sienna in her palette.

Selecting a pure pigment palette is just the start of achieving glowing, vibrant watercolors. You need to learn about color relationships to use colors successfully.

"Mouse" Colors

Colors are like jewels: Each should be placed as carefully as a precious gem in a setting. The proper setting makes the jewel glow and enhances its qualities. Only when you are not aware of the setting, however, is it performing its job well, which is to remain subtle and not overpower the jewellike colors. To form the setting, then, you need what Jeanne Dobie calls quiet, "mouse" colors in your paintings.

A painting filled with exquisite colors that compete with one another will remain unsuccessful, because the viewer's eye becomes confused and is unable to enjoy one color over another. To complement the pretty colors, you need unpretty colors—"mouse" colors, the nonbrilliant mixtures, the bit players who support the stars.

Learn to Use Complements

To help you develop a vocabulary of mouse color, you should understand about complements, the pigments that produce grays. From grade school on, the complements are taught as colors that lie opposite each other on a color wheel. An easier way to remember the complements is this: The complement of the primary blue is simply the remaining two primaries mixed. Yellow plus red produces orange, which is the complement of blue. Try yellow next: The remaining two primaries are red and blue. Mixed together they become violet, which is the complement of yellow. The third primary color is red. Simply mix the other two primaries, yellow plus blue for the complement, which is green.

How to Remember Complements

YELLOW PRIMARY

PURPLE COMPLEMENT

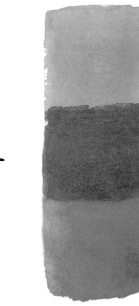

The complement of yellow, red, or blue is a mixture of the two remaining primaries.

RED PRIMARY

GREEN COMPLEMENT

BLUE PRIMARY

ORANGE COMPLEMENT

Achieving Luminous Grays

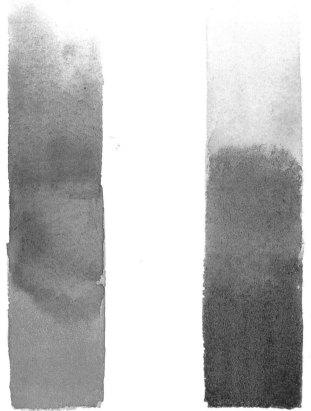

Mixing complements gives you a variety of luminous grays.

In the art of mixing, any time you combine a primary with its complement, the two pigments tend to "cancel" each other out. In other words, they produce a gray. Distinctive grays are at your brush tip waiting to be mixed. Those made from the pure pigments Jeanne Dobie recommends are clear and free of sediment, and unlimited in range.

A good repertoire of grays is essential to landscape painting. The secret is to think of grays not as neutrals, but as an entire spectrum of grays. Neutral means that a gray is not too warm, not too cool, not too yellow, blue, or red, but right in the middle, exactly mixed. But a perfectly neutral mixture can be lifeless, because it is too equal to have a reaction against another color. You want to mix cool grays, reddish grays, and soft, warm grays—grays with subtle nuances that are a joy to the senses.

Compare Lifeless and Luminous Grays

To discover the difference between lifeless and luminous grays, first mix an undesirable neutral gray from aureolin yellow, rose madder genuine, and cobalt blue, using equal parts of each. It requires a bit of mixing to achieve a gray that is not too warm or too cool, or too red, yellow, or blue. Use your knowledge of complements to achieve this result. If your mixture becomes too yellow, add more blue plus red (the violet complement) to gray the color. Should it look green, simply add some red to cancel the green. If it turns orange, add a little blue to neutralize it.

Now turn that perfectly equal but neutral gray into a

variety of luminous grays. The secret is to keep the ratio of pigments in the mixture unequal. Following the illustration at right, paint sample squares of six mixtures, leaving the center of each square unpainted for the time being.

1. Begin by adding more blue pigment to your neutral gray mixture and watch it become a cool gray. Now paint a square with this first gray, remembering to leave the center unpainted.

2. Add a little rose madder genuine to the gray mixture in which the blue is dominant. This transforms it into a lavender-gray.

3. Adding still more rose madder genuine gives it a soft, warm glow, for another gray sample.

4. Now try adding yellow to produce and earth-tone gray (tan).

5. Make another sample by pushing more yellow into the gray and watch it become warmer.

6. Even more yellow plus blue gives you a cool green-gray.

Before you finish this exercise, take a moment to notice that each square is a different, subtle gray. None is neutral. By adding a little more of one color or less of another, you can mix the same three transparent pigments in different ratios for endless variations of beautiful grays. In addition, all the grays can be varied even further by the amount of water

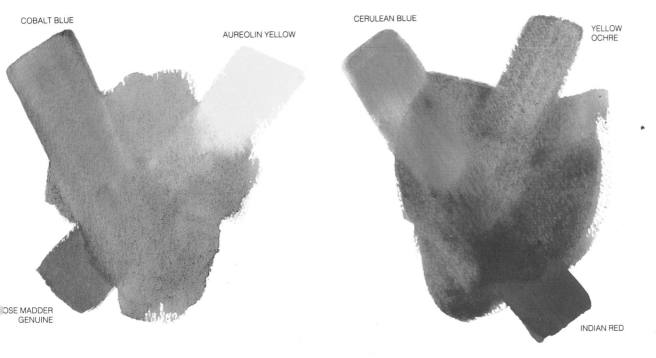

COBALT BLUE

AUREOLIN YELLOW

CERULEAN BLUE

YELLOW OCHRE

OSE MADDER GENUINE

INDIAN RED

When three transparent pigments are mixed in equal amounts, they yield a dull neutral.

Combining three opaque pigments gives you mud.

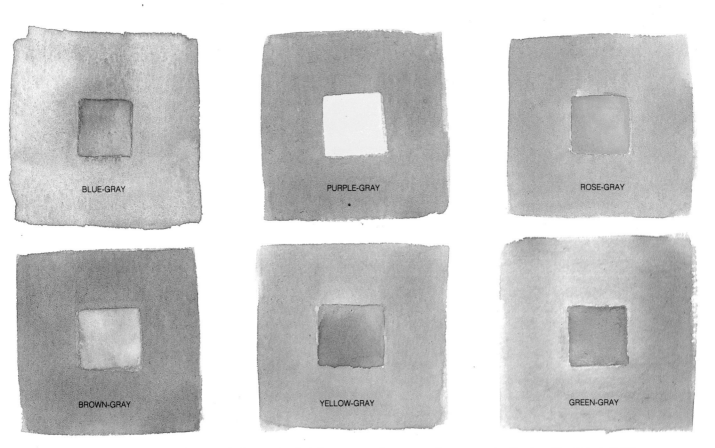

BLUE-GRAY

PURPLE-GRAY

ROSE-GRAY

BROWN-GRAY

YELLOW-GRAY

GREEN-GRAY

The secret of luminous grays is unequal mixtures. Look at these squares from across the room and notice how the centers vibrate.

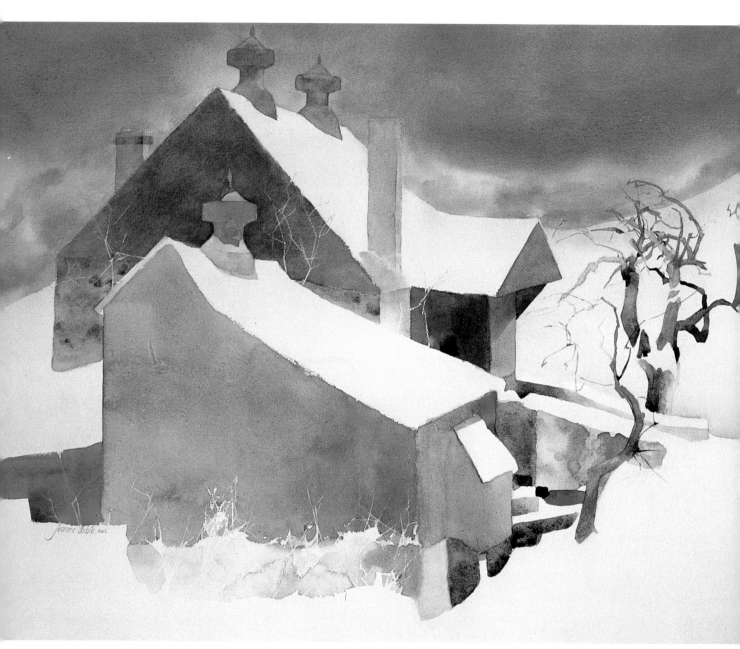

CURLEY'S BARN
Watercolor on Arches 140-lb. cold-pressed paper, 21 × 27" (53.3 × 68.6 cm).

added—less water for darker grays, more water for lighter grays. Beware of opaque pigments, however—especially if three are combined—for they cannot duplicate the same luminous, clear gray.

Now return to the white square left in the center. Each gray square is a setting just waiting for a color gem to be dropped into it. For each gem, select a color that is a complement of the dominant color in each gray. Start with the blue-gray square. The complement of blue is red plus yellow, or orange, so paint a luscious orange color in the square and watch the color vibrate. The purple-gray square might receive a golden jewel. The complement for the rose-gray square is a cool green. The warm, earth-tone square is complemented by a true blue; and so on.

The Power of Grays

To discover how beautiful grays can enhance your painting vocabulary, do a watercolor using grays from each of the following categories:

1. Grays mixed from the three transparent primaries: cobalt blue, rose madder genuine, and aureolin yellow.

2. Grays mixed from complementary colors, such as viridian and rose madder genuine or cobalt blue and cadmium orange.

3. Grays diluted with water—for distant and light hues.

4. Grays that are saturated with pigment (and have very little water)—for darker tones.

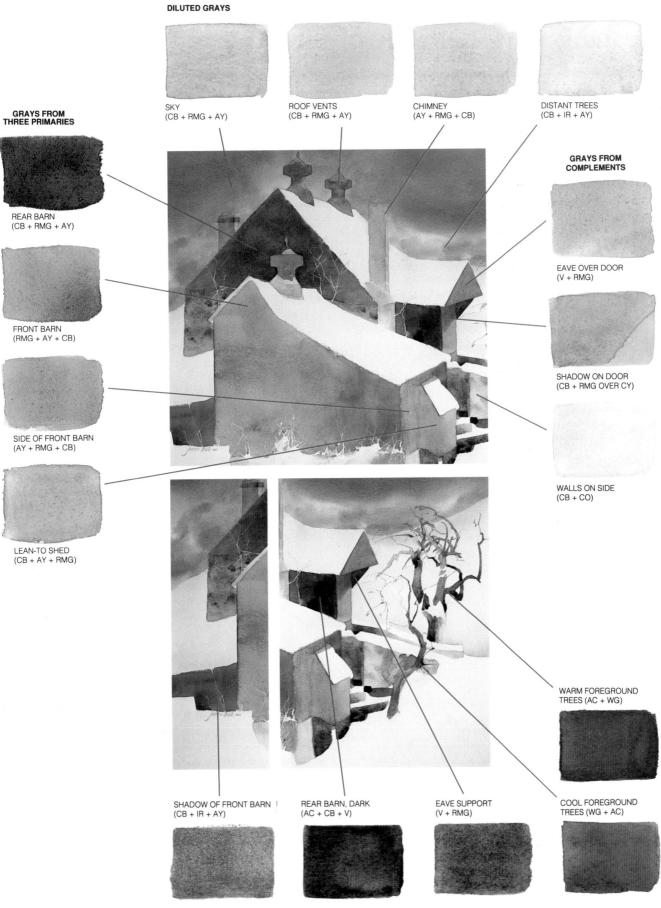

DILUTED GRAYS

SKY
(CB + RMG + AY)

ROOF VENTS
(CB + RMG + AY)

CHIMNEY
(AY + RMG + CB)

DISTANT TREES
(CB + IR + AY)

**GRAYS FROM
THREE PRIMARIES**

REAR BARN
(CB + RMG + AY)

FRONT BARN
(RMG + AY + CB)

SIDE OF FRONT BARN
(AY + RMG + CB)

LEAN-TO SHED
(CB + AY + RMG)

**GRAYS FROM
COMPLEMENTS**

EAVE OVER DOOR
(V + RMG)

SHADOW ON DOOR
(CB + RMG OVER CY)

WALLS ON SIDE
(CB + CO)

SHADOW OF FRONT BARN
(CB + IR + AY)

REAR BARN, DARK
(AC + CB + V)

EAVE SUPPORT
(V + RMG)

WARM FOREGROUND
TREES (AC + WG)

COOL FOREGROUND
TREES (WG + AC)

SATURATED GRAYS

Jeanne Dobie

Facing the Challenge of Green

Greens are probably the most challenging of all colors to mix. Do your attempts to make greens result in dull, grayed mixtures? Or do your greens become thick and chalky from overmixing? Even when a bright green is finally attained, does it seem too artificial for a landscape green? Sadly, some watercolorists solve the problem by avoiding the use of green altogether. But if you skirt around greens with substitutes, then you are missing out on some distinctive colorings. The secret to conquering greens is the choice of pigments and the sequence in which the colors are mixed.

Bring Greens to Life

What are the best pigments to mix with green? Jeanne Dobie recommends that you start with aureolin yellow, which is very transparent. Many students reach for yellow ochre to mix in their greens, believing it is a natural landscape or earth-tone yellow. But yellow ochre is an opaque color and as such reduces the amount of light reflecting through it. Greens made with yellow ochre are not as luminous as greens made with aureolin yellow.

The mixing sequence and ratio now become vital. To counteract the cool effect of viridian, dip your brush into aureolin yellow and mix it with viridian before continuing. Try to keep this mixture as luminous as possible. This basic batch of color is transparent, warm, and bright—too bright, actually, for many greens in nature.

The next step is to slightly modify the intensity of, or "naturalize," the basic mixture. Add some red—but only a small touch. Again, the ratio is important. If you use too much red, the green mixture becomes dull and grayed, because red is the complement of green. Try to avoid the mistake of adding as much red as yellow, for you will be disappointed with the result.

Now explore all the beautiful greens you can make by adding different red pigments, as shown in the illustration opposite. To the basic batch of vibrant green, add a portion of rose madder genuine. See how easily the mixture is transformed into a natural landscape green. Because rose madder genuine is very transparent, the green mixture always remains transparent, without danger of becoming mud.

Light red is Dobie's favorite pigment for changing the basic green into richer, warmer variations. The greatest variety of greens—spinach, olive, and rich, earth-tone greens—can be made with this pigment. If you need a deeper green, cadmium red is a good choice. Indian red also gives you a darker green, but one that is grayer. Since alizarin crimson is a very cool red, reserve it for a very cold, dark green.

As you can see, it is not always the colors used but the way they are used. For colorful greens, develop a habit of adding yellow and green together first, then naturalizing the basic mix with a small amount of red.

For an inventory of even richer, deeper greens, use the same mixing procedure but substitute Winsor green for viridian. Because Winsor green has more carrying power than viridian, it gives you very transparent darks. It also stains the paper, but since most darks are added as the watercolor is completed, the dark areas are already known.

This time, establish a vivid basic mixture using aureolin yellow and Winsor green. With the exception of rose madder genuine, add different red pigments as before to naturalize the green. (Because Winsor green is highly saturated and stronger than most pigments, it would be foolish to mix the weaker rose madder genuine with it.) Make a middle-value mixture using light red, followed by darker mixtures with cadmium red and with Indian red, which yield yet more greens. For the absolutely darkest green possible, add alizarin crimson. Although the transparent aureolin yellow has little effect in deepening the dark mixtures, it will enrich the result and prevent the greens from looking lifeless. Since aureolin yellow is transparent and not a complement, it won't muddy the darks.

You can multiply the number of greens yet again. Eliminating the aureolin yellow in all the mixtures mentioned provides much cooler greens. To do this, simply modify viridian with a small amount of rose madder genuine (without any aureolin yellow) or vary it with light red or cadmium red or Indian red. The greens mixed with Winsor green can also be dramatically deepened by eliminating aureolin yellow altogether.

Notice that no more than three colors have been used to mix the greens. Don't add a fourth pigment, for it obscures the reflective quality of the white paper and results in a sullied mixture.

What About Blue and Yellow?

It may seem incredible that there is a better way of making greens than the usual mixture of blue and yellow, but the ratio of warm and cool in your mixes is of the essence. With the ordinary method of mixing blue and yellow, the green color is half warm yellow and half cold blue. If, instead, you start with viridian, which is half blue and half yellow, and add an equal amount of yellow (warm) plus some red (warm), the blue or cool content is drastically reduced. The result is greens that are kept warm and lively. This knowledge is especially valuable when you're mixing darker greens so that the color remains rich, not dead-looking.

Naturalize the basic transparent green mixture (viridian plus aureolin yellow) with red pigments for bronze-toned greens.

 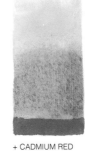

VIRIDIAN
+ AUREOLIN YELLOW

+ ROSE MADDER
GENUINE

+ LIGHT RED

+ CADMIUM RED

+ INDIAN RED

For richer greens, add reds to a green mixed from Winsor green and aureolin yellow.

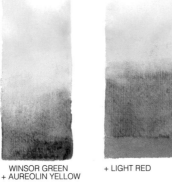 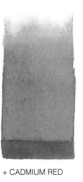

WINSOR GREEN
+ AUREOLIN YELLOW

+ LIGHT RED

+ CADMIUM RED

+ INDIAN RED

+ ALIZARIN
CRIMSON

Vary transparent viridian with reds.

VIRIDIAN

+ ROSE MADDER
GENUINE

+ LIGHT RED

+ CADMIUM RED

+ INDIAN RED

Finally, enrich transparent Winsor green with reds for the darkest greens.

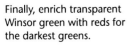 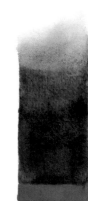 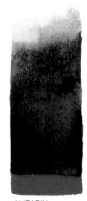

WINSOR GREEN

+ LIGHT RED

+ CADMIUM RED

+ INDIAN RED

+ ALIZARIN
CRIMSON

Personalize Your Greens

To develop a repertoire of your own distinctive greens, experiment with mixing and then choose a scene that invites you to color it green. Just look at Jeanne Dobie's painting *Erin Drumhills*. What country could be better than Ireland for inspiring greens? Here the artist purposely placed the stone wall in the center of the composition as a challenge. Notice how the wall leads the eye through the velvety green hills, which are the center of interest. Working with a vast panorama like this gives you an opportunity to observe how greens are affected by light and space. Even the sky must be considered. The trick in *Erin Drumhills* was to mix a gray-green sky without making it "look" green—using the subtle power of grays.

As you paint your own landscape, see if you can make the brightest, most intense greens the center of interest. Try to make your greens slightly grayer or cooler in the distance. Then mix as many other greens as you wish for the rest of the scene. How refreshing it is to see a painting without the same familiar greens in the foreground, middle ground, and background.

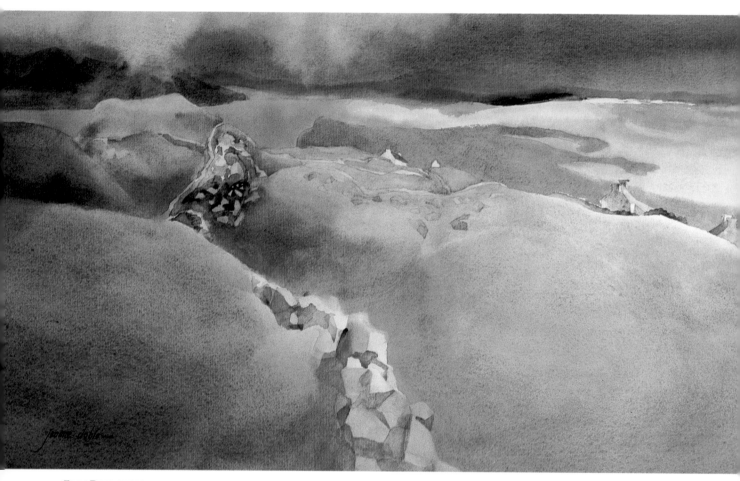

ERIN DRUMHILLS
Watercolor on Arches 140-lb. cold-pressed paper, 14 x 29" (35.6 x 73.7 cm).

The Many Colors of Green

(WG)

(AY + WG)

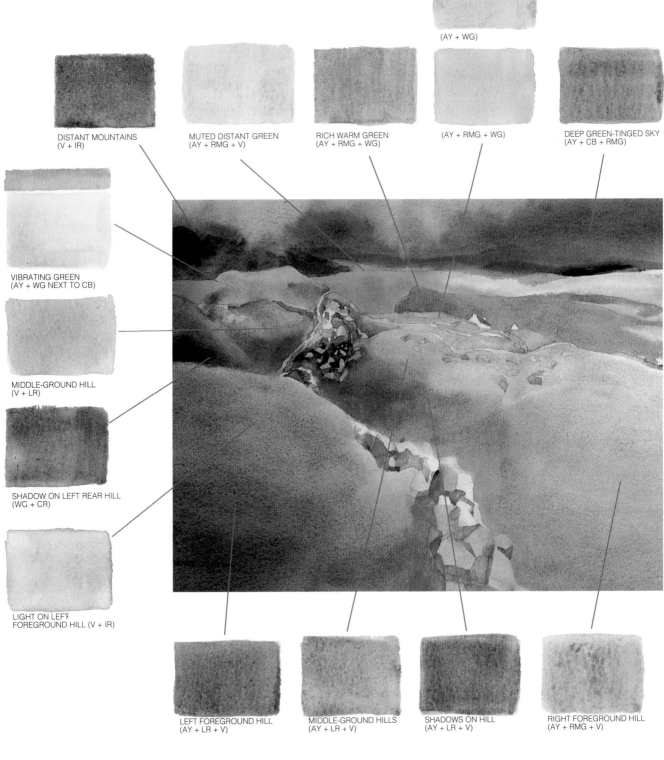

DISTANT MOUNTAINS
(V + IR)

MUTED DISTANT GREEN
(AY + RMG + V)

RICH WARM GREEN
(AY + RMG + WG)

(AY + RMG + WG)

DEEP GREEN-TINGED SKY
(AY + CB + RMG)

VIBRATING GREEN
(AY + WG NEXT TO CB)

MIDDLE-GROUND HILL
(V + LR)

SHADOW ON LEFT REAR HILL
(WG + CR)

LIGHT ON LEFT
FOREGROUND HILL (V + IR)

LEFT FOREGROUND HILL
(AY + LR + V)

MIDDLE-GROUND HILLS
(AY + LR + V)

SHADOWS ON HILL
(AY + LR + V)

RIGHT FOREGROUND HILL
(AY + RMG + V)

Jeanne Dobie

Getting the Most from Darks

Can darks be luminous, bright, and powerful all at the same time? Yes—if you mix them from pure pigments instead of relying on ivory black, Payne's gray, or other purchased colors. Darks should do more than supply a dark value. They are the catalysts for the effect of light. The function of a dark color is to complement the light and help it emit a glow. That means that a dark should not only provide a contrast, but also animate the light. This enlivening quality is effected through the complements.

As discussed previously, when complements are mixed together in equal amounts, they cancel each other out and produce an undesirable gray. If, however, you do not mix them but place them side by side, each enhances the other. To make a light color brighter, try choosing a dark that is the complement of the light. The problem with choosing an ordinary black pigment or just any dark color is that you limit yourself to merely a strong contrast. But if you make the dark color a complement, you immediately create a reaction that transforms the light into a radiant light.

Jeanne Dobie includes no browns, blacks, or purples on her palette because she prefers to mix her own darks from pure pigments. The result? Mixes that are glowing, alive, and contain enormous strength. Her darks are *colorful* darks. To duplicate these powerful darks, look to the staining pigments alizarin crimson, Winsor blue, and Winsor green. No other pigments compare with the strength of these staining colors—and they have enormous carrying power, with an electric effect that can pulsate beyond ten feet.

Amazingly, they remain transparent in spite of their great saturation, making them excellent choices for intense, vibrant darks.

Potent Blues and Purples

To enliven an orange-toned light, you need a deep blue. To make a potent dark blue, slide your brush into Winsor blue. Notice that the color is too powerful in its raw state; it needs naturalizing. Add some Indian red to modify it to a more acceptable dark blue. Sometimes this color looks more natural in a landscape painting than a bright, dark blue.

Another, slightly different dark blue can be made by adding cadmium red to Winsor blue to naturalize the blue. Now mix Winsor blue with a little alizarin crimson. Notice that the result is a more intense dark blue than in the previous mixtures. The reason for this added vibrancy is that the Winsor blue and alizarin crimson are both transparent staining pigments, while Indian red and cadmium red are opaques. Increasing alizarin crimson to an equal amount in the mixture gives you a bright, dark purple choice.

Now start with ultramarine blue, which is very slightly opaque, to discover another range of dark blues. Modify it as you did Winsor blue, with Indian red, cadmium red, or alizarin crimson. Once again, the brilliance of alizarin crimson produces the brightest dark blue. Now reverse this mixture, using more alizarin crimson, for a rich, dark purple. All the dark purple mixes are great foils for golden glows.

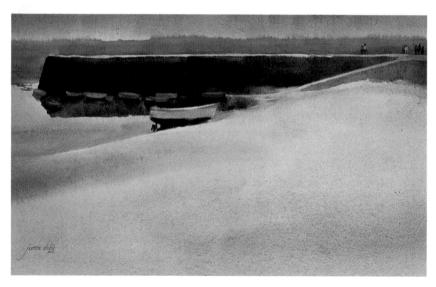

QUIBERON HARBOR
Watercolor on Arches 140-lb. cold-pressed paper, 12½ × 21" (31.7 × 53.3 cm).

Darks don't have to be drab and unexciting. Think of darks as colors that can enliven your paintings and turn the lights into something special. Here, for instance, the greenish shadow cast by the pier reacts with the pinkish sand to make the colors glow.

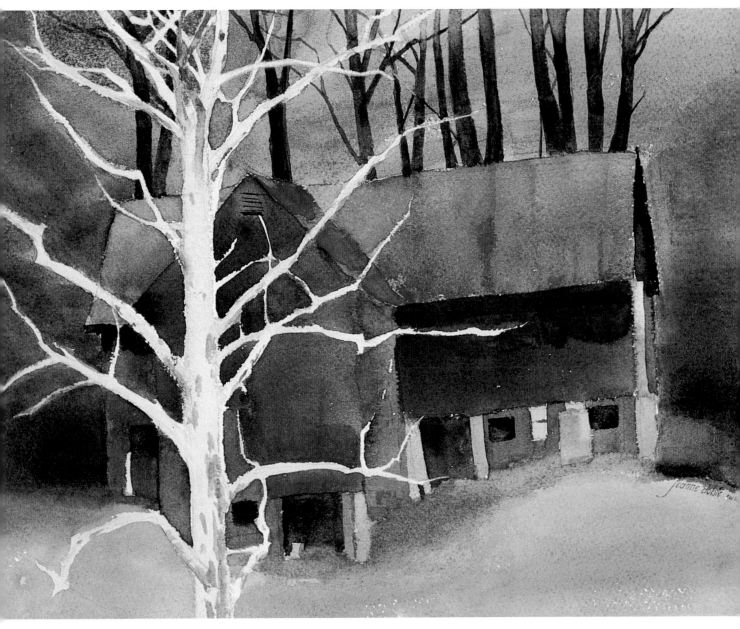

HILLCLIMB FARM
Watercolor on Arches 140-lb. cold-pressed paper,
11 × 15" (27.9 × 38.1 cm).

Although this is a "dark" painting, it has a lot of color. In your next watercolor, make your darks varied and rich colors.

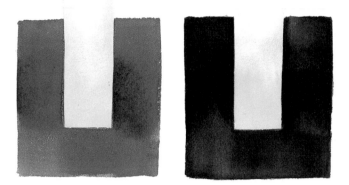

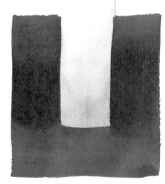

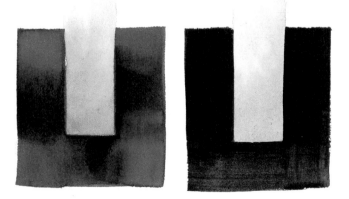

Darks should be a catalyst for lights. Again, the secret is the interaction of complements. Use these examples as a guide and explore other possibilities.

Velvet Blacks

For the deepest velvet black mixture possible, one that outshines any purchased pigment, mix alizarin crimson with Winsor green. Because both pigments are staining and transparent, you get a particularly lustrous dark. Very subtle black variations can be made by changing the ratio. Using more alizarin crimson than Winsor green produces a warmer black, while adding more Winsor green than alizarin crimson yields a colder, seemingly deeper black.

These subtle variations are particularly useful in figure painting, because they can help you describe form. And, variations of the rich, velvet dark made from Winsor green and alizarin crimson complement skin tones exquisitely. Pale pink or red tones can be accented by a cooler mixture (predominantly green), and golden skin tones by a warmer mixture (predominantly alizarin crimson). To see some other possible darks made with Winsor green, look back at the section on greens.

Clean, Clear Browns

The very same pigments used to mix greens can also be used to make a variety of eye-pleasing browns. Again, it's not just the colors you use; it's the way they are mixed.

If you use the pure pigments Jeanne Dobie uses, your brown mixtures will be transparent, free of sediment, and certainly not dull. The secret is to establish a basic orange mixture. Start with aureolin yellow on your brush and add rose madder genuine. Once the basic orange is established, carefully add viridian until the mixture turns a lovely soft brown. This brown is on the light side. Introducing more water then produces a variety of soft tans and earth tones.

Next make a middle-value brown by selecting light red and mixing it with aureolin yellow. When this orange color satisfies you, add viridian, mixing it until you arrive at a bronze brown. Now load your brush boldly with more of each pigment to produce richer browns. Don't worry about the mixture becoming muddy. Aureolin yellow and viridian are transparent and outweigh the addition of opaque light red. Develop still another brown with cadmium red mixed in the same manner.

For a deeper, cooler brown, try Indian red added to aureolin yellow. Indian red is a very opaque pigment, bordering on housepaint consistency, so add it gingerly to the transparent aureolin yellow to avoid overpowering the yellow. Produce an orange mixture first, then add viridian. You'll gain a cooler brown. Invent golden browns by increasing the amount of aureolin yellow in any of the mixtures, or add more red to create warm, reddish browns.

Add alizarin crimson to your blue for a bright, dark hue. Then reverse the ratio for an entirely different dark from the same pigments.

WINSOR BLUE +
ALIZARIN CRIMSON

PIGMENTS
REVERSED

FRENCH
ULTRAMARINE BLUE
+ ALIZARIN CRIMSON

PIGMENTS
REVERSED

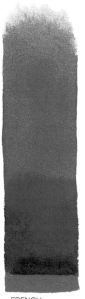

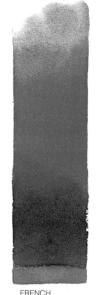

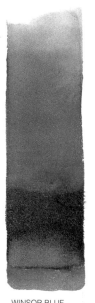

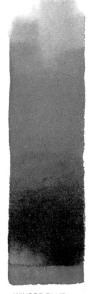

For a modified dark blue, add a small amount of an "occasional use" opaque, such as cadmium red or Indian red, to Winsor blue or French ultramarine blue. Here, though, don't bother to reverse the ratios, because the opaque pigment will overpower the mixture, leaving a dull, lifeless dark.

FRENCH
ULTRAMARINE BLUE
+ CADMIUM RED

FRENCH
ULTRAMARINE BLUE
+ INDIAN RED

WINSOR BLUE
+ CADMIUM RED

WINSOR BLUE
+ INDIAN RED

A mixed black is richer than any commercial pigment. Use transparent Winsor green and alizarin crimson. Experiment with different ratios for warm or cool blacks.

For natural dark greens, modify Winsor green with an "occasional use" red. Again, reversing the ratios is not advised, because the opaque pigment will dominate and dull the final dark.

ALIZARIN CRIMSON
+ WINSOR GREEN

PIGMENTS
REVERSED

WINSOR GREEN
+ CADMIUM RED

WINSOR GREEN
+ INDIAN RED

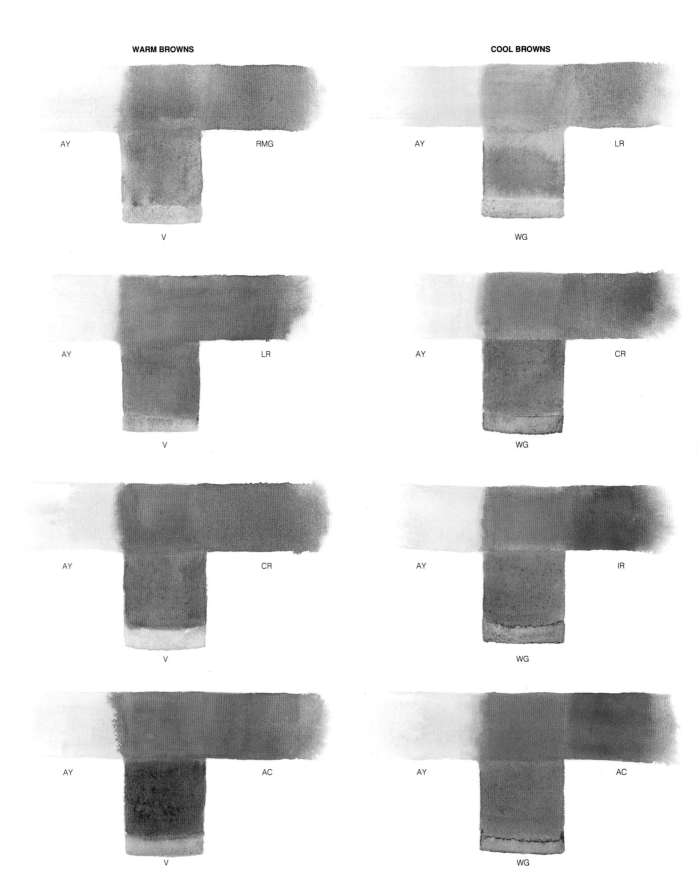

WARM BROWNS

AY RMG

V

AY LR

V

AY CR

V

AY AC

V

COOL BROWNS

AY LR

WG

AY CR

WG

AY IR

WG

AY AC

WG

Browns made with pure pigments are transparent and alive. Begin with an orange mixture; then add viridian for a variety of warm browns or Winsor green for cooler browns. Only some of the possibilities are illustrated here.

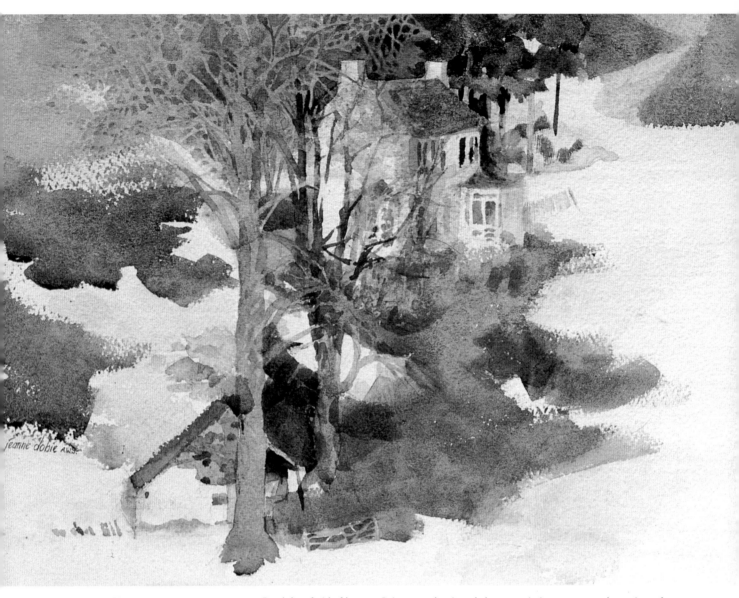

BRANDYWINE VALLEY
Watercolor on Arches 140-lb. cold-pressed paper, 11 × 15" (27.9 × 38.1 cm).

Don't be afraid of brown. Paint a predominantly brown painting to try out the variety of new mixtures you have discovered.

An even richer brown is begun with alizarin crimson (a staining pigment) and aureolin yellow. The resulting vibrant orange may make this one of your favorite brown mixtures. Now add viridian. If you keep your brush saturated (without too much water), the brown is wonderfully intense and rich.

From the same basic pure pigments of yellow and red—with the exception of the weak rose madder genuine—you can make cooler browns by substituting Winsor green for viridian. Again, mix an orange color first and then add Winsor green. Always begin with aureolin yellow, because it is the weakest pigment, and add the red to it, then continue with the green pigment. Since Winsor green is so powerful, it tends to permeate the mixture more than viridian does and results in cooler browns. Should your color turn green, simply add more red and yellow, or start

over. Whatever you do, don't dip into other pigments to adjust the brown. As soon as any mixture has a total of four pigments, the luminosity is in jeopardy. Keep the mixture to two or three pigments at most. There are endless combinations with only three pigments.

Because browns are predominantly warm, even the cooler browns, they best complement a cool light. Like the grays, subtle browns have many indispensable uses throughout a landscape scene. Just look at the variety of browns in Jeanne Dobie's painting *Brandywine Valley*.

Never underrate the role that darks play in a painting. If a dark is large, an interesting shape, or placed in an important spot, it should say something more than "I'm a dull, dirty dark." By using pure pigments and complements, you can create a luminous relationship between lights and darks.

Stephen Quiller

Applying Color Theory:
The Monochromatic Color Scheme

Have you ever noticed when browsing in an art gallery that some paintings use very little color, yet have tremendous impact? Throughout history, such artists as Rembrandt, Vermeer, Monet, and Homer have used a limited palette to create powerful expressions.

Two color schemes that use a very limited palette are monochromatic and complementary. When teaching color, Stephen Quiller likes to start with these two schemes, because with either of them, an artist can learn the relationship between value and intensity and not have to worry about using too much color. However, in actual application, both of these schemes are difficult to execute; working with only one or two colors, you must rely mainly on value to make a composition work. Value, the relative lightness or darkness of a color, is what creates the structure of a painting and is the single most important element to learn. Intensity, the relative brightness or dullness of a color, is also important and must be considered in both the

monochromatic and complementary schemes.

The monochromatic color scheme is the simplest of all color schemes. *Mono* means one and *chroma* means color; thus, this is a one-color color scheme. But that color can be lightened or darkened in value, and brightened or dulled in intensity.

Value is the most important aspect of this color scheme. If a painting is not working, most artists will change a color—try a red or an orange in the hope that, magically, that will be the cure. But the answer is usually in the value of the color. You must ask not only whether the color should be orange but also whether it should be light or dark orange. By contrast, an artist using the monochromatic color scheme cannot change color if the painting is not working; there are only the lightness and darkness to structure the painting and make it work. For this reason, any student of color should spend a lot of time working with the monochromatic scheme.

VALUE CHART

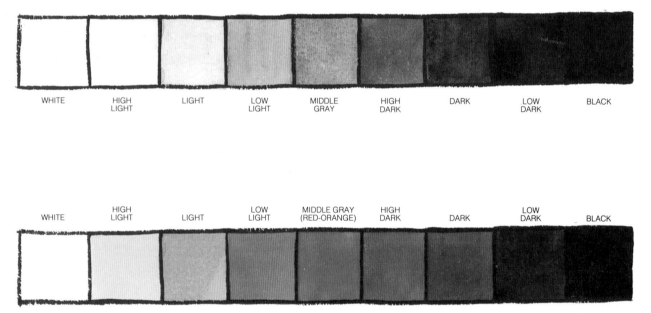

| WHITE | HIGH LIGHT | LIGHT | LOW LIGHT | MIDDLE GRAY | HIGH DARK | DARK | LOW DARK | BLACK |

| WHITE | HIGH LIGHT | LIGHT | LOW LIGHT | MIDDLE GRAY (RED-ORANGE) | HIGH DARK | DARK | LOW DARK | BLACK |

In the black-and-white value chart, there are nine steps from white to black. Actually the number of values is infinite, but for teaching purposes nine will suffice. Each of the seven values between white and black has a name: high light, light, low light, middle gray, high dark, dark, and low dark. Any three consecutive values can be referred to as analogous values. Thus, when talking about a particular area of a painting, an artist might refer to the shapes as analogous light values or analogous dark or middle values. Values that are far apart on the value scale, such as high light and low dark, are referred to as contrasting values. In painting they can be used to direct attention to an area of emphasis. On the second chart red-orange is placed in the middle gray area, because its value is equivalent to a middle gray value.

Three Studies

Here are three studies of one group of buildings in northern New Mexico. All use the complementary colors orange (cadmium scarlet) and blue (phthalo blue), plus black and white (water to lighten). Since this is a monochromatic scheme, orange is the one color that shows in the painting, and blue is used to neutralize the orange. The key to each of these studies is the organization of value and the way the pure and neutralized intensity are used.

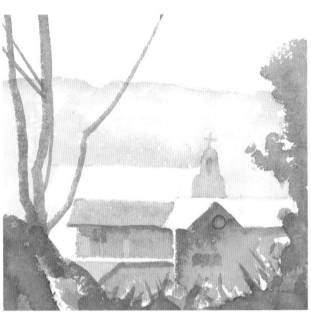

Strong contrast of lights and darks are used to attract the eye. The whites are organized to move the eye around the painting. Also, full-intensity orange is used on some of the roofs to attract the eye. The rest of the color has been neutralized to different degrees to vary the warmth and the movement of the study.

This study uses analogous lighter values. Notice that there is still enough value change between all adjacent shapes so that each shape can be easily distinguished. The lower right building has some full-intensity orange to give it more emphasis. The rest of the composition is painted with varying amounts of neutralized orange.

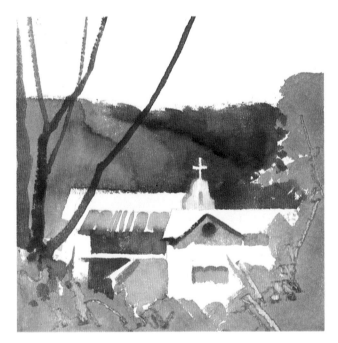

In this study, there is no full-intensity orange; it has been neutralized with blue to give a more earthy feel. Value of the orange is the key. The strongest contrasting lights and darks are placed in areas to attract the eye and direct it around the composition.

Stephen Quiller

The Complementary Color Scheme

Complementary colors are those directly opposite each other on the color wheel. Red and green, and yellow-orange and blue-violet, for example, are two pairs of complementary colors. They make beautiful semineutral colors when mixed together, and complement each other when used together well in a color scheme.

After you have worked with the monochromatic color scheme, the complementary scheme should come easily. The same considerations for value and intensity are needed; you are simply using one more color. Again, using a limited palette can help you create a very effective mood.

The knowledge of complementary colors is important when you're working with any kind of color palette. It was the great American painter John Sloan who said that the painter should think of complementary colors as the opposite ends of one color. In other words, they should always be envisioned together and used together for best results in a painting. With this in mind, the artist can use complements not only while mixing color, but also when underpainting and overpainting or glazing color over color.

Theories about complementary colors began with M. E. Chevreul, a mid–nineteenth-century French scientist who was interested in art. His research led him to write *The Principles of Harmony and Contrast of Colors*, a book, still in print today, that became a "bible" for the impressionists, postimpressionists, and many American painters, including Winslow Homer. In it Chevreul presented his theories of mixed contrast and simultaneous contrast, as well as the theory of successive contrast, which today we call afterimage. He noted that if one stares at a color circle on a white field for a while and then closes the eyes, the complement of that color appears. He further discovered that the eye actually seeks a balance by providing the complementary color. Thus, many artists have since experimented with ways of applying complementary color that are pleasing to the viewer's eye.

Complements in Nature

From a small brown-red rock with gray-green lichen to a spectacular sunset of a golden yellow sky filled with gray-violet cumulus clouds, our earth is filled with pairings of complementary colors. In the spring, red-violet crab apple blossoms play against the yellow-green shimmer of new leaf buds. The burnt red-orange dead spruce blazes against the deep blue-green living spruce behind it. Study the color combinations of the earth and the sky's various atmospheric conditions. Notice how often they contain complementary colors, ranging from subtle to earthy to brilliantly intense.

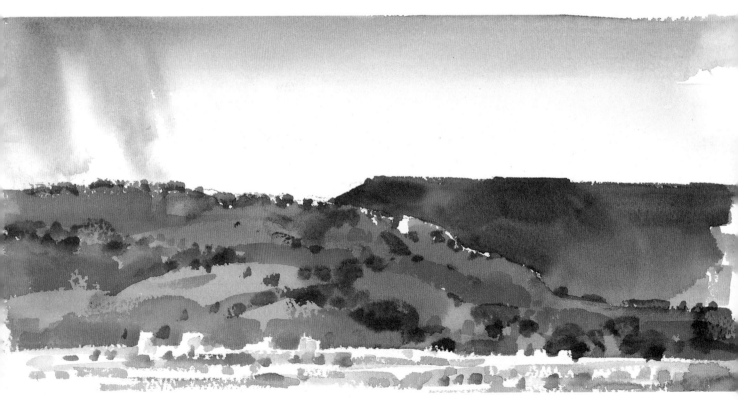

In this summer New Mexico landscape, the red-orange earth mingles with the blue-green chamisa and sage, and with the cedar and piñon on the hillside.

Three Studies

As in the monochromatic studies, there are many things to be considered when working with complementary colors. To get the colors to work well together, you must make many decisions: how to organize the value, how to organize the intensity, how to utilize value effectively with pure intensity, and which complementary color will be dominant and which subordinate.

Here are three studies using the complements red (alizarin crimson) and green (viridian). Notice how the value, intensity, and dominant and subordinate color affect the mood of each composition.

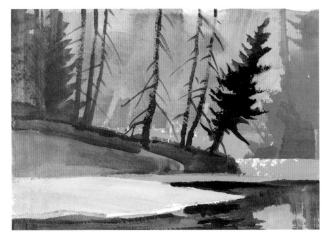

The dominant color is green, used in both analogous and contrasting values. The green has been neutralized to some degree. Red is the subordinate color. It is neutralized with white to create a pink, and is used full intensity in small areas along the bank. This study is primarily on the cool side and has a lot of impact because of the contrasting value.

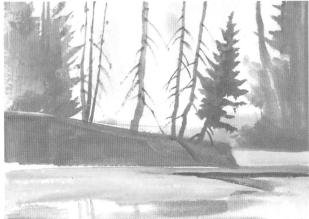

In this study, the mood is quiet and restful. Again, the dominant color is a cool green. The values are more analogous, creating a gentle feeling. The intensity has been neutralized with the complement, or lightened with white in the front bank. Red is the subordinate color, and it is entirely neutralized and lightened. Notice how the color is repeated in order to move the eye around the composition.

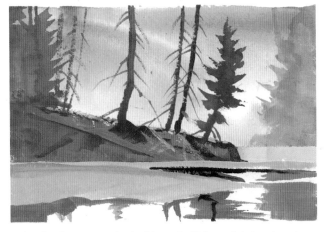

Red is the dominant color in this study. Light and dark red, and bright and dull red, have been used to give a strong impact to the composition. The greatest value contrast is in the area of emphasis, with less contrast in the outlying areas. Full-intensity green has been lightened with white and placed in small accent areas of the composition.

Stephen Quiller
The Analogous Color Scheme

An analogous color scheme is one of the most beautiful, harmonious schemes to work with because the artist is using adjacent, closely related colors on the color wheel. To determine what colors can be used in this scheme, draw a color wheel and mark the primary, secondary, and tertiary colors. Any three adjacent colors can be used together for this scheme. In addition, the lighter and darker values of each color and their semineutrals—the beautiful, not perfectly neutral gray mixtures of two complements—can be used. For the best relationship, one color should be selected as the dominant color, one as the subordinate color, and another to be in between.

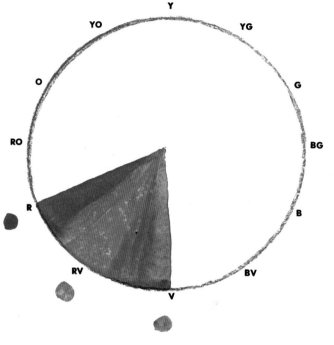

Here is a color wheel with the primary, secondary, and intermediate (tertiary) colors listed. Any three adjacent colors can be used to develop an analogous color scheme, as well as the light and dark values and semineutrals of those three hues. Red (alizarin crimson), red-violet (cobalt violet), and violet (mauve) are the colors used in this example.

Using Analogous Colors in a Study

The same three colors that are shown above can be used in a study for a finished painting. You must consider many things before starting such a study, and most important is the feeling or mood you wish to express in the composition. The red, red-violet, and violet are used here to convey a feeling of warmth, activity, and cheerfulness. Any other three analogous colors could have been chosen to give the composition a distinctly different mood.

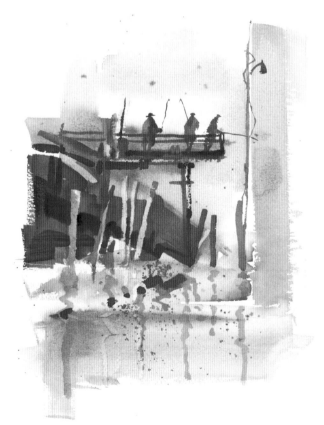

This small study, a sketch of fishermen, wharf, and pilings on the Oregon coast, uses the colors chosen in the previous diagram. Notice that the colors vary in value and intensity to develop a harmonious relationship.

Three Studies

The same three colors in an analogous color scheme can be used in distinctively different ways, depending on the effects desired. The variations are endless because each of the three colors can be used as the dominant, intermediate, or subordinate color and can range from a pure intensity to a dull semineutral, as well as in value from light to dark. In addition, the relationships in intensity and value of the three colors can vary in their degree of closeness or contrast. Here are three studies of the same composition using three analogous colors of red-violet (cobalt violet), violet (mauve), and blue-violet. Notice how each study differs in color emphasis, value, and intensity. Also look at how the various moods have been developed, ranging from serene to austere to dynamic and powerful.

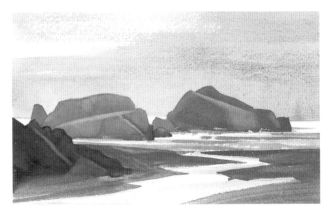

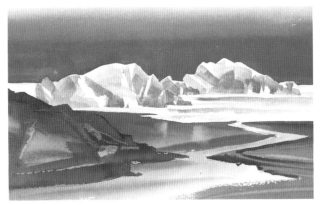

Here, all the color has been neutralized. Even so, notice that the subtle semineutral colors of blue-violet, violet, and red-violet intermingle to give unity to the color scheme. The values have been organized in the rock forms to become increasingly dark as they come forward, and the warmer semineutral of red-violet is used in the foreground sand to bring it forward.

This study reverses the logical sense of color organization by putting pure, strong, contrasting color in the background and the more neutralized color in the foreground. The intense blue-violet of the sky contrasts with the white and pale red-violet values of the distant rock forms, dramatically directing the eye to that area. The foreground sand, rocks, and tidal pool are of closer neutralized values and become secondary areas. Again, as in the other studies, the color has been repeated throughout the painting.

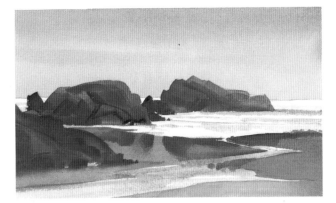

Most of the color in this composition has been neutralized. Pure-intensity accents of red-violet have been placed in the foreground and distant rocks. Darker values have been placed next to the pure-intensity areas to help bring them out. The semineutral colors have been placed, for the most part, in the outlying, secondary areas of the composition and are analogous light values. Notice how the strong, contrasting values bring the eye to the area of emphasis.

Exploring the Possibilities of Analogous Color

Choosing the harmonious colors of an analogous color scheme is a good start in setting the mood of a painting. The key, however, is in the way value and intensity are used, allowing the viewer's eye to move throughout the painting, and thus allowing the structure of the composition to be seen. In the analogous color scheme, each color's complement can be used to neutralize the intensity, and white and black can be used to adjust the value. Full-intensity colors are generally used in small areas, while semineutrals can be used in large passive areas. Strong contrasting values are used mostly in the area of emphasis, with analogous values in large passive areas.

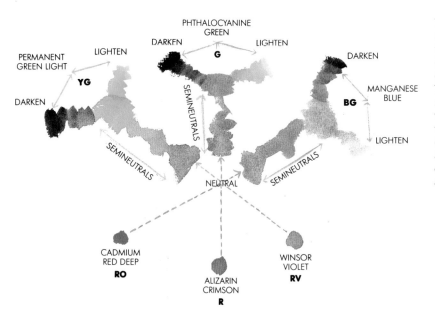

This diagram illustrates the full range of an analogous color scheme. In this example the three analogous colors are yellow-green (permanent green light), green (phthalo green), and blue-green (manganese blue). The color scheme also includes their semineutrals, created by mixing these colors with their complements red-violet (Winsor violet), red (alizarin crimson), and red-orange (cadmium red deep). In addition, each color and its semineutrals can be lightened and darkened in value with white (or water) and black.

Using Dominant and Subordinate Color

As with the complementary color scheme, when you work with analogous colors it is usually better to use each of them in varying amounts. Generally, one color is selected to be dominant, and is used in varying intensities and values in larger areas of a painting. A second color is chosen as the subordinate and is used in small amounts to accent the composition. The third color is intermediate, used less than the dominant color but more than the subordinate one. This ratio makes for a harmonious arrangement.

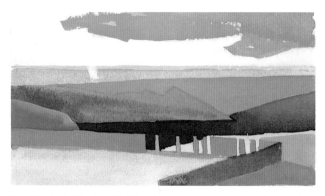

For this study Stephen Quiller chose a cool analogous scheme of green (emerald green and phthalo green), blue-green (cerulean blue), and blue (phthalo blue). Blue-green has been used as the dominant color, blue as the intermediate, and green as the subordinate. Notice that all the colors have been repeated in the composition and that the subordinate color green is used in a light, pure tone next to a dark blue to give a strong contrast and a vibrant accent.

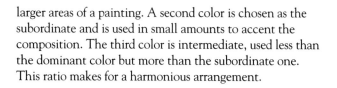
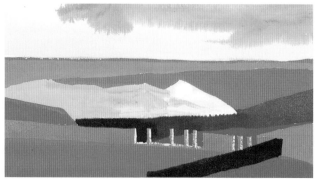

Quiller used the same composition as in the previous study. This time, however, he used a warm analogous scheme of yellow (cadmium yellow light), yellow-orange (cadmium orange), and orange (cadmium scarlet). Orange is used as the dominant color, yellow as the intermediate, and yellow-orange as the subordinate. All the colors have been repeated throughout to emphasize the primary areas and to de-emphasize the secondary areas, thus unifying the composition.

A High-Key Analogous Scheme

High-key colors are those that are light in value. Adding white (or water) to a color will lighten and soften it, neutralizing it to some extent and resulting in a pastel look. An analogous high-key color relationship is often very pleasing to the eye and can give a soft, shimmering effect to a painting. The impressionists Monet, Pissarro, and Degas used this approach, and so did many later painters, including Bonnard. Usually the paint is applied in light tones that are the same or quite similar in value, but whose analogous color changes. Up close, similar colors of the same value shimmer, while at a distance they almost appear as one color.

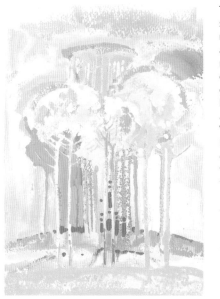

This is an analogous color scheme in a high-key relationship. All the colors are pure and have not been neutralized by their complements. Permanent green light, cadmium yellow light, and cadmium orange are the colors selected. Varying amounts of white have been added to all the colors to give high-key values to the study. Notice that the composition has a pastel quality and a feeling of fantasy. When a painting uses analogous colors of similar value, the eye is treated to a soft, stimulating shimmer.

One Pure Accent, with Two Semineutrals

In an analogous color scheme, one color can be used as a pure-intensity accent surrounded by the related colors in semineutrals. The pure-color accent used in small areas will advance and seem brighter than the surrounding colors, yet will still relate because it is a component of some of the surrounding colors. Pure hue always advances more than a semineutral of the same color, whether the color is warm or cool. This may seem strange when the color is on the cool side. But pure blue, for instance, will advance more than its semineutral, even though the color is neutralized with a warm orange. The darker the value of the surrounding semineutral color, the brighter the pure hue will seem.

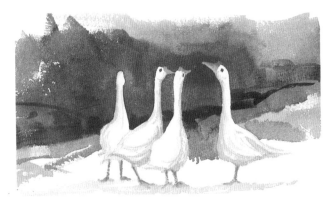

For this study of geese, Stephen Quiller used the analogous colors yellow-orange (cadmium orange), orange (cadmium scarlet), and red-orange (cadmium red deep). Yellow-orange is used as the pure hue accent, while the other two colors are used as semineutrals. Notice the variation of color in the semineutral background, adding subtle interest to the composition; also, the dark value of the background allows the pure yellow-orange to stand out. The same pure yellow-orange is used for the feet of the geese, but appears much darker against the white paper.

The Split-Complementary Color Scheme

The concept of the split-complementary color scheme is fairly simple if you thoroughly understand the complementary and analogous color schemes. Basically, it is an analogous color scheme with one contrasting color. To locate the colors to be used in this relationship, begin by choosing three analogous hues that will convey the dominant mood of your composition. Then take the middle color of the three and select its complement, which will be used as the contrasting accent color.

This reintroduces the concept of warm and cool that was used in the complementary scheme but lost in the analogous scheme. In the split-complementary scheme, the accent color makes all the difference, providing the balance of contrast to the dominant analogous relationship for a rich, unifying color scheme that can be used in a variety of ways.

This is an example of a split-complementary palette. Violet, blue-violet, and blue are the dominant colors in this scheme. Each can be used at full intensity or neutralized, in lighter or darker values. The accent color is the complement of the middle of the three analogous colors, in this case, blue-violet. Blue-violet's complement, yellow-orange, is then used as the accent balancing color.

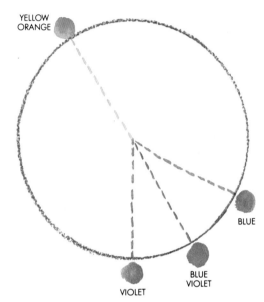

The mood expressed in this study is one of coolness and isolation. Blue, blue-violet, and violet, with yellow-orange as an accent, work well together to create this feeling. The three cool colors have been used in lighter and darker values. Violet was applied at full intensity on the roof. The trees have been painted with a semineutral mixture of blue-violet and yellow-orange. The light yellow-orange in the windows and neutralized yellow-orange on the snow provide a nice accent to the dominant cool scheme.

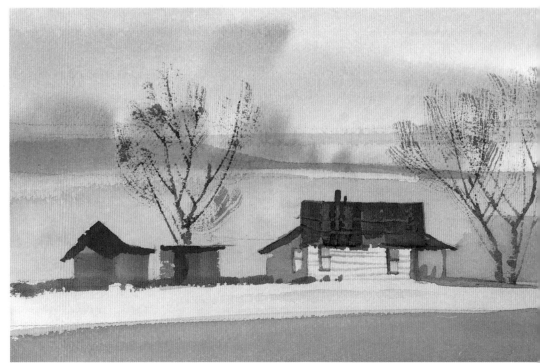

Three Studies

With the split-complementary color scheme, the first thing to decide is what color will work best for the particular mood of the subject. Then your palette should be organized so that there is a dominant, intermediate, and subordinate in the analogous colors. The complementary color should work with and add balance to the composition. The color value and intensity should guide the eye throughout the composition. Finally, any and all paint applications should be integrated in the painting.

Here are three studies using the same color scheme, each with entirely different results. The analogous colors are red-violet (cobalt violet), violet (mauve), and blue-violet (ultramarine violet). The complement is yellow (cadmium lemon). Both red-violet and blue-violet are mixed with their complements yellow-green (permanent green light) and yellow-orange (cadmium orange) in some cases to create their semineutrals.

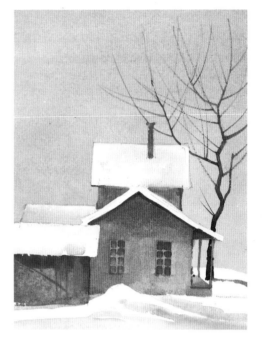

In this study, the majority of the values are analogous light. A few darker values are added under the eaves, on the windowpanes, and in the tree to bring out the forms. The sky is a semineutral ultramarine violet, while the rest of the colors are pure but tinted. The yellow is used as a pale accent color on the roofs and snow.

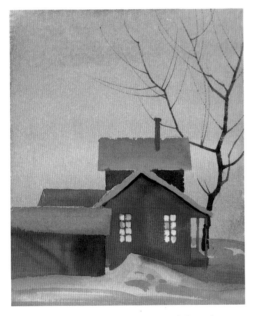

This study is more subdued. Most of the values are on the darker side, and all the analogous colors have been neutralized by their complements. The yellow accents in the windows are pure hue, while the yellow tints on the snow are semineutrals. Notice how the semineutral colors add to the mood of this composition.

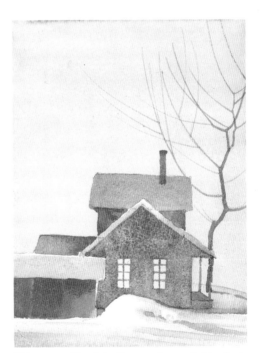

This composition is built on analogous light values, and all the light colors are used as pale semineutrals. Handling the color in this way creates a hazy, soft atmosphere. Observe the beautiful semineutral colors and how they add to this feeling.

Stephen Quiller

The Triadic Color Scheme

To understand how triadic color schemes work, look at the color wheel below, which shows the three primaries, three secondaries, and six intermediates (tertiaries). Working with a triadic scheme means that you would choose three colors that are equidistant from one another on this wheel—colors that, when connected with straight lines, form an equilateral triangle. (A simpler way to locate a triad is to pick every fourth color.) When any two of these contrasting colors are mixed together, they will make beautiful semineutrals, even though they are not complements.

As an example, let's use orange (cadmium scarlet), violet (mauve), and green (viridian)—the three secondary colors—for a triad. With this color scheme there are two cool colors (green and violet) and one warm color (orange). Thus, more than likely, the scheme will be dominantly cool and subordinately warm. Each color can be lightened or darkened in value. Each can also be mixed with either of the other two colors to create a semineutral. Intermediate, or tertiary, triads are similar to the secondary triad in that every mixture of two of the three pure colors results in a semineutral.

The primary triad is the first one many art students think of but the hardest to make work well. This is because when any two of these colors are mixed, the result is a secondary or intermediate (tertiary) color. Thus myriad new colors can be mixed, even if some of them are partially neutralized.

To locate a triadic color scheme, choose every fourth color on this wheel. For example, yellow, blue, and red are connected by the solid triangle, and green, violet, and orange are connected by the dotted triangle. Any three equidistant colors should make a beautiful triadic scheme.

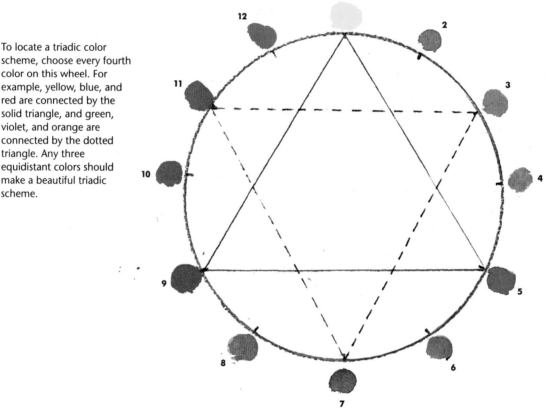

A Secondary Triadic Color Scheme

This triadic color scheme makes use of the secondary colors on the color wheel—orange, violet, and green. Each is equally spaced from the next on this wheel, and all are located equidistant between two primary colors. For instance, orange is halfway between the yellow and red primaries. Because of this, the mixture of any two secondary colors takes on a semineutral tone. For example, orange, which is a mixture of yellow and red, mixes with violet, a blend of red and blue. The orange has yellow in it and the violet has blue. Thus the resulting color is not a fresh, pure red-violet, but a neutralized one. What makes every mixture in this color scheme harmonious is that all of them contain two of the three common colors. Even though they are somewhat neutralized, they all relate to the three pure secondary hues.

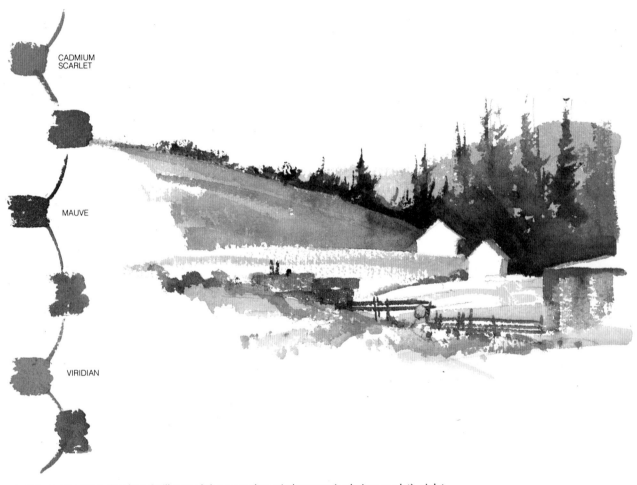

CADMIUM SCARLET

MAUVE

VIRIDIAN

In this composition, Stephen Quiller used the secondary triad orange (cadmium scarlet), violet (mauve), and green (viridian). Much of the color is a semineutral mix of two of the three pure hues. The strong contrasting value pattern and diagonal lines are a major strength of this sketch. Notice that the only pure color in the whole study is the orange on the roof.

BASIC PAINTING TECHNIQUES

Starting with lessons in brushwork and its many variations, the contributors to this chapter—Graham Scholes, Irving Shapiro, Jeanne Dobie, Don Rankin, and Valfred Thëlin—show how to master the classic watercolor techniques of laying washes, glazing, and working with staining and nonstaining pigments.

Graham Scholes
Holding the Brush

There aren't too many ways to grasp a pen or pencil for writing. But a paintbrush can produce many different effects according to how it is held and manipulated on the paper. This series of stop-action photographs illustrates a few ways to achieve specific results.

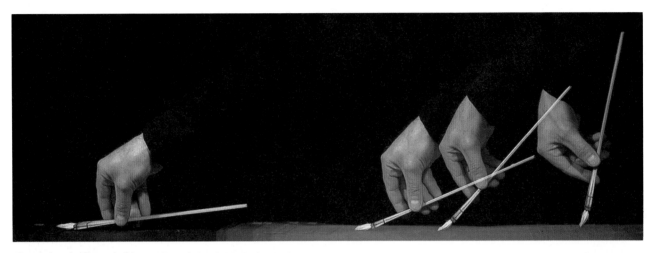

For drybrush effects, hold a moderately loaded hake brush flat and use the heel. Moving from left to right as illustrated, the more you swing the brush vertically, the more the pigment flows, until a solid layer of paint occurs.

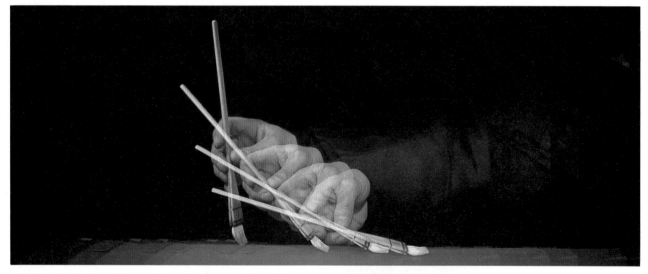

Holding the brush as illustrated here but moving right to left brings similar results.

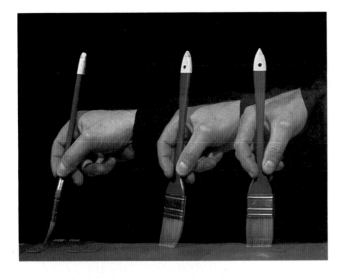

When using a flat brush, you can control the width of each stroke by rolling the brush in your fingers as you draw it across the paper. Notice the position of the thumb and forefinger, where the broad stroke is started, and at the finish, where the stroke is thin. Pulling the brush flat across the paper makes a wide stroke; turning it so that the narrowest part is angled toward you causes the brushstroke to get narrower.

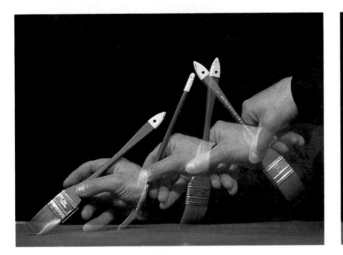

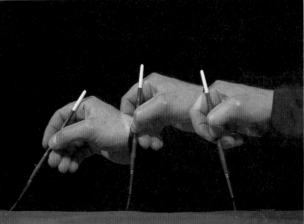

A petal-shaped stroke is achieved with more wrist action. Hold the brush firmly in your fingers and, toward the end of the stroke, twist the brush and lift it off the paper to give the petal its pointed tip. (In the photograph the action has been spaced to better illustrate the motion of the hand.)

Round and rigger brushes are held well up on the handle for a looser type of stroke. A combination of finger and arm action is employed, depending on the stroke length you need.

Irving Shapiro

Developing Expressive Brushstrokes

Your brushwork will contribute much more to the quality and temperament of your final watercolor than you probably imagine. Don't dab at the surface; be bold and assertive with your brush. It doesn't matter whether your technique has a tight or loose flavor. Choose your language—but speak it with fluency.

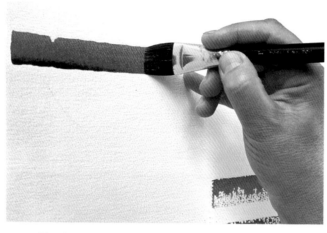

Vertical brush on Arches cold-pressed paper.

Slanted brush on Arches cold-pressed paper.

Carrying a Vertical Brush Slowly

To get this solid brushstroke, choose a flat brush and load it with wet color. Hold your brush almost perpendicular to the paper. Then carry it across the paper slowly enough to permit liquid color to flow everywhere that the brush makes contact with the paper, including the wells or deep spots in the textured surface. As in the photograph, steady your hand by letting your little finger touch the paper. Of course, be sure your finger is clean and dry, and that the paper is not wet with color where your finger is going to rest.

Carrying a Slanted Brush Rapidly

Here you can see the uneven stroke created by a slanted brush. Notice how the artist's hand is lying almost back-down on the paper. From this position, you can hold the brush at an angle that's quite low to the paper, so that the color is dispersed not by the brush's tip but by its broad side. Then, when you carry the wet brush *quickly* across the paper, the liquid simply doesn't have a chance to settle into the indented parts of the paper surface. The liquid color hits only the high spots so you get a textured, glistening brushstroke. Although this brushstroke looks dry, it's the result of a *wet* brush being carried quickly across a paper that has "tooth."

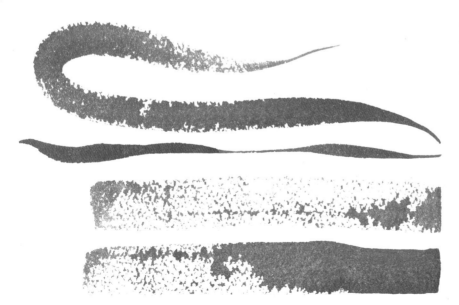

Playing with Different Rhythms

To get these different brushstrokes, carry the brush vertically at times and more horizontally at other times, without lifting it from the paper. Try this out as an exercise in rhythm within a single brushstroke. Also, try easing up and bearing down on single brushstroke movements for a variety of weights and rhythms.

Brushstrokes made with a #12 round kolinsky sable on Arches cold-pressed paper.

Controlling Edges

Softening Edges

Painting watercolors requires thinking ahead and anticipating the temperament of the medium. If you want to soften or blend the edge of a wash or brushstroke, you can't wait until later. After laying in the area, quickly rinse your brush, wipe it to remove much of the moisture, and carry the damp brush along the wet edge you want to diffuse. Continue to rinse and extend the blend until it has lost its clarity as a crisp edge. But remember to be quick. Once an edge is left to set for very long, especially if it isn't wet enough to begin with, you can't extend it; it won't soften or blend. In the examples shown at right, one brushstroke is blended at the short, right edge; another is blended the full length of the stroke on its under edge; still another has just a part of its underside softened.

Softened edges on Arches cold-pressed paper.

The Principles of Blending

To learn more about blending edges, try practicing different methods. In the top example at left, the paper was tilted and tipped to direct the paint's flow. You'll be surprised how much control you have.

In the bottom example at left, the modeling of the coil gives a sense of its movement in space. The somewhat darker value at the top and the more accentuated dark behind and around the lower area act as foils, dramatizing the coil's three-dimensional shape. Moreover, some of its edges are clarified by the "negative" shapes. At other points, however, the coil's edges are only inferred—there is no graphic identification at all, but the eye reads these lost edges to fill in the form. To get the textured edge at the bottom of the dark foil, a wet brush was carried very quickly across the paper. At such speed the color hits only the high spots of the paper. Working more slowly allows the color to settle into the low spots, giving you a solid or untextured statement.

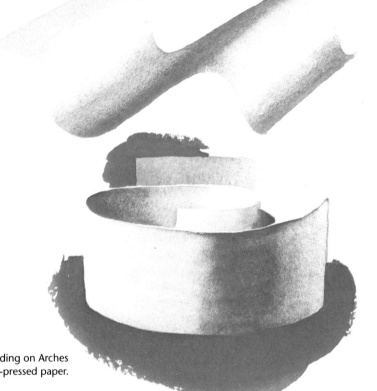

Blending on Arches cold-pressed paper.

Blending too slowly on Arches cold-pressed paper.

Blending Too Slowly

Here you can see what happens if you're slow about blending. Edges will set and not be extendable; "flowers" will crop up where you don't want them. All in all, if you take too much time, you'll see all sorts of things happening that you probably don't want.

Irving Shapiro
Basic Wash Techniques and Effects

In exploring the possibilities of washes and brushstrokes, practice counts. Much of the visual effectiveness of your watercolors will depend on your mastery of rhythmic brushwork, fluid action, and assertive handling. A good painting isn't something you just stumble into. Yes, there will be times when wondrous accidents just happen on your paper—that's the capriciousness of this medium. But the best watercolors—even those that seem marvelously free and casual—flow from artists who are directing their skills and craft.

Flat wash on Arches cold-pressed paper.

Graded wash on Arches cold-pressed paper.

Laying a Flat Wash

Begin with a flat wash, one that creates a uniform value within a given area. Choose just one color and put a generous amount of it on your palette. Dip your brush into the pigment, bring the brush to the mixing area, and add the amount of water that will give you the value you want. Remember that this value will almost always appear darker in your mixing area than it will once it dries on the paper. Mix your color well enough to prevent clots of pigment from being transferred to the paper. Now you're ready to start laying a wash.

Tilt your paper slightly and, using a fully charged brush (one that's loaded with wet color), start at the top of the area you intend to cover. With no hesitation, put down a wet brushstroke the full width of the area. Work with some speed to prevent the bottom of the brushstroke from "setting"—that is, from standing long enough to permit a hard edge to form and dry. Now scoop more of the liquid color from your palette onto your brush and follow the first brushstroke with another—and another, and another, until the intended area has been covered. A bead of liquid will settle at the very bottom of your last brushstroke. Don't worry—this should happen if you've been working wet enough. However, if you want a truly flat wash, you have to equalize the wetness of the painted area. To do this, quickly rinse your brush after your last stroke, wipe it on your paint rag, and touch the damp—not wet—brush tip to the bead

of liquid resting on the bottom. The damp brush will absorb the excess liquid, leaving a more uniform value.

Creating a Graded Wash

For a graded wash, begin as you did for the flat wash—but then, as the wash progresses, add water to the pool on your palette for each successive brushstroke. In this way you'll get an increasingly lighter color. You can control the degree of gradation by the amount of water you add to your pool of color. If you want to take the other direction and gradually darken your wash, just add more pigment to your pool of color for each successive brushstroke.

Working Wet-in-Wet

In laying a flat wash as described above, you worked on a flat surface. It's probable that even though you intended to create a uniformity, you could still see some brushstrokes. These can lend character to a work. Nevertheless, if you want to create an absolutely uniform value, without any evidence of brushwork, repeat the process of laying a wash just described, but this time, first wet the area that's to receive the wash. Dampen the paper with a brush or sponge. Then lay the wash rapidly within this wet area. Because of the paper's moist condition, the brushwork will diffuse, pretty well eliminating any brushstroked look within the wash area. Simply put, this technique is called *wet-in-wet*. Try it with the graded wash as well.

Experimenting with Variegated Washes

Still another type of wash is the variegated, or varied-value, wash. Using your brush, with varying proportions of pigment and water, you can sculpt your wash to create an informal, free mingling of value and shape. Try the process used for the example shown here. First wet the overall area with a 1" flat brush and clean cold water. Then, with the paper lying flat, apply different amounts of water and pigment to the already wet surface. The rhythm and action of your brush will determine the shapes you create. Be direct, though—don't hesitate.

When you're working wet-in-wet, keep in mind that the water on the paper surface will dilute your color. To compensate, use more concentrated color in your mixing tray.

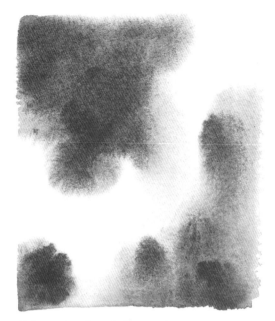

Variegated wash on Arches rough paper.

Variegated wash on hot-pressed surface.

Trying Out Different Surfaces

Experiment with washes on a variety of paper textures. The example above was done on a hot-pressed surface, painted wet-in-wet. A hot-pressed surface has very little "tooth," so color reacts and flows much differently than on cold-pressed or rough surfaces. It's more difficult, for instance, to blend color with the uniformity possible on these other surfaces. On the other hand, the "runs," veining, and erratic edges that form make some exciting painting experiences.

Handling "Blooms"

If you leave the bead of liquid that settles at the bottom of the last brushstroke, it's apt to back up, and you have a *bloom,* or *flower,* due to an unequal degree of liquidity within the painted surface. This "flower" effect was created deliberately by allowing the wet brush to touch a damp wash of color. Since "blooming" is a characteristic of watercolor, you may at times want this to happen. If not, either work wet into freshly wet handling or wait until the surface has completely dried before continuing.

Bloom on Arches cold-pressed paper.

Jeanne Dobie

The Art of Layering with Glazes

You can physically mix one color or another. But you can also "mix" color optically. To do this, you take advantage of one of watercolor's inherent qualities: its transparency, which allows you to overlay colors for exquisite effects. This is the art of unmixed color, or glazing.

Glazing is a process of applying sheer layers of pure pigment, one over the other, to produce a desired color effect. It differs from a regular watercolor wash in that the colors are not mixed together but applied separately and allowed to dry thoroughly between applications. The word *glaze* means "glasslike." Glazes should be very transparent so that it is as if the viewer were looking through sheets of colored glass to the layers beneath. The result appears as a color mixed by the eye.

Artists of all levels of experience can benefit from glazing. Beginners will find that glazing provides control over washes. If, for instance, you have ever lost your whites in a wet-in-wet technique, you will appreciate the glazing method. Or if white paper gives you stage fright, that, too, can be easily overcome by covering most of the paper with a glaze. In addition, working with glazes automatically simplifies a painting into a value pattern. Glazing can also challenge the advanced painter and stimulate creativity. By taking color apart and putting it together again, new ways of thinking about color come into being.

Glazing imparts a luminosity not attained by any other method. This makes it a natural choice for capturing the subtle nuances of an overcast day or a predominantly gray

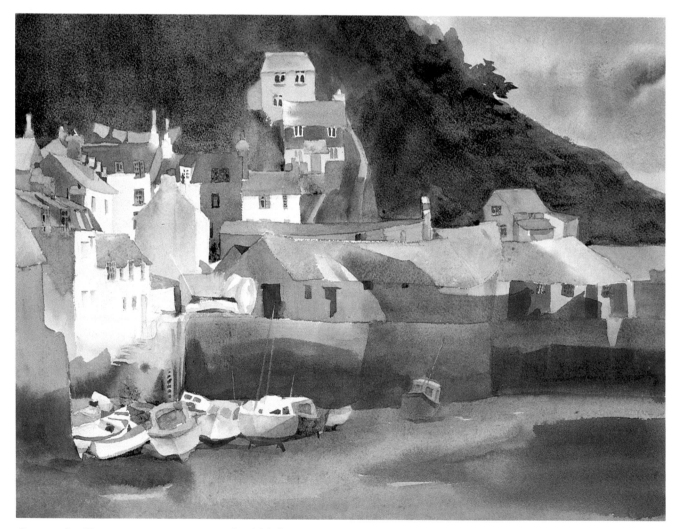

CORNISH SEA VILLAGE
Watercolor on Arches 140-lb. cold-pressed paper, 12 × 16" (30.5 × 40.6 cm).

Don't label a painting unsuccessful until you have tried a glaze. At first Jeanne Dobie felt dissatisfied with this painting—it just didn't convey the feeling she wanted. When she added a glaze to one area—the shadow at the bottom—the whole painting changed dramatically.

scene. The translucent grays obtained by glazing can enliven a potentially dull painting.

Turn to Jeanne Dobie's finished painting of an Ohio River barge at the end of the following demonstration. The river was enshrouded with early morning fog as the sun sluggishly tried to burn through. The unusual warm lighting behind the fog could never have been captured with ordinary wet-in-wet effects or gray washes. But the glazing method came to the rescue. By taking the final desired mixture apart and applying the pigments one at a time in glazed layers, Dobie was able to duplicate the sun shining through the fog.

Glazing looks and sounds easy, but most artists have trouble when they try it the first time. Follow the demonstration, checking each step along the way to spot any problems. Don't skip ahead; patiently execute each step.

Glazing Preparation

1. *Choose a dry sheet of watercolor paper that has been stretched taut.* Because the major portion of your painting will be glazed, you want it to be as smooth as possible. Unstretched paper expands when wet and buckles, developing hills and valleys. The paint runs down and settles in the valleys to become an uneven wash.

2. *Tilt your board.* It should be at approximately a 15-degree angle to give you as much control as possible. Now the wash can only flow downward.

3. *Select a wide brush with a fat heel.* The thicker the heel of the brush, the more readily it will store abundant amounts of wash.

4. *Mix the wash.* Use transparent pure pigments to attain the optimum glow. The most effortless way to obtain a good wash is to start with the pigment first and then add water, not vice versa. Pick up a generous amount of fresh pigment on your brush. Place this in the bottom of a paper cup, then add the water. If the mixture seems too strong, adjust it with a little more water. If the mixture seems too weak, simply add more pigment. *Be sure to mix twice as much wash as you think you'll need.* When a painting is dependent on a glaze, the worst disaster is to run short of color. Always be prepared with an ample wash.

5. *Design the white area to be saved.* Whites really sing when surrounded by a glaze.

The First Glaze

Now you are ready to begin. Remember, instead of mixing pigments together in a single wash, you are going to apply them separately, one by one, over each other. The final effect should optically approximate the color you want.

Look again at the finished painting *Along the Ohio*. To duplicate the warm effect of the sun burning off the fog, Dobie began with a yellow layer. Since yellow is the lightest and most delicate color, it does not cover when used on top of another pigment. If you wish yellow to glow, always place it on the paper first.

Jeanne Dobie likes to use aureolin yellow because it is so transparent that it is unbeatable for capturing light. Another advantage is that aureolin yellow is not a staining pigment and will lift from the paper, should you accidentally paint through some of your white. Try to avoid using staining pigments in a glaze. They tend to stain or dye the underlayers and consequently destroy the translucent quality. If you must use a staining pigment, generously dilute it.

Begin with the first yellow glaze. Dip your brush into the yellow wash and begin a stroke across the top of the paper. Here is where a good wash brush is helpful, as it will constantly feed color until the brush reaches the other side. A thin-heeled brush quickly empties, requiring frequent redipping, and the glazing stroke may not be as smooth.

Notice that a bead has formed at the bottom of the stroke as the excess paint flows downward. Return to the edge and begin another stroke, just catching the bead as you move across the paper. Try not to paint over the bead, or you'll leave a double yellow stripe. Continue to paint each succeeding stroke, left to right (or, if you are left-handed, right to left), being careful to catch the bead.

The secret is not to go back over a glazed area or attempt any repairs. If you do, you will add more water, which must flow or expand somewhere. A few seconds later it will spread and reappear as blooms or blossoms.

As you paint, you may encounter a problem with "pinholing"—white dots left behind where the paint won't flow into the valleys of the paper. Alleviate pinholing by simply changing your brush to an upright position, vertical to the paper. This forces more paint downward to fill the pinholes.

When you reach your nicely designed white area, continue to use horizontal strokes, but lift the brush to skip over the white shapes. Avoid painting "around" your white shape. Don't worry if the edges are not straight or carefully executed; you can correct them later if you want (remember, aureolin yellow lifts easily). The minute overlays of the glazes are usually so light as to be barely noticeable. Moreover, they add a little color vibration at an edge that might otherwise be too clean-cut.

After saving your white area, you'll notice that a bead has become trapped at its top edge. Pick this bead up with a thirsty brush—one that has first been wet, then squeezed between your fingers to remove excess water. Just touch it to the bead to absorb it instantly.

Glazing Step-by-Step. In this demonstration, done on location for a workshop, artist Jeanne Dobie wanted to capture the elusive quality of sun burning through the fog. As you follow the steps, keep in mind how easily the three glazes could be varied to gain any atmospheric effect desired.

1. Glazes should not be equal. This first glaze of aureolin yellow, which simulates the sunlight, is painted strongly. Notice that Dobie has kept the white shape simple so that she can continue glazing without interruption.

2. The second glaze of rose madder genuine is diluted to retain the feeling of sunlight through a morning mist.

3. The third glaze of cobalt blue is "barely there" to keep the illusion of sun behind the fog.

4. Here Dobie has added an extra layer of the blue glaze to the river area to deepen it. Without waiting for the glaze to dry, she included the reflections and two glints of orange.

5. Because the underlying color shines through the layers, this glazed painting is more luminous than one done with the wet-in-wet or gray wash method. Moreover, the glazes suggest the atmospheric layers of mist and convey the mood the artist intended.

ALONG THE OHIO
Watercolor on Arches 140-lb. cold-pressed paper, 14½ × 21" (36.8 × 53.3 cm), collection of Pat A. Lusk.

To alleviate pinholing, when the paint won't flow into the valleys of the paper, change the angle of your brush so that it is vertical to the paper.

Remember to collect the bead at the top edge of your white area with a thirsty brush.

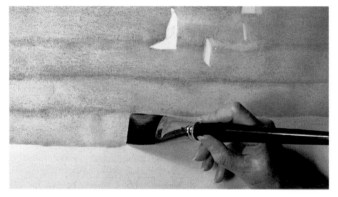

Be sure to catch the bead with each successive stroke. Don't paint over it, or you'll leave a stripe.

Try not to go back over a glazed area. Any excess water can spread, leaving unwanted blooms.

Before you step back to admire your first layer of glazing, take a tissue and wipe the edges of the paper. This simple precaution gets rid of any excess water so that it can't creep back into your painting and create unwanted blooms or textures. Now take a good look and assess your yellow layer as it dries. Is it too light or too dark, or just about right? If it is too light, wait until it is completely dry, then put on another glaze layer. If it is too dark, again wait until it is thoroughly dry and reglaze, this time with pure water only. Some of the excess color will collect in the bead and be washed off the sheet when the glaze reaches the bottom of the painting.

It's important to adjust the yellow glaze before you continue. Unfortunately, you can't correct it later after the other glazes are added. As mentioned before, the yellow pigment becomes opaque when it is applied over other pigments, so that the transparent quality of the glaze would be lost.

Don't despair if your first attempt results in too much or too little color. Glazing requires several trials to develop an expertise in estimating how much pigment is needed. Eventually, with practice, you will be able to judge how much red, yellow, or blue is required to produce the desired effect.

Subsequent Glazes

When your yellow glaze dries, you are ready for the second glaze. This time use the most transparent red—rose madder genuine. Again, mix an overly generous wash in a paper cup. Then, with the same patience, carefully stroke from edge to edge, catching the bead that forms with each succeeding stroke. Leave your white shapes and pick up the extra bead on top with the thirsty brush. As you finish, don't forget to wipe the edges of the painting to eliminate excess water and prevent unexpected textures.

Now assess the second glaze. This layer needs to be adjusted only if it is too dark. (To do this, reglaze it when dry with water only.) If it seems too light, you may choose to continue with the next glazing layer, and judge later if an adjustment is necessary. Red and blue glaze layers can be reapplied over one another for a deeper color at any time. It is only the yellow pigment that doesn't work successfully on top of another pigment.

Once the red layer is dry, begin the final layer. Cobalt blue—the most transparent blue—is the best choice for this glaze. Again paint across the paper, controlling the bead as you continue painting stroke by stroke down the paper. All this glazing practice has probably made you an expert at flowing washes by now. Remember to save your white shape, then collect the bead at the top of it, and wipe the excess from the edges of the paper. Your glaze is complete, unless you wish to add another layer of red or blue (or both) to obtain a special effect. For the Ohio river barge painting, an extra blue glaze was added to deepen the water area.

As you finish the last glaze, you can continue with the painting without waiting for the last layer to dry, especially if you want some softly blended edges. In *Along the Ohio*, Jeanne Dobie immediately added the muddy reflections to blend into the water. At the same time, she introduced the two glints of color reflected from the smokestacks. As you can see, a glaze acts as a perfect foil for such special color effects.

Extra Hints for Success

You can alter the glaze layers to accent any color you choose. *Avoid making all three layers equal*— you'll only produce a dull neutral. A closer look at the glaze in the barge painting reveals a soft, warm glow penetrating through the grayed atmosphere. To achieve this result, Dobie made the yellow layer strong; the red and blue layers were kept weaker so the warmth would dominate. Similarly, if you want a blue-gray sky, use a strong blue glaze and fainter glazes of yellow and red. For a purple-gray effect, keep both the red and blue layers strong with the yellow layer weaker.

Don't eliminate a layer. Let's say you decide to drop the red layer because you can't see any red tones in the sky. But then you may be unhappy when your sky turns green. Paint a very pale, "barely there" red glaze to prevent that from happening. Always use three primaries and control the results by strengthening one or two colors.

The time-consuming and careful execution of glazes is well worth the effort. Notice how the white areas glow beautifully against the glazes. The delicate layers are the next value deeper. All that is necessary to complete your painting is to add the middle values and darks to accent your whites and glazes, and make them luminous.

If you're not convinced about the value of glazing, try an experiment. Mix your three colors together in a wash, then compare the result with the same colors layered separately in a glaze. There *is* a difference!

Don Rankin
Exercises in Glazing

The following paintings of apples are obviously very simple, but each one is designed to help further your understanding of the glazing technique. The first phase demonstrates the "correct" method of applying the lightest colors first, followed by the darker values. The second phase alters the sequence of the washes: A lighter color is sandwiched between two darker colors. The third phase uses the same colors but reverses the color order.

Everyone is familiar with the apple, a common object that is readily available. These exercises were chosen to show you that you can exert as much control over tonality as you wish. Whether you paint loosely or more realistically, the approach will work. You have the freedom to choose your route.

In all three exercises the colors are Indian yellow, Winsor blue, and Winsor red. These colors reflect a basic primary arrangement that's part of the expanded primary system

Don Rankin uses when he paints. To begin, take a piece of watercolor paper and a 1" Aquarelle brush. Then mix up a wash of each of the three colors on your palette (one with plenty of mixing room). Make up enough to complete several washes.

Phase One

In the first operation you will build the study from light to dark. Many people feel that this is the correct way to paint transparent watercolor because it almost always insures good results. Also, when painting from light to dark, you have the opportunity to modify and refine previous passages of color with a stronger wash of color. The painting is created by developing it in successive stages of color. In some cases, the same wash of the same value is repeated; in other cases, the wash is either strengthened or changed.

Step 1. Lightly sketch in the apple. You can omit this step if you feel confident enough to lay the first wash without any guidelines.

Step 2. Apply a simple flat wash of Indian yellow. Except to follow the contour of the apple, note that the wash is laid in very evenly without any harsh or abrupt edges. Cover the drawing fully and carefully with this first wash; these first few washes will set the mood for the whole painting. Although this is a rather tight rendition, try to strive for a controlled looseness in all of your washes. Remember, in this medium every stroke and every layer of wash leaves its mark.

Step 3. Make sure the paper is bone dry before you apply the next wash. You can test for dryness with the back of your hand—if the sheet is cool, the paper is still wet. Once you feel confident that the paper is dry, dampen it with clear water and lay in a wash of Winsor red. The wet-in-wet effect magically suggests the beginning of form in the apple.

Step 4. Wait again until the paper is completely dry and apply another wash of Winsor red, keeping it at the same intensity as the first red wash. Look closely at the left side of the apple. Note that the wash is diluted in that area, an effect that helps to heighten the illusion of form. Rankin discovered this technique one day when the color in his brush ran out. Instead of dipping it back in the paint, he diluted a portion of the wash with water. So in this case, a simple accident led to discovery instead of disaster.

Step 5. In this step an added feature is introduced—a color square with the step number under it. It's meant to help you by indicating just what shade of color is being applied to the painting.

At this stage, the apple is beginning to come to life as another layer of red wash is applied. Two changes occur here. First, a very small amount of Winsor blue is mixed into the Winsor red. This is done to intensify the red and to come closer to the true color of the model. Second, only a portion of the apple is painted. Once more you should rely on color to develop the form of the apple, so that you feel as though you are painting and not merely applying color to a shape. Finally, note that the top highlight has been colored in with the last red wash.

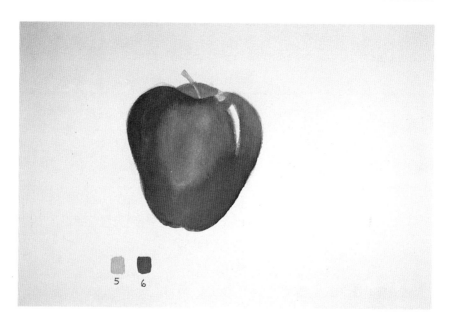

Step 6. In the final stages, begin to apply darker tones of color toward the sides of the apple. Here, as in step 5, use a brush loaded with clear water to feather the edges of a heavy stroke. With this technique, you will combine the soft or blended edge characteristic of the wet-in-wet method with the strength of a direct wash. The final result is a wash with one definite edge and the other edge softly blended or feathered.

Step 7. This is the time to add some of the darkest tones, mainly in the areas of the stem and on the sides of the apple. Use various kinds of brushstrokes to suggest texture and variety in the skin of the apple.

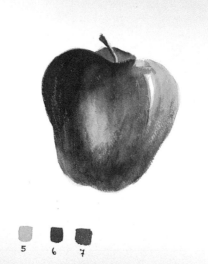

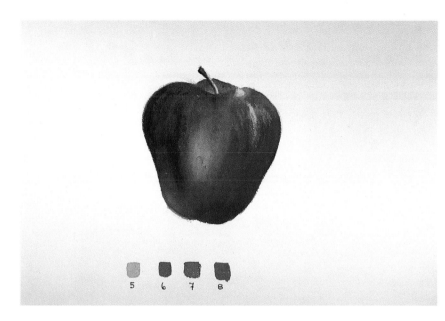

Step 8. To further develop the tonality of the apple, apply another wash of Winsor red. Remember that successive washes of the same color tend to darken the overall tonality of the passage. By darkening the shadow values, you can make the highlights and middle-tone values appear more distinct because of the contrast.

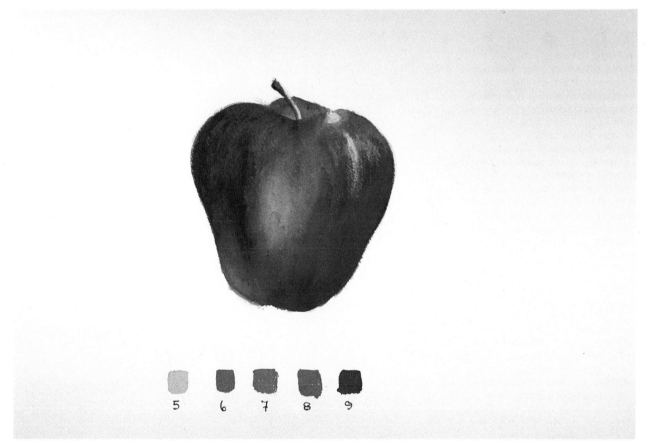

Step 9. Apply a final overall wash of Winsor red and Winsor blue that is considerably stronger than the previous washes. For the shadow areas, use a darker, cooler wash to adjust the values.

 The apple was painted in the strict manner of applying succeeding washes of at least equal if not darker value. The result is a transparent glow.

Phase Two

In this exercise, you will paint the same apple with the same colors. However, the sequence of colors is reversed. This time "correct" procedure will be altered slightly.

Step 1. Sketch in the same apple as your model.

Step 2. Wet the entire sketch with a uniform wash of clear water. Make sure that the entire drawing is evenly damp, or unexpected dry spots may show up suddenly as you apply the wash. Then with a dilute wash of Winsor blue, lay in the first preliminary wash, planning your strokes to imitate the basic form of the apple. Since this is pure wet-in-wet technique, don't try to control the washes except by the general pattern of the strokes. As the wash dries, note that it takes on a very soft, subtle appearance. This effect will be very beneficial in the later stages because it convincingly conveys the feeling of mass and form.

Step 3. In many ways this step is a continuation of step 2. Its purpose is to help you see the initial wash. At this stage, it may be helpful for you to create your underpaintings in two or three phases. As you gain experience and confidence, you can condense these stages into one or two operations. So at the end of step 3, your apple should look very much like the example. You should have a fairly well finished monochromatic painting. Refrain from carrying the shadow values to a very deep state. Right now they are just a little lighter than they should be in the finished piece, so that in the final washes, blue tones will not overpower the red tones.

Step 4. In this step a traditional rule of watercolor is broken: Lighter wash is applied over a darker one. Normally, this will produce an opaque effect. But you can avoid this effect here by using a very transparent light wash. In this case, apply a wash of Indian yellow and allow it to flow over the entire piece, including the shadow and highlight areas.

Step 5. At this stage, you need to refer back to the color bar. It will inform you about the correct strength of Winsor red wash that you'll need. You might find it helpful to paint a few small swatches of color and let them dry before comparing them with the color bar. This way you will know just how strong to make your wash. As you apply the wash, study its effect. Suddenly, the apple comes to life. Notice how the blue underpainting suggests the pattern of the apple's skin and that the secondary highlights are becoming apparent in the middle area of the apple.

Step 6. Apply an additional wash of Winsor red. At this stage the primary objective is to increase the red tones of the apple without destroying the effect of various middle-tone values and reflected lights that have been developed in the underpainting. To accomplish this, dilute the red wash with clear water in the middle area of the apple where the Indian yellow shows through.

Step 7. Add a very slight amount of Winsor blue to the red wash to make the red tones more intense and cool. Concentrate the color over the shadow areas and make the wash more dilute near the highlights.

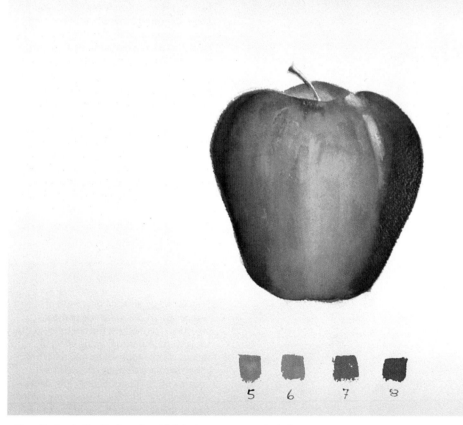

Step 8. Apply the final wash, which is the strongest red of all. Now the color values progress in a steady, convincing relationship. At this stage stop or continue to define detail.

Phase Three

This is the final phase of this exercise. Here the same colors are used once more, but in a different sequence from the first two phases.

Step 1. Start with a pencil sketch or paint in the basic contour of the apple without a guideline.

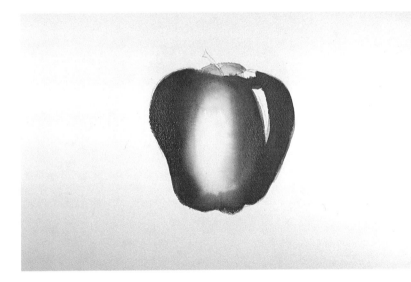

Step 2. Apply a diluted wash of Winsor red to a thoroughly dampened drawing. Note the soft edges at the center of the apple created by the wet-in-wet effect. Once the paper is completely dry, apply a second wash of Winsor red. (Although at this stage the apple has more the look of a ripe tomato, be confident that this bright tone will change.) Dampen the center of the apple with clear water to preserve the wet-in-wet look of the first wash. As the second wash is applied, it will naturally flow in toward the center, imitating the effect of the previous wash.

Step 3. Apply a wash of Indian yellow to thoroughly dry paper. Note the strength of the color by examining the color bar at the bottom.

Step 4. Introduce Winsor blue to the sequence of color.

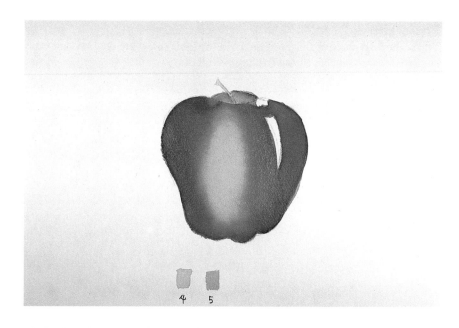

Step 5. Add a little more blue mixed with a slight touch of Winsor red. Note that in this phase, the tones of the apple are different from the first two exercises.

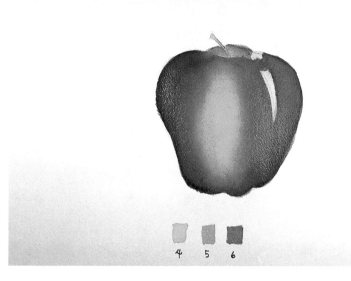

Step 6. Continue to add even stronger washes at this stage. The color is a combination of Winsor red and Winsor blue. The intention here is to continue to suggest the development of form. The darker wash only helps to emphasize how different this apple is in appearance.

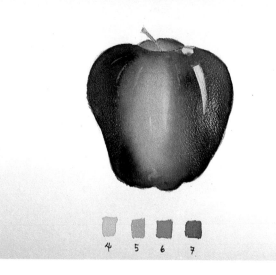

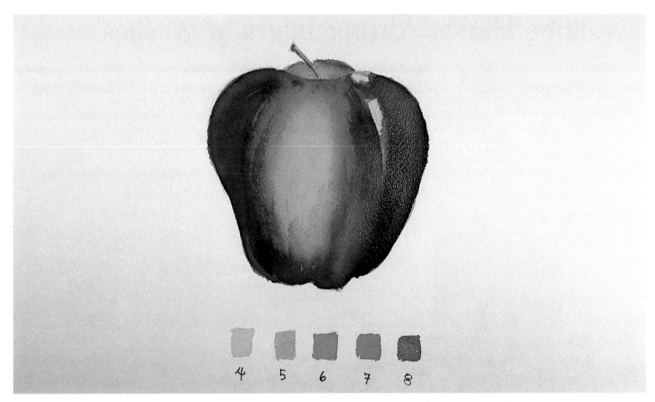

Step 7. This is the final attempt to strengthen the form of the apple. While this mixture of Winsor red and Winsor blue definitely establishes the shadow values on the apple, it doesn't do much for traditional apple color. Note that although the contrasts have been balanced to suggest the form of the apple, the color value has been drastically altered.

Different colorations occur when you alter the color order of your washes. These apples all have a different appearance even though only the color sequence was changed. Remember, you are applying layers of color over white. Each layer influences the layer above it. In some cases the first layer of color will dominate the final color. In other cases this effect will not be as apparent. In phase one, yellow was the first color down; it had the effect of warming up the red and making it a bit more lively. After the yellow came the blue, and then the final washes were in the red family. The final result: a red apple with warm undertones.

Phase two uses the same colors (examine the color bars) as phase one, but this time the staining value of Winsor blue was used to advantage to execute a detailed underpainting. This underpainting was then modeled with washes of yellow and finally red. Note the character of the finished apple. It somehow seems to have more weight than the phase one apple. This can be attributed to the effect of the blue underpainting, which exerts a lot of influence on the final

color. The end result is a harmony of all the colors used.

Phase three is a clear demonstration that underglazes don't always dominate the final color. You have to give the reds credit, though; they are trying to come through. But the Winsor blue is just too powerful to take a back seat to the red and yellow underglazes.

The conclusion to be drawn from these exercises should be obvious. The order in which you apply color has a direct impact on the final color achieved.

Assignment
Follow the basic progressions in these exercises, using other combinations of red, blue, and yellow. Observe your experiences with these colors, noting expected and unexpected changes in colors. Take notes and compare the results from color combination to color combination. After you make these observations, choose some of your own favorite colors. Experiment with them and note any variations.

Don Rankin
Avoiding Harsh, Abrupt Edges in Washes

Unfortunately, unwanted harsh edges that occur while you are trying to build up layers of wash are among the main obstacles you must overcome to master the glazing technique. Luckily, much of this can be prevented by proper planning and by using the correct technique.

Most of the time, harsh edges occur when you are trying to butt two color planes against each other—for example, where the sky meets the horizon, a mountain range, a tree line or a rooftop, or where water meets land.

To make better transitions, you can feather the edge of the paler or lighter wash in the area where the other darker color will meet it. After the wash or series of washes dries, you can apply the darker wash. The darker wash will cover the feathered edge of the lighter wash and no seam or abrupt edge will show.

Don't give unwanted harsh edges a chance to build up. Unless you like the rugged look, make sure you dampen your paper before you apply the initial wash.

This is a typical direct wash. The pigment was applied directly onto dry paper. All of the edges are crisp.

In this wet-in-wet example, the color is delicate and all the edges are soft. This will make it easier to blend and overlap colors for a smooth transition. Another approach would be to use a modified wash that looks similar to a graded wash.

This wash can be blended on its softer edge with other washes. You can "feather" a soft edge with clear water.

Three washes of the same color and the same strength were used to produce this example. You can see a few hard edges in this color block. These occur because it's not possible to paint over the same area time after time with absolute precision. Don't try to fight the consequence of not being a perfect machine. Work around it.

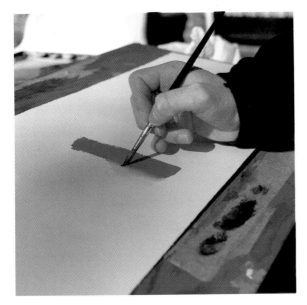

Here Don Rankin demonstrates one method for feathering an edge. First he applies a typical flat tone, or a direct wash. Before it can dry, he loads a brush with clear water and paints it on the side of the wash. The result is an instant bleed. This is a great technique for blending the edge of a color where you want a soft edge. However, be careful that you don't mar the wash you have laid down. Always make sure the wash is very damp and is not well advanced in the drying stage. Also, be sure your brush is fully loaded with moisture.

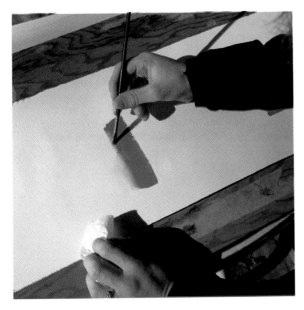

After the wash is dry, Rankin uses a damp bristle brush to soften the hard edge. You can also scrub or scrape out the offending edge.

FLAT-TONE WASH

Don Rankin makes a typical flat tone by pulling his brush back and forth over an area using horizontal strokes. With the brush, he literally pushes a puddle of wash across the paper. When the brush reaches the lowest point, the moisture is also there in the form of a small puddle. This puddle has to be soaked up; otherwise it will look like one of the four examples shown here: 1) The wash left at the bottom discolored the tone. 2) The wash is streaked as well as uneven. 3) Not only is the wash uneven in value, but a small "explosion" is evident in the lower right corner. 4) Here, as the wash was drying, the excess moisture was drawn into the drying area, creating a streaked, uneven wash.

1.

2.

3.

4.

To avoid uneven, streaked edges, you should have a tissue handy when you have completed your wash. Touch your brush first to the area to be soaked up, then to the tissue to remove the excess moisture from your paper.

Take your brush and lightly apply the tip to the puddle of wash. Your damp brush will act like a sponge and draw the moisture up. If the puddle is fairly large, you may need to do this more than once. In cases where the puddle is really big, use the corner of a tissue instead of a brush. Be careful not to disturb the color.

Here, Don Rankin's first wash covers the sky and comes down below the horizon line. He did not stop at the horizon line because it would have been impossible for him to match another wash perfectly. If washes don't match, an unwanted edge is going to form.

Rankin resolved this problem by painting well below the horizon line and feathering the wash until it blurred into near oblivion. To do this, you must make sure your water and brush are clean. The object is to develop a wash that can be covered effectively by the next wash without harsh edges showing through.

Where the sky meets something at the horizon—whether it is a mountain range or the sea—there is a chance for an unwanted harsh edge to appear. If you obey the rule of feathering the lighter wash, everything will work just fine. This sample contains two washes, and everything has been kept very transparent so you can see both layers. The first layer is the sky. After the paper was dry, Rankin applied the second darker wash. It covers most of the first wash and defines the mountain range. He allowed some of the lighter wash to peek through in the foreground for variation.

Valfred Thëlin
The "Controlled Drip" Technique

To execute a controlled-drip painting, you brush clean water onto a sheet of paper exactly where you want the pigment to go, working your way up from the bottom of the sheet and forming the shapes of your subject. Then you drip paint onto the wet area and tilt the paper to move the pigment into the appropriate places.

When using this technique, you must let the painted surface dry completely before adding another coat. A terry towel laid underneath the painting absorbs the moisture evenly and rapidly, allowing the paper to dry flat.

To learn about the controlled drip technique, start with a small painting like the one shown here. Choose a simple subject so you can concentrate on gaining control. For this painting,

Valfred Thëlin chose a limited palette of Winsor blue, Hooker's green dark, and cobalt blue.

With only the tip of his 1½" flat brush completely saturated with water, Thëlin ran the brush over the dry paper in a diagonal line. This encouraged a diagonal wash to flow across the full width of the paper without damaging the surface.

While the paper was still very wet he dissolved Winsor blue in a large puddle on his palette. Holding the brush in the center at the edge of the wet surface, Thëlin squeezed it between his fingers, forcing pigment to drip out in one continuous stream. Then he removed it quickly to prevent further dripping.

Now the medium really goes to work. As it begins to spread into the wet area, it follows the diagonal wash across the paper but will not pass over to the dry surface. By picking the paper up on one side or the other, you can make the color bleed more. Hold the paper by the edges between the palms of your hands to avoid getting fingerprints on it, since these can cause stains and create a pigment resist. Turn and twist the paper to encourage the paint to move over the wet area. You will find that it takes a bit of concentration to make the pigment run where you want it. To avoid backruns (blooms), drain off excess

To encourage the color to move along the line a little further, Thëlin took a #5 round brush loaded with water only and moved the stroke along the edge.

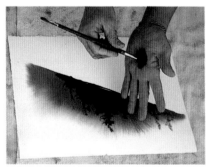

When the drying was half over but the paper was still damp, Thëlin took his #10 round brush and spread the bristles apart in the palm of his hand (he calls this a "mutilated brush").

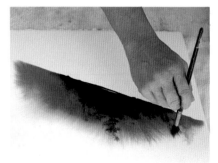

With his mutilated brush Thëlin stroked a series of vertical lines to indicate pine trees. He then crossed the vertical lines with horizontal ones to suggest branches.

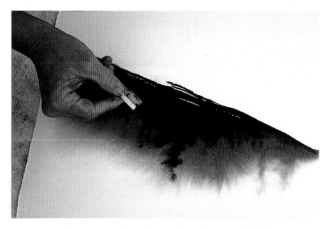

He scraped in tree trunks with a single-edge razor blade.

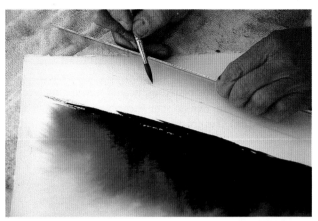

When the painting was dry he dipped his #5 brush into cobalt blue and, holding it against a ruler slanted at a 45-degree angle, drew a very thin straight line to suggest ski tracks.

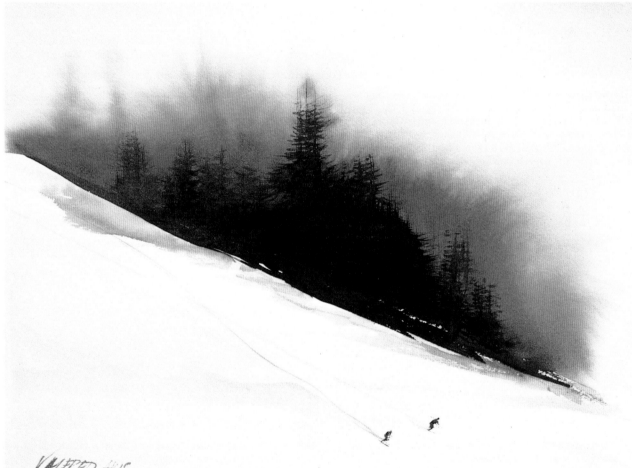

SNOW SKIERS
Watercolor on Arches 140-lb. cold-pressed paper, 11 × 15" (27.9 × 38.1 cm), collection of the artist.

Then with a touch of red Thëlin painted the torsos of the skiers, and indicated their skis and legs with dark blue. The size of the figures helps define the expanse of the ski area, putting everything into perspective. He finished the painting by adding some shadow lines, some more trees, and his signature.

Valfred Thëlin
Executing a More Complicated Drip

Once you've mastered the basics of the controlled drip, you're ready to experiment with more complex subject matter. When working on a complicated painting such as this, Valfred Thëlin likes to start with a warm yellow, first light, then dark. The yellow on white paper seems to add a glow that reflects through the drips of additional colors and gives the painting a warm, even glaze. He finds that a meditation process seems to occur when he's watching the pigments blend and explode as they slide across the paper.

As you continue experimenting, you'll find many different ways of using this technique, alone or in combination with other techniques.

First Thëlin lays in a very wet wash of clear water, covering the area he wants to flood with color and forming the initial silhouette at the top of the water line. Still using plain water, with a 1½" flat brush he creates the shapes of the lighthouse, building, and rocks; then he corrects the lines with a #5 round brush to get a fine, straight edge. The paper is now very wet, with an even surface tension.

For the first color Thëlin mixes up a large puddle of cadmium yellow and alizarin crimson and fills his brush with it. With his index and middle fingers he slowly presses the color out of the brush, letting it drip onto the surface at about the center of the picture area. Then he watches it spread and do its own thing.

While the paint is still in motion, he sharpens some of the edges at the top of the paper with a #5 round brush.

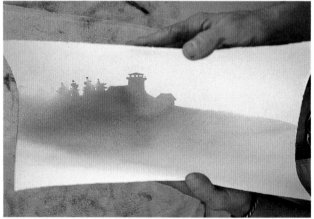

Now he picks up the paper and curves it to encourage the paint to flow away from the top, directing the color while allowing the pigment's granular quality to form a texture.

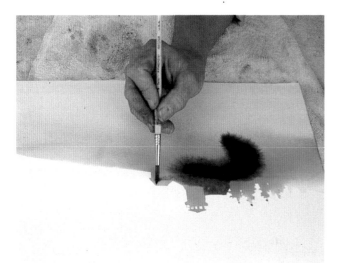

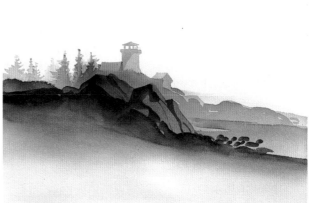

This is a repetition of the first step, only this time Thëlin is using alizarin crimson and Winsor red along the silhouette; he lets the color run to the edge of the paper and drips the excess off.

You can continue this process as many times as you wish, each time getting the color in the foreground cooler and darker. Let part of every successive layer show.

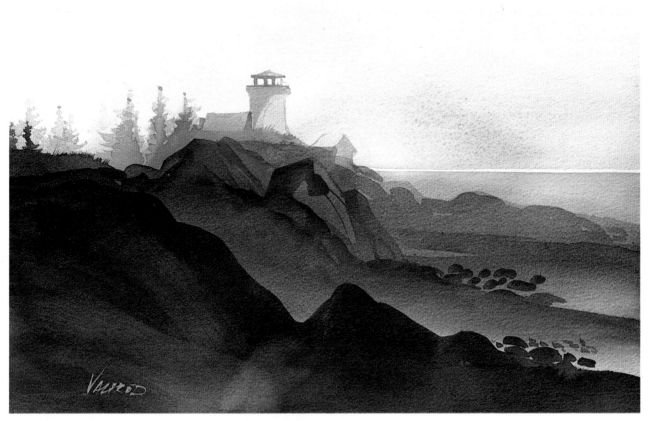

LIGHTHOUSE POINT
Watercolor on Arches 140-lb. paper, 11 × 15" (27.9 × 38.1 cm), collection of the artist.

The last color Thëlin adds is the cobalt blue of the sky and a wash of Winsor green to establish the horizon line in the background. In the finished painting you can see all the colors working with one another, the red glow of first light hitting the lighthouse and the stones reflecting in the tidewater area below.

Graham Scholes
Taking Advantage of Staining Pigments

Pigments that rate high in staining quality offer watercolorists certain technical advantages. Sap green is one such color. In this demonstration Graham Scholes mixes several nonstaining pigments with it and, using a lift-off method, shows how the sap green leaves traces of itself behind that let you create shapes within a dark background. You will find this approach easier than trying to dodge around such intricate negative shapes.

The palette used for this demonstration consists of sap green, Antwerp blue, cerulean blue, ultramarine blue, new gamboge, burnt sienna, raw sienna, and alizarin crimson.

While camping by a stand of cedar trees during a workshop tour in British Columbia, Graham Scholes got the idea of combining the intriguing patterns of the hanging branches with the pattern formed by a line of clothes he spotted hanging in a clearing. To combine these two striking images, he had in mind an abstract treatment for the clothesline and loose realism for the cedar trees.

First Scholes does a quick sketch to sort out some of the compositional problems. The circular foreground, three vertical trunks, and arching horizontal background of the clothesline add up to an interesting mix of line. The sketch helps him see the need to establish a pattern of shapes in the foreground that will complement the background.

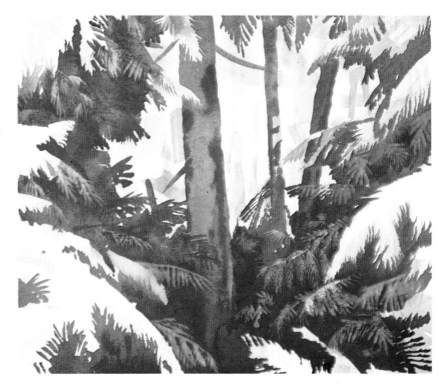

Scholes uses five colors in the first wash: cerulean blue for texture, plus Antwerp blue, raw sienna, alizarin crimson, and new gamboge. With the first four hues he develops the structure of the clothes; to establish the yellow-greens of the cedar branches, he uses a mixture of new gamboge and Antwerp blue. He makes sure a few of these branches are blue so some background color appears in the foreground for harmony and continuity.

After allowing each wash to dry, Scholes develops the design of the clothes with 1½" and 2" sky wash brushes using two more glazes, cerulean blue and Antwerp blue. These values can be strengthened once he establishes the foreground.

Although the sketch defined the position of the three trunks, Scholes lays some real tree branches on the painting to confirm the best arrangement for these elements. He can then visualize the design for the wreath of cedar boughs. Another method is to paint the forms on a sheet of Plexiglas with any dark pigment, then place the Plexiglas over the painting. Mix soap with the pigment so it will adhere to this surface. This suggestion has limitless uses for determining compositional situations at any time during a painting. Here the artist shifts the Plexiglas from left to right to consider his options.

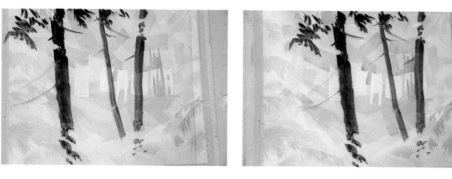

Scholes wants a combination of hard and soft shapes for the cedar branches, so, beginning in the upper left corner, he wets the paper and waits until it reaches the satin-wet (medium-wet) stage. Then he applies a very strong mix of ultramarine blue and sap green. In some areas he applies the colors separately and allows them to flow and mix at will on the paper. He drops in some alizarin crimson in the same way with a ¾" nylon bright brush to create interesting and important touches of color amid the green foliage. He blends these colors up to the yellow branch that was established in a previous wash, and when this section is almost dry, he lifts off color with a #6 bristle brush to redefine the branch shapes.

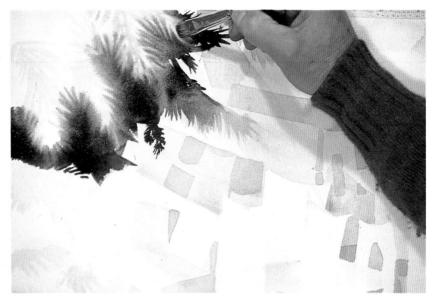

The artist works his way around the painting in medium-size sections using the four brushes shown here, developing the ring of cedar branches until he reaches the top right-hand corner. He is careful to avoid using any sap green in the random areas of alizarin crimson and mixed light greens, as he does not want it to overpower them.

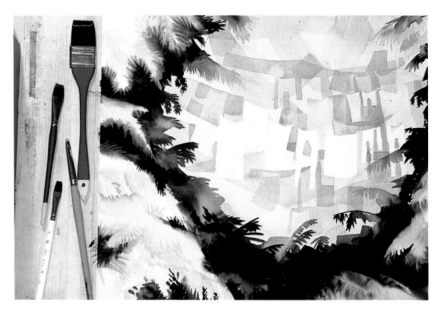

Before proceeding with any further details in the wreath, Scholes drops in the tree trunks with a mix of burnt sienna and ultramarine blue.

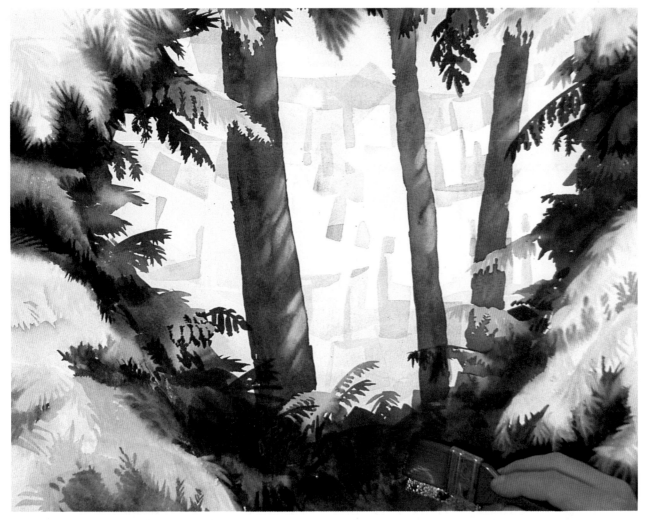

With his bristle brush, Scholes lifts out the shimmer of sunlight on the trunks, then adds a few cedar branches along the top edge and down each side of the wreath. At the bottom left corner he washes off some of the dark values, but the stain of the sap green remains. A glaze over the light branches at mid-left and the bottom of the wreath is needed for continuity and to tie more darks to the edges of the composition.

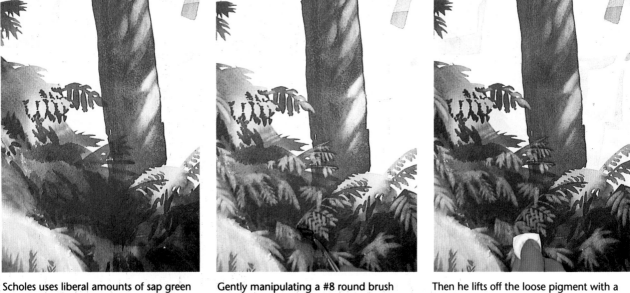

Scholes uses liberal amounts of sap green in the dark wash at the base of the tree trunk.

Gently manipulating a #8 round brush dipped in clean water, he loosens pigment to define negative leaf shapes.

Then he lifts off the loose pigment with a dab of tissue.

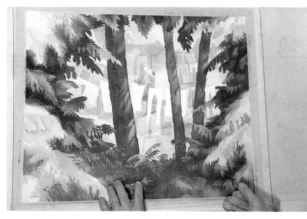

Using the Plexiglas overlay again, Scholes now aims to determine the best location of color for the clothes hanging on the line. After trying several variations, he decides on red, yellow, and blue, using deeper values of blue at this stage to strengthen the pattern.

With his rigger brush, Scholes adds a few dead branches and bark details using ultramarine blue and burnt sienna. As the final touch, visible in the completed painting (right), he adds a light blue glaze to a small area at left, subtly defining a cedar branch that brings more blue to the foreground.

CEDAR CHEST
*Watercolor on Arches 300-lb. cold-pressed paper,
18 × 22" (45.7 × 55.9 cm).*

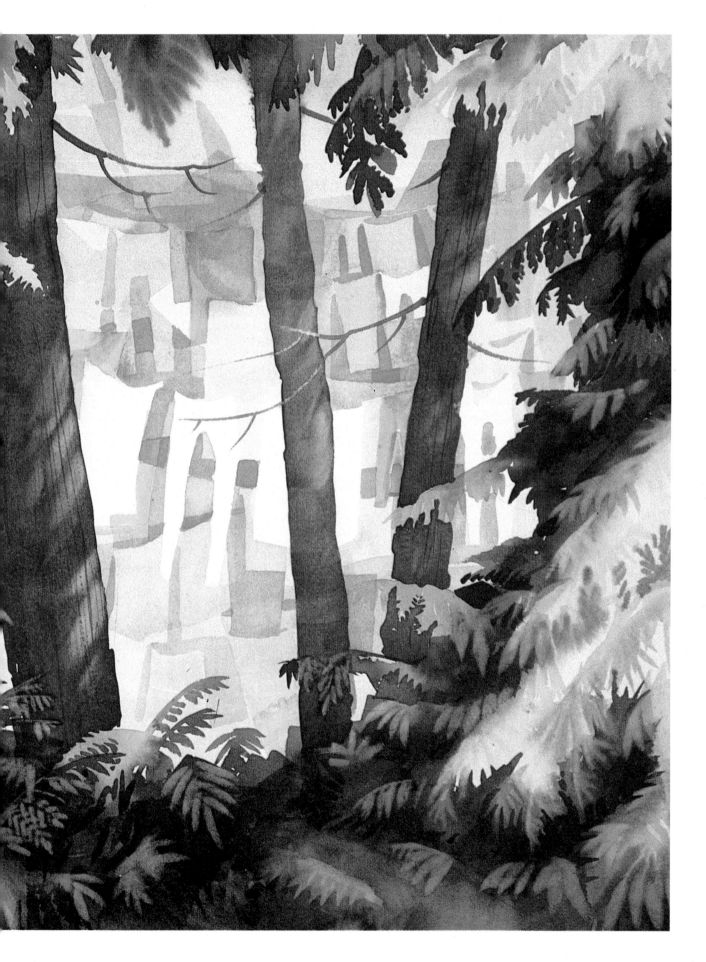

Graham Scholes
Working with Nonstaining Pigments

Manganese blue has two very useful features: It is a heavy pigment and settles quickly on a painting surface, meaning that in a mixture other pigments will settle on top of it; and it rates zero on the staining scale, meaning that you can scrub it off a painting with a bristle brush. Before you go ahead and use this technique, test your paper first to insure that it will withstand the rigors of scrubbing. If surface fibers lift off when you attempt to remove color with a bristle brush, use another paper—one with good wet strength.

Mixed with two other hues to neutralize or gray it, manganese blue is particularly useful when you want to depict natural-looking sun-and-shadow patterns on snow, which you can achieve by removing color where necessary. The knack, as this demonstration shows, is to get the right blend and apply it properly so that removing the manganese is fairly easy.

Many students have trouble getting the correct combination of the three colors and keeping them well mixed before application. Another inherent problem is that once you apply the mix to the paper, it's very difficult to put another glaze on top of that layer without disturbing and spoiling it. For better success with the manganese technique, try the method shown in these next few pages. (Ultramarine blue and burnt sienna are two other nonstaining pigments that can be effective with this approach.)

Scholes's palette for this demonstration consists of manganese blue, Antwerp blue, brown madder, burnt sienna, and raw sienna.

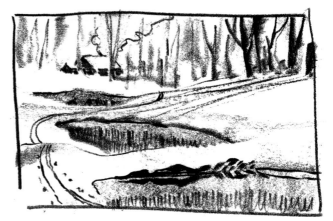

As a preliminary step Scholes makes a pencil sketch to establish the arrangement and values of shapes for a composite image of things he's seen while snowshoeing and skiing. He calls this "imagineering"—calling up information from memory and using his imagination to engineer a composition from these various facts.

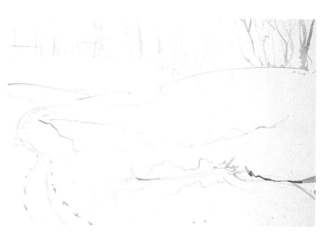

Instead of using pencil to establish the location of these compositional elements in the actual painting, Scholes sketches them right on the dry paper with a rigger brush and manganese blue. (If you prefer a soft-line image, you can do the sketch on wet paper.) The amount of manganese you pick up on the brush should be just enough to let you see the image but not so much that it will dominate the finished painting—unless, of course, you want this color to be an important part of the design (in this drawing the blue is very strong so it will show up in the photograph). The beauty of manganese is that it can be removed completely with a bristle brush.

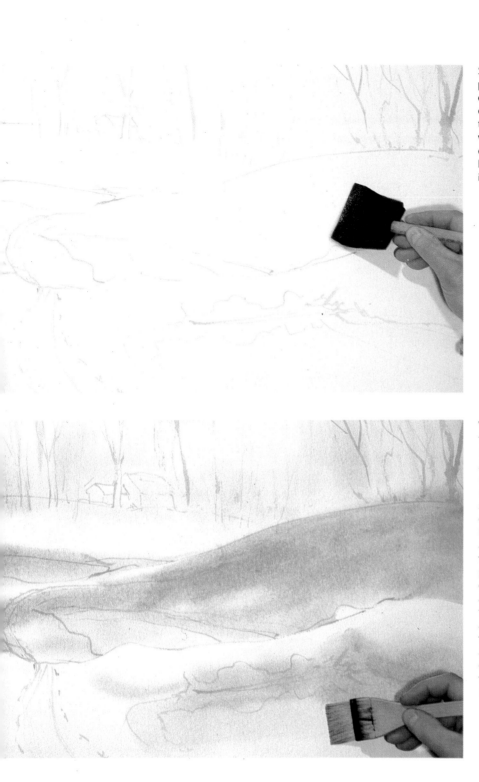

Scholes wets the paper thoroughly with a poly brush, leaving only a narrow section dry in the foreground along the top edge of the snow on the log. Because he wants the paper to absorb lots of moisture so it will stay damp longer for the next step, he doesn't use a hair dryer but allows it to dry back to a satin-wet (medium-wet) stage on its own.

When the paper is mat wet (barely damp) to satin wet he applies a light value of manganese to the background area with a 2" hake brush, intensifying the color to a medium-light value for the shadows in the middle ground and foreground. To get the soft contour of the hill in the middle ground, he uses very little pigment in the brush so the color won't run into the white areas. Above the artist's hand the blue forms a sharp edge against the white of the paper, which he had left dry to get this effect and create the sunlit snowbank. The area he is painting in this step is damp so the manganese will spread downward into a soft shape; he keeps the pigment away from the upper dry area. It is important to apply these washes gently so they will be easier to scrub off later. Brushing on color vigorously works the paint into the paper, making it difficult to remove.

After drying the manganese wash with a hair dryer, Scholes rewets the paper, the same as in the first step. A medium-light value of warm gray mixed from brown madder and Antwerp blue is gently glazed over the manganese blue areas. (For greater texture you can use a mix of ultramarine blue and burnt sienna, which are more granular.)

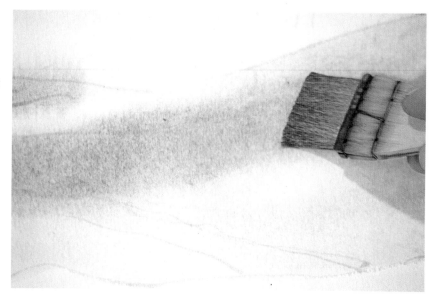

Varying the gray to create cool and warm tones gives the snow interesting hues. When applying the gray, allow some room for the pigment to migrate to the edge of the manganese blue. Start about half an inch back from the edge of the already established white areas. A knowledge of the wet-in-wet technique is important here. If paint creeps beyond the chosen area, as it has on the hill above the artist's hand, use a damp brush squeezed dry with a tissue to pick up the stray pigment.

At the mat-wet stage of this wash Scholes drops in the dark areas where the snow meets the water. The shape is rendered so it represents both the shadow and its reflection at the water's edge. If the surface had dried before he was ready to add this detail, Scholes could easily have rewet the paper about an inch above and below the area where he wanted to put down pigment to obtain the same results, without harming the existing wash. A water line may form at the edge of the wetted area, but this can easily be removed by gently dabbing with a tissue.

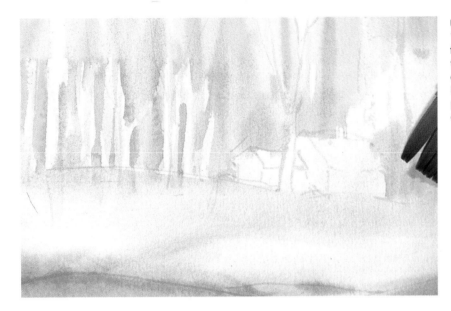

Using raw sienna and burnt sienna on his 1½" sky wash brush, Scholes lays in the first value of the forest background. Notice the split in the brush, which enables him to develop two shape widths with one stroke. He blends the soft areas with water and paints around the shapes of the cabin and chimney smoke.

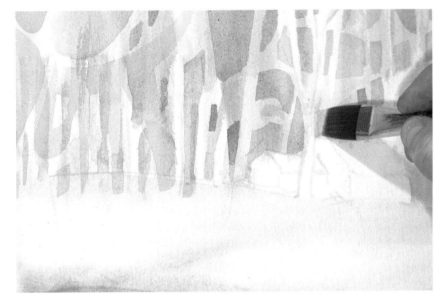

On a dry surface Scholes defines some of the larger abstract shapes within the forest, mixing brown madder with raw and burnt sienna. Notice that the manganese blue underdrawing is not interfering with the design.

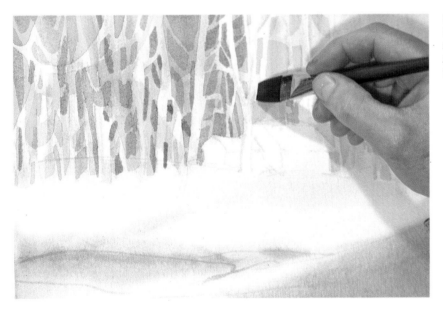

Scholes completes the calligraphy—the intricate network of trees—by introducing some blues, a mixture of manganese and Antwerp blue with a touch of brown madder.

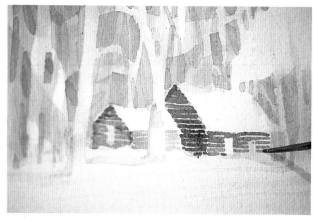

With the background value established, Scholes drops in the log cabin, proceeding with his washes pyramid-fashion (light, then medium, then dark) for the three values. The darkest will be the shadow lines under the eaves.

At the top right corner of the painting he renders the trees with a 1" slanted bristle brush and a mix of Antwerp blue and brown madder. A ½" ox-hair flat would work nicely too, using the drybrush method.

Using a damp #6 bright bristle brush, Scholes creates the pattern of sunlight on the snow by gently scrubbing off the two washes that make up the blue shadow. When removing color, apply the same pressure you would normally use when writing softly with a pencil. Blot the loosened pigment that piles up around the edges of each shape with a tissue before moving on to the next.

Here Scholes has blotted half of one shape to show you the comparison; note the soft, diffused edges where excess paint has been cleared away. The darker spots of blue in the right-hand corner are shadow values of shrubs. He had put these down before lifting off the pattern of sunlight on the ground by rewetting the area and dropping in a strong mix of the three snow colors when the surface was mat wet.

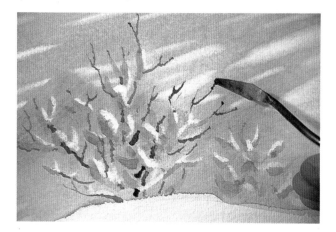

To create the white, sunlit snow on the shrub branches, Scholes wets a couple of shapes at a time with clean water and blots each with a tissue within a couple of seconds, then removes the color with a white plastic eraser. This produces hard edges that project forward and appear closer to the viewer than the softly sunlit areas behind them. Antwerp blue and brown madder work great for the branch structure, which Scholes applies with a palette knife.

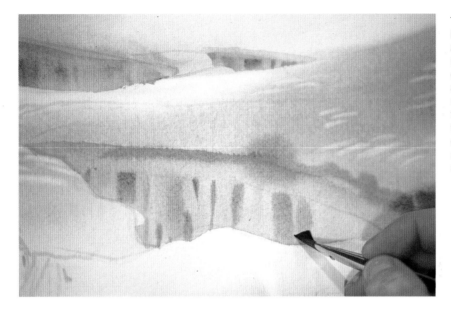

The first value Scholes applies to the pool is a muted blue mixture of Antwerp blue and brown madder. The value of colors he uses for the reflections in the pool must be darker. When the paper is mat wet he applies these one at a time, starting with raw sienna and using very little moisture in the brush to keep the reflected shapes of the forest fairly sharp. Next he uses a mix of raw sienna and brown madder. The moisture content of the paper and brush are just right for a softly defined pattern.

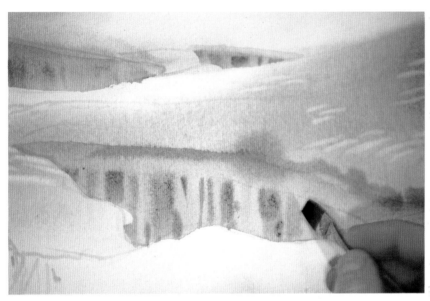

The secret of completing the reflections in one wet-in-wet wash is to work back and forth across the area, keeping the moisture level of the section constant. If the area starts to dry, resulting in hard lines, the best approach would be to dry it thoroughly and rewet with clean water before proceeding. Here Scholes applies the last value of muted blues to finish the pool.

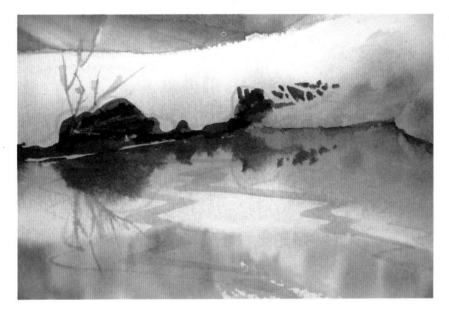

With the darks of Antwerp blue and brown madder, Scholes completes the snow-covered log; now comes the reflection in the foreground pool. The paper looks dry but is cold to the touch—just the right amount of moisture for the pigment to creep to a slightly jagged edge in a few places. He drops in the reflection, mimicking the shape of the log. The small shrub on the log and its corresponding reflection give the area a little more interest, while a couple of zigzags in the water provide a touch of movement.

To define the ski trail Scholes uses a #8 sable-and-nylon combination round brush and a mixture of manganese blue, Antwerp blue, and brown madder.

As finishing touches he indicates ice in the foreground pool, creating a circular path of vision around the right-hand corner of the painting. To recapture some whites, he scrapes the surface with a razor blade and adds a little glaze of blue near the ice to darken the water.

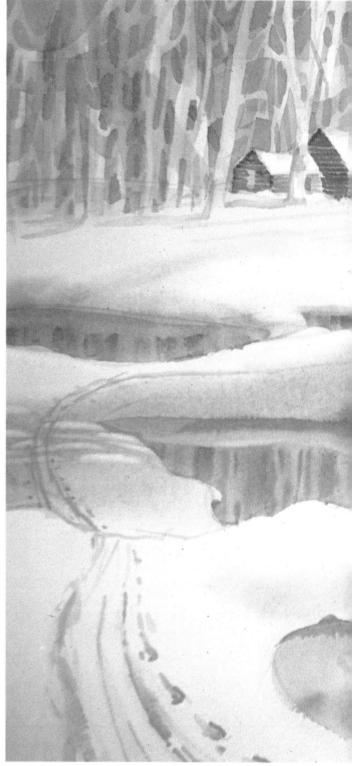

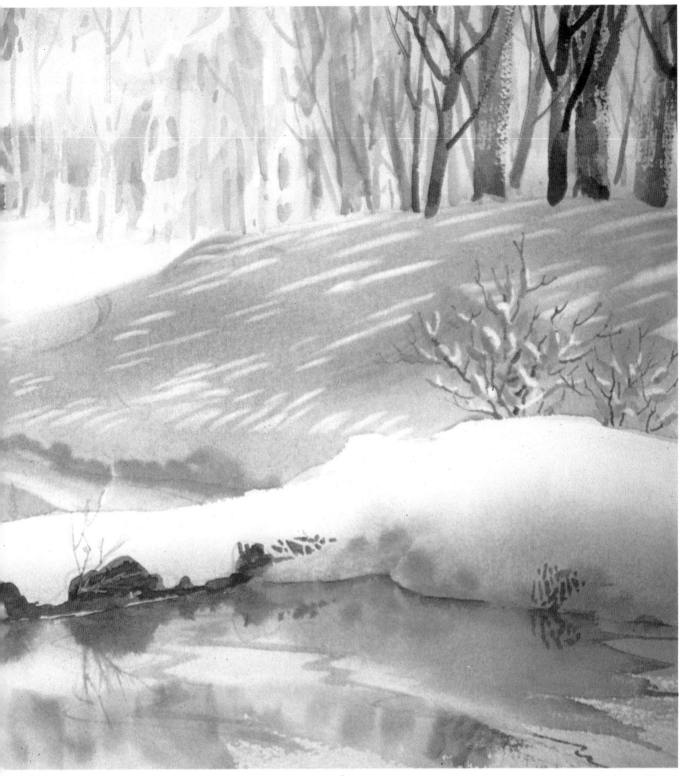

THE TRAIL HOME
Watercolor on Arches 300-lb. cold-pressed paper, 15 × 22" (38.1 × 55.9 cm).

TEXTURES & SPECIAL EFFECTS

Drybrush, spattering, masking, and other texturing techniques that expand the artist's repertoire are just some of the ways to achieve visual excitement in your painting. If you want, for instance, to simulate the textures of wood, grass, water, or fur, Don Rankin can show you how. If vibrant, sparkling color and texture are what you seek, John Koser's primary palette and unique, "non-contact" method of paint application may help you achieve it.

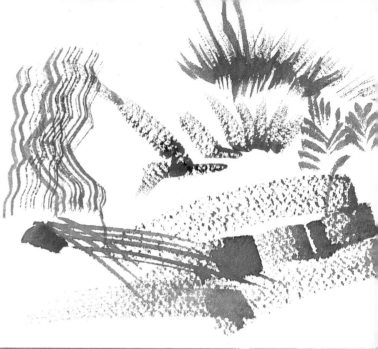

Stephen Quiller

A Wealth of Possibilities

Drybrush on Rough Paper

To make the wavy stripes on the left, Stephen Quiller used a fairly dry ⅝" single-stroke sable brush with the fibers spread apart, pulling it over the paper in an irregular way. For the effect at upper right, he used a fairly dry #8 round sable with the hairs splayed to lightly stroke in brush patterns. By turning the brush around, he pulled the pigment down and created the negative grass shapes. The strokes going off the top edge were made with the same brush, which was pointed and contained more pigment. The more graphic strokes at right were made with a #3 round sable. Quiller directed the brush by pressing it and moving it to the side to bring it to a point, creating a pinecone form. For the center area he used a #8 round sable, and for the lower part, a ⅝" single-stroke sable. Both brushes were dragged lightly across the rough paper, which lends sparkle to the strokes. The crosshatching at lower left was done with a ⅝" single-stroke sable turned on its edge, using somewhat more water.

Scarring and Scraping

After thoroughly wetting a piece of Arches 140-lb. cold-pressed paper, Quiller washed on color and, while this was still wet, used a coping saw (or comb) to make the parallel lines. The color seeps into the scarred area and stains it. When the paint begins to dry, color can be scraped off with the blade of a mat knife (or a pocket knife) held like a butter knife, the effect you see at upper right.

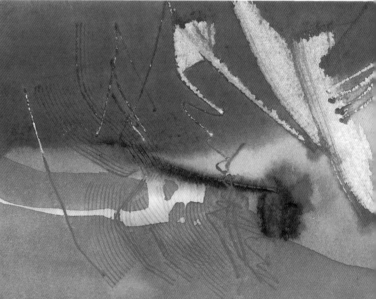

Spatter

Here you see two kinds of spatter, at top executed on dry paper and at bottom on paper that has been wet. At left Quiller used a toothbrush loaded with pigment and tapped it lightly to eliminate excess. Then he turned the toothbrush face down, brought it close to the paper, and dragged his thumb across the bristles. At right, he loaded a ⅝" single-stroke sable with pigment, held it in one hand, and tapped it lightly across the back of his other hand to create what he calls directional spatter. A round brush creates a different effect. Keep in mind that too much pigment on the brush may spoil the effect with large globs of paint, so get rid of the excess.

Salt Application

First Quiller wet the paper, then he applied the pigment. When the paper was at a medium wetness, he shook table salt over it. The wetter the paper, the greater the lifting of color. If the paper is nearly dry, it lifts very little. Rock salt can be used for a different effect. While this texture is visually exciting, like other textures, it must not be used to excess or as a crutch when you don't know what else to do.

Blowing and Rolling

The delicate fiberlike shapes were made by applying red, blue, and green pigment to paper, then blowing on this with a straw while it was still wet. The force you use in blowing determines the kind of line produced. Below this is the effect created by applying paint with a small brayer, or roller, similar to the kind used in printmaking. Pigment can be rolled on in broad bands, or the brayer can be rolled on its edge, creating the lines you see in the middle and extending off toward the upper right.

Additional Experiments

Experiment with many different ways of applying paint. You may find some new, unique kind of application that is perfectly suited to your way of painting. Here the combed texture at left was created by pulling a coping saw across a thick application of titanium white acrylic while it was wet. Quiller also touched some areas in the upper part with his fingertip. After allowing the acrylic to dry for about eight hours, he washed burnt sienna over it; this seeped into the depressions and enhanced the texture. If you wash pigment on the acrylic while it is still wet, it will shrivel, creating quite a different surface. For the spots of color at upper right, Quiller used a cotton swab. The irregular strokes at lower right were made with a small pointed stick.

Don Rankin
Combining Textural Effects with Glazing

Don Rankin uses many different items for creating textures and unusual effects in combination with the glazing technique. There are countless possibilities. You can use your fingertips, fingernails, or a sharp-pointed stick to create delightful smudges and fine grass lines and twigs. Try using a wadded paper towel to apply color, or tissue to blot out and create fleecy clouds or frothy waves. Natural sponges provide an excellent way of developing controlled as well as random textural patterns. Rankin keeps several sizes available in the studio; those he uses most often are no larger than 2 × 3". A sponge can make a lovely tree, especially small maples and fruit trees in bloom. With cheap grocery-store sponges that measure about 4 × 2½", you can produce uniform, predictable textures for concrete walls, sidewalks, and so on. Use your imagination and always be on the lookout for new ideas, but avoid gimmicks that may overpower the painting itself.

With glazing you are working in layers, which means you must be careful to use a light touch with sponges and similar tools so you don't scrub or lift an earlier wash off the paper. A light touch also prevents a heavy buildup that can create an unwanted opaque effect.

For this painting Rankin used a fairly wet sponge. The little spots of color on the fringes of the shape were applied last, after most of the moisture had been pressed out of the sponge. You can also glaze with a sponge, creating mixtures of colors and shapes to make a natural-looking tangle of scrub growth, grasses, weeds, or patches of wildflowers.

In this example, Rankin used a dry man-made sponge to apply several layers of pale Thalo blue, new gamboge, and vermilion. He repeatedly picked up pools of color washes and laid them down flat on the paper until a pleasing texture was built up. He left the wash fairly weak on the left side of the example to reveal what the first layer of wash looked like. As he approached the window, he darkened the wash by increasing the amounts of red, blue, and yellow. For the final touch, he then used a square-edged brush to paint around the windowsill to strengthen the shadow effect, using the same color he'd used with the sponge. This wash acted like a glaze to unify all of the previous sponge work.

The foliage just above the horizon was created with the artist's fingertips. Rankin made the dark marks while the wash was very wet, so that the wash seeped into the gouges in the paper. For lighter lines you need to wait until the wash is almost dry, and then scrape. Fingernails or a sharp brush handle will scrape away pigment to expose the white of the paper—or a previously dried staining wash.

The crest of the wave in the middle ground of this example was blotted out with tissue just before the wash dried. If the blotting had been done sooner the crest would appear lighter than it does here. Rankin suggested waves in the foreground by using a square-edged brush. These highlights can be dulled by applying another wash to cover the pure white of the paper.

Here, a sky filled with fluffy clouds was achieved by blotting the sky washes with a facial tissue. Each time Rankin applied a wash to the sky, he blotted the area with a tissue while it was damp. After each layer dried, the process was repeated.

This sample shows the types of texture that can be created using a paper towel. First a flat wash was applied. Before the wash dried, Rankin laid a piece of paper towel across the wash and tapped it with his fingers. Then he lifted it from the wash. The result can be clearly seen in the upper portion of the wash block. The lower section shows the effect of daubing color over the previous wash.

Don Rankin

Using Sponges, Tissues, and Other Tools

In this two-step example you see how Don Rankin glazed a large, flat rock. First he established the preliminary shape using a 1" Aquarelle brush to paint flat washes. After this had dried, he used a sponge to model texture.

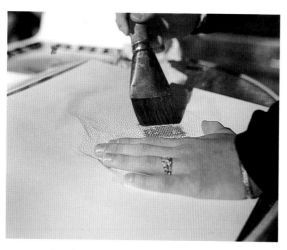

Here Rankin shows how to create texture with a piece of nylon mesh. Holding the mesh in place on the paper with one hand, he applies color through it with a large square-edged bristle brush.

In this study of a honeycomb, Rankin used a man-made pattern in conjunction with the glazing technique. First he brushed in the basic shape of the nest with its lights and darks. The areas he wanted highlighted were left pure white; the shadow areas were darkened using several washes of color. Once the desired balance between shape and light and dark had been established, it was time to define the cells. Rankin positioned the mesh over the painted shape so that he could create a pattern that would imitate the way a nest is constructed. Then, working with a large square-edged bristle brush, he began to apply darker color over the mesh.

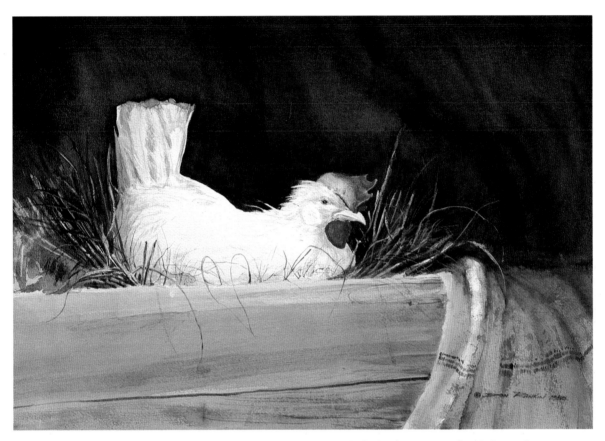

SETTIN' HEN
*Watercolor on Arches 140-lb.
cold-pressed paper, 15 × 22"
(38.1 × 55.9 cm).*

To begin this painting, Don Rankin applied a bright orange underpainting to the background, taking care to avoid the white hen, the plank, and the portion of the draped burlap bag. Once the orange was dry, he dampened the paper and applied a very dark mixture of India ink and vermilion. He used a bristle brush to disturb the wash when it was still slightly damp. Just before the wash was completely dry, he used the sharp handle of an Aquarelle brush to pull some of the dark color out around the chicken and toward the side near the burlap. The result is the straw. Rankin drybrushed the planks using a mixture of vermilion and Thalo blue with some of the darker ink mixture he used for the shadow between the planks. This textured surface was glazed with a wash of cerulean and manganese blue just to put some life into the piece. The overall burlap color is pale new gamboge and vermilion with just a hint of Thalo blue. Rankin created the texture in the burlap bag by painting over a wire screen.

Don Rankin

Drybrush Techniques

Drybrush works well with the glazing technique. You can begin your painting with a series of glazing washes, and then use the drybrush approach for hatching, stippling, feathering, and daubing, using the brush like a pencil to develop a finished look. This is a very useful method for creating the illusion of meticulous detail.

Handle beginning washes like any other watercolor approach, making use of a fully loaded brush. Once you have applied several layers of color, reduce the amount of water in your brush; at this stage it should be only half-loaded.

Use a tissue to blot a daub if it appears too strong. You can repeat the cycle of daubing, stippling, and hatching with blotting to create controlled textures. When you use the hatch stroke, reduce the amount of water in the brush even more, until it is merely damp. The object is to have enough moisture to produce a thin, pencil-like line. In hatching, you use the point of the brush to draw, almost as if it were a pencil. But if you use small riggers or other thin brushes, you will need to increase the amount of water for them to perform well.

To begin painting, your brush should not be totally dry. Swirl it around in damp pigment on your palette. Then squeeze most of the moisture out at the base of the brush using a tissue, leaving the pigment on the tip of the brush intact. To make sure that your brush is operating properly, drag it across a piece of scrap paper. The moisture level is correct when the paint leaves a rough mark.

To create a feather stroke, where the edges are feathered and easy to blend, use a fairly large brush, allowing it to spring against the paper. In a stipple stroke only the tip of the brush touches the paper. If you press a little harder, you will have a daub stroke. Finally, with the hatch stroke you can hatch, crosshatch, and double or triple crosshatch to create graded tones and to add interesting texture to the image.

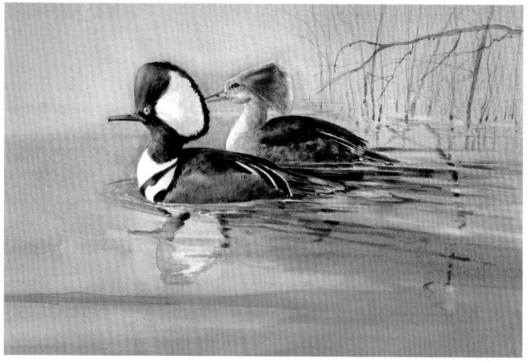

HOODED MERGANSERS
Watercolor on Arches 140-lb. paper, 12 × 16" (30.5 × 40.6 cm), collection of the artist.

In this painting there is a strong contrast between a soft wet-in-wet background and a fairly sharp drybrush rendition in the point of interest, the ducks. The following illustrations show how the detailed texture of the ducks was accomplished in a sequence of wash and drybrush applications. Unless otherwise stated, each wash was allowed to dry before another was applied.

Here is the feather stroke painted over an underwash of Thalo blue. To produce a feather stroke, you need to use a red sable brush that is at least a #6 or larger in order to get the right feel or spring. This stroke can be used for developing graded tones, blending, or softening edges of color. You can also use it to tone down or intensify a color in a given area.

In this sample, you see two colors glazed over a portion of the feather strokes and the underwash. The feather strokes help to build texture and form as well as modify color, while the glazes help to modify the texture and visually unify the section being worked.

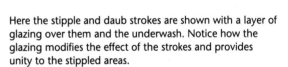

The stipple (top) and daub (bottom) strokes are both made with the tip of the brush. The only difference is the amount of pressure exerted. This sample shows how these strokes look over an underwash. By using these strokes, you can produce various textural forms. For instance, it is possible to stipple many colors in close proximity to one another to create another color altogether. You can also overlap these strokes to create a wide range of color blends.

Here the stipple and daub strokes are shown with a layer of glazing over them and the underwash. Notice how the glazing modifies the effect of the strokes and provides unity to the stippled areas.

This is a sample of the hatch stroke. It is probably the most exacting, noticeable, and controlled of the strokes shown, and is used to build textures, define form, and create depth in the tone of a color.

Here you see hatching and crosshatching with glazes over portions of the strokes and the underwash. Once again notice how the glaze is used to unify color and texture into a pleasing whole.

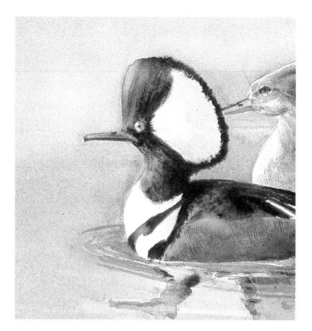

Now take a look at how Don Rankin applied some of these techniques to the male duck's head, which is enlarged here so that you can easily compare each stage with the finished image.

A dilute wash of Thalo blue is applied to the head. Note that the blue is not an even tone. Instead, Rankin used the color to suggest lighter and darker areas of the form.

Next, a wash of Winsor violet is applied to the majority of the head. Each application of color refines the form of the head.

A small portion of Thalo yellow green is washed on in two key areas of the head. Since this color tends to be opaque, it can be used to create a wispy effect and produce an illusion of a glowing green. In contrast with the violet, the Thalo yellow green gives an iridescent quality to the feathers.

Notice how this layer of Thalo blue tends to pull the other colors together. This is a strong example of the effect of glazing. Thalo blue is dark enough to unify the colors, yet its transparency allows the colors to hold their own.

Here, various drybrush strokes are incorporated into the head—hatching, daubing, stippling, and feathering. Rankin used a color mixture of indigo and vermilion with occasional daubs of Winsor violet. It is important to note that the long strokes are imitating the way the feathers grow. Compare this step with the finished head. Look for all of the stipples, hatches, and strokes.

With all of the textural strokes completed, it is time for more glazes. There is no rigid time set for a glaze, but it should be done after you have completed a portion of strokes. Remember, you use glazes to help unify areas of color or to darken a passage of tone. Use these glazes with caution. Your brush should not be loaded with a full charge of wash. These washes or glazes should be applied with a great deal of care and delicacy, and they should almost always be slightly darker than any preceding color. A wash as dark as or darker than the preceding one will create a transparent effect; a lighter wash over a darker one will look opaque.

Don Rankin
Simulating the Textures of Weathered Wood

In this pair of four-step sequences, Don Rankin demonstrates how he approaches painting weathered wood siding and wooden roof shingles. The swatches that accompany each step show the exact color used for each application.

Step 1. As he examined his subject, Rankin looked for a local color that could serve as a common color theme for the wood siding. He chose a gray made up of new gamboge and manganese blue. These were blended with a great deal of water to produce a greenish gray and applied in vertical strokes (to suggest the planks) with an Aquarelle brush.

Step 2. While this first wash was drying, Rankin began to mix a slightly cooler, darker gray to contrast with the previous warm gray. This gray mixture was made from cerulean blue and Winsor red. This time Rankin drybrushed the cool gray onto the dry paper, allowing a great deal of the warm gray to show through.

Step 3. Now comes an even darker gray made up of half Winsor blue and half Winsor red. This wash was used only to designate the wood planks.

Step 4. For the finishing coat, Rankin cooled the temperature of the gray by adding cerulean blue to the Winsor red and Winsor blue mixture. This wash was applied carefully with a drybrush technique. The drybrush strokes suggest the grain pattern of the wood.

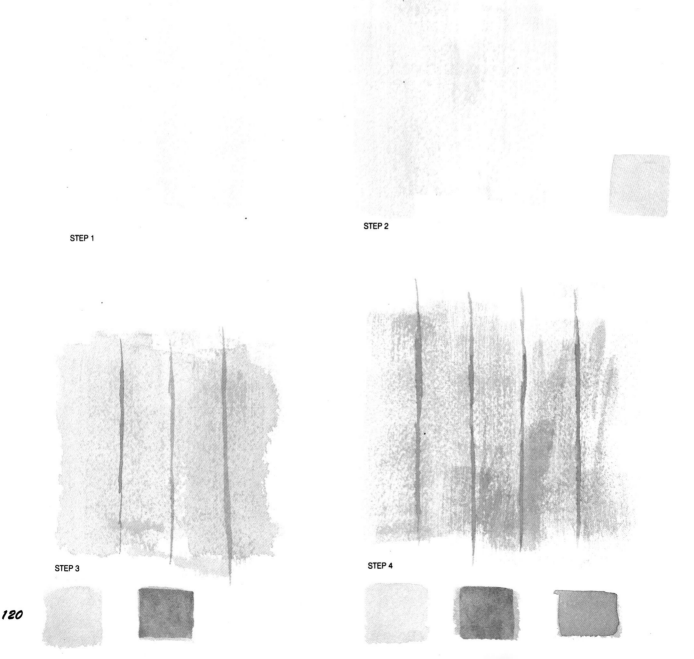

STEP 1

STEP 2

STEP 3

STEP 4

Rankin's approach to painting the wooden roof shingles is very similar to the techniques used for creating the weathered siding. The paint is applied with an up-and-down movement to imitate the vertical movement of the shingles.

Step 1. The first wash was a mixture of Winsor red and Winsor blue.

Step 2. The second application of wash was a slightly stronger mix of the first wash. Note that part of the earlier wash is showing through, so it should be obvious that this second wash was applied to a dry surface. Otherwise the dots of original color wouldn't shine through the second wash.

Step 3. By increasing the Winsor red in his wash Rankin was able to produce a darker gray. This wash was also applied to dry paper.

Step 4. Still more Winsor red was added to make the darkest value. This wash was applied with the edge of the brush to simulate the pattern of roof shingles. Notice that underlying washes create color variation.

STEP 1

STEP 2

STEP 3

STEP 4

Don Rankin
Building the Texture of a Tree Trunk with Color

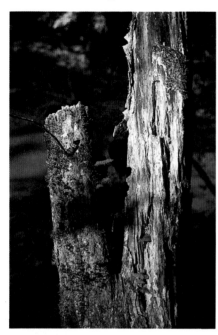

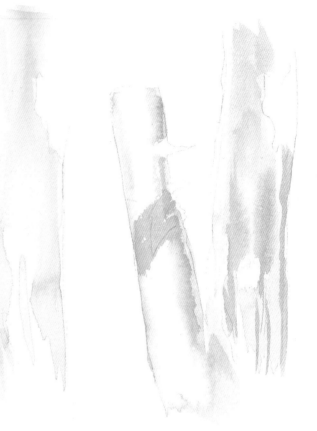

STEP 1

STEP 2

This exercise in developing the texture of a tree starts off with a broad pattern of color. With each step, additional refinements are made to that broad pattern until the final stage is reached. In other words, a nebulous shape of color is refined and altered to create a final image through the use of successively darker color. You can't expect to always achieve perfection with the first stroke; rather, you start with a strong foundation and build upon it.

Step 1. In the first application of wash Don Rankin chose two colors, one warm and one cool. The cool gray was a mixture of new gamboge, Winsor red, and cerulean blue; the warm gray on the right side was a mix of new gamboge and Winsor red. The warm wash was applied in a fairly direct manner; and the cool wash was applied in two thin strips, one on the left and the other on the right of the trunk. This left a gap of pure white paper. Then, with a #5 brush loaded with clear water, Rankin dampened the center section, causing the two washes to flow together, creating a highlight in the center.

Step 2. As the warm and cool washes were drying, Rankin mixed a wash of new gamboge, Winsor blue, and Winsor red. This was applied to the still damp, warm section of the tree to set the stage for some of the later washes.

Step 3. To the brown mixture, the artist added a bit more Winsor red to produce this rust color, which was added to

both the left and the right sides of the tree. On the left, it would provide the basis for the lichens or mossy growth on the tree trunk; on the right side it was used for some of the darker shadows.

Step 4. The reddish-brown mixture was further altered by adding Hooker's green dark to produce a dull brownish green. Note this color application in the darker areas of the trunk.

Step 5. In the final wash Rankin used Winsor blue mixed with Winsor red to create a gray-blue color, which he used to refine some of the shadow areas. In some of the darker areas, he added the blue over the dark green to intensify the shadows. An even stronger mixture was used to create some of the darkest shadow passages. This color was also used on the left side of the tree to suggest a barklike texture.

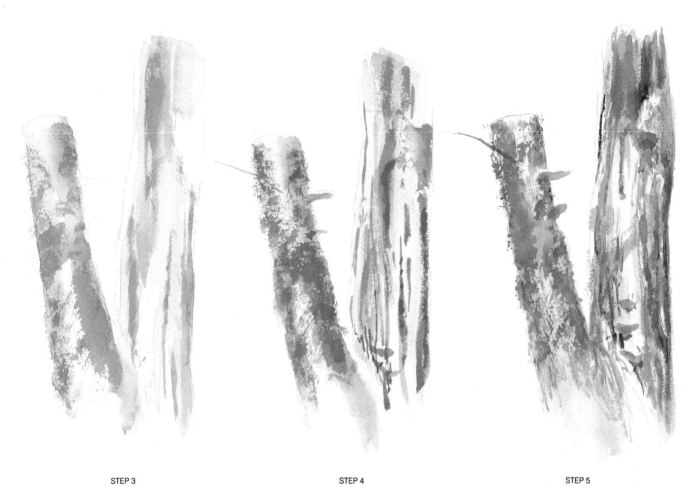

STEP 3

STEP 4

STEP 5

Water and Grass Textures

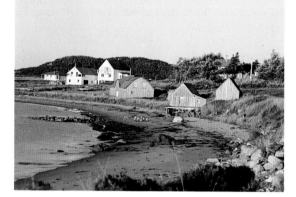

STEP 1

For color accuracy this photograph comes very close to capturing the clear, clean quality of light Don Rankin saw one September afternoon. But because light quality is subjective, it is perhaps best discussed and understood in terms of color. In particular, Rankin got a sense of a pale yellow light permeating the entire scene. In developing a painting of this site, he would use that color influence to advantage. While the photo helps you to see the interplay of light and color in this scene, there is also an interplay of textures at work. Many of these textures are somewhat subdued because of their position in the picture plane, but they still exert an influence. In the following demonstrations, Don Rankin shows how he goes about translating the common textural elements of water and grass into paint.

STEP 2

Water is such a changeable element; it moves with the current or the wind and changes color depending upon what is in or near it. If you want to paint water well, relax and learn to observe it first. Water has many moods, but it provides some clues for mastering those different moods. For example, have you ever tried to paint pounding surf and then worked very quickly to try to capture a particular wave? Did you know that if you wait long enough, that wave will invariably repeat itself? So if you keep watching, you'll be able to capture the basic shape and texture that a fast-breaking wave makes. Of course, one foolproof technique is to carry a camera and capture that wave in time. But sometimes it's more fun to capture the feel of a wave with a pencil or pen and ink. The point to remember is that water typically has a pattern or rhythm, and that knowledge can be very useful when you are trying to capture water on paper.

STEP 3

Step 1. For an overall unifying color, Don Rankin chose a mixture of new gamboge and manganese blue. The new gamboge is so weak as to be barely noticed, but he used it to liven up the wash.

Step 2. While the wash was still wet, he mixed up a darker wash of Winsor red and Winsor blue. Using the edge of an Aquarelle brush, he painted ripples into the still wet initial wash and let it dry. Note the mottled effect produced. This technique is often all you'll need to create the desired effect.

Step 3. Once these layers were dry Rankin applied another wash. This time the mixture was darker because he added more Winsor blue to the second wash. Toward the top of the example, he used a fast horizontal stroke with the Aquarelle brush. Note that some of the paper is covered completely by the darker color, but toward the left side the color begins to break up into a spotted, more mottled look. This breakup occurred because Rankin moved the brush so fast that only the top portion of the cold-pressed paper was colored in, which left the previous color that lies in the depressions untouched. Note the subtle variation in color between the waves. This occurs because some of the areas were still damp when the second wash was applied, causing color to merge in some of the little waves and not in others.

As you look at the grass in the photograph, you can probably see at least four distinct colors or variations. For a base color, Rankin decided on a golden tan.

Step 1. Rankin mixed new gamboge and Winsor red to create this golden tan wash, then applied it to the entire area except for the rocks.

Step 2. While the tan wash was drying, Rankin added a little green and let it bleed into the damp portion of the wash. The green is a mixture of sap green and new gamboge.

Step 3. Once the previous wash had dried, he added a mixture of Hooker's green dark and sap green. This time he scrubbed the brush around to suggest a little weed texture.

Step 4. The final application, done in drybrush with a square-edged Aquarelle, is a brown composed of Hooker's green dark, Winsor red, and new gamboge. After this first application, Rankin recharged the brush and used the edge of it in the foreground behind the rocks. He allowed the side of the brush to scrub around in this area to create a little more texture. The last application of the dark brown wash was made with a #4 brush in the shadow areas around the rocks and the two or three well-defined stalks of brown grass.

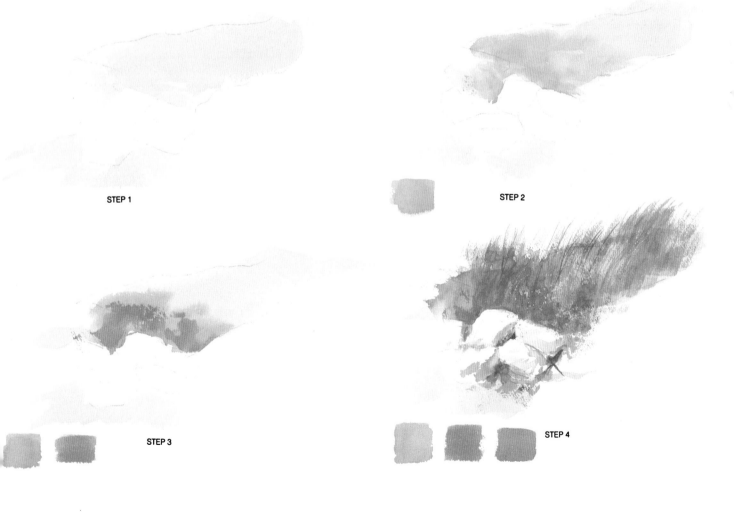

STEP 1

STEP 2

STEP 3

STEP 4

Don Rankin

Underpainting for Texture and Form

The technique of underpainting has been in existence for many years and has most often been used with such mediums as egg tempera and oil; it has almost never been in popular use with watercolor. Yet because of watercolor's transparent nature, underpainting with this medium can be a powerful, useful tool. Here, specifically, underpainting refers to a planned execution of design using a color of unusual contrast or a color of harmony. Its purpose is to enhance the form, the contrast, or the detail of a painting, to create texture and increase color intensity. Although a simple color wash laid on a piece of paper can qualify as an underpainting, usually it's something more complex.

Taffy

Taffy is a typical example of a painting whose foundation is a combination of a simple prewash and a more complicated underpainting. Since this is a portrait of his daughter's cat, Don Rankin wanted to make sure he maintained a likeness of his subject, which he knows well and has observed closely. He has used light washes of Winsor blue and Thalo blue to carefully underpaint portions of the cat's body, as well as selected areas of the quilt. The choice of a blue underpainting served two purposes. First, as a calico tabby, Taffy's blend of colors ranges from a pale champagne to pale blue-grays punctuated with chocolate markings, and in certain lighting conditions her coat displays a slight hint of blue. Second, both Winsor blue and Thalo blue are excellent transparent staining colors, a physical characteristic that allowed Rankin to create as involved an underpainting as he liked without fear of spoiling the finished painting, since these colors sink into the fibers of the paper and are indelible once they dry. Thus, the stain stays in place without lifting throughout the course of painting. In a situation like this one, the approach liberates you from the concern of losing the likeness as the painting develops.

A word of caution: Underpaintings of this nature can cause problems if you get too strong with your color. "Strong" means you could get too heavy-handed and use washes that are too intense, or that you could leave abrupt harsh edges that will not mellow as you apply additional color. Remember, you are dealing with transparent watercolor washes; even the most opaque colors will still exhibit a degree of transparency. Therefore, the watchword is sensitivity. Be sensitive to your subject. If it happens to be soft fur, convey that feeling in your underpainting by feathering and blending edges to create softness. Experience will show you that soft, blended washes will have less tendency to produce harsh, jarring edges when and where you don't want them. Also they will be easier to modify if you need to do some altering of the image.

As mentioned, *Taffy* contains a prewash that serves as an underpainting. After his sketch was translated into a working line drawing on the sheet and the blue underpainting was completed, Rankin laid in the background, a bright orange created by mixing cadmium orange with a small amount of vermilion to make it hotter. This color was almost too bright, but the brightness was soon modified by the darker washes that were subsequently laid over it. Rankin used this bright color because he wanted a vibrant background. The orange acts like a supercharger under the intense mixture of dark washes, which are composed of a mixture of Thalo blue and vermilion. The wash was applied with a 2" bristle brush. Just before it dried completely, Rankin ran a dry bristle brush through the wash to disturb it and create texture. As you study the finished painting, note the lighter color adjacent to Taffy's back. In that area the water used to dampen the paper before the dark wash was applied diluted that wash and allowed some of the basic underpainting to shine through.

This sketch was done to better understand some of the particular forms, such as stripes and other fur patterns, found in Taffy.

Step 1. The underpainting is a vital part of the beginning of a watercolor painting. It was planned and executed to freeze the likeness of the cat and to build the flow of the design. Note those areas that are strongly colored and those that contain much weaker passages of color. Compare these areas to the same areas in the finished painting.

In this particular case, Rankin used a combination of brushes to build his underpainting. In the beginning the cat was dampened with clear water and the initial Winsor blue washes were applied in a broad manner with a 1" Aquarelle brush. Some of the blue wash was allowed to flow freely within the confines of the drawing space. While this basic passage was still quite damp, additional color (blue) was applied in shadow areas around the neck and on the middle portion of the back. These washes were allowed to dry. Since the paper was damp, the shadow washes dried with soft edges. In this manner, Rankin was able to begin conveying the feeling of soft fur. After the sheet was dry, more specific detail was added, such as the eyes, the shadows inside the ears, and the arrangement of Taffy's stripes. The smaller details were painted with a #6 Winsor & Newton Series 7 brush. For a final effect, Winsor blue was drybrushed, with a light concentration of color, along Taffy's back and under her chin.

Step 2. The background wash is composed of cadmium orange with a slight hint of vermilion to warm it up. The wash was applied with a lot of strength; Rankin wanted it to be bright so it would supercharge the dark washes that would come later. Note that this wash is not smooth and even across the paper. Instead, it has variation, designed to help create the effect of light. Examine the background wash and compare it to the finished work, where it looks as though light is glowing and reflecting off the unseen side of Taffy's back. This auralike effect can be produced by manipulating the underwash. If you look at the orange area near Taffy's back, you will see that it is not as strong as the wash in the upper portion of the paper, where Rankin had dampened the paper with clear water before he applied the orange wash. As he carefully painted around the image of Taffy, the water flowed to this lower point, which naturally created a wetter area on the paper. As the wash was laid onto the paper and allowed to spread out, it became paler in this area of concentration.

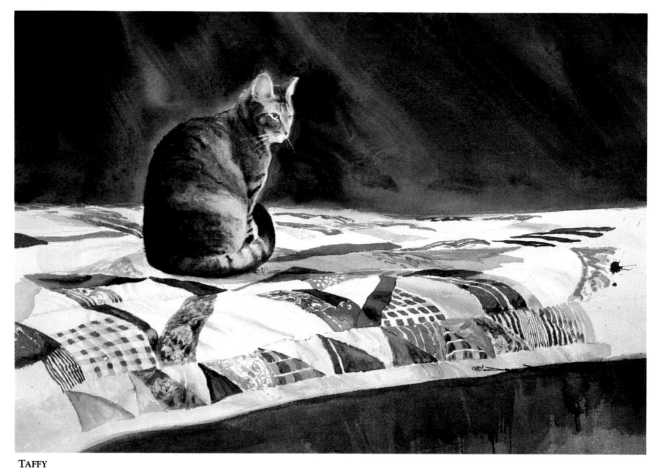

TAFFY
Watercolor, 15 × 28" (38.1 × 71.1 cm), collection of Carol Rankin.

Don Rankin

Developing the Texture of Fur

This detailed sequence is a re-creation of the actual painting; it is intended to reveal the development of the fur in Taffy's coat. Because these steps were done after *Taffy* was completed, there may be some variation in color when compared to the painting.

Step 1. After the blue underpainting was completed, the orange background was laid in. Its bright orange is created by mixing cadmium orange and a small amount of vermilion together in a cup. Although this color approaches the garish, Rankin used its intensity to shine through the darker washes that will be applied later.

Step 2. Here Rankin began to concentrate on developing the texture. His first wash was dilute new gamboge and Grumbacher red. Notice that he reserved the white of the chin and left the eyes white. While this first wash was still quite damp, he applied additional passages of wash to strengthen such areas as the shadow side of the neck and face. These washes were done while the first wash was damp to promote a sense of softness. Remember, fur is soft; take advantage of the soft effect of wet-in-wet.

Step 3. At this stage the colors are beginning to mingle. The second wash is a repeat of the first one, but this time the value is darker and thus the color is intensified. These two washes establish a unifying tone that is found all over the cat's body. To further suggest the look of soft fur, Rankin dragged a brush across the paper, letting the texture of the paper itself break up and create furlike strands in the preceding wash. Note that at this point the likeness and character of the cat are beginning to develop.

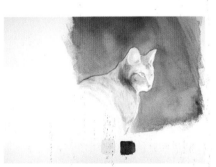

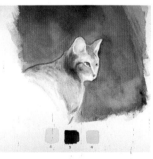

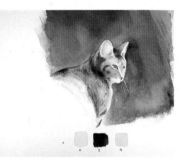

Step 4. The dark portion of the background and the darkest patches on the fur were achieved with a mixture of Thalo blue and vermilion. When you mix these two colors together in generous proportions, the result is a rich brown. A slight alteration in the mixture, say more blue than vermilion, will produce a purple. Too much red will produce a red-brown. In the background this mixture was allowed to flow across the sheet, which had been dampened in that area. Care was taken to keep the cat dry while the dark passage was applied to the damp portion of the paper.

Step 5. Several washes of Thalo blue were applied here to define and cool shadow areas as well as to build up more fur texture. Also, some darks were adjusted and the expression in the eyes was refined. The last step consisted of scratching out the whiskers with the point of an X-Acto knife.

Finishing Touches. Even though these steps appear to be very ordered and precise, the actual painting sequence is not always that easy. While in general this painting followed the sequence outlined, there were times when several washes were carefully applied in order to achieve the look of one step. The reason for this is that it is always easier to look back upon a completed painting and analyze the steps taken. However, when you take those steps for the first time in a new painting, you will find it a good idea to be cautious as you develop your work. Think each step through as much as possible. Then, as you gain experience, the progression of a watercolor will become much easier.

Graham Scholes

Maintaining Contours with Masking Tape

Whenever you need to define texture in a landscape where accurate shapes and contours are important, masking tape is a helpful tool.

For this painting, Graham Scholes used a palette of just four colors: cerulean blue, Winsor blue, raw sienna, and brown madder.

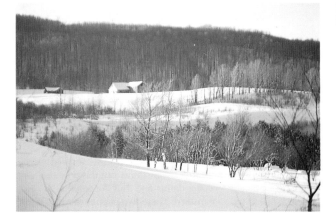

In winter Ontario's Blue Mountain is a study in rolling blue contours.

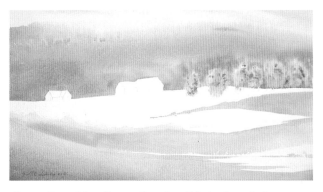

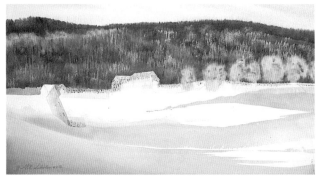

On a satin-wet (medium-wet) surface Scholes drops in the warm raw sienna yellow of the trees on the distant hill and to the right of the barns, aiming to achieve soft edges. When the distant hill and sky area are dry, he rewets them and applies a wash of cerulean blue and Winsor blue with a 1" nylon bright brush, taking care to bring the blue up to and around the trees at a mat-wet (barely wet) stage to maintain their soft edges. As he paints the background, he creates the negative barn shapes, leaving the paper dry where they appear.

When the paper is dry, Scholes puts down masking tape along the bottom of the background hill and over the barns. Since the next step is to be painted in drybrush, there is little chance of the pigment wicking under the tape. With a slanted bristle brush he works in short, vertical drybrush strokes to apply a dark mixture of cerulean and Winsor blue, plus some brown madder to gray the mix. In a few areas he blots the damp brushstrokes with a tissue to soften the lines. Dodging around the yellow middle-ground trees requires care in maintaining their soft contours.

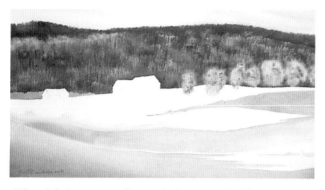

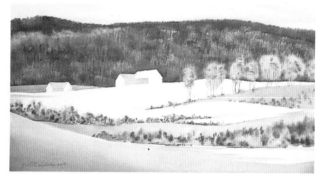

When Scholes removes the tape he has a crisply defined line that marks off the dark trees of the background from the white snow.

At this point Scholes wets the midsection of the paper, from the bottom of the line of trees down to the bottom of the first blue contour, allowing the area to dry slightly until it is mat wet. He then drops in the shrubs wet-in-wet; this step is repeated for the next two contoured lines of shrubs. Raw sienna dominates, and stays in place because it is granular and heavy. Additions of brown madder and Winsor blue create the darker shrub forms.

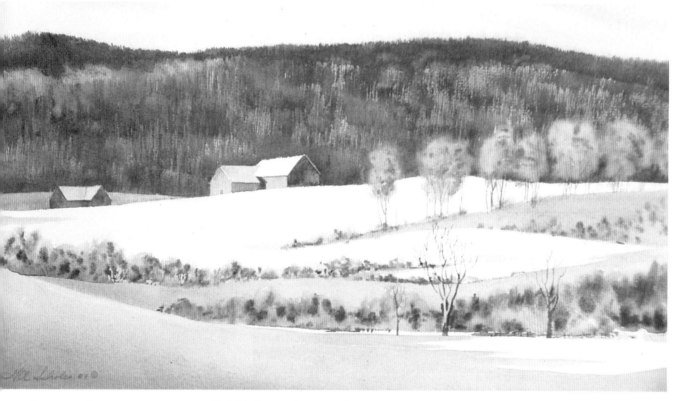

BLUE AND GOLD
Watercolor on Arches 300-lb. cold-pressed paper, 12 × 22" (30.5 × 55.9 cm).

To finish the painting, using the same three colors Scholes adds details to the barns and the three small bare trees nearest the foreground.

Valfred Thëlin

Depicting the Textures of an Autumn Landscape

Masking out areas with various materials is one way of maintaining the original white ground of your painting surface. Valfred Thëlin prefers to paint around such spaces, treating them as negative areas rather than covering them up for protection, but when he finds it necessary to use a masking technique, he chooses between masking tape or a wax medium such as crayon, candles, paraffin, or wax paper.

Of all possible ways to cover an area he wants to preserve in a painting, masking tape is Thëlin's favorite. He uses it to mask around rocks, trees, and overlapping white areas like boat bows and masts. He also uses tape to create a specific design by applying it in patterns, putting it down and picking it up again and repeating the process to make a series of transparent lines and hard edges, as the demonstration shows.

Wax resists may be spread over wide areas of white paper or over a base color. In this demonstration Thëlin used wax to create the twigs. Wax paper provides a good resist; place it over your painting surface before you start to paint, then sketch trees, twigs, highlights, or whatever drawing you want to stay white on the paper throughout the painting. To remove the wax from an area, lay a paper towel over it and press with a warm iron.

Thëlin also finds that Vaseline (petroleum jelly) works as a resist to create rock effects; it does not stain and evaporates afterward. The insect-repellent spray Off, another unusual material to try, creates a spattering effect that lends itself well to beach and rock textures. To get specific results, apply it in a series of patterns.

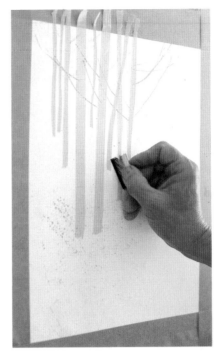

To create the trees for this composition, first Thëlin placed a strip of draftsman's tape on the surface of the board (it comes off more easily than masking tape). He then took a razor blade and cut through the tape, giving irregular edges to the tree trunks. The piece he removed was used for another tree.

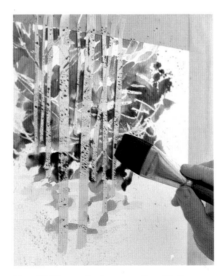

Next Thëlin washed on a series of fall colors, placing darks at the bottom and lights at the top.

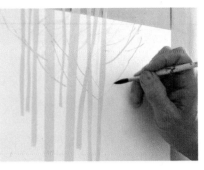

Next Thëlin used a masking fluid, in this case Moon Mask, as a resist to maintain the whites.

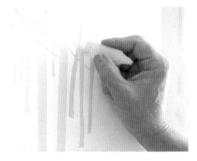

With a wax candle, he drew in the limbs of the trees. Sometimes when he wants a very fine line Thëlin lays wax paper over the surface and draws on it. Wax may be added at any time to protect a color from additional washes.

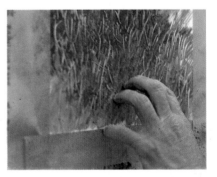

He used a razor blade to highlight the rocks and to suggest a stone wall behind the trees. In the foreground, which he had underpainted with new gamboge and Winsor green and covered with Hooker's green, Thëlin used his fingernails to scratch in grass, using larger strokes in front and smaller ones in the distance.

132

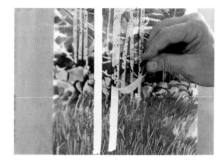 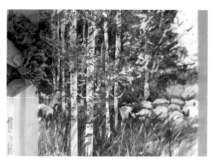

Next Thëlin removed the masking tape from the trees, working very slowly to avoid tearing the surface of the paper. If necessary, you can use a hobby knife to lift it.

After removing the masking tape, he added a bit of soap to his pigment so the paint would cover the wax surface. Then he dipped a sponge into the prepared colors and developed leaf patterns over the birch tree trunks.

To finish, Thëlin washed a soft mauve mixture of cobalt violet and Winsor blue over the background trees to push them back into the distance. Finally, he applied a rubber-cement pickup to lift out the masking fluid he had used in an earlier stage.

BIRCH TREES
Watercolor on Arches 140-lb. cold-pressed paper, 20 × 16" (50.8 × 40.6 cm), collection of the artist.

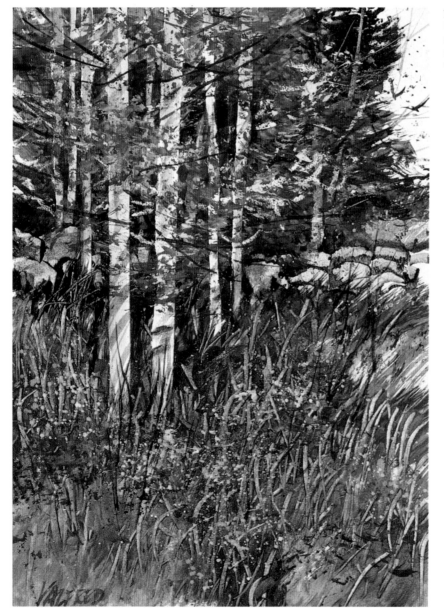

Valfred Thëlin

Painting with a Razor Blade

When using the razor-blade technique for his rock paintings, Valfred Thëlin begins by getting down the large shapes in the colors characteristic of a given area's geological forms. For Maine rocks he uses Winsor blue and sepia umber to create a gray tone. Moving down the coast, he adds a bit more orange, overglazing with orange and sepia umber to bring up the underlying color. In the Southwest he leans more toward the reds and oranges.

For this painting of rocks of the Northwest, Thëlin began with gray tones to develop the forms he needed. While the surface was still damp, he came back into the shapes with a razor blade (a credit card would also work), using it almost as if it were a snowplow to squeegee off color. The top edge of the blade left a distinct line as it pushed the pigment off, suggesting the rocks' edges.

Thëlin let the color move around, creating light and dark areas, pulling pigment downward to create shadows. Then he added dark trees behind the rocks. This technique is very rapid.

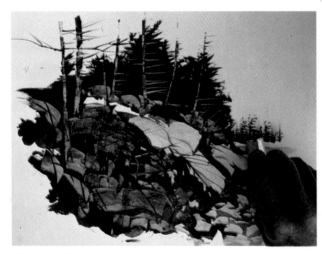

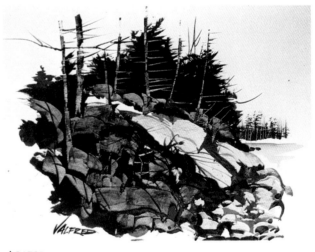

He finished by scratching out details of the trees with his razor blade.

ACADIA
Watercolor sketch, 11 × 14" (27.9 × 35.6 cm), collection of the artist.

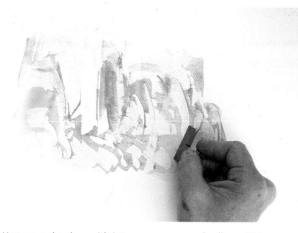

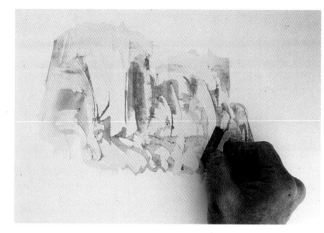

Western rocks glow with intense oranges and yellows. Using a thumbnail sketch as a reference, Thëlin first put down a wash of cadmium orange, then scraped it out with a razor blade.

After this was completely dry, Thëlin added a second wash of cadmium orange with a touch of sepia umber to darken various areas.

Then he dipped his split 1½" flat brush into sepia umber and ran it horizontally across the surface to suggest the striations characteristic of this rock formation.

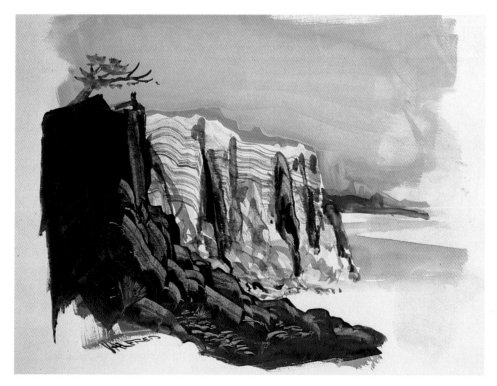

Last, he washed alizarin crimson and Winsor blue over the foreground, then scraped lights out of the dark, shaded areas with a razor blade. Thëlin completed the sketch by adding the sky and the tree atop the darker rocks.

CAREFREE, ARIZONA
Watercolor sketch, 11 × 14"
(27.9 × 35.6 cm), collection
of the artist.

Valfred Thëlin

Working on a Gesso Surface

Playing with watercolor on gessoed paper, board, canvas, or wood panel is an entirely new experience and a fun exercise. Try applying gesso to your surface with a roller instead of a brush or varying the thickness of the paint application to create an interesting texture. You might even try putting gesso on with a palette knife or a piece of cardboard. You can add even more texture by cutting into the surface while the gesso is still wet. Conversely, if you want a slick finish, smooth your gesso-coated surface down with sandpaper. It usually takes several layers of gesso to establish a good working surface; just make certain you let each layer dry completely before adding the next.

When you apply watercolor over a textured surface, allow the pigment to seek the texture lines on its own and create interesting patterns. You can pull out whites anytime you wish using a clean, damp flat or round brush that is "thirsty" enough to lift color and create new designs and lighten specific areas. A spray of water on a gessoed surface glazed with watercolor can create some very unusual effects too. Since the gesso seals the surface so the watercolor cannot be absorbed into it, the water spray moves the pigment to develop wonderfully exciting shapes and patterns. All you need to do is look for them.

When working on a gessoed surface, Valfred Thëlin first lays in his light shapes. While the pigment is drying, he takes a palette knife and scrapes out color to create white areas. The texture lines of the underpainting begin to emerge and add interesting patterns to the composition.

When your finished painting is dry you need to apply acrylic spray (such as Krylon #1303) and then seal the surface permanently with polymer medium.

This gesso underpainting was applied with a palette knife to create a rough texture that suggests tree forms. Thëlin let it dry before proceeding.

He put various greens over the dry gesso, allowing the pigment to seek the textured lines of the underpainting. Then he picked out forms with a thirsty brush.

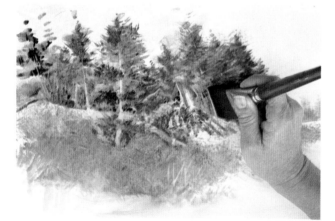

Here Thëlin added more color, as well as the two figures.

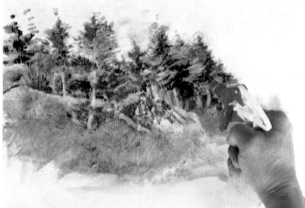

When the figures were dry, Thëlin sprayed the painting with water to get an overall textural wash. Because the gesso prevents it from being absorbed into the paper, the pigment sits on the surface and is easily moved with water.

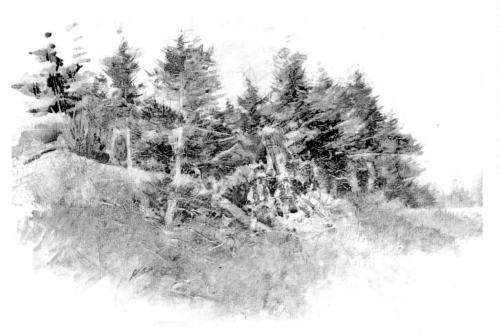

When the painting was completely dry, Thëlin reached back in with his thirsty brush and lifted out highlights on the trunks of the birch trees. Finally, he washed light blues over the foreground and over the trees in the background. You can see the texture of the gesso underpainting coming through, building the tree limbs and the patterns of rocks around the hunters.

TWO IN THE WOODS
Watercolor and acrylic gesso on Arches 140-lb. paper,
16 × 20" (40.6 × 50.8 cm), collection of Vincent Thëlin.

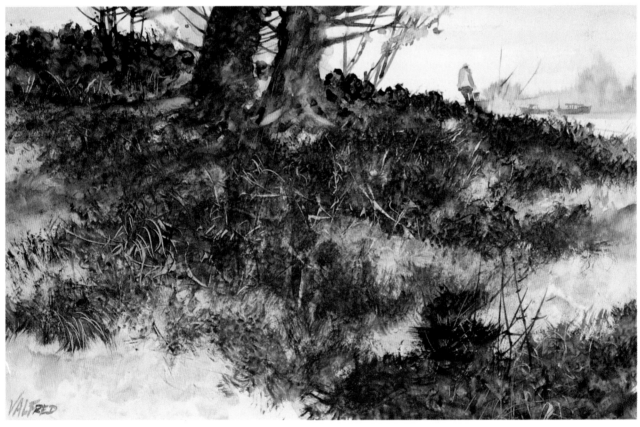

DUPLICATE TREES
Watercolor and acrylic gesso on Arches 140-lb. paper, 24 × 30" (61.0 × 76.2 cm), collection of the artist.

This picture was completely underpainted with gesso, then overpainted with watercolor, from which Thëlin pulled out the grass forms with a thirsty brush. For the background details he used sepia umber and Winsor blue, then wiped out the pigment, leaving a stain in the gesso base.

John Koser
The Non-Contact Painting Method

During the course of his struggle with watercolor, John Koser became aware that he often found more color excitement on the surface of his palette than in his paintings. Mixing yellow and red together on the palette to get an orange, then toning it down with a touch of blue, he would carry the mixture on his brush to the painting surface. But in the process he left behind on the palette the vibrant potential of the unmixed primaries.

Out of a gradual self-assessment, Koser developed what he calls the "non-contact" method, in which the primary colors are mixed not on the palette to create secondary and tertiary hues, but directly on his painting surface. He wets the areas to be painted first by randomly flecking and spattering clean water onto the surface, leaving sparkling islands of dry white paper. Then he applies the primary pigments in the same manner. He usually starts with yellows, followed by reds, and then the blues, working quickly to take advantage of the surface's wetness and letting the colors mix right on the paper to form a variety of greens, oranges, and purples.

The basic method for mixing color this way is outlined here; try the procedure as you read along.

Mixing Greens

With a natural-bristle toothbrush, Koser flecks water onto a patch of paper. Next, he uses the toothbrush along with 1" and 2" flat brushes to fleck and spatter yellow pigment onto the wet area. Immediately afterward, he rinses out the same brushes and then dips them into his blue pigment to spatter on top of the yellow. From this random paint application, you can see that where equal amounts of yellow and blue mix, a green is formed. Where only a small amount of blue reaches a spot of yellow, a warm yellow-green forms; where there is more blue than yellow, a cool bluish green forms. Areas where the yellow and blue remain unmixed enhance the surrounding color. Spattering a pinch of red onto bright green mixtures will mute them to more natural hues, and will introduce hints of orange and purple wherever it touches unmixed yellow and blue.

Mixing Oranges

Using the same spattering technique, Koser first wets the paper, then flecks yellow pigment onto that area. While the yellow is still wet, he spatters red into the yellow. Orange forms where equal amounts of the two colors mix; yellow-orange appears where minute amounts of red join large islands of yellow; and red-orange appears where large amounts of red mix with yellow. A small amount of blue will tone down the brashness of the orange, and will introduce hints of green and purple wherever it touches unmixed yellow and red.

Mixing Purples

The first spattering of clean water is followed by reds, then blues. According to how much of each pigment lands in a given spot, the purples that form will vary from cool bluish purple to warm reddish purple. You can add minute amounts of yellow to introduce touches of orange and green.

MIXING GREENS

INDIAN YELLOW

INDIAN YELLOW + PHTHALO BLUE

INDIAN YELLOW + PHTHALO BLUE
+ ALIZARIN CRIMSON

MIXING ORANGES

INDIAN YELLOW

INDIAN YELLOW + ALIZARIN CRIMSON

INDIAN YELLOW + ALIZARIN CRIMSON
+ PHTHALO BLUE

MIXING PURPLES

ALIZARIN CRIMSON

ALIZARIN CRIMSON + PHTHALO BLUE

ALIZARIN CRIMSON + PHTHALO BLUE
+ INDIAN YELLOW

139

John Koser

Demonstration: Composing a Painting in the Non-Contact Method

The concept behind the non-contact technique is to spatter and fleck water and pigments into designated areas of the painting surface, building up the composition one section at a time. While you are applying pigments in one area, the other parts of the paper are covered with resists made of mat board or with a liquid mask (frisket) to keep them from receiving paint.

John Koser usually begins a painting by making a 35mm slide of the drawing of his chosen subject and projecting this image onto his painting surface. He then draws in the basic shapes of the composition. Once satisfied with this, he makes a tracing of the drawing, from which he will make his mat board resists. The tracing is composed of the basic painting areas—the main shapes, foreground, middle ground, and background. Next, Koser rubs the back of the tracing with graphite pencil, then places it, graphite side down, on a piece of mat board and draws over the lines of the tracing with a pen to transfer the image. Then he cuts out the mat board shapes, bevels the edges, and waterproofs each piece with acrylic spray.

Koser assembles all the mat board resists on the painting surface except for the area he wants to paint first. Using a natural-bristle toothbrush, he flecks and spatters water onto the exposed area. Immediately after this step, he begins to apply the pigments with different size brushes—the toothbrush, a 1" Aquarelle, and a 2" sky flow—with spattering and flecking motions. He usually applies colors in this sequence: first yellows, then reds, then blues. He waits for the paint in this section to dry, then removes all the resists to evaluate the painting. Then he proceeds with the next area in the same manner.

In the following sequence John Koser demonstrates his basic procedure for composing a painting, this one of a covered bridge spanning the Elk River in northern California's Humboldt County. Koser has made the covered bridges found in this area the subject of many of his paintings, aiming to capture the light, temperature, color, and mood of the day and the season. August is a time of contrast between the warmth of the sun and the coolness of the shade. In this painting the effect of the long summer days has begun to tell in the foliage of the trees and the color of the wild grasses.

For his painting surface Koser used a piece of watercolor board (100 percent rag paper bonded to pH-negative four-ply cardboard). His palette consisted of Indian yellow, burnt sienna, ultramarine blue, and Winsor blue.

Koser drew, redrew, adjusted, and readjusted the major shapes of the foliage, shadow, roof, road, and fencing until he had a workable painting plan.

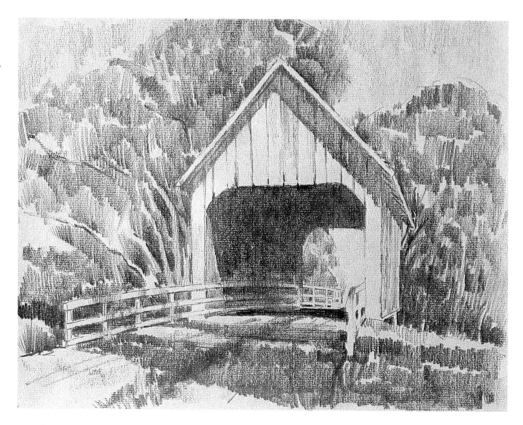

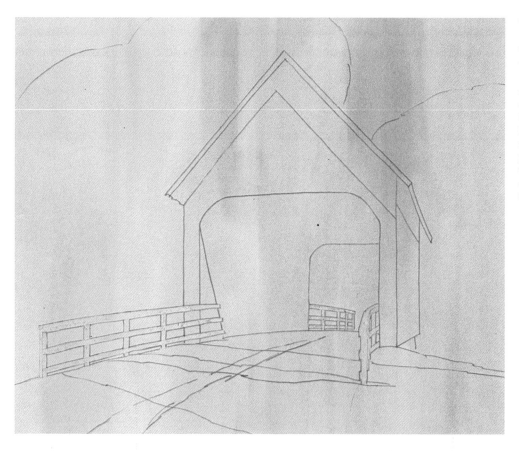

The pencil sketch on the painting surface was made from a projected image of the original sketch. Koser placed a 2" margin of drafting tape around the edge of his watercolor board to keep it dry. Then he applied high-key underwashes of his four palette colors. When the washes were dry, he applied a liquid resist to the fence.

For this stage, Koser needed to construct the mat board resists. He made a tracing of the drawing you see in the previous step, dividing the tracing into workable painting areas. The tracing was then transferred onto the mat board. With a mat knife Koser cut these shapes—his resists—from the board, then beveled their edges with a razor blade and waterproofed them with a clear acrylic spray. Next, he assembled the resists on his painting surface, lining them up with the pencil drawing.

Koser removed the resist from the area he wanted to paint first, the large U-shaped area that makes up the sky and background foliage. This he painted in the non-contact method, spattering first clear water, then his yellow, red, and blue pigments in succession. Several applications of paint, in the same sequence, were needed to build up the value, intensity, and shape of the area. The non-contact method must be done rapidly to maintain the wetness that allows the pigments to mix properly. When the freshly painted surface began to lose some of its wetness, Koser used the handle of his brush and his index finger to trace out trunks and suggest branches of trees. All the mat board resists were then removed for an evaluation of this first painted area.

Next, all but the large foreground shape was covered with the resists. The way Koser directed the water and pigment droplets here played an important role in depicting the long shadows of the trees on the road. Koser began with the sunny part of the foreground, then built up the color and pattern of the shadows by spattering in a horizontal direction. The tip of a wet round brush was used for some refinement of the shadow shapes, but the "splash-painted" areas produced the most excitement.

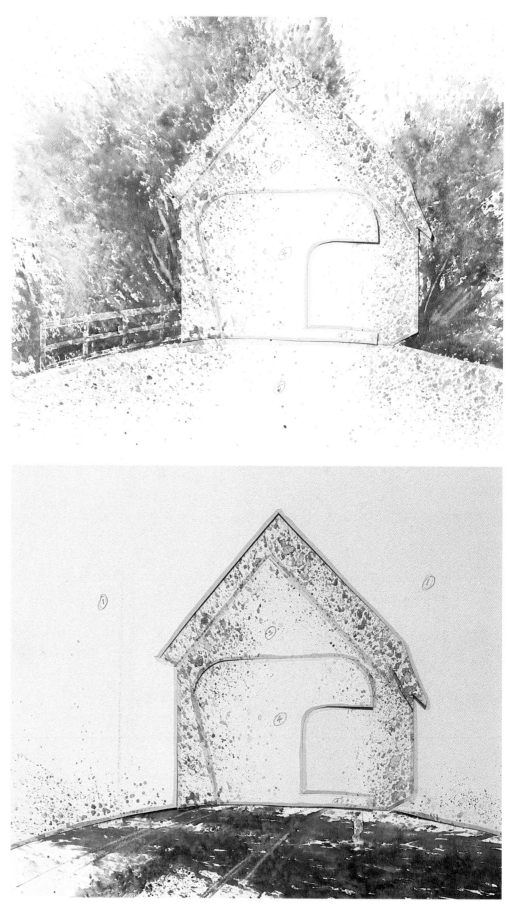

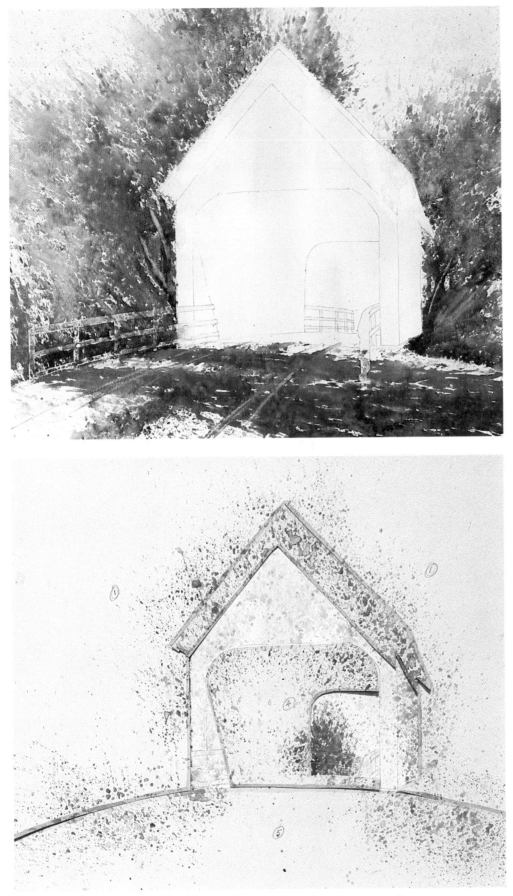

Koser removed all the mat board resists to review the value, intensity, and color of the two painted areas.

Then he reassembled the resists on his painting surface except for what was to become the sun-drenched front of the covered bridge and the opening at the end of the bridge. Using his brushes, he applied water and primary colors in the same manner as before, but this time he had to keep diluting the paint with water to get a value light enough to suggest the brightness of sunlight.

The next area to be developed was the shadow under the eave. With all resists in place except for this section, Koser flecked and spattered water and pigment in the usual manner, this time using a minimum amount of water and a more concentrated amount of pigment than had been used in any of the other areas.

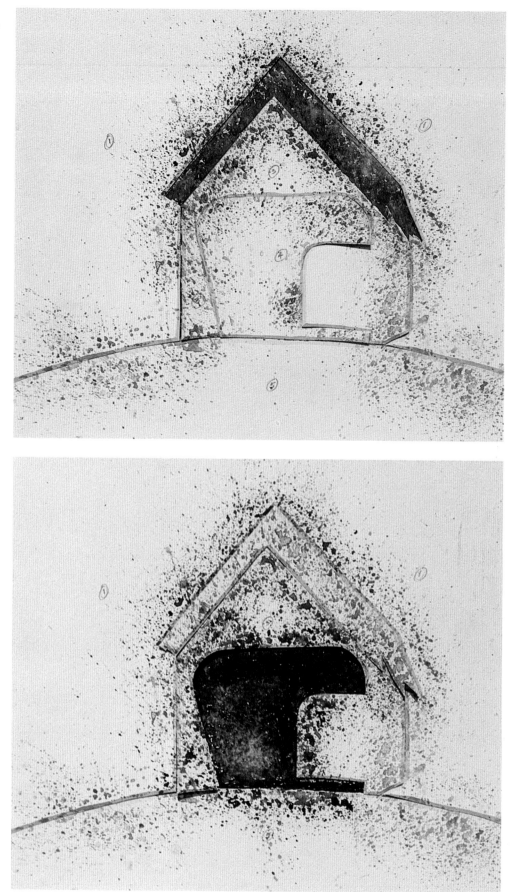

For the final major paint application, Koser needed to produce the darkest shadow area, the interior of the covered bridge. Water was applied with a toothbrush and a 1" flat brush, followed by concentrated amounts of yellow, red, and blue, letting the red and two blues dominate. By now, most of the painting surface was covered. When the paint was dry all the resists were removed.

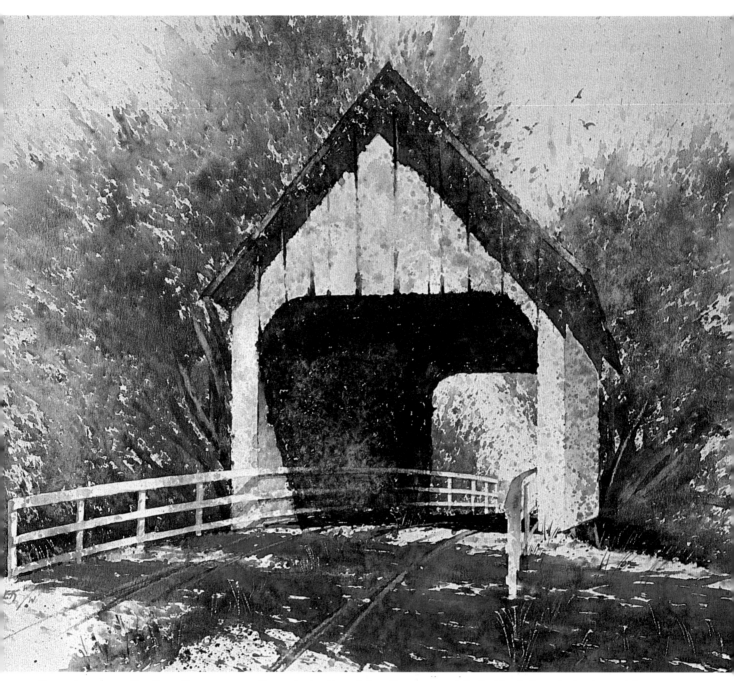

EARLY AUGUST ON ELK RIVER ROAD
*Watercolor, 20 × 24" (50.8 × 61.0 cm),
collection of Mrs. Eileen Knourek.*

After reviewing the painting, Koser removed the liquid resist from the fencing and the drafting tape from around the edges. The white fence was lightly flecked with diluted amounts of pigment to bring it into harmony with the rest of the painting. A few areas of the bridge were given some calligraphic marks. These refinements were done with a round brush in a restrained manner so as not to interfere with the overall spontaneous quality of the painting style.

John Koser

Texturing with Plastic Wrap

Plastic wrap, wax paper, and aluminum foil are all possible materials for adding texture to watercolor paintings. Basically, you press the wrap onto your painting while it is still wet or damp, and thus the random wrinkles of the wrap will reposition the wet pigment (and lift some of it off when the wrap is removed) to create interesting patterns. Stretching the wrap across the wet watercolor surface results in an irregular linear pattern.

You can vary the density of the textures produced. Tightly crumpled wrap pressed onto the wet watercolor produces areas of dense texture, whereas crumpled wrap that has been straightened out before application to the wet surface produces subtler textures.

Plastic wrap is most effective when left in place until the surface is dry. If you remove the wrap while the painting is still wet, you will lose most of the texture and excitement.

In the initial stage John Koser used a resist of aluminum foil to preserve the white of the boat and sail, sealing it to his painting surface with a liquid resist that follows the outline of his pencil drawing. Once this dried, he made a second application of liquid resist. Then he wet the sky area and applied broad strokes of yellow, followed by some red, then some blue to introduce the cloud movement, and finally a bit of green.

Koser monitored the drying process of the sky and allowed the surface to change from a sloppy glisten to a moist satin surface. Then, to introduce directional lines and textures, he stretched a sheet of plastic wrap across this area, pressing it onto the wet paper surface. He allowed the paper to dry completely before removing the plastic wrap.

Next, he wet the water area, painting around the wake. Then he charged the surrounding seas with the same colors he used in the sky. Some very diluted green and yellow were introduced into the wake. When this surface reached a moist, satin finish, Koser joined parts of the wake and the sea with a damp brush. Then he stretched some plastic wrap over the wet area, removing it only when the paint had dried completely. The tension and texture of the sea area is compatible with the sky. The small strip of shoreline was rendered in the same manner as the sky and ocean.

Here, all the plastic wrap was removed and the three painting areas were evaluated.

The ship and sail resist were easily removed. Then Koser wet and charged portions of the sail shapes with diluted amounts of yellow, red, blue, and green. He lightly spread plastic wrap on the moist surface. When the paint was dry, varied texture patterns were revealed within the sail boundaries.

COURAGEOUS
Watercolor, 20 × 29" (50.8 × 73.7 cm),
collection of Mr. and Mrs. Arthur Nelson.

Koser added figures in the boat and made some minor adjustments to complete the painting.

COLLAGING &
OTHER UNUSUAL
TECHNIQUES

Collage (though it has a relatively long tradition), painting with sand, solar painting, monoprinting—these are all techniques that fall outside the realm of "classical" watercolor painting, yet inspire inventiveness in the medium. Gerald Brommer, an authority on collage, explains this versatile art and its materials in depth. Maxine Masterfield, a pioneer of art techniques that favor an interaction with or inspiration from nature, demonstrates some of her innovations with sand, sun, and other elements. Valfred Thëlin and John Koser share their individual ways of creating watercolor monoprints.

Gerald Brommer

Basic Collaging Techniques

Since Pablo Picasso and Georges Braque first began adding collaged materials to their paintings in 1912, artists have explored the process in countless ways. All kinds of paper, cloth, wood, plastic, and metal have been adhered to surfaces of paper, cardboard, canvas, and Masonite. Not only has collage been combined with almost every painting medium, but also it has been used alone—without paint of any kind.

The French called the pasting technique developed by the Cubists *papier collé,* which simply means "pasted paper." The Anglicized term *collage* refers to the process of pasting paper to a surface. To artists, the term implies selection, skill, and sensitivity in using paper materials and adhesives. A collage can take on many meanings, depending on the past experiences and current purposes of the artist using the materials.

In the next several pages Gerald Brommer focuses on the process of adhering papers to watercolor surfaces to provide a textured ground for painting. Although the collaged papers may stand on their own as part of the painting structure, generally the collage process is used here to create exciting and sensuous surfaces, with the collaged papers almost losing their identities for the sake of a unified painting.

As a rule of thumb, collage should be used only when the process helps to improve your painting, enhancing the surface and making the painting more exciting. It is counterproductive to attach papers to a surface if this causes confusion and creates unnecessary problems. Always remember, however, that your responsibility as an artist is to make the best paintings possible and to articulate your feelings and impressions through visual means, using paint on paper. Take advantage of every available resource to help you fully communicate your ideas and concepts. Only by exploring the possibilities of collage can you determine whether this method will enhance your work.

An imaginary coastal scene derived from several studies, this painting is constructed on a richly textured ground of Oriental papers. The textures of rocks and rushing water dominate the surface, which is woven together with vertical and horizontal lines and contrasting colors and values.

COASTAL IMPRESSION
Watercolor and collage, 22 × 30" (55.9 × 76.2 cm), collection of Mr. Harry Holt.

Materials and Tools

Collage implies working with materials of various kinds. Gerald Brommer focuses on the use of transparent watercolor, Oriental (rice) papers, and white glue in a variety of combinations. You are encouraged, however, to try any other material that might seem useful in developing your own personal visual vocabulary.

Paints and Brushes

When combining watercolor and collage, use the same paints as for a transparent watercolor painting. Although any watercolor brush can be employed effectively with this combination technique, flat brushes are best for the initial application of paint to collaged surfaces. Choose flat soft-hair brushes (sable, synthetic, or a combination) in ½", ¾", or 1" widths, depending on the size of your work.

Later, as you develop your own techniques and style, you may select a pointed brush, in any size. While sable brushes work very well on collaged surfaces, the abrasive textures can rapidly wear down the delicate pointed tips. Brushes with combinations of hairs (sable and synthetic, for example) are therefore far more economical.

Adhesives

Basic to the collage process is an adhesive to hold papers to the surface. There are many glues, pastes, waxes, and adhesives that stick to paper. In working with watercolor and collage, however, the adhesive material must work *with* the water-based medium, not fight it. In general, waxy materials should be eliminated, as they resist applications of watercolor.

Two products seem to work well with watercolor: white PVA (polyvinyl acetate) glue and acrylic matte medium. Do not, however, use these materials full strength. Both need to be diluted with water to provide surfaces that accept watercolor without resistance. Although other adhesives have certain desirable properties, they may be more difficult to work with (extended drying time and resolubility, for example). However, do experiment.

Clear plastic cups work well as containers for your glue and for the water needed to dilute it. A piece of cardboard makes an excellent disposable surface on which the glue and water can be mixed to desired consistencies.

Brushes for applying glue should be firm enough to control both the glue and the paper. Bristle brushes, flats or brights, in ¼" to ½" sizes (#6 to #8, for example) are most useful. Because PVA glue and acrylic medium dry to rocklike hardness, be sure to clean your brushes thoroughly in warm water immediately after use. If you forget, hold the dried brush under the hot water faucet for a minute or two, or soak it in hot water for several minutes until flexible.

Many kinds of adhesives will stick paper to paper, but diluted acrylic medium or white glue work best for the processes described in the next few pages. At times Yes! glue may be helpful in sticking pieces of heavy watercolor paper (300 lb., for example) or papers other than the Oriental handmade varieties to the surface. Use a stiff bristle brush to mix the glue and water to a desired consistency and apply it to the painting surface.

Your regular complement of watercolor brushes (flats and rounds) and current palette of colors are all that you need for the painting process described later. Bear in mind that because the collaged surface is somewhat abrasive, synthetic brushes will outlast sables.

This selection of white Oriental papers is laid out on a dark background. Note the variations in thickness, opacity, and fiber content. (The more opaque papers are lighter in value in this photograph.) Observe, for instance, the difference between the two Unryu papers in the first and second rows. The three lace papers (lower right) represent only a few of the patterns available.

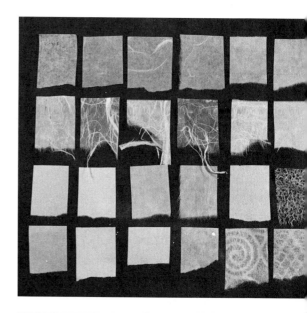

There are not as many natural-colored papers as white papers, but the textural variety is just as great. When seen against a dark background sheet, the most opaque papers generally appear lightest in value. Note the different characteristics of the two Kasuiri papers in the second row.

KINWASHI NATURAL	KINWASHI	KASURI	YUNGLONG	A.K. TOYAMA
KASUIRI	KASUIRI	CHIRI	KITIKATA	BUNKO
OKAWARA	MITSUMI NATURAL	KOCHI	SEKISHU	GAMPI TORINOKO NATURAL

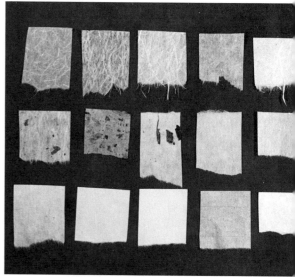

The same papers are shown on a light table, which emphasizes the types of fibers. The more opaque papers allow less light to pass through them and therefore appear darker here.

GASEN KYOTO	GAMPI GASEN	YOROSHI	UNRYU	KOZO GASEN	MULBERRY
HORUKI MIYA	HORUKI LIGHT	HORUKI HEAVY	UNRYU	NIPPON	NATSUME
KOZO HEAVY	TORINOKO	SUZUKI	KOZO LIGHT	IYO GLAZED	LACE
GOYU	MASA	GAMPI TORINOKO WHITE	MORIKO	LACE	LACE

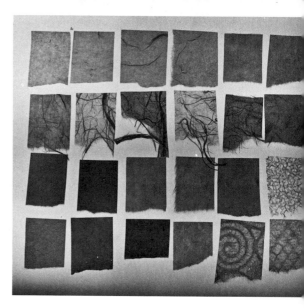

Grounds

Grounds are the surfaces on which paintings are made. Watercolors, for example, are usually painted on paper. For a collage, the ground should be sturdier than the papers applied to it. The heavier the collage materials are, the heavier the support should be. While excellent collages have been made on stretched 140-lb. papers, it is a decided advantage to use 300-lb. or heavier paper, which need not be stretched. Watercolor boards also make fine collage supports, as do mounted papers.

For the techniques described here, rough paper is best, because its texture is most compatible with that of Oriental papers. When smooth papers (cold- or hot-pressed) or illustration boards are used, there is a distracting textural difference between the Oriental papers and the supporting ground. All of the demonstrations included here are carried out on Arches 300-lb. rough paper unless otherwise noted, but you are encouraged to experiment with other grounds.

Oriental Papers

Most of the papers used as collage materials here are handmade papers from Japan. Commonly called "rice papers," these sheets are mostly made from five basic fibers: kozo, gampi, mitsumata, sulphite, and manila. Varying combinations of these fibers, plus a few additives, produce the scores of decorative, textural sheets on the market.

Oriental papers are long-fibered and difficult to tear, making them ideal for printmaking. Many are acid-free, and most are highly absorbent. Their other characteristics range from completely opaque to nearly transparent, from thick to thin, from white to neutral to black, from smooth to highly textured, from inexpensive to costly. Since the papers are handmade, however, the quality and composition may vary from one maker to another. Papers with the same name, purchased from different suppliers, may differ noticeably.

The sizes of the papers are almost as variable as their content. Most are about 24 × 36" (61.0 × 91.4 cm), but many are smaller and a few are larger. When ordering, note the sizes, to avoid disappointment when the sheets arrive.

The illustrations show how some of these papers look. There are many more than those pictured here, but a basic supply of six to ten papers will provide a great variety of texture. It is best to stick with white and neutral papers, since it is difficult to alter the hue of colored Oriental papers with watercolor. When papers have alternate smooth and textured sides, they should be collaged so the textured (absorbent) side is up. Most papers, however, are about as absorbent on one side as the other.

All the papers have Japanese names, which may be difficult to remember. It is helpful to write the names on small samples and keep them for reference and reordering. A list of ten basic papers might include: Chiri, Kasuri, Kinwashi heavy, Kinwashi white, Natsume, Unryu (or Yoroshi), Mulberry, Kasuiri, Okawara, and Horuki. The choice, however, is a personal one, and it will take some time to arrive at your own basic selection of papers.

Paper Sources

If you have a paper source in your city, you can choose your papers by feeling them and noting their opacity and textural characteristics. If art supply stores do not stock Oriental papers, try shops in Asian neighborhoods or Oriental specialty stores. If no ready supply is available, write to one of the following suppliers. All will send samples, some in book form and others assorted in envelopes, for a fee.

Daniel Smith Inc., 1111 North Nickerson Street, Seattle, WA 98119

New York Central Supply Co., 62 Third Avenue, New York, NY 10003

Aiko's Art Materials, 714 North Wabash Avenue, Chicago, IL 60611

The Paper Source, 1506 West 12th Street, Los Angeles, CA 90015

Stephen Kinsella Inc., P.O. Box 32420, Olivette, MO 63132

Yasutomo & Co., 235 Valley Drive, Brisbane CA 94005

H. K. Holbein, Inc., 1261 Shearer Street, Montreal, Quebec H3K 3E5, Canada

No single source carries all the papers available, since there are simply too many varieties and variations. Obtain several catalogs to insure the widest possible selection. Do not fall in love with any particular paper, because it may be discontinued.

Gerald Brommer's painting taboret has compartmented drawers that contain torn Oriental papers of various types, arranged according to opacity, texture, and color. When he begins a collage, he selects his papers and places them alongside the painting, to be retorn and applied as needed.

Gerald Brommer
The Basic Layering Process

There are many variations to the layering process with watercolor and collage, but this exercise introduces the fundamental techniques. After these basic steps are understood and mastered, you can begin to explore the possibilities of the medium in the context of your own work. To concentrate on the process, it is important that you eliminate subject matter from your first collages. If you try to make trees, barns, or rocks, you will miss much of what happens in the layering process. Getting acquainted with the medium is the goal here. Working with abstract designs will make it possible for you to concentrate on texture, layering, and painting processes.

Begin by cutting a half-sheet of 300-lb. watercolor paper into six pieces, each about 7½" square. For most landscape painters, squares work best for developing abstract images because rectangles immediately suggest objective landscapes.

A design concept called bridging is useful in establishing a directional orientation. Visual movement will emanate from an area of emphasis created by intersecting two bridges, one generally horizontal and the other vertical. Complete a series of sketches to familiarize yourself with the bridging concept (see the sketches here). Make your bridges go to the edges of the paper to involve the entire sheet in the design.

After the feeling of bridging is established in your sketches, begin painting similar designs on the squares of paper. Use a limited palette so color mixing does not become a dominant feature. Also, in the beginning, restrict yourself to light and middle values. Bear in mind that extra-heavy pigment can cause glue to discolor when the collaging process begins. Paint all six squares and allow them to dry.

Now select five or more kinds of Oriental paper (the more you use, the more exciting the result). Tear each sheet into pieces that measure about 2 × 4". When you begin to collage, tear off pieces of about ½ × 1" and glue them to the painted surface. Use a ½" bristle brush to apply the glue mixture to the painted surface. Place the torn paper on the glued area and use the same brush to flatten the edges and to adhere the paper firmly to the ground.

Because the edges and fibers of the torn paper will show up in later color layering, place the collaged pieces to help direct the eye to the center of interest. Try distributing the pieces of paper on the surface to balance the textures. Overlay two pieces of paper to create a third, layered texture. Leave the four corners of the square blank, but have some fibered papers act as transitions between the painted and unpainted areas. On several squares, you may decide to leave some painted areas uncollaged, while on other squares all the painted areas will be covered with textured papers. Allow the collage to dry completely.

All the steps up to this point have been aimed simply at preparing a ground for painting. The actual painting will be done on the textured, collaged surface. Of course, some

color from the initial painted layer may show through the collaged layer. Some of these areas may not even require additional painting.

Because the collaged surface is not as absorbent as either the 300-lb. watercolor paper or the Oriental papers glued to it, you must use a drybrush technique when applying color. Dip a flat brush in a watercolor wash and then partially dry it by touching it to a tissue or a paint rag. Now explore several techniques. First, caress the paper with the brush. Then brush firmly. Next, scumble and scrub. With each technique you try, carefully observe what is happening on the collaged sheets. Become aware of subtle color changes as the color comes in contact with several kinds of paper—some more absorbent and differently textured than others.

Experiment further. Paint one wash over another. The colors beneath the collage layer will emerge with the overpainting. Colors can gradually be intensified and darks can be added where necessary. Do not simply apply the same color on top of the collaged papers as you have used below them. Complementary colors may be interesting, but even slight changes in hue can emphasize the textural surface. Warms over cools and cools over warms can be visually stimulating. If colors are too intense, or if water begins to form puddles, blot with absorbent tissue or a paint rag.

Allow the collaged surface to suggest the placement of color and line. Make soft edges and hard edges. Use a pointed brush to add linear passages. Read the developing

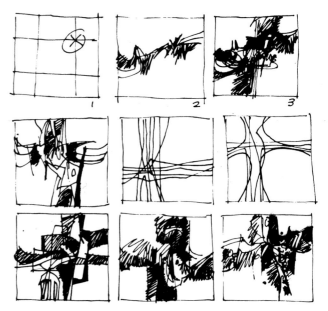

Use design sketches such as these to remind you about the arrangement and placement of visual elements in your work. Sketch 1 suggests a method for locating the center of interest; 2 illustrates the first step in bridging space; 3 shows the finished bridging concept. The remaining sketches explore different bridging possibilities.

painting and respond to what is happening on the surface. Be sure an area of emphasis is established in each design.

There should be some white or light-value areas near the center of interest, as well as light values that lead the eye from the center of interest to the white corners. If these light values have been lost in the painting process, they can now be reestablished by collaging again. Use a semiopaque paper (such as Unryu or Yoroshi) and collage pieces where needed. The papers can be toned completely or partially to work into the collaged surface. They should not appear to float above the surface or seem glued on top of the painting. You can

recollage several times, until the design is satisfactory. Check the principles of design—balance, movement, emphasis, contrast, unity, pattern—and adjust as needed.

Rotate the finished designs and notice any obvious directional orientations. Most designs made in this way will have several viewing situations that feel comfortable. Remember that the purpose of this exercise is to establish methods of working with the medium; to become aware of some of the possible textural effects; to enjoy the process; and to begin to see how the painting itself can suggest techniques and provide directions.

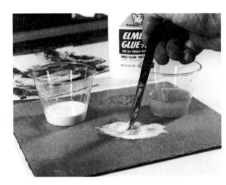

After sketching and painting the surface with initial colors, you are ready to try the basic layering process. Mix glue and water to the consistency of thick cream.

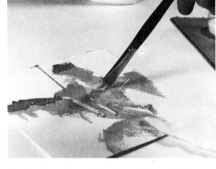

Apply the glue and water mixture to the painted surface in an area a little larger than the size of the torn piece of Oriental paper. Brush firmly, but do not scrub.

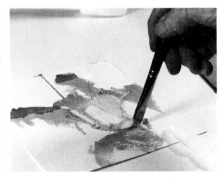

After applying the textured paper, use the same brush—but do not add more glue—to stick the paper firmly in place. Seal all edges to the ground.

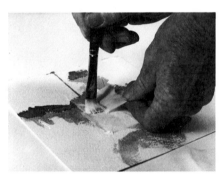

Keep adding pieces of paper until as much of the painted surface is covered as desired.

When dry, use a flat watercolor brush to add color. Use a nearly dry brush at first, to remain cognizant of the textures.

Line can be added with a pointed brush. Use existing textures and shapes to key the placement and direction of line.

If necessary, parts may be recollaged—to reintroduce light values, for example.

Use fibered papers as transitions to unify the positive and negative areas.

Gerald Brommer
Exploring the Layering Process

Use this demonstration as a guideline. On a 7½" square of 300-lb. Arches rough paper, paint a cruciform design in watercolor. The crossing of vertical and horizontal bridges creates a natural area of emphasis. Spatter and scratch out color to provide an initial indication of texture.

When the paint is dry, attach torn pieces of Oriental paper to the surface using a mixture of glue and water (or acrylic medium and water). With a stiff bristle brush, adhere the papers firmly to the ground. (Note the variety of papers evident in this small study.)

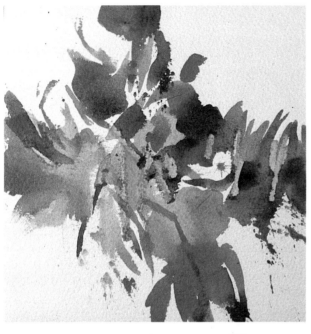

When the glue is completely dry, the textured ground is ready to accept color. Use a fairly dry brush and colors dark enough in value for the textures to be easily seen. Establish color dominance early in the process, but also remember to leave light-value areas to provide passage to the center of interest.

Textures can be enhanced and pattern and visual movement established by adding color washes. Here the layering is evident: You can see initial color showing through the collaged papers, along with added color on top. If you encounter loose, unglued paper edges while painting, scrape them off with a fingernail, brush handle, or razor blade.

Next, apply darker washes, but preserve the color dominance. As you add color shapes, key them to existing shapes and fibers, following paths, edges, and lines already in existence. Try to distribute color over the surface to establish balance. Be sure to let the color dry somewhat while you're working, because very wet papers absorb color too readily. (It's a good idea to work on several paintings at one time.) To bring the painting into focus, concentrate the visual activity near the center of interest. Begin to add dark accents there with both shape and line. Let existing fibers suggest a path for your lines. Also begin to strengthen contrasts—as was done here by adding some blues to the warm colors.

In the final stages you should pull your painting together. Complementary accents, spattering, and colored lines can all help to establish unity. Notice here how cool blues have been pulled over existing warm color shapes and whites to unify the surface. Additional lines help tie the positive and negative areas together. If necessary, you can recollage to emphasize the visual passage of light to the center of interest.

Gerald Brommer
Working from Nature to Abstraction

Using collage techniques can help you understand how to design abstract compositions with nature as a starting point. This demonstration shows you how to use the painting itself as resource material, instead of constantly referring back to an original photograph for details and directions. This is an important concept for artists to understand and nurture.

Gerald Brommer took this photograph of the California coastal village of Mendocino with the idea of someday using it as the subject for a painting, so the center of interest—the church—is already favorably situated. The format is primarily horizontal, with several vertical thrusts that stabilize the movement.

These sketches show several organizational possibilities. Notice how basic visual movement and compositional balance are explored.

After exploring different design formats, Brommer makes a simple drawing to indicate the arrangement of the major shapes in the scene—cliff, beach and water, buildings and trees, background. This drawing is based on his sketches rather than on the photograph; in turn, the drawing becomes the basis for his initial painting.

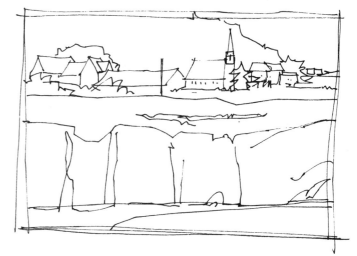

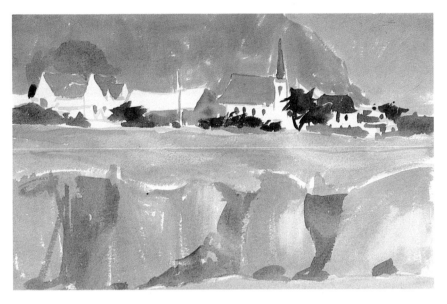

With a large round brush, Brommer outlines the major shapes on a quarter-sheet (11 × 15") of Arches 300-lb. rough paper. Knowing that this image will be drastically altered, he doesn't take special care to make anything precise—this is just a nice, loose statement. The colors approximate the light values of local colors in the photograph, but all the landscape elements are reduced to simple, basic shapes.

When collaging the first pieces of Oriental paper to the painting, Brommer allows abstract shapes to dominate. Instead of tearing the papers into specific shapes to cover hills, houses, or cliffs, he uses them as they come and lets them overlap painted shapes. New, collaged shapes begin to emerge, developing rhythm and pattern.

The original subject is neglected as different Oriental papers are stuck down in vertical and horizontal orientations. Some of these papers obliterate color, while others allow color to show through. Note how the texture of some papers is enhanced by color showing through. Already the surface has an abstract quality not present in the simple painting. Now Brommer begins to apply paint to the textured ground.

At this point a decision must be made. Should the painting follow its current abstract direction? Or should the original scene be reconstructed on the textured ground? Here Brommer decides to explore the abstract possibilities. Using a relatively dry flat brush, he puts down light-value shapes, keyed to existing edges and paper shapes. He is not concerned with the subject matter at this time, only with the development of a pleasing abstract design. Although he chooses bluish greens and brownish yellows—two dominant hues in the subject—completely different colors could have been selected. The light pattern is beginning to evolve.

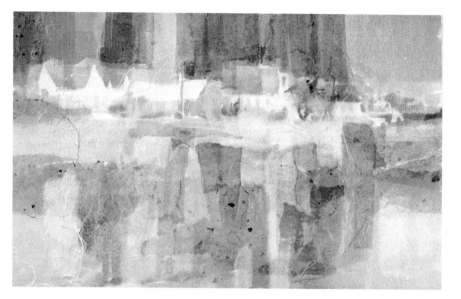

Still using a drybrush technique, Brommer adds darker values, especially in the foreground and the right and left margins, to tie these extremities to the center of interest. The whites remain as part of the established pattern, but the purplish roofs introduce a new color, which must be distributed to several parts of the painting. Notice that the artist has eliminated the water at the bottom in favor of emphasis on the vertical shafts. The presence of water is implied, however, at the lower left. By bringing out some diagonals, keyed to existing fibers in the papers, Brommer increases the visual interest and counterbalances the emerging strength of the verticals.

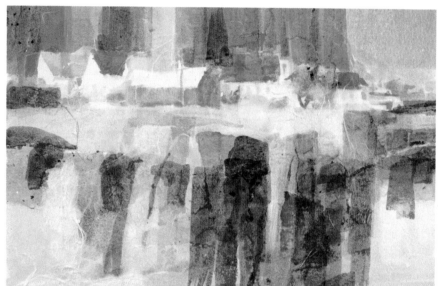

Now Brommer adds very dark marks to establish accents and spatters some color for a transition from the white negative space to the textured and painted areas. By strengthening certain colors and introducing grays, he clarifies the light pattern and the center of interest. Notice the blues he has added to the lower left to suggest water, and how these blues are repeated in several places on the surface. You should always be aware of size variations in shapes over the surface.

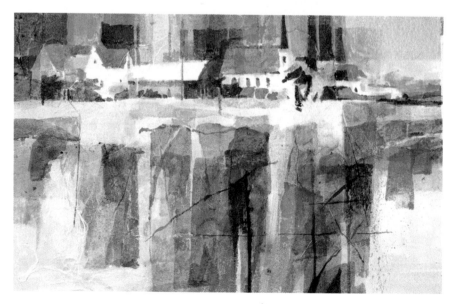

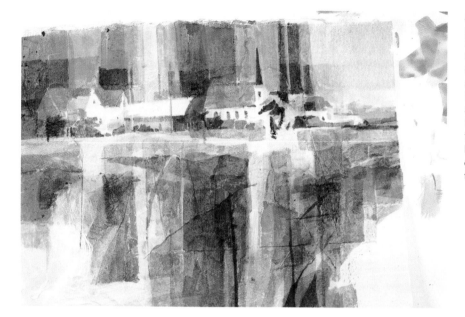

Although Brommer refers to the original photograph for some details, his main interest is still the abstract design. By adding golden yellows and greens to existing shapes and over some whites, he strengthens the presence of the two hues. He also pulls greenish-blue washes over areas to augment the passage of light. Note the passage from the buildings to the foreground and the background, in both light and middle values. Also observe how diagonals are emphasized in the cliffs to counter overly strong verticals.

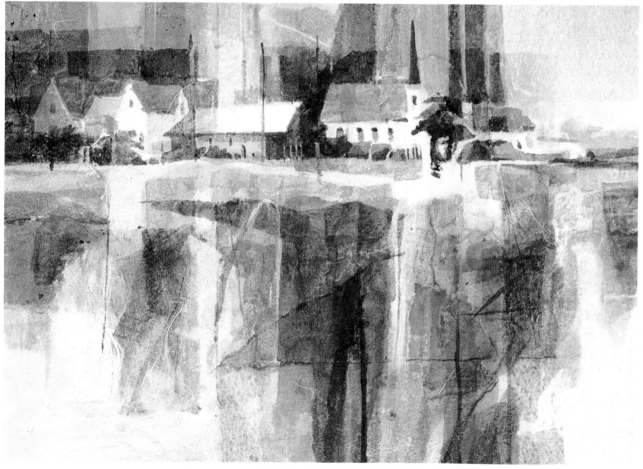

Near the end Brommer reintroduces collage in several places (lower right, lower center, and upper center) to stress the passage of light. These newly textured areas have to be toned a bit to work them into the surface and establish unity. Finally, using a wet bristle brush and a tissue to lift the paint, he softens a few edges. The result is an abstracted landscape, based on a photograph of nature. The painting could have moved toward a more nonobjective solution at several steps, or it could have moved toward a more naturalistic finish.

Gerald Brommer

Transforming a Finished Painting

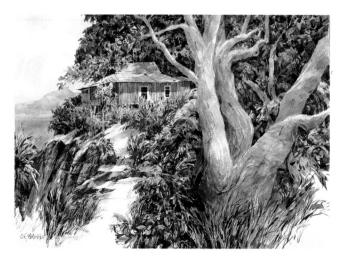

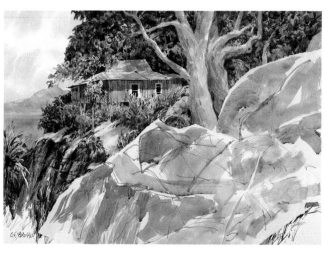

This watercolor of a hillside cottage on the island of Hawaii had been finished, signed, and framed. Indeed, it had already hung in several galleries. When the painting was returned to Gerald Brommer's studio, however, he felt that the visual emphasis was equally divided between the trees and the cottage; instead, one needed to be subordinated to the other. He decided to diminish the importance of the trees and enhance the visual dominance of the cottage.

To help him visualize such a drastic change and its effect on the total composition, Brommer tore several large pieces of bond paper and temporarily laid them over the lower part of the painting. After adding some neutral watercolor washes to kill the intense white, he could see how the composition might work. He decided to collage the foreground of the painting with Oriental papers, without any preliminary scrubbing of color.

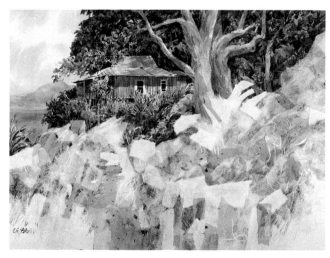

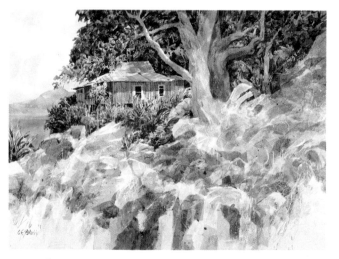

The next step was to select the Oriental papers. Because Brommer wanted to create an impression of jungle rocks and undergrowth in the foreground, he chose the papers with these textures in mind. He also used some opaque white papers to drastically alter the existing value pattern. All these papers were applied directly to the painting, and the collaged surface was allowed to dry completely.

Using a ¾" flat sable, Brommer began brushing some foliage and rock colors over the dried collage. These were exploratory trials, made with his eyes squinted, to initiate appropriate light and dark patterns. He did not draw on the collaged surface, although that was an alternative.

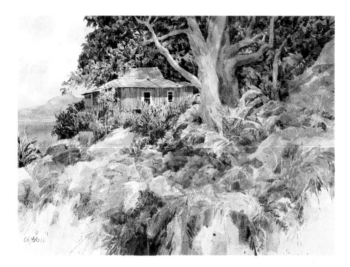

Working from memory and imagination, and stressing principles of composition (especially movement and balance), Brommer added more color with both flat and pointed brushes. Notice that some of the calligraphic lines in the original painting are repeated in the newly collaged areas. Also observe how the dark values balance the painting and direct visual movement. At this point the artist still had a sense of exploration and trial, knowing that more paper could be collaged at any time.

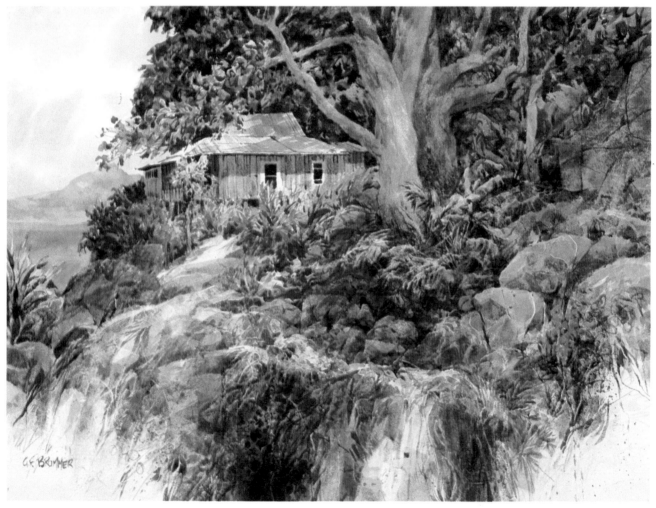

BLUE HOUSE ON THE KONA COAST
Watercolor and collage, 22 × 30"
(55.9 × 76.2 cm), collection of Mr.
and Mrs. Jack Fuhler.

In the finished painting, there is a clear visual movement to the center of interest—the house. Because the trees have been darkened in value and pushed into the shadows, the house stands out. The foreground is a bit out of focus as far as detail is concerned, but details come into focus near the center of interest. There is a transitional feeling of going from unfinished to finished areas, from negative to positive, from more abstract to more representational. The repetition of colors from the background in the foreground and the weaving of dark and light passages help to unify the whole.

Stephen Quiller

Using Collage to Create the Illusion of Depth

The idea for this painting came from one of many sketches Stephen Quiller had done along the Oregon coast (study 1). Right from the beginning he knew he wanted to create an illusion of depth through a contrast in texture, using a smooth background and a heavily textured foreground. He decided to limit his palette to concentrate on the texture.

In his studio Quiller did a series of paintings to explore the textural effects created by adhering stained rice papers to the painting surface (studies 2 and 3). Although he did these paintings on nearly full-size sheets of watercolor paper, he still considers them studies. In addition to learning about suitable collage effects, Quiller was also practicing painting the swarms of small shorebirds that added so much interest to the beach.

Quiller cut a sheet of appropriate size from a roll of watercolor paper, then soaked it in the bathtub for about forty-five minutes, blotted it with towels, and stretched it on reinforced canvas stretcher bars. When dry, it was tight as a drum. He then put the stretched paper on his easel. When working this large, it's important to be able to step away from the painting to look at it.

After wetting the paper, Quiller washed in the smooth, distant sky with cerulean blue and a little cadmium red light. When this had dried, he painted the most distant rocks using cerulean blue and brown madder alizarin. You can see where he scraped some areas with a pocket knife to give them character.

At this point Quiller referred to his sketches and preliminary studies to help him decide how to develop the rest of the painting. He knew he wanted to leave the large white area in the middle distance untouched to suggest the bay at low tide, and he knew the foreground would be collage. For the collage he tore several types of rice paper into different sizes and shapes. The larger pieces were paper with a relatively smooth texture, while the smaller pieces were very fibrous. These he put beside his easel.

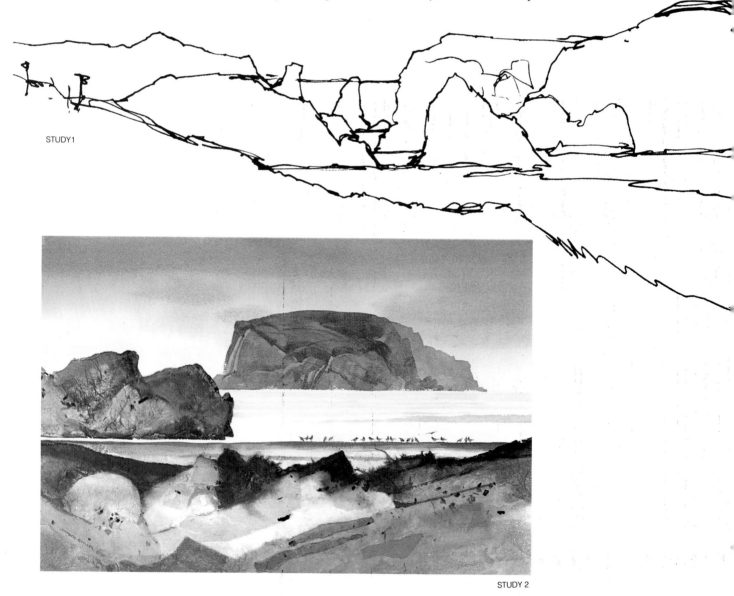

STUDY1

STUDY 2

164

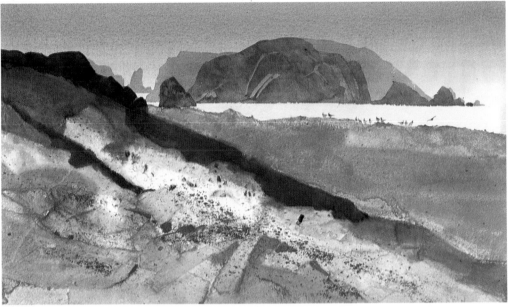

STUDY 3

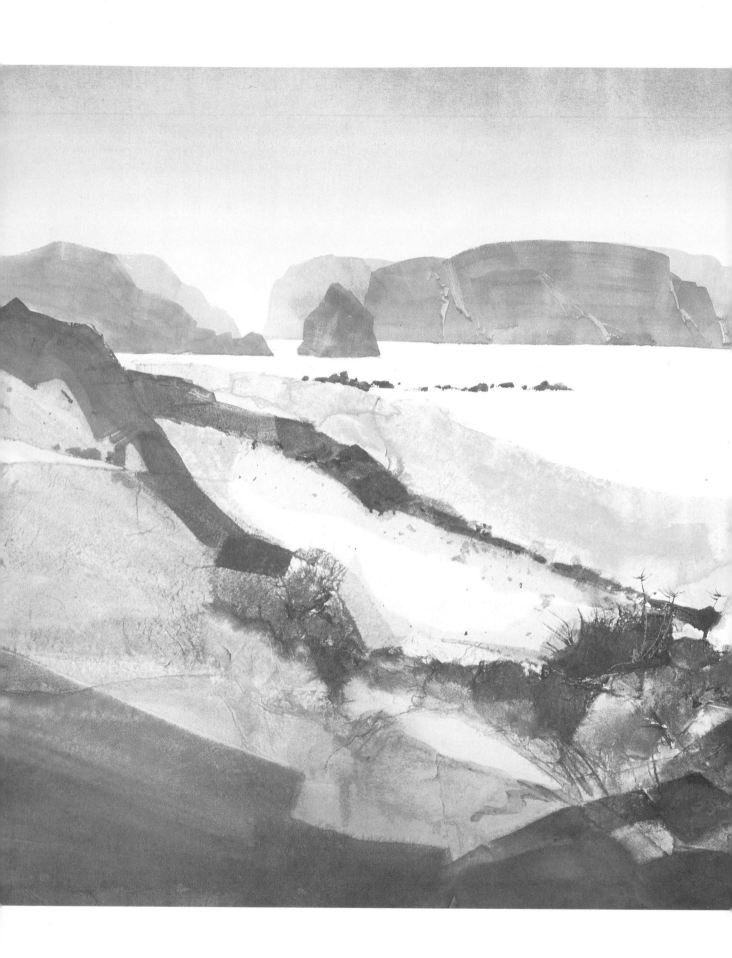

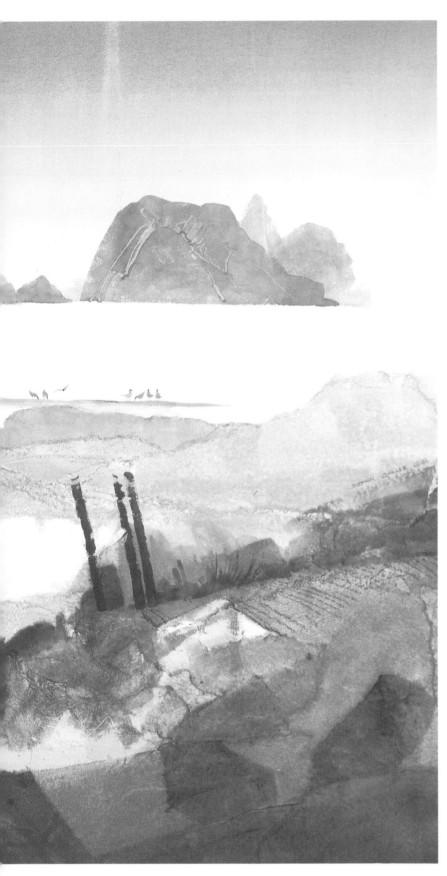

To begin the collage, Quiller first saturated the lower two-thirds of the watercolor paper with polymer matte medium, diluted fifty-fifty with water. This would be his adhesive. Next he washed on large masses of varying mixtures of burnt sienna, cadmium red light, burnt umber, and cerulean blue, taking care to leave some areas white. Because he was working on an upright surface, this paint began to suggest forms as it flowed down. As he began to see something happen, he reinforced it by applying a piece of the torn rice paper, working rapidly. If he obliterated some color, he added more. He continued working spontaneously back and forth, alternating paper collage with color washes, until he reached the definition of forms he wanted. Then he stopped—it is easy to kill a painting by going too far using texture of this type.

When everything was dry, Quiller strengthened and darkened the values throughout the composition. One light area in the lower left foreground seemed too similar to other shapes nearby, so he toned it down with a wash of cerulean blue. This is the kind of thing that can be done only during the final moments of painting.

The last touches were the pilings and the small shorebirds, the forms and quick movements of the birds adding life to the coastal landscape.

TIDAL POOLS
Watercolor and collage on Arches 140-lb. cold-pressed paper, 33 × 51" (83.8 × 129.5 cm), collection of the artist.

Maxine Masterfield
Interpreting Nature with Poured and Textured Color

There are many ways artists can achieve the look, as well as the essence, of nature's myriad textures, especially when the painting techniques mirror the methods used by nature itself. For example, you can allow paints to soak into or be resisted by prepared surfaces the way that nature allows rain to seep into the earth or drip off nonporous surfaces. Maxine Masterfield has developed experimental techniques incorporating plastics, cellophane, wax paper, and other materials that are stretched, twisted, and weighted down over poured paints and inks to capture various natural forms. The basic method is presented here.

Materials

Various hot-pressed watercolor papers, 90- or 140-lb.

FW colored inks, Steig Luma watercolors (both are lightfast and nontoxic), and thinned tube watercolors or acrylics

Plywood boards at least ⅛" (3 mm) thick; staples or gum tape for fastening paper to boards

Fine-mist spray bottle for adding water

Air-mist bottle (available from beauty supply shops) for fine mists of color

Plastic bottles with applicator tips for holding and applying colors

Soft rubber rollers for spreading and guiding colors

Assorted brushes, including Japanese hake brushes for broad washes and fine liner brushes for opaque ink

Variety of plastic cloths for texturing works

Movable easel (such as MobilEasel; for information, call (206) 367-1272) that allows plywood board to be tilted.

The MobilEasel's ability to tilt and rotate is very useful for controlling the flow of poured colors.

Pouring the Colors

Prepare the watercolor paper: Wet, stretch, and staple or tape it down to a sheet of plywood and leave it to dry. When you are about to start pouring colors, attach the board to a mobile easel so you can tilt it to any angle. Then lightly mist the paper with water to help the colors flow freely and give the colored areas feathered edges.

Now you are ready to pour or squirt colors onto the paper. By tilting and straightening the board, you can influence where the colors flow. Keep your spray bottle of water handy so you can thin out colors and add washes if necessary. Color or water can be added anytime to areas that seem either washed out or too concentrated. Level the board when the colors are where you want them, before you start placing your texturing materials into the wet color.

Adding the Texture

First stabilize the moving easel. Then place various kinds of objects on top of your wet painting. Natural objects such as shells, stones, leaves, grasses, and feathers work well. Woven fabrics, wax paper, plastic wrap, foil, and even bubble wrap all create interesting textures, many of which echo effects found in nature. Just be sure none of your texturing objects will dissolve in water.

Wherever your texturing objects touch the paper, the wet color will be attracted and form puddles. As the painting dries, the pigment will be concentrated along the edges of those puddles. This means that the texture varies according to the contact material and how it is prepared. (For example, wax paper can be crinkled, twisted, or folded before you place it into the wet colors.) Where nothing touches the paper, the colors are free to mix while they dry, leaving no patterning or texture.

Defining the Results

Once the painting is dry, remove the texturing materials. (Plastics and natural materials such as leaves and shells can be taken off when the painting is still slightly damp, but wax paper will stick if you try to remove it before the painting is completely dry.)

Occasionally a painting is complete when you remove the materials; if not, you will usually have an immediate impression of what the painting is striving to be. The pattern will suggest a particular element in nature by its inherent line and rhythm. At this stage you can help the image along by adding lines and washes, and sometimes by eliminating elements that intrude.

Sometimes Maxine Masterfield will add opaque lines with a liner brush to provide the kind of detail that can give a work a needed focus or strong directional pattern. With some works she repeats the process of applying colors and

textures in selected areas; other times she may use an opaque wash to cover large unwanted areas. It is also possible to mask and spray over selected areas with an air mist bottle, and to cut areas from several works and collage them together. Combining these methods until she is satisfied is Masterfield's regular practice.

Here Masterfield poured yellow (almost squirted it from the plastic applicator bottle) first horizontally, about a third of the way down the paper. She then tipped the board slightly, so that the yellow flowed smoothly to the edges. After leveling the board, she added red below the yellow in two horizontal lines, so that some of it blended with the yellow. The blue was added last, in several shorter lines.

Using a soft, wide brush, Masterfield opened two paths for the red and blue puddle to flow down. With the board level, she also misted water over the colors to keep them loose and liquid until she was ready to place texturing materials on them.

Masterfield carefully placed several lengths of accordion-pleated wax paper on top of the wet colors. The colors spread and crept under the contact areas, forming veins of feathered lines. She did not cover the painting with plastic while it was drying because she wanted open spaces free of color and texture.

She further defined some areas with white line, and cleaned up others with white ink. She then cropped the painting for a closer focus and titled it *Waterfall.*

WATERFALL.
Inks on Morilla paper, 22 × 30" (55.9 × 76.2 cm), collection of the artist.

Maxine Masterfield

Capturing the Look of Sedimentary Rock

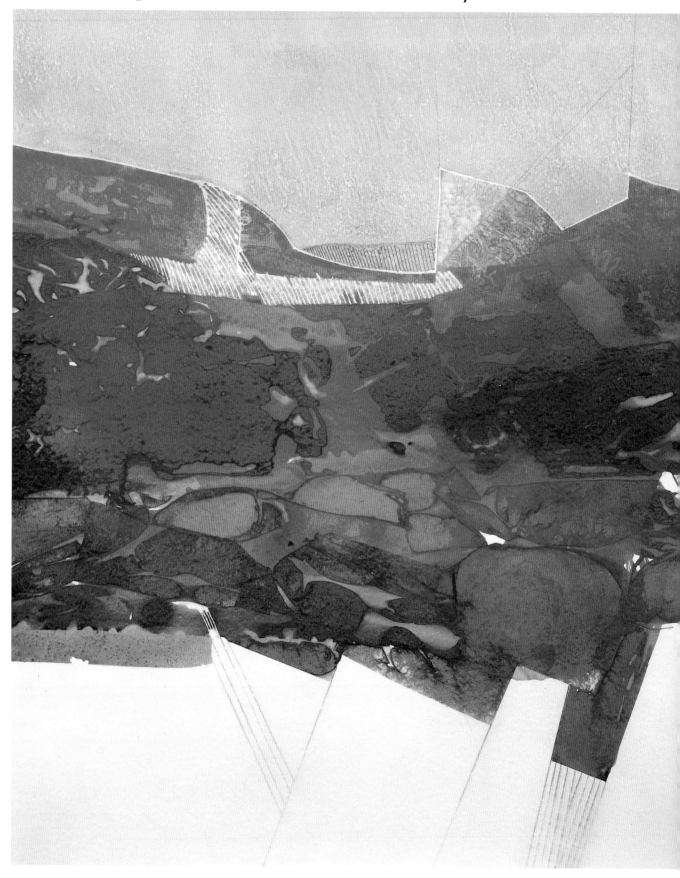

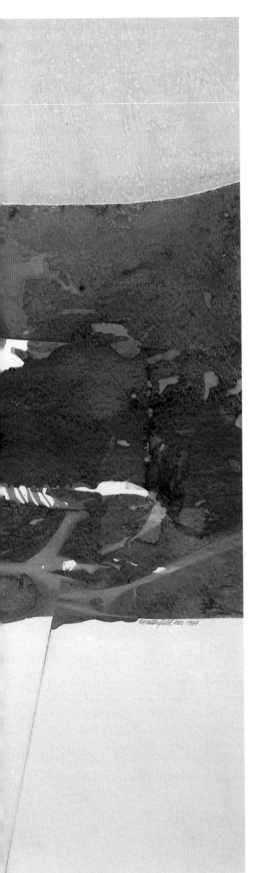

This is a painting from Masterfield's bright-colors series using rainbow pours of red, lavender, blue, and yellow inks. She placed a large, heavy plastic sheet over the pour and weighted it down, being careful to trap air bubbles under the plastic. (It is the trapping of air that caused the rocklike shapes.) After the covered painting dried, the artist removed the plastic and decided the image looked like layers of earth.

At that point, the central colors looked good but the foreground and background needed to be established. Masterfield washed in a layer of tinted white for the sky and added some salt for a slightly mottled texture similar to that of large, worn boulders. In the foreground she had left a large area of white, and she decided it looked like a fence. For a final touch she added the white line drawing: a fence she felt she could stand behind and look out to the edge of the earth.

BEYOND THE EDGE
Inks on Morilla paper, 38 × 44" (96.5 × 111.8 cm), private collection.

Maxine Masterfield
Painting with Sand

On a morning walk along the beach Maxine Masterfield became fascinated by the rhythmic patterns formed in the sand by the action of the waves. She began to imagine a sheet of watercolor paper at the edge of the beach, covered with sand and washed over by waves, so that rivulet patterns would be left on it.

From months of experimentation she refined a technique that would let her accomplish this in the studio. First she sprinkles a thin layer of very fine sand on smooth paper attached to a board (rough paper doesn't work). To simulate the wind, waves, erosion, and retreating tides, she sprays a light mist of water over the sand until a shallow layer of water floats over it. If the board is tipped, the water will rush through the sand, leaving a rippled design similar to that left on a beach by the water receding at low tide.

To preserve the sand design in a more permanent form Masterfield then applies inks and paints in a fine spray. The sand acts as a resist, absorbing the color to produce lighter sections in the finished painting. Different effects can be achieved by first "drawing" into the sand, pressing in various objects, or varying the drying time between spraying on the mists of water and of color.

Materials

Morilla 140-lb. or other cold-pressed watercolor paper

Air mist bottles (one for each color, one for water)

FW, Rotring, and watercolor inks

Large pump sprayer (garden-type) for water

Fine sand (ground quartz, not glass)

Mesh sifter

Small plastic pails for pouring water

Sliced shells and other objects for pressed designs

Mobile easel (see previous demonstration)

Setting Up Your Materials

For best results, sand paintings should be allowed to dry undisturbed. Thus, do the painting in whatever place you intend to let it dry.

Staple a piece of cold-pressed paper, smooth side up, flat to a board. You can leave it white or work on paper colored with a wash that has dried completely. If you want your painting to include the shapes of light, fine-lined objects such as net or sea grasses, lay them onto the paper before adding sand. If you want the shapes to show as colored lines, lift the objects before spraying on the color—but after spraying on the water, so that the sand is damp enough not to fall back into the design crevices. If you prefer the objects to leave white lines with colored edges, keep them on the painting until after the color is dry.

Adding the Sand

Either use a sifter to sprinkle sand onto the paper, or presift the sand to remove any debris and then throw it across the paper. Start with an even, light layer of sand—⅛" is plenty.

At this stage you can make sweeping, windlike designs in the dry sand with a fan, hair dryer, or straw. You can also scrape across the surface or press objects (such as sliced shells or coral) down through the sand. Be sure to press down all the way to the paper surface if you want clear color lines or areas of color with no sand texture. To keep the edges of the object's shape clear, leave it in contact with the paper while you spray on the water.

Spraying On Water and Color

Slowly apply a light spray of water over the sand areas while tilting the board in the directions where you want it to go. Spray from the middle and tilt to let the water wash through the sand and off the board, carrying the excess sand from the depressions of the design with it. The thicker the sand, the less color will penetrate to the paper underneath.

The drying time after you spray on the water is very important. If color is applied immediately after the water, the painting will be soft because the wet sand will dilute the color as it reaches the paper. Some color may also flow off the paper with the still-running water, causing a leopard-skin effect. If the sand is left to dry completely before the color is sprayed on (which takes about a day in the sun or up to a week indoors), the result is white paper wherever there was sand, and strong color with hard edges wherever there was no sand. You can experiment with many intermediate states of dampness, or even apply some colors while the sand is wet and others after it is dry. The sand lightens as it dries. Test it for dryness by sticking your finger into the deepest part.

When you are ready to add color, keep the board flat. Using an air mist bottle, spray the lightest color over the sand, and gradually work up to the darker colors. Inks work best for this technique. Be sure to allow the painting to dry completely before brushing off the sand, or the colors may smudge. Test the dryness as described above.

Simply tilting the board will cause the dry colored sand to slide off. If some sand sticks, remove it with a whisk broom.

Sift sand through a strainer to remove impurities. If you like, push cut shells into the sand to open a shape.

Spray the sand lightly with water to set the shapes; the dampened sand becomes heavy enough not to move if the board is tipped. Spray on more water and tip the board in different directions to form rivulet patterns as the water runs off.

Now spray color over the sand and into the areas where the sand has been washed away. Notice how saturated with color the sand is.

When the painting is completely dry, brush off the sand. You will see a pattern of lighter sections where the sand absorbed color, and stronger color where the water exposed the paper surface.

Maxine Masterfield

Further Advice on Painting with Sand

Using the sand method on Artcor (a sturdy, water-resistant foam-filled board ¼" thick) creates a very different effect from what you get with absorbent, textured papers. Instead of permeating the surface, the color beads up and gives an appearance similar to coral.

Using various sizes of grains of sand in different areas of the same painting leaves interesting textural passages. You might even want to experiment with other types of granular materials to see what happens. Always test first on small pieces. Beware of any sand or dirt that contains plaster or concrete powder, because such sand will harden and strip your paper when you try to remove it. Also, some materials may have impurities that will affect your colors by bleaching them, changing their hue, dirtying them, or making them settle unevenly, creating blotches instead of the texture you want.

Sometimes after all the sand is removed from a sand painting, the results are too pale and uninteresting—all over or in isolated sections. The painting can be developed further. If you have freed it from its board, restretch and fasten it down tightly once more. Then follow all your original steps, being careful this time to leave enough open patterns to register the inks, and to use deeper colors than the first time. Sometimes the problem is that all the colors were allowed to merge into a muddy gray. If you isolate the hues by using

rippled sand "trenches" to contain them, they will keep their purity. Be sure the painting dries undisturbed, level, and completely before you brush the sand off the surface.

If only certain portions of a sand painting need to be redone, sift sand only onto those areas. (Don't try to use sand to mask the parts that are all right. Because you cannot see them, you may inadvertently invade them when you tilt the board to form patterns.) If the sand does not form an unbroken boundary to keep the new colors away from the saved areas, tilt the board slightly to keep the water and colors away. If the area you wish to save is in the middle of the painting, redo one edge at a time, always tilting the flow away from the finished areas that you want to preserve.

Blowing the sand away is another method of redoing a sand painting when there are various areas that need a smattering of texture here and there to give a more connected feel to the design. Sift the sand lightly in the needed areas. Then instead of spraying all the sand with water to hold it or create a pattern, drip or trickle water onto the sand exactly where you want the light area of the design to be. You then can either tilt the board and let the remaining sand fall away, or use a hair dryer or fan set on low to blow the dry, light sand off the painting. Spray your colors carefully, and allow the painting to dry completely before brushing the sand away.

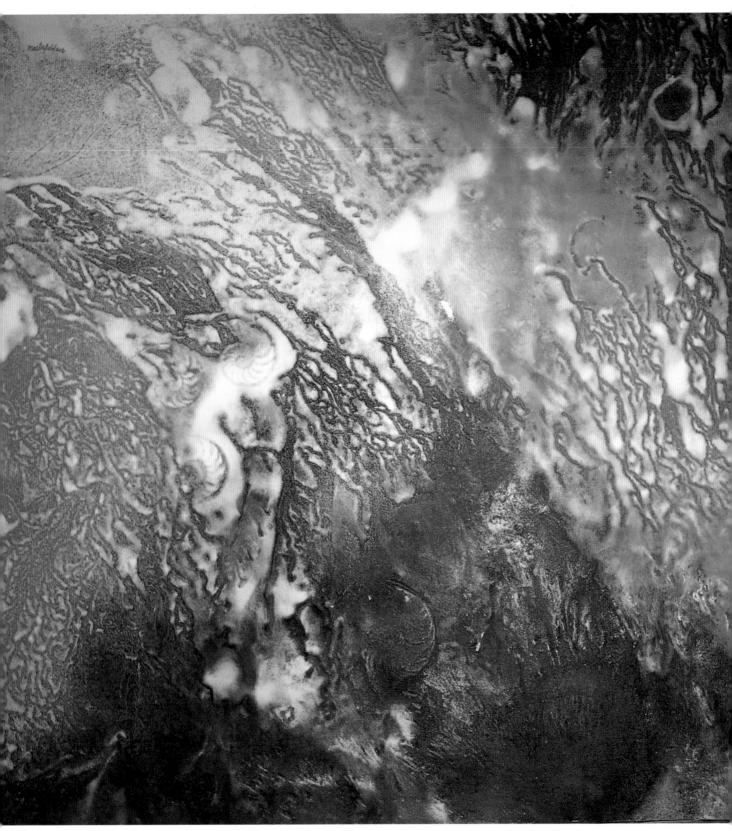

DUET OF SEA AND SKY
Inks on Morilla paper, 46 × 46"
(116.8 × 116.8 cm),
private collection.

This painting contains not only the pattern of the water's flow, but also the shells and other debris that mingle on shore beneath reflecting waters. The setting sun casts its colors onto the water. There even seems to be a last veil of shadows, as if clouds were passing overhead.

Shells and fossils were pressed into the sand before the pattern was established, and the bottom areas were exposed surfaces where the deep colors formed the shadows.

Maxine Masterfield
Working with Filaments and Fibers

Nothing unifies a design more than a tracing of connecting lines that form their own textured pattern. The most versatile source of lines has always been fibers and woven threads. Maxine Masterfield is particularly fascinated by the line quality of threads that were woven and are then pulled apart, retaining a kinky texture. For use with poured inks and watercolors, she has come to prefer gauze, cheesecloth, and nylon stockings, which are easily pulled apart and made to "run" interestingly. However, any fabric works well if it can be unwoven or have threads pulled out from it.

Fibrous materials can act as resists to shield part of a painting's surface from color. But fibers can also absorb color and hold it next to the paper, or even carry it like a wick away from where it was applied. Working with fibers can yield stark, clear lines or pale lines edged by feathered color, in single or multiple layers of delicate patterns.

Materials

Aquarius II, Rives BFK, or Arches cold-pressed paper

Air mist bottles (one for each color, one for water)

FW and Rotring colored inks; liquid watercolors

Baster or pipette

Cheesecloth, gauze, string, netting, lace, other woven materials

Preparing the Materials

Whether you are using cheesecloth, gauze, nylon stockings, or any other woven materials, first be sure that they are clean of any contaminants (such as bleach or detergent) and not coated with anything water-resistant, such as oil, starch, or waterproofing. If you are going to use threads that shrink and react to water, test them out first so you know what to expect; some rayons bunch up when wet.

Pull and run the material by cutting it open and laying it flat. (Some materials, such as stockings, start out as tubes.) Unhook the top and bottom threads before pulling to unravel, making the size weave you need for the design. You will probably want some large open areas, and some holes of varied size if your plan includes placing objects with the fibers. The more you unweave the fabric, the more interesting the patterns become, and the more they read like lines rather than fabric in the finished painting.

To complement your fibers, choose objects with a definite open design, not just a solid shape. When using leaves, seed pods, feathers, or any other kind of natural material, be sure it is pliable enough not to crumble or crack apart before giving a sharp image. Some natural materials dry quickly, so you may want to use them as soon as you get them, or keep them moist. (If they curl up and the edges do not maintain contact with the paper, you will lose that part of the design.) Threads, even crinkled ones, will weigh down with the ink or paint you add to the painting.

Preparing the Paper

Stretch the paper flat, smooth side up, and staple it to a flat board that can be moved (in case you want to dry it in the sun). Wet the entire surface of the paper slightly, which prepares it to absorb the color evenly. There should not be puddles or dry spots.

Setting the Design

Arrange the materials you are planning to use in the opposite order from how you want them to appear in the finished work. Objects that will appear in front of the fiber lines must be put down first, and objects to appear behind the fibers must be set on top of them. For objects placed in open areas, stretch the pulled fabric first, make the holes where you want them, and then fill them according to your plan.

When the materials in your design are in place, mist the fibers with water to prevent them from moving once the color is applied. If they move before the painting is dry, they may smear some of your image lines.

Applying Color

Before starting to spray your colors, remove any objects that are *on top of* the fiber design; you can easily replace them now that you know where they will go. (Any objects you placed *under* the fibers should stay down, and will leave white shapes in the finished painting.) Spray on your first layer of color, which will set the fiber lines and leave color under the top layer of objects. Then replace those objects, and go on applying color.

Begin with the lightest color you intend to use, and work your way to the darkest color. Remember that some of the colors will appear darker when they mix, so save the contrast until it's really needed. Spray the color sparingly at first so that you have better control. It is best to spray in the direction of the fibers, so that the color flows with them. Wherever you have enough color but it is not flowing properly, add a fine spray of water.

Controlling the Effects

Experiment with different cheesecloths; some are cotton, some nylon. You may prefer the less absorbent synthetics to cotton gauze.

The absorbency of the fibers you use, the amount of water used with the color, and the speed at which you dry your painting will determine the line qualities of your painting. If the threads attract the color and hold it until it dries, there will be a strong color line. If the threads were already saturated with water or weak color before the strong color reached them, they will resist the later color and shield the paper below them from that color. This will give the appearance of a light line edged by some feathered color. Wherever a puddle of wet pigment covers the paper between the filaments and dries in stages, there is a feathering effect that makes the filament lines less distinct.

If you have built up several different color areas where the wet colors are being separated by threads of your fabric, don't move the board until the painting is dry, and don't use fans or blow dryers, because they can move the liquid. A heat lamp or the sun will dry the painting more quickly without disturbing the ink puddles, but heat evaporation also tends to leave concentric rings of color in large, open areas. You may like this effect, but if that is not what you are looking for, the best bet is to go easy on the amount of liquid in the first place—especially the water.

If you already have too much liquid and you don't want the effects of long drying or heat drying, you can carefully siphon off excess water from different areas with a baster or pipette. But do it all at once as soon as you are through spraying, or you will not get an even coverage of color in that area. You can also add color or water to a small area by dripping it on with a baster or pipette.

If you see that the piece is drying too light, you can add more color. If it is too dark, let it dry first, then spray on some light opaque inks or metallic paints (wear a protective mask when working with metallics). Unless you deliberately want to lose an object's shape or the pattern of the threads, leave everything in contact with the painting until you are completely finished spraying the final coat.

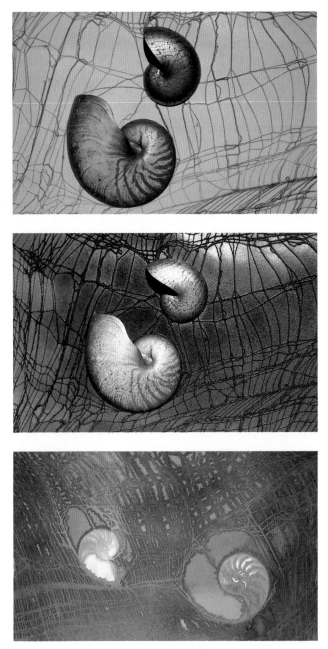

First Masterfield stretched prepared cheesecloth over the smooth side of white watercolor paper. She then set sliced shells, flat side down, between or on top of the fibers. To set the design in place, she misted it with water.

Next the artist sprayed on color, and more water wherever the color was too dense or not flowing well. When the painting was completely dry, she removed the shells and fabric, leaving the strong shell patterns you see here.

Composing with Various Weaves

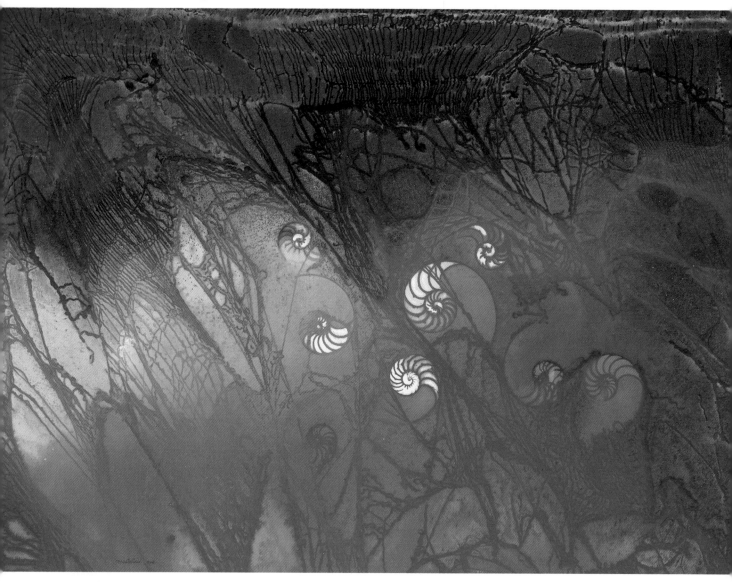

ANOTHER HABITAT
Inks on Arches cold-pressed paper,
34 × 48" (86.4 × 121.9 cm),
collection of the artist.

Living under the tangle of "sea nets," where light filters down in deep, exaggerated colors, are small and perfect inhabited shells. The ocean is teeming with activity and life forms, wonders that we seldom get to see.

For this painting Maxine Masterfield opened up cheesecloth to long, thin strands and placed it over stretched paper. She then tucked some sliced shells into the open areas of the cloth, and slowly poured a bucket of water over it. The flowing water carried the filaments into a natural composition, which she allowed to dry until it was just slightly damp.

The artist then sprayed on orange, red, turquoise, and lavender inks. The color was absorbed by the fibers and also traveled under the shells, outlining the walls inside them.

For finer lines, run nylon stockings and stretch them in layers. (Three layers are shown here.) Mist or staple the ends of the fibers to hold them in place, and spray your design first with water, then with color.

Add more colors from light to dark, and leave the painting to dry completely.

CLEARING DAWN
Inks and metallic paint on Arches cold-pressed paper, 20 × 30" (50.8 × 76.2 cm), collection of the artist.

In this instance, when the inks and paper were completely dry, but before removing the stapled weave, Masterfield sprayed gold paint through the weave in selected places, preserving the color pattern of the weave lines.

Maxine Masterfield

Further Advice on Working with Filaments and Fibers

When your piece is completely dry, you can remove the fabric and objects to see if you are satisfied. The work may be almost complete in itself, with just a few touches needed for definition. Of course, some artists just use the line patterning as inspiration to suggest a subject for which the lines become merely a background texture.

If you think the colors and design are altogether too weak to use, you can start over again and cover it all up. You can also cut out the best areas to use for collage.

Another solution for very pale fiber paintings is to cover with shapes any areas you wish to preserve, and stretch some new fibers across your design. Then spray with opaque or metallic paints. The areas shielded by the new fibers will remain the pale colors of the original painting. If you choose new colors that contrast well, a bland piece can be transformed into a highly appealing one.

When a painting turns out too dark or unfocused, design another layer of fiber lines and objects to complement it. This approach works best *before* you remove the original fabric and objects. Leave everything down to preserve the initial pattern, and cover some or all of your painting with new fibers and shapes. Then apply a light opaque or metallic spray. When it is dry, look carefully again before removing anything. You may want yet another layer, even if just in a small area or two. In the finished piece, each successive layer of lines will appear as if behind the previous one. If you have worked from light to dark through all your layers, there will be a pleasing sense of dimension to your work.

There are more experimental and messy ways of working with fabric that you may want to try. One is to saturate the fabric with color either before (really messy, so you may want to wear rubber gloves) or after it is placed on the prepared surface of the paper. This insures that the color will penetrate the fabric and show a sharp linear pattern. Once the line color is well set, opaque or darker sprays of color can cover up any drips or smears that are not wanted. Do not move the fabric until the painting is dry and finished.

With this method, too, a second layer of fiber pattern can be added. Just remember that the open or unpatterned sections will give you what you see, so be sure you like that last layer of colors you put down.

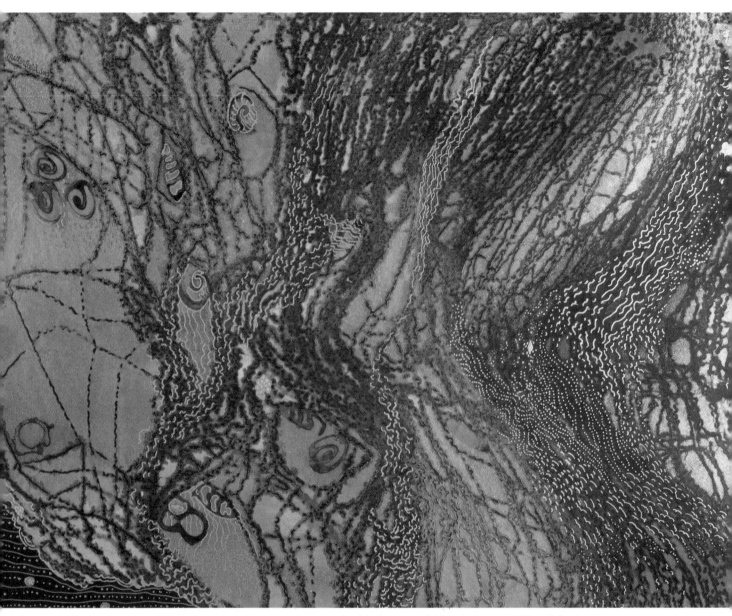

MOONLIGHT CATCH
Inks on Arches cold-pressed paper,
31¹⁄₂ × 40" (80.0 × 101.6 cm),
collection of Bonnie Christensen.

Maxine Masterfield says the detail and energy of this painting remind her of the tiny creatures that purify the water and at the same time feed small fish. Sometimes they are luminous and give an eerie glow to waves crashing on the beach at night.

She varied the basic steps of the fabric method by opening up cheesecloth until it became a tangle of wavy string. After the image was captured, she felt a need for more line. With a silver pen she added details to the curvy lines of the threads, being careful to follow the flow of the original pattern.

When the light hits this painting the silver lines reflect back, just as Masterfield imagines the creatures in the filtered moonlight would do.

Maxine Masterfield
Solar Painting

In developing this technique, which relies on evaporation to create unique effects, Maxine Masterfield devised what she calls a solar box: a wide, shallow box or pan with sides at least 1" high, in which a painting can be suspended in water and pigment. The solar box is then placed in the sun (or, if that is not possible, you can substitute lamps, heaters, or a hair dryer with a deflector, taking care not to blow it directly at the painting). As the water evaporates, the pigment slowly adheres to the paper, gathering into any wrinkles there like silt on the bottom of a riverbed. The water and colors do not run off the way they would from a flat board, so no color is wasted.

Retaining the water and pigments over or under the paper is half the battle. The other is controlling the movement of the water so that it doesn't wash together and muddy all the colors. Making sure the work can sit still in a solar box while it dries is important.

Materials

Solar box or pan with sides at least 1" high (see below)

Light, malleable papers (such as Dippity Dye, the newly developed Solarmax, and Japanese rice papers)

Medium-weight papers such as Rives BFK and Arches

FW and Rotring colored inks (or other permanent dyes or inks)

Acrylic and watercolor paints

Spray bottles for water and colors

Baster or pipette

Using the Solar Box

As mentioned, a solar box is some type of shallow pan that will hold water. It must be wider than the painting. For small works a 9 × 13" glass baking dish will do. For larger paintings, you may prefer to build your own solar box. Masterfield's is made of a sheet of bathroom wallboard (similar to Formica), with sides of V-shaped plastic about 1" wide whose intended use is to protect wallpaper in corners. She scored and bent the corner strip to fit the bottom of the box, and adhered it with clear bathroom silicone.

To make a solar painting, you should work wherever the painting will dry, because it's almost impossible to move before it dries. Begin by placing some objects in the bottom of the solar box. To avoid tearing your paper, don't put twigs or sticks or anything sharp under it; string can be used for linear effects. Wrinkled plastic is excellent for complex patterns of ridges. The objects need not be very thick, but they should lift the paper slightly in some areas.

Now add a sheet of Dippity Dye, Solarmax, or rice paper. Spray on water and add color carefully with a pipette or baster. You can then add more objects on top of the paper, and more color or water under them with your pipette or baster. You should end up with about 1/8" of water over the paper.

Evaporating the Water

If the painting dries undisturbed, colors carefully dropped into separate areas of the water will stay separate. Sometimes slowly moving water creates swirling patterns of colors—and the pattern changes dramatically as it dries. As the water evaporates, it gradually pulls away from the paper, causing patterns to form along the contours of the objects in the pan or any wrinkles or depressions in the paper. The sun is your most helpful ally here. It is crucial to leave your solar box in a place where it will not be disturbed.

If you need to resort to forced-air heaters or fans, aim them so that the air movement is a steady stream over and across the work, not directly onto it. Ripples in the water will stir up the settling pigments.

Sometimes a specific area can be quickly lightened or dried with an absorbent towel, tissue, or sponge. To open some white spots, you can even let the falling force of a drop of water push the pigment aside as it splashes down. This must be done while the work is still wet, because the pigment is permanent once it dries.

Flattening the Finished Painting

Solar paintings do not dry flat, but conform to the shape of the objects in the box. To smooth out a painting once it is dry, iron it on the lowest setting between sheets of tissue paper. You can also lay it on a sheet of glass or Formica, with the side of the paper containing the most pigment facing up, and wet it with a brush. (Don't use a sheet of plastic for this, because the painting will stick.) Blot-press out any bubbles with a soft paper towel, and then let the painting dry again. Place dry paper towels over the entire painting, then place a plywood board or other heavy weight over it, making sure the weight is evenly distributed. Drying time generally takes about a week.

A Few Variations

Ridges that lift up part of the painting surface can be created by placing wrinkled plastic below lightweight paper, by soaking and drying medium-weight paper to make it buckle, or even by folding or crumpling the painting surface itself. For control over placement of color, try using a pipette to add and remove liquid exactly where you want it; this won't disturb the pigment that is already there.

Concentric rings and feathered effects can be achieved by letting puddles of color dry slowly and removing water at regular intervals. If you want to try adding smaller rings within a dry depression, first add water to create a puddle smaller than the existing ring, and then introduce small amounts of pigment to give color to the edges as it dries. Remember that if you add color while the puddle is still wet, the colors will mix.

Once you have mastered the technique of making one solar painting at a time, you can make two or even three paintings simultaneously by sandwiching objects between the sheets of paper and leaving them to dry in the solar box. For this technique, use stiffer paper for the bottom sheet and more malleable paper (such as tissue or rice paper) for the top sheet. The lower side of the top sheet should touch the water, but its upper side should start out dry. As the lightweight paper absorbs moisture, it will mold itself to the contours of the objects below. (You can spray on more water to help it do this.) The two paintings will echo each other but will not be identical. The bottom sheet will retain more color, since the pigmented water dries on top of it rather than below it, and the colors and texturing objects usually leave different impressions on the two images.

Here Masterfield put wrinkled plastic into a solar box and added enough water and ink to fill the low areas; the highest folds of the plastic protruded from the liquid. She then added a sheet of fine paper, which began to absorb the color and mold itself to the plastic. In fact, in the photograph it is difficult to see the paper at all.

The flattened, finished painting reveals where the paper was lifted out of the color by the plastic. The side that faced downward in the box will always retain the most color, but either side can be chosen for the finished painting.

SOLAR HEAT
Inks on Dippity Dye paper, 22 × 30" (55.9 × 76.2 cm), private collection.

Maxine Masterfield
Making Two Paintings in a Single Process

SEA FAN
Inks on Rives BFK paper, 16 × 26" (40.6 × 66.0 cm), collection of Gloria Gemmill.

SEA FLOWER
*Inks on Japanese rice paper, 18¼ × 30" (46.4 × 76.2 cm),
collection of Joyce Parmley.*

The two paintings above were created simultaneously. *Sea Fan* was the bottom sheet on which Maxine Masterfield placed a sea fan, flat-ribbed side down. She then added color and water. The parts of the paper that were not weighted down with the fan warped and rippled, and the color seeped into the valleys.

Masterfield then placed the fine paper for *Sea Flower* on top. Since the top side of the sea fan was less regular than the bottom side, its image on the top sheet looks more like flower clusters.

For *Arctic Dreams II*, Masterfield again placed a sea fan over the paper, and also some fabric in the upper corners. This time the image registered with remarkable clarity, descending like layers of patterned ice over a dark pool.

ARCTIC DREAMS II
Inks on Rives BFK paper, 26 × 40" (66.0 × 101.6 cm), private collection.

Monoprinting

An interesting experiment with watercolor is monoprinting. To make a monoprint, set out pigment at random on a smooth surface of glass, plastic, or tile, and create a pattern with it. Then place a piece of bristol board or hot-pressed paper over the painted surface, and apply pressure with your hand, a ruler, or a brayer to transfer the pigment onto this new surface. Then lift the board or paper from the painted surface, and turn and twist it until something emerges from the patterns that form. You may wish to add some detail to this or keep it an abstract design; the preference is yours.

In a monoprint, the interaction of colors and their drying times are important factors in developing the effects you're after. One of the reasons to choose bristol board over paper for this technique is that it dries faster; the water does not have as far to go to penetrate the surface. If you want, you can slow down the drying time and keep the surface damp by spraying it with water from an atomizer. When necessary, you can go back into the surface with a wet brush, but work quickly, because slow or repeated strokes will cause a blossom to develop.

Valfred Thëlin laid glass over a piece of hot-pressed paper and marked the paper's corners on it so he would know the perimeters of his painting surface. Then he removed the paper and turned the glass over to preserve his perimeter marks. He mixed up pigment and placed it directly on the glass.

After moving the pigment around, Thëlin placed the paper face down on top of the glass and used both hands to press against the surface.

Removing the paper rapidly gives one type of pattern, removing it slowly another. You might want to try making two or three prints using the same amount of color, but pulling the paper off at different speeds to discover the various effects.

After making several prints onto the paper, allowing it to dry between printings, Thëlin used a razor blade to create the rock formations. The mountain form was caused by the monoprint itself.

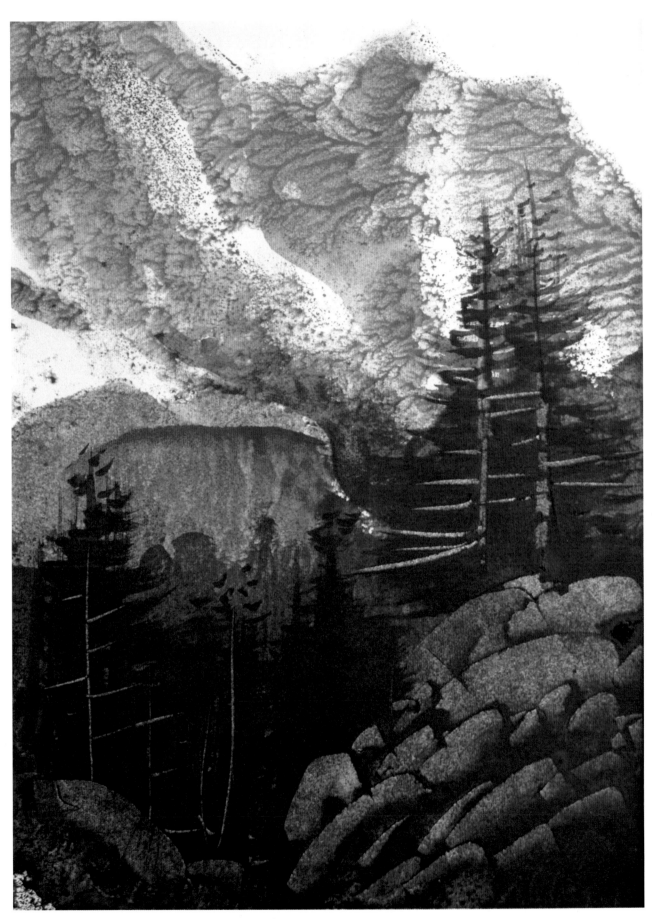

BEAR PASS
Watercolor on hot-pressed paper, 16 × 14" (40.6 × 35.6 cm), collection of the artist.

John Koser

Another Approach to Monoprinting

You can produce a large number of textural designs with monoprinting. In John Koser's method, watercolor pigment is brushed onto a textured surface—a leaf, a piece of cardboard—to be used as an applicator, which is then pressed onto watercolor paper. Pigment transferred to paper in this manner will give you some sense of the texture of the applicator itself.

When you use this process, the paper can be wet or dry or a combination. Wetting the paper is best accomplished with a large flat brush such as a 1" Aquarelle or a 2" sky flow. The wetness of the paper will also affect the types of patterns that develop. A wet surface results in soft, diffuse patterns, while a dry surface results in firm and crisp images.

You can get a variety of textures depending on what you use to apply pigment. You might try, for instance, leaves, screen mesh, and corrugated cardboard or mat board in different sizes and shapes. You can waterproof cardboard or mat board with acrylic spray to make it nonabsorbent, meaning that most of the pigment you pick up with this applicator will be transferred to your paper; conversely, a more absorbent applicator soaks up some of the pigment itself and thus transfers less of it to the paper.

You can also create monoprints with objects such as pen caps, bottle caps, rubber erasers, and the like. Just dip the object into paint and stamp it onto the paper in a repetitive motion to create a patterned design.

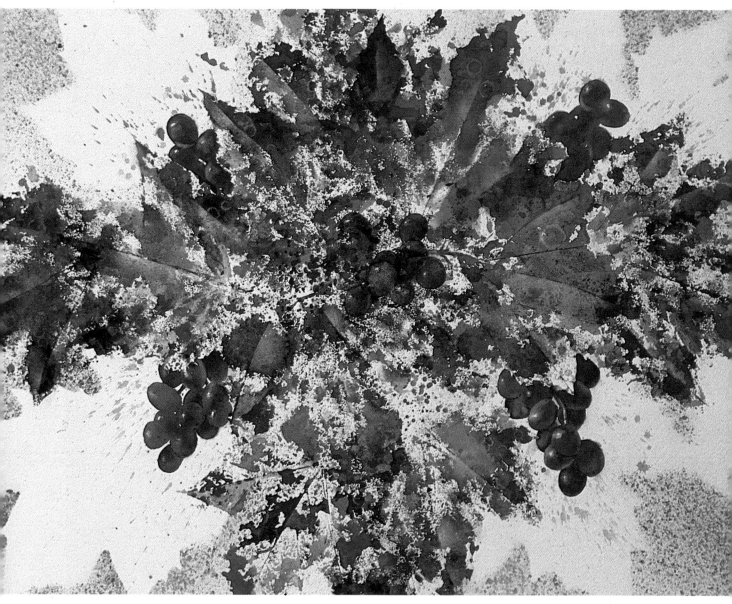

SONOMA SUMMER
Watercolor, 16 × 24" (40.6 × 61.0 cm), collection of the artist.

To create the painting at left, John Koser began by applying yellow pigment to a grape leaf with a paintbrush.

Then he pressed the leaf face down on a sheet of watercolor paper.

When he lifted the leaf off the paper, its imprint remained.

While the yellow area was still wet, Koser applied blue pigment on top of it using a small piece of mat board as an applicator. This resulted in a variety of greens. Then, while the paint was still wet, he added minute amounts of red with a toothbrush. This enhanced the other hues and created some new ones.

Using grape leaves themselves rather than a paintbrush to create this monoprint inspired the image that resulted.

ARTISTIC PRINCIPLES

Regardless of experience, instinct, or renown, every artist constantly grapples with composition, design, and value. Understanding the principles involved—line, shape, positive and negative space, rhythm, shadows and light, and color—is the key to knowing how to arrange all these elements successfully into expressive, visually compelling works. This chapter will help you grasp, then work with these essential components of good picture making.

David Millard
Keeping a Sketchbook

David Millard is a strong advocate of keeping a sketchbook, an essential tool in any artist's repertoire and one that he himself is seldom seen without. This practice will prove to be a valuable learning experience. It will provide:

A record of progress. How you grow through the years in the way you see as an artist is important. With a sketchbook your work in drawing, composition, color, and general creativity is bound and stored for ready reference. The accumulation of sketching and painting ideas will eventually become your private gold mine.

A portable laboratory. A sketchbook will travel with you wherever you go, so you'll always be ready when that unexpected "winner" pops up in front of you, when the light is just right, a group of figures ideally placed, and the colors perfect. At times like this, a note or two of what you saw, jotted down quickly on a page, is all you need to prompt your mind to experiment with making this sketch into a painting.

A place in which to develop your creative flow. Rapid and frequent sketching is the way to accomplish this, and to evolve your individual painting style. Expressing what you feel and see thus becomes an intuitive process.

A place for practice and experimentation. When you experiment, you dare new things. And when you try noting four different versions of a subject on a sketch page, you will be growing in your own manner, just as the masters did through the centuries.

An opportunity to develop your pencil-sketching abilities. The pencil is a primitive tool. It flows directly from your arm and body, without interference in the action. There is no dipping involved, as there is with ink; no mixing problems, as with a brush in watercolor. Just an easy, gliding motion that allows you to make a delicate, searching line or, with a carbon pencil, the richest darks—just a rub of a finger will produce a tone of velvet. Your sketchbook page will respond readily to the range of values a carbon pencil provides.

A casual, informal place in which to work. You won't find an easier, more comfortable method of creating than drawing with a pencil in your sketchbook as it rests on your lap.

An inconspicuous mobile recording device. Because a sketchbook is easily hand-held, with no easel required, you can move in and out of situations with little attention attracted to your efforts.

A cure for "white fright." Many novices are intimidated when faced with an expensive sheet of watercolor paper. Working out your ideas in a sketchbook first gives you a chance to practice on inexpensive paper, saving you a lot of bad guesswork and letting you do your experimenting and weeding out before you paint on good paper. It's a great builder of confidence.

What Sketchbook Should You Get?
The Super Aquabee-brand sketchbook, size 9 × 12", has been David Millard's favorite for years. It has a nicely textured, laid-grain paper that is heavy enough to take all kinds of watercolor washes applied over your carbon sketches.

Caution: Use only the page on the right-hand side when the book is open. It is the correct side of the paper, where the tooth or grain will do the best service to your carbon drawings. Never use both sides of a sheet in your sketchbook, or the pencil will ghost or offset onto the facing page and spoil your sketch there. Since the Super Aquabee is spiral-bound, it always closes in the same precise position. Therefore it travels well, usually discouraging smudging in transit. Just don't put a heavy weight on it, as the pressure might cause your pencil drawings to smear.

What Kind of Sketching Materials Do You Need?
A carbon pencil is essential. Millard recommends a Conté Extra Fine Drawing Pencil, #2; a Hardtmuth Carbon Pencil 190A, #3; or a Rowney Carbon Pencil, BBB. Since carbon is soluble in watercolor to some degree, it can contribute rich darks to your washes in the form of a modest granular deposit. Your carbon sketches will also hold strongly to the paper and will take a lot of abuse when watercolor is combined with it. But if you use your fingers rather than a tortillon (a rolled piece of pencil-shaped paper available in art supply stores), be sure to wash your hands well afterward.

How Should You Use the Sketchbook?
Draw or paint in your sketchbook for at least fifteen minutes every day. Try to set aside a specific time of day to do this. Get into the habit of daily sketching. If you put it off one day, you'll put it off the next, and perhaps the next. The greatest gift an artist has is not talent, it is self-motivation. Talent is developed by working, by sketching, by the continual use of your watercolors throughout the years.

If you plan ahead the day before and set up a project to be captured in carbon in your sketchbook the next day, then you are starting your self-motivation program and will begin to accumulate a volume of material for future watercolors. Vary your projects to include landscapes, still lifes, and figure groups. By carrying a sketchbook everywhere, you will find material wherever you go.

The more you use your sketchbook, the better you'll get. If you practice regularly, your facility with the medium will increase, and so will your speed. As the speed and volume of

your work increase, the stiffness in your sketching will disappear and you will begin to acquire a creative flow, from which your own style will develop.

As you move up the plateaus of ability, you will be encouraged to spend more time sketching and watercoloring. You will have a record of progress, proof that you are making it as an artist. By working every day you become a doer and not a doodler.

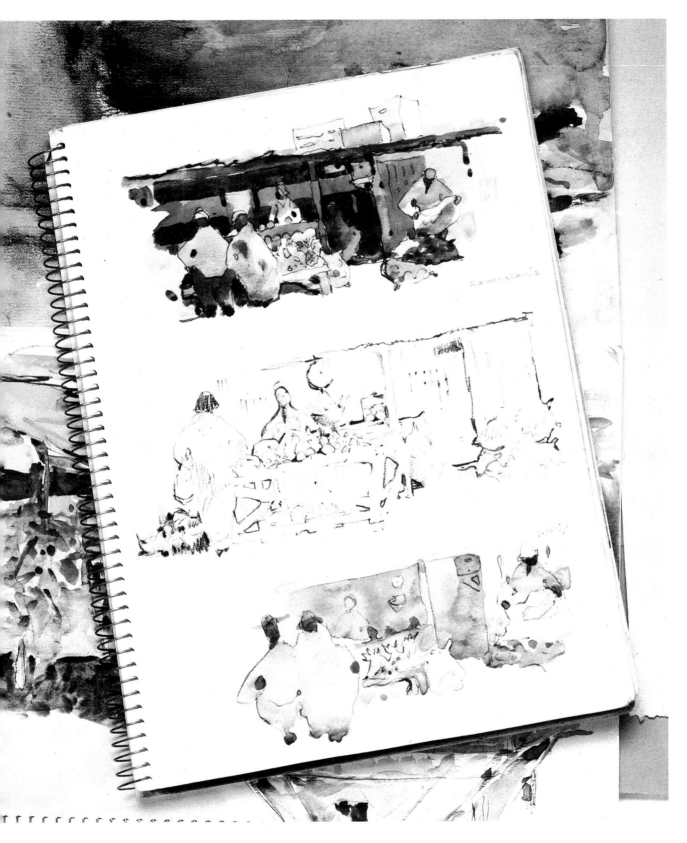

John Koser

Drawing As Exploration

Exploratory drawing, as John Koser calls it, is the initial stage in discovering the various possibilities for composing a subject. In this type of drawing you can investigate the forms and characteristics of your subject from different perspectives, working freely and trying many compositional ideas on the spot while the actual scene is before you.

For exploratory drawings Koser likes to use pencil or charcoal, as well as felt-tip pens or stubby laundry markers, implements that flow quickly and with ease. He aims to capture the subject as a whole, shading in various shapes rather than getting caught up in specific details.

If you want to break away from your typical patterns of composition, try doing quick, spontaneous exploratory drawings. When you look at your subject, pay attention to any design it may suggest. Look at the values and think of them as shaded shapes. Think of how to arrange these shapes into a composition. This is the time to work out new ideas.

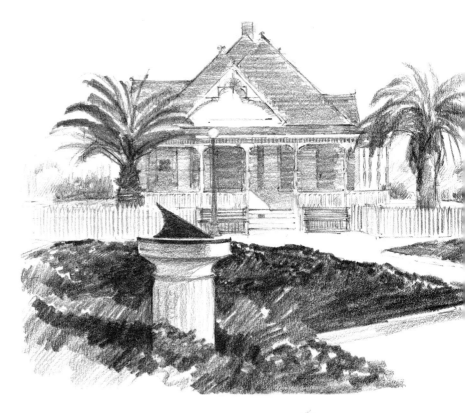

ARBORETUM SUNDIAL STUDIES
Pencil, 9 × 12" (22.9 × 30.5 cm).

Koser feels exploratory drawings are enhanced by the speed with which they are produced. He works rapidly, setting time limits for each sketch so he doesn't get trapped by unimportant details.

STILL LIFE STUDIES
Charcoal, 9 × 12" (22.9 × 30.5 cm).

With charcoal, Koser was able to work quickly to establish the values and the large, simple shapes of these still life setups.

Stephen Quiller

Understanding Positive and Negative Space

Because positive and negative space are vital ingredients in all compositions and absolutely essential to his own way of seeing, Stephen Quiller chooses the concept as the beginning point for a discussion of how to achieve exciting, effective composition. Understanding the concept of positive and negative space will enable you to perceive form in new and different ways and will thus affect your entire thinking about composition.

In Chinese philosophy the positive, bright, masculine principle is referred to as yang, while the negative, dark, feminine principle is called yin. The interaction of these two principles is said to influence the destinies of all living creatures, a concept that can be compared to the way the interaction of positive and negative space influences the destiny of a painting.

In a painting, the positive space generally is the object itself—that which is drawn or painted. Positive space is "active" and generally contains the greatest contrast, texture, and color. Negative space is usually the area surrounding the object. It may be characterized as "passive," as quiet and restful, for it generally lacks detail, offers less contrast and texture, and makes use of subtle colors. Both the positive and negative areas are equally important in a composition, as you can see in the examples shown here.

Create Rhythmic Arrangements

In this straightforward pencil drawing of familiar weed forms, both the positive space (the shapes of the weeds themselves) and the negative, or empty, space (the areas around them) are carefully considered. The arrangement of the weeds sets up a rhythm that unifies the composition. Although in part this rhythm is generated by the curving shapes of the weeds, it also depends on the unequal division of positive and negative space. Keep in mind that an equal amount of positive and negative space is apt to cause confusion, as the areas compete with each other. Here you can also see how overlapping the weed forms creates exciting small pockets of negative space.

Simplify the Positive Shapes

When the same arrangement is shown as a silhouette, it is easier to see the overall shape and pattern of the forms. To create a similar simplification of the forms you see, simply squint your eyes so you lose the details of structure. Notice here how the large form of the milkweed helps to balance the sunflower above. There's a unity from the repetition of curving forms in the stems and heads. But there is also variation in size and texture, which prevents monotony.

Reverse Positive into Negative

In this reversal of the previous figure, the weeds become the negative area. Now you can see how a shape can be developed by drawing or painting around it. What is usually considered empty space becomes the active, painted area, and it could be handled in a far more complicated manner than here. Leaving the subject underdeveloped and painting around it can be a challenging new way of visualizing and realizing forms.

Develop Interlocking Relationships

Although someone once said, "There are no lines in nature," you can use lines to define the boundaries between the positive and negative areas and articulate a strong interlocking pattern. Notice where the shapes extend beyond the edge of the picture plane. When designing a composition, always consider the way your shapes relate to the edges of your paper or canvas. Here, by extending beyond the frame, the forms create new and exciting areas of negative space.

Use Enclosed Negative Space for Excitement

Tiny pockets of negative space can generate visual excitement through variations in size and shape. Here Quiller has made the pockets dark so they are easy to locate. But negative pockets could also be areas of light perceived beyond a dark, positive form, such as a tree, and could serve to create the form of the tree itself. Negative space can work for you in many different ways; here it interacts with other, positive spaces and helps the eye dance through the composition.

Stephen Quiller

Choosing and Sketching Your Subject

When deciding on a subject, remain open to all ideas. If you go back to sketch a subject you noticed the day before, keep your mind open—something else along the way may be even more interesting. For example, Stephen Quiller explains that he once set out on skis, intending to sketch a subject he'd seen previously. Something about rhythm of the motion set his mind idling in neutral. He wasn't particularly looking for a subject at that point. Suddenly, the beauty of a long shadow across a pocket of water in the melting snow seemed to jump at him. He immediately stopped and sketched it, and later the sketch became a painting. Quiller never did get back to his original subject, but it didn't really matter. He accomplished what he wanted to because he was adaptable and receptive to a different subject.

Once you discover a subject, ask yourself what makes this particular subject important to *you*. This may take some soul-searching. Does the appeal lie in the color? the mood? a suggestion of movement or power? Only you will know the answer. After you have decided what the appeal is, focus on that, do all you can to emphasize it, and eliminate everything else.

At this point you're ready to do some preliminary sketches of your subject. Don't rely on one sketch; instead, do a series of sketches. Move the subject around, pulling it forward or pushing it back, and adjust the values. Also change the format—making it horizontal, vertical, square, perhaps even oval or circular. From this series of sketches, you will be able to choose the one that best emphasizes what you want to say about your subject.

Stephen Quiller's three sketches of apple pickers shown here were all done on toned paper, which is helpful when you are deciding on values. He used pencil for the darks, permanent white gouache for the lights, and dots of

APPLE PICKERS

cadmium red light gouache for the apples (although the color is not reproduced here). There is no one "correct" format among these sketches; all of them could be used for a finished painting. But making these sketches in different formats gave him a better idea of what would work best for what he wanted to say about this subject.

Horizontal Format
The first study gives a broad view of the apple trees, baskets, pickup truck, pickers, and apples on the ground as well as on the trees. The long light cast across the composition is what Quiller emphasized.

Nearly Square Format
In the next study Stephen Quiller has included a ladder with a figure at the top. There is a nice balance between the figures on the ground, the figure on the ladder, and the left branch of the tree. But there is a lot going on, almost too much. It would be important to decide what to emphasize before beginning a painting based on this sketch. The figure on the ladder might have to be suppressed in some way, perhaps by losing it in a shadowed area. The nearly square format, however, is necessary; if more space were added above the tree, in the foreground, or at one side or the other, the composition would have far less impact.

Vertical Format
Finally, Quiller has moved in closer and eliminated the ladder entirely. The truck becomes important, as well as the contrast and texture in the tree branches. Although the area of brilliant light has become larger, the shadowed leaves and branches in the upper part of the composition make the overall feeling somewhat somber and moody.

Stephen Quiller
Overlapping Forms

These two simple line drawings both contain the same elements: mountains, a building, trees, and foreground shrubs. One, however, is clearly more interesting than the other. Why do you suppose this is so?

The first study is flat and dull because each element stands separately, isolated in its own space. There is little illusion of three-dimensional space, so essential in a landscape.

The second drawing shows what can be gained by overlapping the forms. The foreground shrubs extend above the middle distance; the building stands in front of spruce tree and cottonwood; and the tree branches project over distant mountain ridges. Overlapping helps to create unity and adds depth and excitement to this composition, as it can to yours.

Adding Rhythm

Musicians aren't the only ones who use rhythm; it's used by painters and graphic artists as well. A beat can be felt in a painting just as clearly as in music. It's important, however, to select the kind of rhythm that will enhance the effect you desire. Soft curves can lend a restful or carefree feeling, while jagged shapes and broken lines can suggest energy or hostility. Certain subjects lend themselves to particular rhythms, as you can see in the examples shown here.

In Stephen Quiller's drawing of a seascape with dunes, the repeated curves of the grass, dunes, larger land forms, and clouds set up an even, flowing beat. He's added some small, intricate shapes for variety, which accent and enhance the flowing rhythm.

The second drawing, with its vertical format, emphasizes the irregular angles of the dead spruce. Quiller has created agitation by using small negative spaces and by making the shapes outside the branches, for the most part, sharply triangular. The texture of the bark, created by small, jagged strokes of the brush, adds variety and at the same time echoes the basic triangular shapes. Overall, the staccato rhythm of this drawing generates a feeling of restlessness.

To learn more about rhythm and how to emphasize it, study the work of well-known artists in books and museums. Compare, for example, the curved forms and flowing rhythms in the paintings of Thomas Hart Benton and Charles Burchfield. Then look at how Piet Mondrian suggested animated movement in his painting *Broadway Boogie-Woogie*.

Stephen Quiller
Selecting a Geometric Motif

The geometric motif is simply the geometric form basic to the composition. There are three main types: rectangular, triangular, and curvilinear. More than one motif may be combined within a composition, but it is best to have one predominate.

Rectangular Motif

In the diagram of *In the Bathtub* by Pierre Bonnard, you can see the artist's expressive use of horizontal and vertical lines. Horizontals tend to convey restfulness, while verticals suggest boldness. Here Bonnard's format is a vertical rectangle, and the composition is made up of a series of rectangles of different sizes. In the actual painting, this geometric motif is overlaid with busy patterns, but the color is soft and quiet, and the overall feeling is static. Bonnard often used rectangles in his compositions, and the way they fit together establishes the underlying dynamics of his paintings, although color and pattern were also important to him.

From the linear diagram, you can also see that Bonnard does not offer a literal rendering of his subject. The forms in his painting have been interpreted and exaggerated to make the painting work. Remember this when you start to paint; what you see is not necessarily what you want to use in your painting. Because it interests you, it can be a starting point, but don't hesitate to rearrange the forms.

Triangular Motif

Edgar Degas was a master of composition; nothing happens by chance in any of his paintings. The bird's-eye view he chose for his *Ballet Dancers* was unusual for the time and was influenced by Japanese prints. You might experiment with a viewpoint other than eye level in your work.

Degas's composition is a series of interlocking triangles created by the figures, arms, and costumes. The different sizes and directions of these triangles create visual interest and excitement. These triangles, however, aren't precise or literal. In the actual painting, for example, three red spots on the heads of the dancers create a triangle, while a fourth red spot leads the eye into the composition on a diagonal. The nearly square format concentrates the action and makes it all work in a visually satisfying way.

Curvilinear Motif

A curvilinear motif usually, although not always, creates a lighthearted effect. In the diagram of Paul Gauguin's *On the Beach*, notice how the shapes of the hair are repeated in the foreground. Small active shapes repeat and yet contrast with the larger, curvilinear forms. The graceful movement throughout creates a feeling of joyousness.

Stephen Quiller

Laying the Value Foundation

The term *value* refers to the lights and darks in a painting. Value is closely related to color, but it is not the same. Values form the foundation of a painting; they might be described as the bone and muscle holding a painting together, while color serves as the skin. As mentioned in the chapter on color, oil painters originally used a technique called *grisaille*, in which they made an underpainting of gray-green tones, concentrating on the lights and darks to establish the forms. When this dried, color was glazed over the grisaille layer. The old masters knew how confusing it can be to work in both color and value at the same time.

To avoid this confusion, Stephen Quiller recommends that you do a series of value studies like the ones shown here. His subject is an interesting pattern of churches and buildings near Truchas, New Mexico. In each study, the arrangement of the forms and the focus are the same. But the different handling of darks and lights suggests three very different paintings.

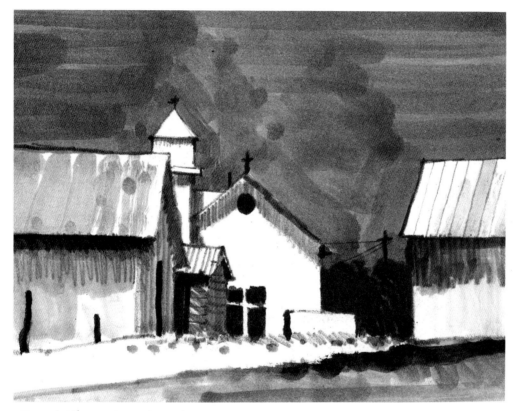

Toned Sky with Light Subject

Although Quiller's value studies are reproduced here in black and white, he often uses a wash of burnt sienna, mixed from oil paint and turpentine, plus an ordinary drawing pencil for line. The oil wash can be used to dissolve the pencil lines if very dark areas are desired. In this first study, he's used a middle-value wash for the sky and foreground and a somewhat paler wash for the buildings at the side. This keeps the greatest concentration of contrasting lights and darks around the church, the center of interest.

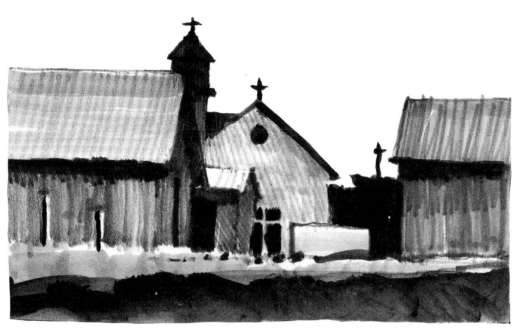

Light Sky with Contrasting Buildings

When doing value studies, Stephen Quiller always squints his eyes to lose the details and see the large masses. In the study above, he's left the sky area untouched and used a middle value for the buildings on the side and for part of the foreground. The buildings are nearly silhouetted against the bright sky, and interesting light-dark patterns emerge around the church. The dark foreground serves to pull the eye into the composition.

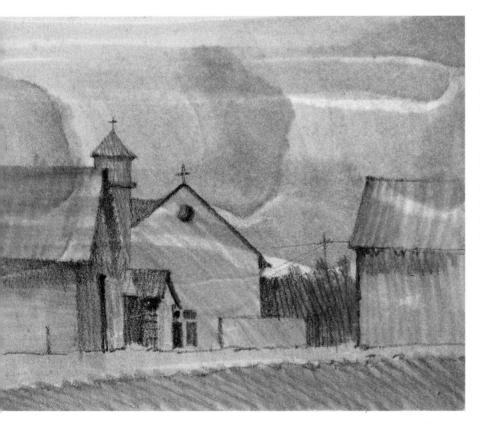

Analogous Values

Effective compositions can be created without vivid contrasts of light and dark, as is evident in the study below. Here the value contrast is very subtle and low key. As in the other studies, the contrasting lights and darks are concentrated around the church. Notice how the various value changes help to create the illusion of three-dimensional form. Also observe the softly diffused shadows under the eaves, which are typical of a day with low light.

Irving Shapiro

Principles of Line and Value in Composition

Irving Shapiro defines composition as a studied arrangement of elements, following recognized principles of design. He emphatically uses the term *principles*, not *rules*, because rules allow no room for interpretation, and such inflexibility is antithetical to the freedom of personal expression inherent in art. In contrast, a principle, which may be defined as a concept of historically proven worth, offers unlimited possibilities for artistic exploration; it is something to meditate upon, digest, and interpret. Let's look at some basic principles regarding line and value in composition.

Bringing Out Angular or Rounded Forms

Here angles tend to dominate the arrangement not only because of their dynamic interest but also because the soft, rounded shapes act as a foil to the angles, without being too contrasty. The dark shadow under the roof dramatizes the structure's strong light and furthers its angular impact.

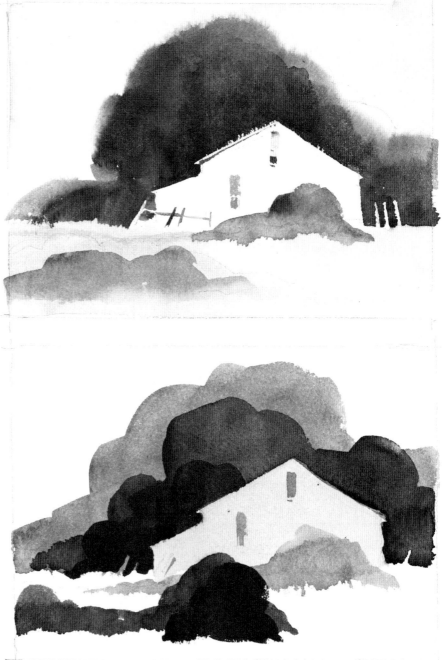

Although the basic arrangement here is similar to the first sketch, the lighting is weaker and so the value contrast has been reduced. Also, the rounded shapes have a more clearly defined form, which is reinforced by the introduction of overlapping trees and shrubs. In addition, the fence is more incidental and the windows more casually indicated, which helps reduce the impact of the angles. In all, the interest is shifted to the rounded shapes.

Working with Diagonals

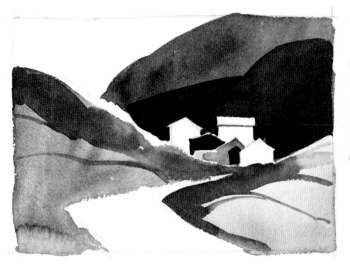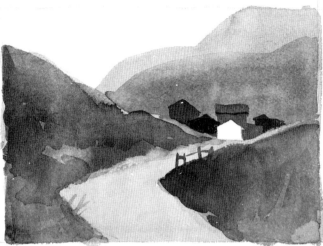

In this study the diagonal movement creates force and tension, commanding attention. The strong value contrasts and rhythmic contours of the hills add to this emphasis.

In contrast, here the muted value contrasts diminish the diagonal thrust, as does the diffusion of some of the strong diagonals in the hills. The suggested verticals of the grass and fencing deliberately break the otherwise uninterrupted diagonal movement of the road.

Handling Hard Edges

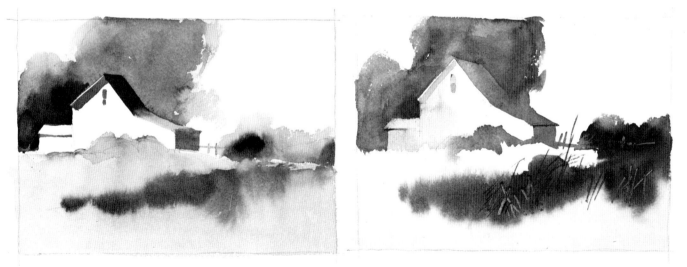

Hard edges invite attention and project interest, almost regardless of size and shape. Here, however, the hard edges are so pronounced that they distract from other elements in the design.

The edges of this building are less interesting than in the preceding sketch because of the reduced value contrast. By "losing" its edges, the structure seems of only secondary importance. On the other hand, the soft-edged foreground patterns have become compelling through sharper value distinctions and the inclusion of crisp lines suggesting blades of grass. Though the grasslike forms seem incidental, they do coax the eye into focusing on the soft-edged mass.

Moving Away from Symmetry

The static quality here is perhaps exaggerated—few artists would compose a painting in this way. But it is meant to underline how you're apt to end up with an actionless, spiritless painting with such formal symmetry.

Even though the arrangement of masses here is basically the same as in the preceding sketch, the subtle value differences and suggestion of asymmetrical patterns in the ground and sky provide some animation and movement. Note how the deletion of one window provides an off-center feeling and lessens the static quality of the house.

This sketch is clearly the most visually effective of the three. The structure has been moved off-center, the window placements offer variety, the chimney is less formally positioned, and the large trees and shrubs are more individualized in shape. Even the sky and cloud shapes take on more flowing, lyrical movements.

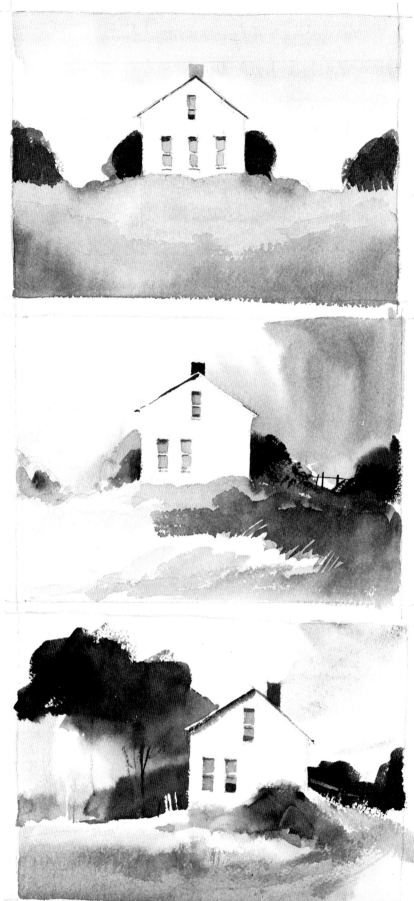

Avoiding Repetitive Sameness

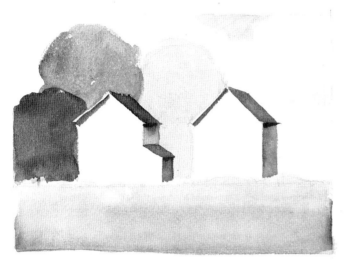 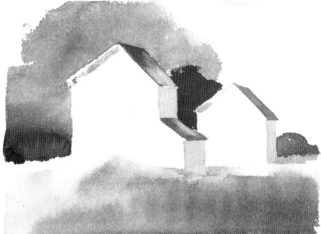

This sketch is, in a word, stagnant. The buildings are too similar in size, the tree masses too similar in volume, and the cloud and trees too similar in mass and shape. To make matters worse, almost equal measurements are used for the width of the buildings, the space to the edge of the paper on the left, and the depth of the foreground. In all, this example is a disaster in terms of adding rhythmic movement and dynamics to your composition.

This composition is much more animated than the preceding one. Not only do the two buildings vary in size, but overlapping them emphasizes their different positions in space. Reread the caption for the preceding sketch and you'll see how alterations have breathed life into this study.

Eliminating the Discomfort of Tangents

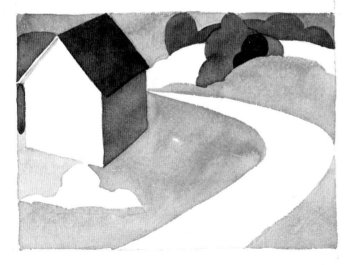 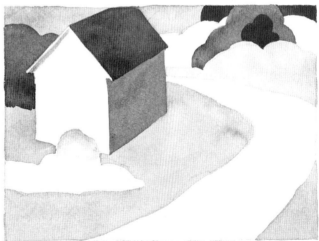

This is almost a caricature of the visual discomfort created by tangent points (where the design elements barely touch each other). The tangential touching makes for such a minimal relationship that it's like an unpleasant poke in the ribs. How many times can you find elements just meeting at a point? If you find thirteen, you've come up with the right number.

Here, each of the tangents in the preceding example has been eliminated either by overlapping forms or by separating them. Note particularly the shift in the relation of various forms to the picture's edges.

Irving Shapiro
Creating Illusions with Value

Darks are low values, whereas lights are higher values. What must be remembered, of course, is that the eye will "read" value in relation to other values. You therefore must provide potent contrasts for any value you wish to accentuate. By the same token, if you want to create subtlety, consider the possibility of reducing your value contrasts.

Making Edges Expressive

Value relationships can define the edges of forms in different ways. The cube on the left is an exercise in a subtle high-value statement. The value contrasts are reduced to a degree where the form is discernible but not commanding. You can see some of the edges, but others are only inferred, creating a sense of the lost and the found.

 The cube on the right asserts its identity through value contrasts that portray substance and accentuate volume. Here some of the edges are pronounced and unmistakable. Others, however, are more diffuse, although recognizably stated, and one is suggested but not delineated.

Projecting the Foreground

In this series of planes, the value relationships force the projection (or forward thrust) of the very dark foreground shape. Notice how the white square immediately behind the black one augments the projection by providing dramatic contrast. However, you can also see an accent of the dark square in the most distant plane. Although it isn't large, it declares itself a feature of interest by its pronounced value contrast. Just cover the small dark square with your finger and you'll have an undisturbed progression of planes. This is an example, then, of how value can direct interest and focus within your composition.

Adding Interest

This sketch also contains a progression of planes. Here, however, the major dark value lies in the most receded plane. It's just not true that your composition must go from dark to light, light to dark, or any other cliché. What matters is how you create relationships of value, edge, and so on. For example, to make the foreground project in this sketch, Shapiro introduced the very dark circle in front. This variation in the otherwise straightforward progression from light foreground to dark background sets up a feature of commanding interest. Once again, cover the circle with your finger—the progression then presents itself without accentuated interest in any particular plane.

Building Form with Value

Value relationships are crucial in giving dimension to form. Let's look at how washes can be used to clarify value relationships as you build your forms.

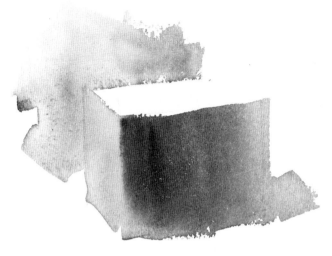

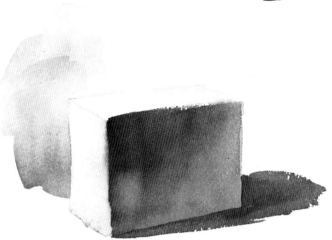

Making a Direct Statement

This sketch directly states the value relationships: It's all been painted in one, rather quick handling, using one color—ivory black. The variations in value result from either more water or more pigment being added as the area is being painted. Notice that external foils have been added to the box to give some sense of its location in space.

Developing the Initial Statement

Here the form is developed further by letting the first wash dry and then using additional washes to enhance the value relationships that define volume and describe edges. In the small sketch on the top right, you can see how this technique applies to a landscape setting.

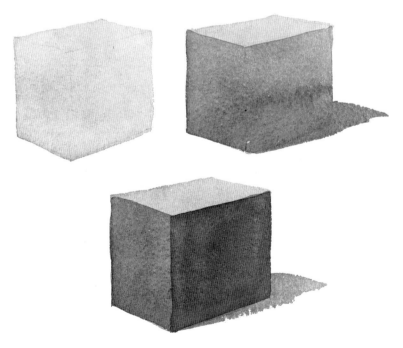

Working Less Directly with Glazes

These three steps show how to build a cube by using a series of overlapping washes, or glazes. First, the overall form is given a local value. This might also be described as toning the total form with what will serve as its lightest value. When this tone has dried, an additional value is given to two of the exposed planes, as well as the cast shadow. What you see in the top plane is the original value. Finally, when all has dried, still another glaze is added, indicating the darkest plane and completing the suggestion of solidity and dimension. Both methods described here can be used, painting some elements directly in a single wash and applying glazes in other parts.

Charles Reid
Making a Value Scale

Making value scales is good practice in helping you to see a range of values from light to dark. Many students see only the lightest or darkest tones and have trouble seeing and painting the values in between. Even though it's possible to perceive as many as ten distinct values from white to black, Charles Reid has found through years of teaching that so many differences are too subtle for students to see at first. Therefore he suggests that you work with a six-value range (five values plus white). Later, when you can express all six values in your paintings, you can try to extend your values to ten.

In making the scale, Reid recommends that you keep the individual boxes fairly large, about 1½" square. This will help you hold a single value over a fairly large area. You might even try using larger squares, say 3 × 3". Holding a value with only minor variations in a large area is difficult, especially in watercolor. But it is good practice.

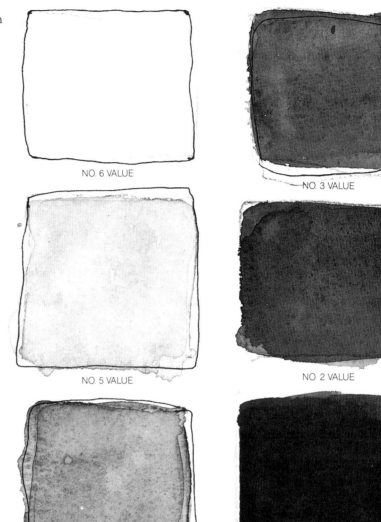

NO. 6 VALUE

NO. 3 VALUE

NO. 5 VALUE

NO. 2 VALUE

NO. 4 VALUE

NO. 1 VALUE

Seeing Value Shapes

Positive shapes usually suggest an object or figure in a painting and negative shapes suggest what's behind it, that is, the background.

Example 1
The model is sitting on a bench on the model stand and there are two stools on the right. There are also some pictures in the background and a window. In deciding which space is positive and which is negative, you must decide what items are in the object area (positive) and what is part of the background (negative). Obviously the pictures and window are objects. But they're also part of the background. The decision is one of focus.

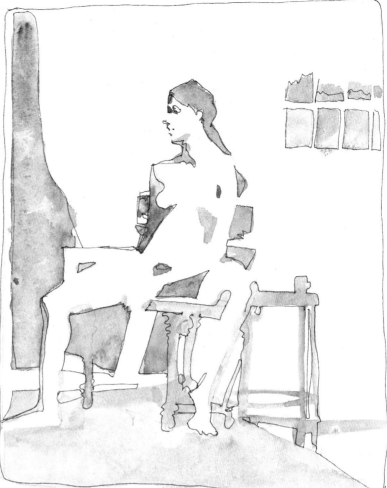

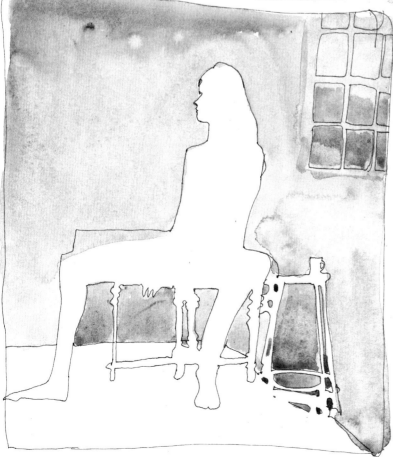

Example 2
Charles Reid finds it helpful to think of negative and positive shapes in terms of value. Here he painted all the negative shapes dark and all the positive shapes light. The result is that the figure, stand, and foreground objects are positive, or white, shapes, and all else is dark, or negative, space. Simplifying what he has seen has forced Reid to mass the foreground figure and objects into a single large shape.

Adding Values to Drawings

In the next few pages Charles Reid shows you how to develop your drawings into six-value compositions (five values plus white). Limiting the number of values you use forces you to simplify small values into larger areas.

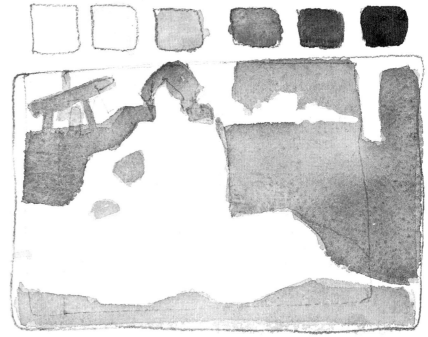

Preliminary Value Sketch

Before Reid begins his contour drawing, he determines the values in a preliminary sketch. This sketch describes what he calls the "big idea," the major theme of the painting. He leaves out all the small details and generalizes the middle values and darks into a single value. He leaves the light and light-middle values just as white paper. (Compare this sketch with the final stage of the composition and you'll understand what Reid is doing here.)

First Wash

Now Reid makes the contour drawing of the subject and covers all the areas that will have tone with a light wash, being careful to leave some areas white. Too often students cover up light areas in watercolor and then wish they still had the white paper when it's too late. Don't cover any area you're not sure about. You can always cover it later.

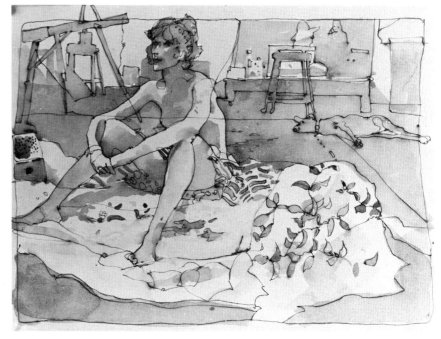

Reid doesn't worry if the values aren't exactly even. There's bound to be a certain amount of variation in such a wash. But he keeps the wash light, though definitely darker than the white paper. He's not ready to let any middle or dark values drift into the painting yet. He's just deciding which sections he'll be leaving white.

Notice that Reid is careful not to paint over boundaries between toned areas and areas of white paper. He keeps these shapes accurate and strong. For example, the model's back has a good shape, one he doesn't want to lose, while on the other hand, he deliberately loses other boundaries that are less important. Remember, you don't have to worry about losing boundaries between areas of similar value, but you must be accurate in painting boundaries of greater contrast.

Second Wash

Now Charles Reid adds the middle values. To make the figure stand out more and the white cloth she's sitting on seem whiter, he darkens the values around her. Going even one value darker can make a big difference. As he adds the middle-value tones, he begins to make smaller separations between some of the values, but he still tries to keep masses of the same value connected. For example, the hair and the block of dark tone above the model's left shoulder are connected as a single tone, and the darkest areas on the dog and the legs of the French easel are massed in with the rug. Notice how tying in dark areas has also forced many light areas to merge.

Third Wash

Once the major decisions are made, Reid begins to work in smaller and smaller areas, all the while thinking in terms of the painting as a whole. He tries to keep the values balanced throughout the picture by avoiding too much weight or darkness in any one area. However, as he points out, he made the model's hair too dark and dominant for this stage—he's developed a focal point too early. Focal points and centers of interest are fine, but you can't forget the rest of the painting. Pay attention to the background and corners of your painting. That's where you'll find your problems.

To balance the darks of the model's hair, Reid darkened the trash barrel on the upper right. He also fills in the values behind the model. Now the hair no longer dominates the picture. Reid advises that when working with a figure, it's not necessary to overstate contrasting values to create an area of interest, since the viewer's attention is normally drawn to a person in a painting, without these contrasts.

Reid darkens the pattern on the robe near the model. Its small forms offer a good contrast to the large simple areas in the rest of the painting and add interest too. Even though the pattern in the striped robe is dark, it doesn't stand out too much, because it's on a dark rug.

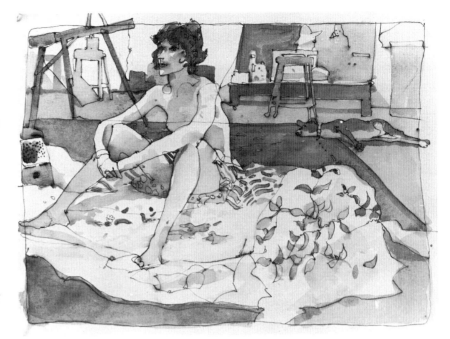

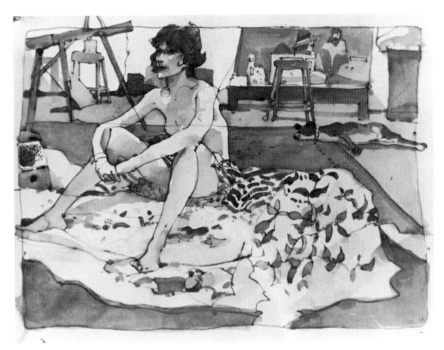

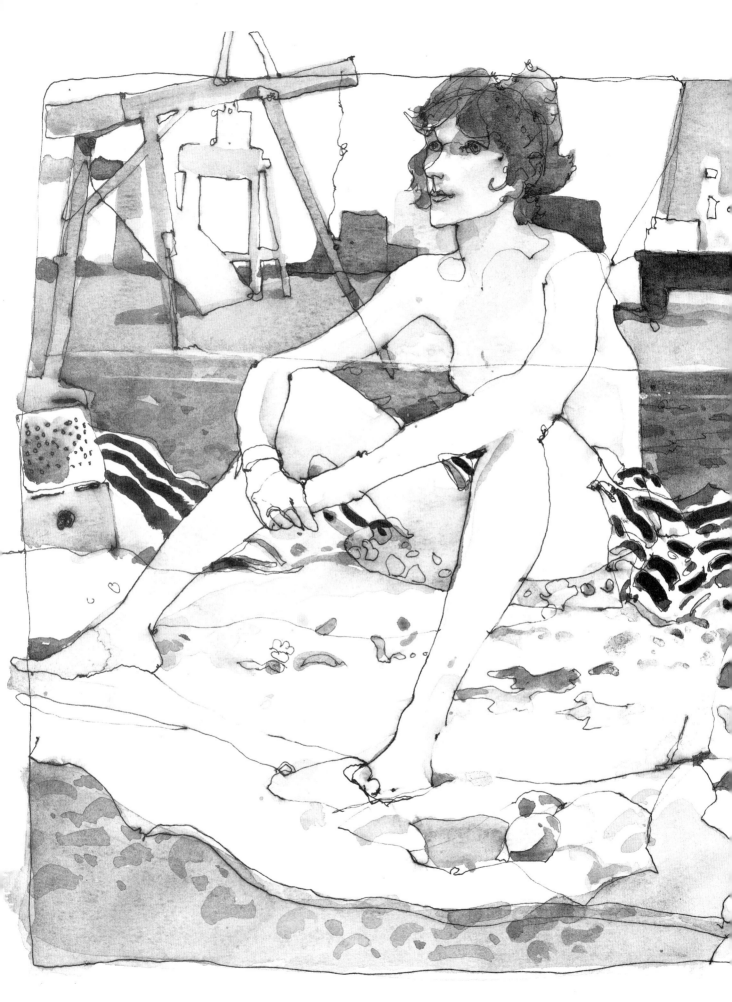

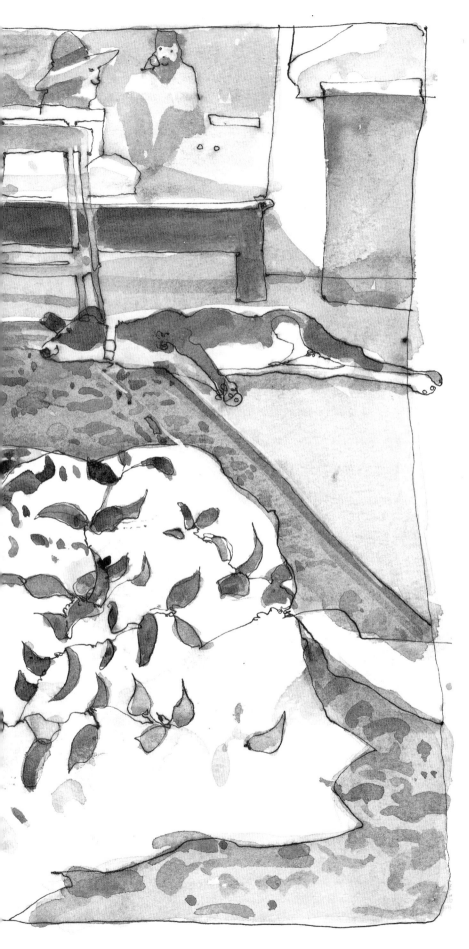

Fourth Wash

Charles Reid adds the darkest values—such as the pattern on the dark rug—last. He also darkens his deepest values now. Since the values are accurate, they don't jump out of the painting but keep their place, adding weight and interest to the painting as a whole. The biggest problem in the last stage is that, in an effort to make specific forms important by surrounding them with darks, it is easy to isolate the forms too much.

Look at the figures in the background. How many values on the figures match adjacent values in the background? Wherever they match, you have a connection or bridge, what Reid calls an "escape route." Whenever you paint, you must always look for places to put escape routes. Here you'll find them where the hair meets the background darks, also around the legs and under the model's right arm. Painting demands a constant effort to make some things stand out and other things merge. Everything can't be equally important in a painting. You must decide what's really vital and make it stand out—isolate it or underline it—and lose or underplay the unimportant areas.

Local Value vs. Light and Shade

If your painting looks muddy or confused, it's probably due to an error in value rather than one of color. Sometimes the colors are overworked due to inexperience in handling the medium. In that case, the solution would be more practice.

However, more often, a painting looks confused or muddy because of an awkward or unattractive selection and arrangement of values. You might have seen too much and tried to paint it all or tried to duplicate the effects of light and shade on objects. The result is a jumble of information. The values are jumpy and scattered and the painting lacks focus.

Light and Shade

Light and shade make objects look real. They also give objects form—make them look round, square, or whatever. But if you add light and shade before the basic values are established, you may make the lights too dark, and end up with a confused muddle of unrelated values.

A strong light may be so distracting that when it falls on a black coat, you may forget all about the coat being black and paint the light-struck section of it too light, almost as if it were white. The same may hold true for a white shirt: In shadow it may look so dark that you may paint it almost as dark as a black shirt would appear in the light. Remember, a black coat is still black no matter how much light you shine on it, and a white shirt is still white, even in shadow. You may think you know this, but too often we paint not what we know but what we think we see.

Local Value

From his own student days Charles Reid quotes one of his art teachers as saying, "The darkest dark, out in the light, is darker than the lightest light in shadow." What he meant was that the lighted side of a black object is always darker than the shadowed side of a white object because of its intrinsic nature—its local value. And the local value of the object always influences the values of light and shade on it, regardless of the intensity or dimness of the light. Therefore,

to avoid breaking up your main values, you must establish the local values of your subject first, then paint light and shade on it. Again, "local value" is the overall value of a particular object regardless of the effects of light and shade. You can determine the local value of an object by squinting.

Normally, when you look at a scene, whether you are looking into the foreground or at a distance, your eyes focus on a fairly small area. However, the longer you look at your subject, the more detail you see. This is where squinting comes in. Squinting makes you much more aware of the shapes and silhouettes of the various objects. It also makes it harder to see the details, the unimportant little lights that complicate the true value of the objects you're painting—their local value.

Once you have established your local values as broad, flat areas and shapes, you can add light and shade. But remember, the local value of each object is never changed by more than about a value either way when light and shade are added. If you go much darker or lighter than that, you will break up your painting and destroy the local value of your subject.

This information is not intended to interfere with your personal expression in any way. It is just good advice. You must separate personal expression from academic facts and rules. Many fine modern artists have deliberately disregarded traditional rules of painting—people like Picasso, van Gogh, Bonnard, de Kooning, and others. But breaking these rules was due to a conscious decision, based on what they wanted to say. They did not do it out of ignorance or ineptitude. Every artist's goal is personal expression, but before you can get to that stage, you need some signposts, and that is all that rules are meant to be.

The following sketches are based on an exercise Charles Reid's former art teacher used to assign his students to help them understand local value and the effects of light and shade on it. He used a scale of nine values, from black to white, but for our purposes, a simplified scale of five values plus white will do just fine.

Sketch 1: Local Value

Charles Reid has painted three versions of the same man. The first one was done entirely in local value. No particular light is visible; the coat is simply black and the shirt white. Notice that Reid has tried to use all six values in this sketch. Can you identify them? Matching them with the grays in the value charts in the preceding section will help you practice recognizing them. Notice the clear, simple quality of this sketch. As a painting it's understandable and obvious. That's what painting in local value means—nothing complicated or difficult, just a simple, clear statement of what you see.

Sketch 2: Adding Light and Shade

Now let's shine bright light on the little fellow. Notice that the local values in the light are now about one value higher (lighter) than they were in the earlier version, and the values in the shadow have become about a value darker. (In this very simplified situation the black coat can't be painted any darker, so Reid has just left it black.) The point of this sketch is to show you that even if you add light and shade, they should never destroy local value.

Sketch 3: Confused Version

The third example shows what happens if light and shade get out of hand and destroy the local values of objects. Perhaps in the right hands this fragmented approach would be fine, and this may be the most expressive sketch of the three. But take a closer look. Notice that there is no real value identity in any area, no clear foundation for those slashing accents that, with a solid foundation of local value, could have been an exciting approach to painting.

Charles Reid

Controlling Values

Now that you understand the difference between local value and light and shade, look at these two series of drawings and paintings Charles Reid has done from old photographs. Each group of illustrations will teach you something about values. The Civil War soldiers show how to group your values. The sketches of horse and rider describe how to connect shadow values and emphasize textures.

Civil War Soldiers

Compare these two sketches of Civil War soldiers. Why is it that one appears jumbled and confused while the other has clarity and strength? Reid deliberately limited himself to the same three values in both sketches, so the weakness of the first sketch is not due to the selection of wrong values. So what is wrong with it?

Sketch 1. The error lies in the arrangement and grouping of the values. There are too many small pieces of unrelated value details in the sketch, and they are breaking up the picture as a whole. This is the same mistake that created confusion in the sketch of the little man on the previous page.

Sketch 2. In this sketch, to correct the confusion, Reid simplified the values by grouping them into larger shapes of the same value. To do this, he looked for two different types of shapes: outside shapes (like the silhouette of the figure) and inside shapes (smaller shapes within, such as the shadow on the soldiers, their buttons and medals, and their swords). Wherever the local values were similar, Reid massed these shapes together. For example, he tied in the dark costume of the soldier on the right with the shadow behind him. Notice that he kept the costume dark even though light shone on it.

Reid also made shadow shapes descriptive—they follow the forms they are on. For example, notice how rounded the shadows are on the chest and arm of the soldier on the left, and how much more interesting its shape is than it was in the first example. Wherever there was no definite shape, Reid left the paper white. Halftones were also left as white paper.

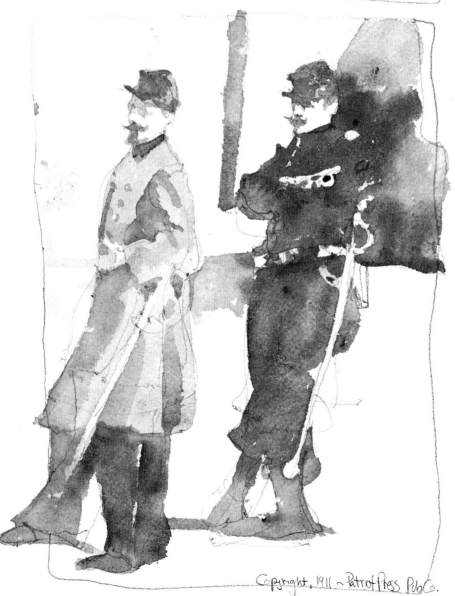

Copyright, 1911 ~ Patriot Press Pub Co.

220

Horse and Rider

These sketches were also based on an old photograph, but the point here is that a drawing done in local value alone is flat. You still need to add light and shade to it in order to describe form (sketch 2) and texture (sketch 3). Just be sure these values don't break up the original local value.

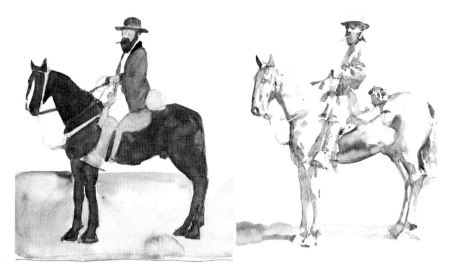

Sketch 1. This first illustration shows the horse and rider painted in local value alone. Notice the posterlike feeling that occurs when you use broad, simple shapes of a single value.

Sketch 2. This time Reid painted only the shadow shapes on the horse and rider. Then he erased his drawing lines so just the shadows remained. Even with the lines erased, the painting is still quite recognizable. This is because shadow shapes can effectively tell a story without any line to help.

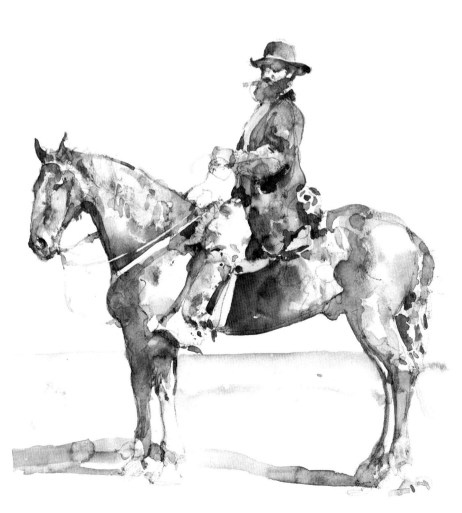

Sketch 3. This version is much more complicated than the others. Even though the rider is still done in fairly simple values, the horse looks freshly groomed and shiny. Its coat reflects many small highlights, making it harder to see the local values there. This time Reid is describing the surfaces of the objects.

The texture of the surfaces you paint affects the way you interpret them. Local value is easier to see on a matte surface (such as a coat or hat) than on a shiny surface (like glass, water, metals, and materials like silk or nylon) because on a matte surface light and shade areas are closer in value. On a shiny surface the difference between lights and shadows can be as great as four values. You must keep the nature of the surface you're painting on in mind. But remember, even on a shiny surface you can't lose the local value. If you squint, you'll see a local value on the horse. It just isn't as obvious as it was in the first example.

Charles Reid
Simplifying Values in Shadow

In the illustration shown below, the fisherman is in backlighting. Light is seen only around the edges of his form, with some light catching the side of his face and hand. Everything else is a shadow.

Just as in painting the lights, simplicity is the key to painting shadows. Even though there are a few minor variations of value within the shadows, this image is essentially a dark silhouette against a light background. Had Reid added a lot of small details and halftones to the figure, he would have destroyed its impact. The fewer value changes in the shadows, the better. You must forget reflected light for the moment and just record the essence of the shadow.

Simplifying Values in the Light

Perhaps by now you're beginning to see how important it is to simplify your values. Strong values can hold a painting together, direct the eye to specific areas, and create a beautiful abstract pattern. And you can get these strong values by constantly averaging minor variations into a single value shape.

To show you how simplified light values can carry a painting, look at the illustration at right, which Charles Reid did for *Sports Afield* magazine. Notice that the sky has been left untouched, while the water has a minimum of detail, just enough to show that it is indeed water. Had Reid added any more detail in either area, it would have confused and cluttered up the painting. Now look at the light-struck areas on the men and the boat. There are some small darks on the clothing of the man steering the boat, but essentially the light values there are quite simple and easy to see. Cluttering up these light areas with middle values, or halftones, would have destroyed the strong effect.

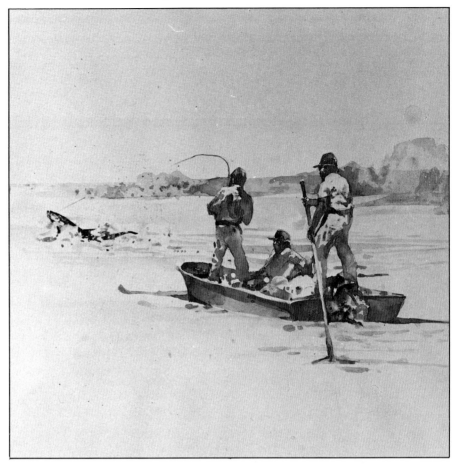

Don Rankin
Making the Transition from Value to Color

The evolution of Don Rankin's painting *South of Wellfleet* (over) makes a perfect subject for discussing value scales. The development of the painting begins with a 35mm color slide and a black-and-white photo, followed by a rough sketch and a three-value study.

Every color in the spectrum has its counterpart in a value of gray. When Don Rankin encounters a scene like the one that inspired *South of Wellfleet*, his mind automatically begins converting color scales to the gray scale. Although there are some maverick colors that can be difficult, you will usually find some place on the gray scale to put them. Also, not everyone sees color in exactly the same way, so when converting color to gray values, you have to trust your own judgment.

You may at this point wonder why you would want to take beautiful color and see it as gray. The answer is that understanding the gray scale will give you a stronger command of developing the forms in your painting. It's similar to spotting the essential shapes in your subject. When you can reduce your image to a graphic, three- or four-value study that works, then you have the makings of a successful painting. Conversely, when you understand how color converts to a gray scale, you can turn the process around and translate a gray photograph into beautiful color.

Color Photo Reference. Often it is form and not color that catches Don Rankin's eye in color photographs. In the color photo shown, he was attracted by the sweeping, elegant lines of the overlapping shapes. He was also intrigued by the unexpected image of boats landlocked in a grassy field, and decided it made an excellent painting subject.

Black-and-White Photo Reference. A good black-and-white photograph can have as many as ten distinct values ranging from absolute white to solid black, with a number of gradations in between. But clearly distinguishing so many gradations can be difficult, as the shifts between them are very subtle. Thus, for the purpose of this lesson, Don Rankin has reduced the number to six. Juggling fewer values makes it a little easier for painters.

When you use black-and-white references—when color has been stripped away—you are confronted with very apparent shapes. Without the element of reality color provides, you are forced to look at the image in an abstract way and can see the values more readily. If you squint your eyes and look at this photo, you may see perhaps as few as four values of gray. But if you look at the photo without squinting, you may be overwhelmed by the wide range of values you perceive.

Two-Value Sketch. In this planning sketch Rankin has reduced the values to just black and white. If you compare this sketch with the photographs, you'll see that certain alterations have been made for design's sake. For example, in both photographs, the sky area was almost nonexistent. In the sketches, Rankin enlarged that area and made it the light-value component in the composition.

Three-Value Sketch. The two-value sketch pretty much expresses what Rankin wants to say, but he finds its mood a little harsh. The three-value study suggests a softer feeling and acts as a bridge between the photographs and the finished painting.

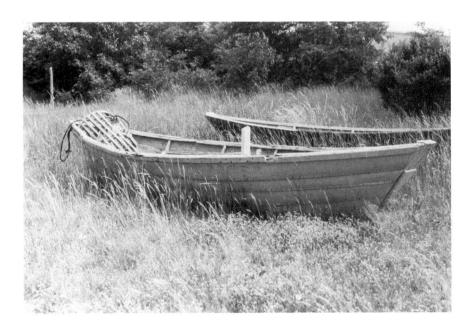

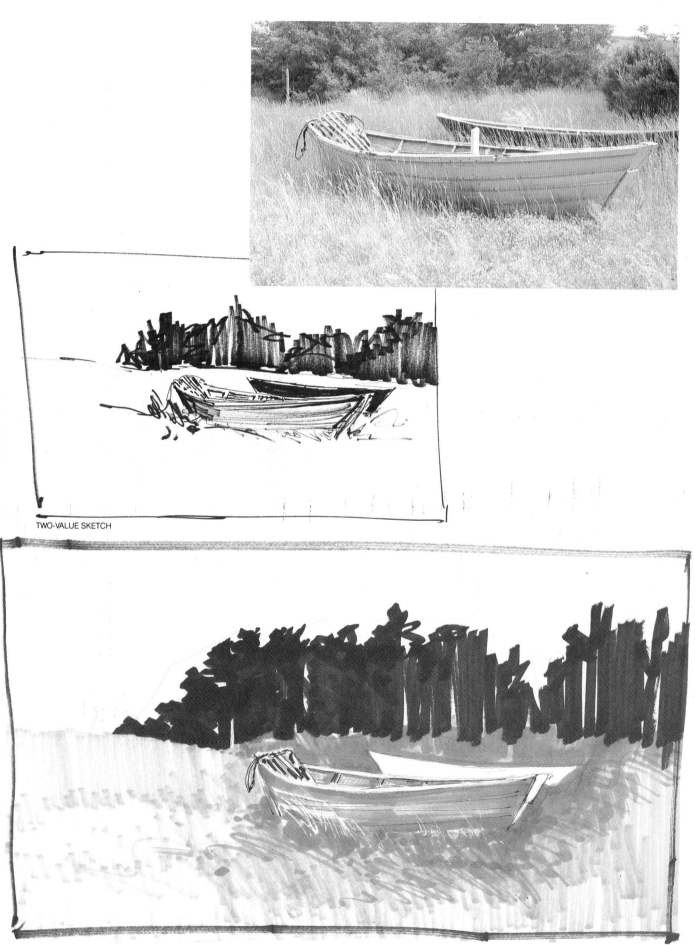

TWO-VALUE SKETCH

THREE-VALUE SKETCH

Finished Painting. Now the metamorphosis is complete. The actual scene had sparked Don Rankin's interest and emotions, but to communicate that feeling, he had to speak the language of painting, where form and shape, as well as color, must carry the message. One very obvious transformation that took place between photo and finished painting is the difference in the amount of sky area. In the painting, Rankin wanted to open up the space by adding more sky. And in other areas as well, he didn't allow the photographic image to tie him down. While the photo has some merit of its own, it has several weaknesses as a potential painting. For example, the boat shapes are easily lost in the grassy field. While that is not necessarily a problem, Rankin wanted the boats to be a little more distinct, so he altered the values and increased the contrast. He also moved the wooden post farther into the background to enhance the feeling of distance. Of course, this was not the only approach he could have taken; a painting has many solutions.

Another set of decisions had to do with translating value into color. In this, Rankin had the advantage of knowing

SOUTH OF WELLFLEET
Watercolor, 14 × 22" (35.6 × 55.9 cm).

the site firsthand as well as having the photo references. The palette for *South of Wellfleet* consisted of new gamboge, Hooker's green, Winsor blue, Winsor red, and indigo. These colors were mixed in various proportions to create the range of values you see. The grass is a mixture of new gamboge and a little Winsor blue. The drybrush shadow areas are made up of Winsor blue, Winsor red, and a small amount of Hooker's green, just enough to influence the resulting color. The near boat was created from a mixture of Winsor red and Winsor blue; a much lighter wash of these same colors was used for the distant boat. The sky is a pale wash of Winsor red and new gamboge. The base color in the tree line is Hooker's green dark and new gamboge, while the shadows are strong mixtures of Winsor red and Winsor blue, with the strongest values containing some indigo.

The colors were Rankin's personal choice, based on intuition and the photo references. However, other colors of equivalent value on the gray scale could have been used; it's all a matter of which ones will work for you as you translate the values of your subject into color.

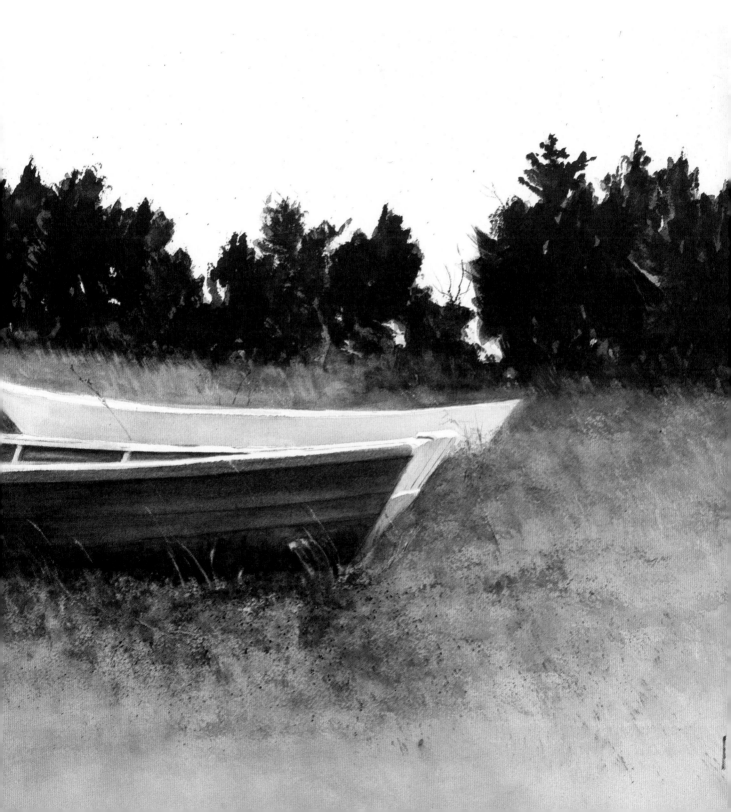

Irving Shapiro
Creating Illusions with Color

Thoughtfully characterized and insightfully stated, color can speak a powerful compositional message. We know that in a painting illusions of space and distance can be created through size relationships, foreshortening, and overlapping planes. But color can also be a forceful means of punctuating the illusions of perspective and atmosphere. One of the fundamental principles of color is that warm colors project (come forward), whereas cool colors recede. But before you take this neatly packaged thought and make all your foregrounds warm, remember that all principles are open to interpretation. Look at Irving Shapiro's examples of uses of color that seem to break the "rules."

Playing Up Contrasts in Intensity

Here the distant color, though warmer in temperature than the foreground, still recedes because it's grayer than the cooler color. In other words, by graying (muting) a warm color, you can provide the illusion of receding planes. Even though it's cooler, the more intense (less gray) color will, by comparison, appear to come forward.

Emphasizing Value Contrasts

Suppose you want a cool, grayed foreground and a warm, ungrayed background. In this example, the value contrasts are emphasized in the foreground but diminished in the background. Even though the colors of the foreground are relatively cool and muted, the visual impact of the value contrasts is commanding, thereby projecting the foreground.

Accentuating Edges

Crisply defined edges have a magnetic quality. Here the foreground color is both cooler and grayer than the background. But notice the highly descriptive definition of content in the foreground, with its unquestionably harder-edged presentation. By underscoring description in the foreground, you can dramatically carry this plane forward, regardless of the color in the receding planes—as long as you keep the background edges softer and reduce objective description there.

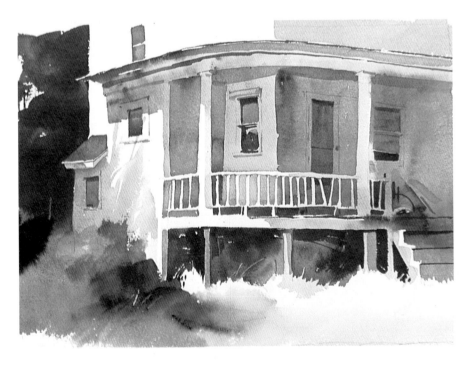

Choosing Unorthodox Colors

Almost any combination of colors can be used in a painting—as long as they are handled sensitively and with skill. In fact, it's a good idea to rock the boat now and then by choosing a combination that seems offbeat. You may be surprised at the colors Irving Shapiro has used for this subject—Payne's gray, burnt sienna, and olive green—unorthodox choices that nonetheless appear comfortable and natural here. Try an experiment using green, brown, and black. It may sound astonishing, but you can create lush-looking foliage that is, in effect, brown and black; or a light that seems rich and intense even though there are no yellows, blues, or violets.

Irving Shapiro
Developing a Center of Interest

The center of interest is essentially whatever you want to develop as the element of cardinal importance within the composition; it is an integral and dominant part of the design. You might call this the focus, catalyst, or nucleus of the painting—but the meaning is the same.

In determining what the dominant interest is to be, you also have to decide how you're going to give it life. The following sketches each show a different way in which you can reinforce the center of interest. Of course, there can be many directional elements, all working in visual concert. What these few examples underscore, however, is the individual use of line, value, color, description, or dynamism.

Line

In this sketch the linear construction of a tree, as delicate and subtle as it is, establishes a focus that is enough unlike the other painting elements to make it the unmistakable center of interest.

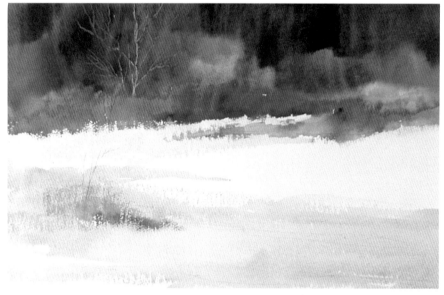

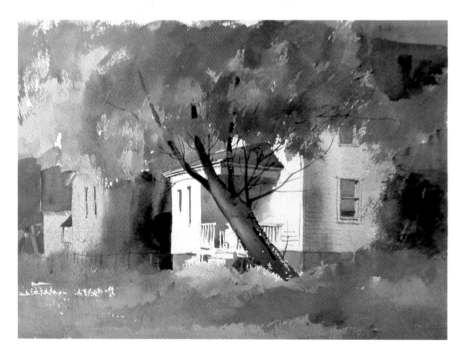

Value

Although the color is chromatically high in various passages, the accentuated value contrasts in the front portion of the house emphasize this area over others.

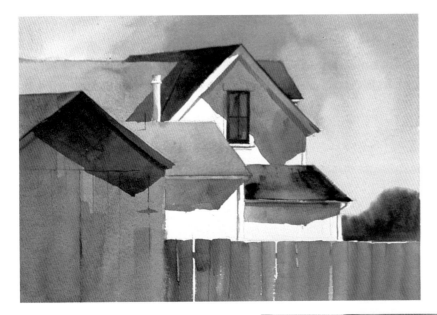

Color

The strong geometric shapes and overlapping planes make this study quite potent. What lends certain areas arresting importance here is their aggressively interpreted color. Although shapes are assertively stated throughout the composition, the color is purest under the eaves, where the eye is intended to settle.

Description

Both the color and value contrasts are strong in several passages here. However, delineation of content is reserved for the boulder, which is the center of interest. Even the brushwork of the ground becomes more defined as it approaches the boulder.

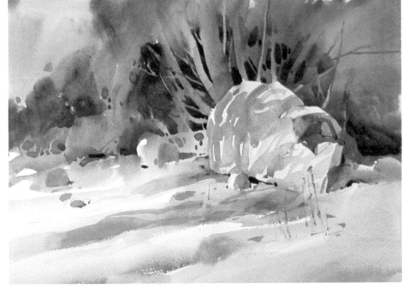

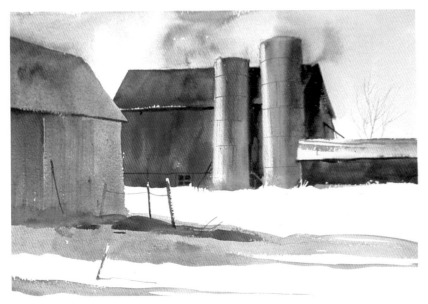

Dynamism

In this sketch the shapes are all assertive, with pronounced edges and little variation in description. The value contrasts are largely powerful. What, then, has been done to focus interest? It is the dynamics of color and the dynamics of the angular barns against the rounded silos that activate optical interest.

PERSPECTIVE

Establishing three-dimensional forms in space convincingly requires a knowledge of perspective, whether you paint landscapes, still lifes, or figures. Howard Etter and Margit Malmstrom explain the basics here simply and succinctly.

Howard Etter & Margit Malmstrom

Expressing Three-Dimensional Forms in Space

Our seeing is composed of a multiplicity of visual cues that are instantaneously processed by the brain. One visual cue is that objects close to us appear larger than the same objects far away. This seeming diminution of objects as they recede enables us to judge the distance between ourselves and the objects in our environment as well as the distance between one object and another.

The way we see is also affected by the position of our eyes. Although both eyes focus simultaneously, each eye receives a slightly different image, which, when fused by the brain into a single image, results in our perceiving the image in depth. At distances greater than several hundred feet, the image received by each eye becomes nearly identical, and visual depth perception is lost. Depth perception includes our seeing the atmosphere itself—haze, dirt particles, moisture—which can obscure sharp vision at certain distances.

How do we organize the things we see so that we're able to transfer them onto a flat piece of paper or canvas? Three major aspects of how we see come into play here: *light,* which defines the shape, depth, and location of what we see; *cone of vision,* a mental construct that reveals how much of a subject we can include in the picture without distortion; and *viewing distance,* which is the distance between observer and picture surface and gives us the size of the painting, the angle of view, and the relationship of subject to picture format.

Perspective Tools

Getting what you see down on paper or canvas involves imitating visual cues to create the illusion of depth on a flat surface. In doing this, you'll work with these concrete tools: the *picture plane,* a term that applies both to the working surface and to an imaginary surface we interpose between our eye and the subject, and that allows the viewer to see depth as if it were flat and a flat surface as if it had depth; the *station point,* which defines the point of view of the picture; the *eye level/horizon line,* which gives the viewer the angle of

view up or down, the spatial relationships within the picture format, and the location of the vanishing points; and the *vanishing points,* which give you the angle of view in terms of width and allow you to plot lines that go back in space.

Mastering the Cube in Perspective

To understand how to apply perspective to a three-dimensional object in space, you can begin by drawing a cube—the basic three-dimensional form—from various angles. The cube is evident in most man-made objects, including houses, skyscrapers, interiors, cars, even boats. Once you master the cube, you will be able to draw any cubelike object from any position—from above, from the side, straight on, or from inside.

When you draw the cube, you'll be using the three perspective systems that apply to rendering forms in space. You'll see how the cube, or any three-dimensional object, casts shadows, and how shadow projection according to perspective principles enables you to enhance the reality of any object you draw.

Applying Perspective to the Figure

When perspective is applied to the figure, it's often called foreshortening because of the way forms that recede in space seem to be "shortened" relative to how perpendicular they are to the picture plane; the more nearly at a right angle they are, the more foreshortened they will appear. This is most noticeable when any long part of the body (fingers, arms, legs) points straight out at the viewer. To paint the figure in perspective, you must learn to see the body as a combination of geometric forms that exist in space in relation to one another and to the picture plane. These you can then render in terms of straight linear perspective, and then use light and shadow creatively to define and clarify the various forms.

Eventually you will be able to apply the basic elements of perspective to any subject, be it landscape, still life, or the figure. Just a few possibilities are presented here.

Perspective Systems: One-Point Perspective

A cube can technically be described as a three-dimensional rectangular prism, which means that it has six flat surfaces (or faces) in three sets of matching pairs, each surface at a right angle to the surfaces adjacent to it. It has a total of twelve edges, in three parallel sets of four, each set at a right angle to the edges adjacent to it. In other words, it's a box. It's the orientation of the sets of edges to your main line of sight—and thus to the picture plane, which is always perpendicular to the main line of sight—that determines how many vanishing points you'll need to draw the cube. The number of vanishing points—one, two, or three—defines the perspective system you'll use.

One-point perspective occurs when two faces of the cube and two sets of edges are parallel to the picture plane. In this position, *one* set of edges goes back to converge in *one* vanishing point.

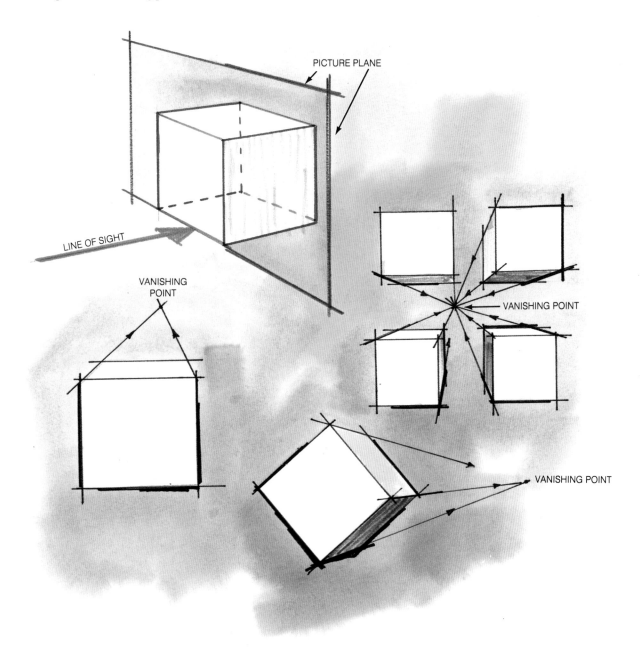

PICTURE PLANE

LINE OF SIGHT

VANISHING POINT

VANISHING POINT

VANISHING POINT

Howard Etter & Margit Malmstrom

Two-Point Perspective

Two-point perspective occurs when you rotate the cube so that *none* of the faces
are parallel to the picture plane, but *one* set of edges still is. Now *two* sets of edges
go back in space to converge in *two* vanishing points.

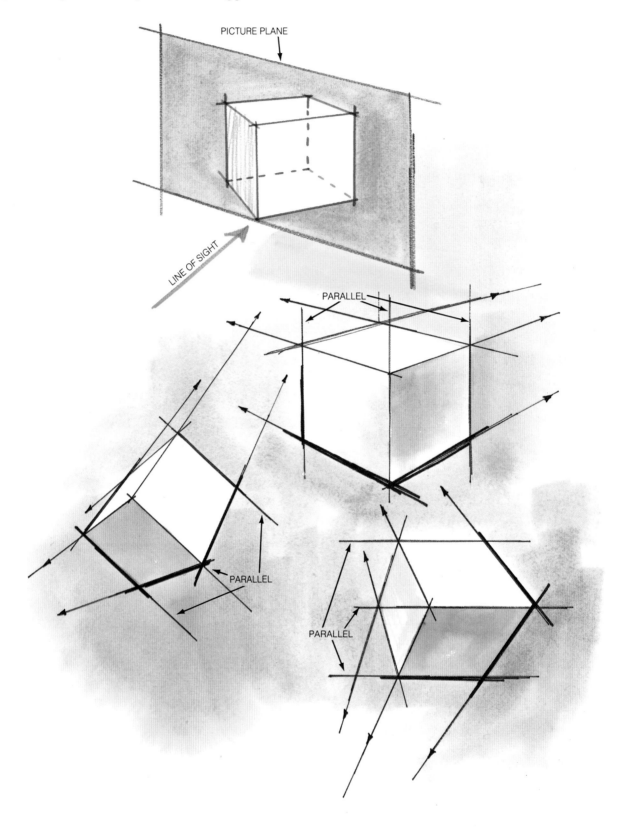

PICTURE PLANE

LINE OF SIGHT

PARALLEL

PARALLEL

PARALLEL

Three-Point Perspective

Three-point perspective occurs when you rotate the cube once again, this time positioning it so that none of the faces and none of the edges are parallel to the picture plane. Now all *three* sets of edges go back in space to converge in *three* vanishing points.

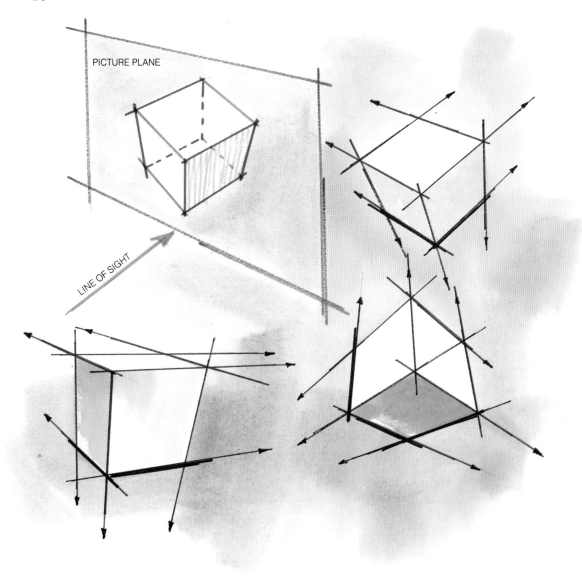

PICTURE PLANE

LINE OF SIGHT

If you draw your cube level, that is, with its edges horizontal and vertical, as if it were a box sitting on a table, your vanishing point(s) in both the one-point and two-point systems will be located on the eye level/horizon line. In the three-point system, two of the vanishing points will be on the eye level/horizon line and one will not. If you tilt the cube off level as you rotate it, your vanishing points for horizontal lines will be located on an auxiliary eye level/horizon line that will tilt left or right as the cube is tilted. The vertical edges, which tilt toward or away from

the observer, will converge to a vanishing point located on a vertical line, called a *vertical vanishing trace*, that will change its angle as the vertical edges change theirs.

Whether level or tilted, it's the fact that the cube has two sets, one set, or no sets of edges parallel to the picture plane, leaving *one* set, *two* sets, or *three* sets, respectively, to converge in vanishing points, that determines the perspective system. The terms *one-point*, *two-point*, and *three-point* perspective apply only to the system used to draw individual objects, not to the entire painting.

Howard Etter & Margit Malmstrom

Shadow Projection

Although you can fully define a form through the use of line alone, there are times when it could be made more interesting and more realistic with the addition of light and shadow.

Because all rays of light, whether from the sun or from an artificial source, travel in straight lines, the shadows caused when anything blocks their path follow the same rules of perspective as any other linear phenomenon: Shadows that recede into the picture depth are defined by parallel lines that converge in a vanishing point, and the light rays that cast the shadows will converge to a separate vanishing point; shadows that are cast parallel to the picture plane are defined by lines that do not converge, and light rays parallel to the picture plane do not converge. It's the angle of the rays of light, from whatever source, relative to our station point and our picture plane, that determines the direction and perspective effect that the shadows will have.

When changing or inventing light-and-shadow effects on buildings, or any structure, you can choose from several possibilities:

Both faces in sunlight. Here, the shadow vanishing point on the eye level/horizon line is located between the two main building vanishing points, and the sun is behind the observer.

Both faces in shadow. The shadow vanishing point is still located between the two building vanishing points, but the sun is in front of the observer.

One face in sunlight and the other in shadow. Now the shadow vanishing point is outside the two building vanishing points, and the sun is either in front of or behind the observer; or to the side, parallel to the picture plane.

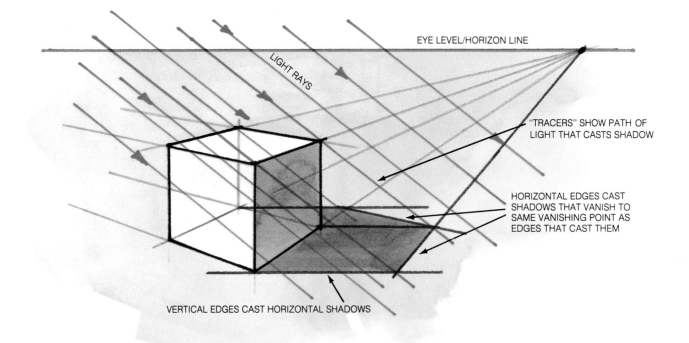

EYE LEVEL/HORIZON LINE

LIGHT RAYS

"TRACERS" SHOW PATH OF LIGHT THAT CASTS SHADOW

HORIZONTAL EDGES CAST SHADOWS THAT VANISH TO SAME VANISHING POINT AS EDGES THAT CAST THEM

VERTICAL EDGES CAST HORIZONTAL SHADOWS

In this illustration, sunlight strikes a cube resting on a level surface. The light rays come from the side and are parallel to the picture plane.

Here, sunlight strikes the cube from over the observer's shoulder or behind the observer (in front of the subject). The light rays are no longer parallel to the picture plane.

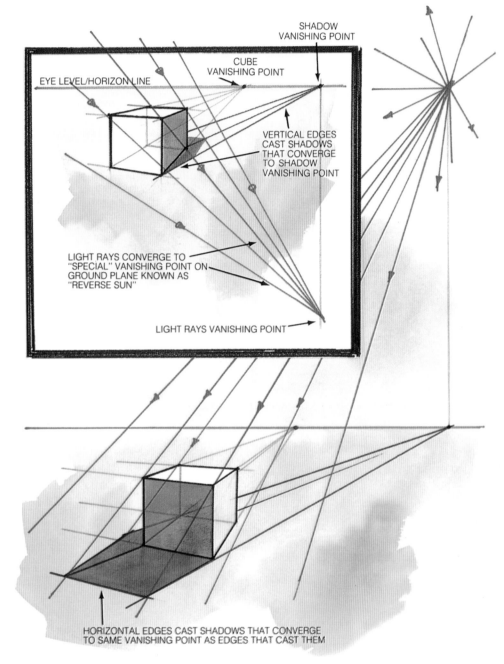

SHADOW VANISHING POINT

CUBE VANISHING POINT

EYE LEVEL/HORIZON LINE

VERTICAL EDGES CAST SHADOWS THAT CONVERGE TO SHADOW VANISHING POINT

LIGHT RAYS CONVERGE TO "SPECIAL" VANISHING POINT ON GROUND PLANE KNOWN AS "REVERSE SUN"

LIGHT RAYS VANISHING POINT

This time the cube is lit by sunlight coming from in front of the observer (behind the subject).

HORIZONTAL EDGES CAST SHADOWS THAT CONVERGE TO SAME VANISHING POINT AS EDGES THAT CAST THEM

Howard Etter & Margit Malmstrom

Composing a Scene at Medium Eye Level

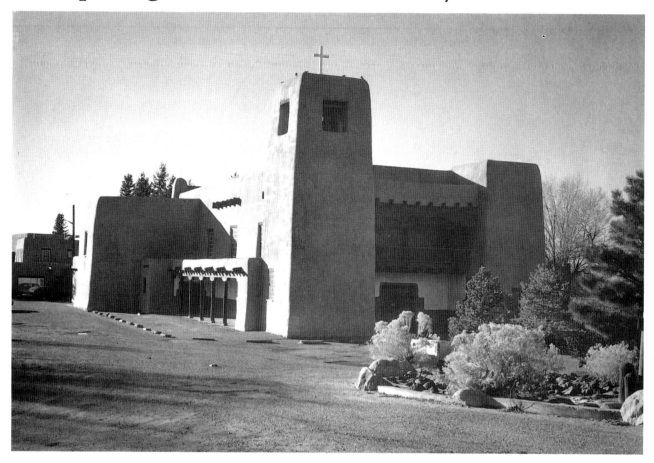

A well-known landmark in Santa Fe, New Mexico, this church is located near the oldest church in the United States. Although it has less historical significance than the older church, it is nevertheless interesting to the artist. Since it stands slightly apart from nearby structures, it can be viewed from a number of vantage points and different angles of light. This photograph shows the church lit by dramatic afternoon sunlight. In the morning, the façade of the building is bathed in light, which reveals other aspects of the forms of the structure. The final painting uses morning light, even though the source shows afternoon light. The point of view here is straight ahead, at medium eye level.

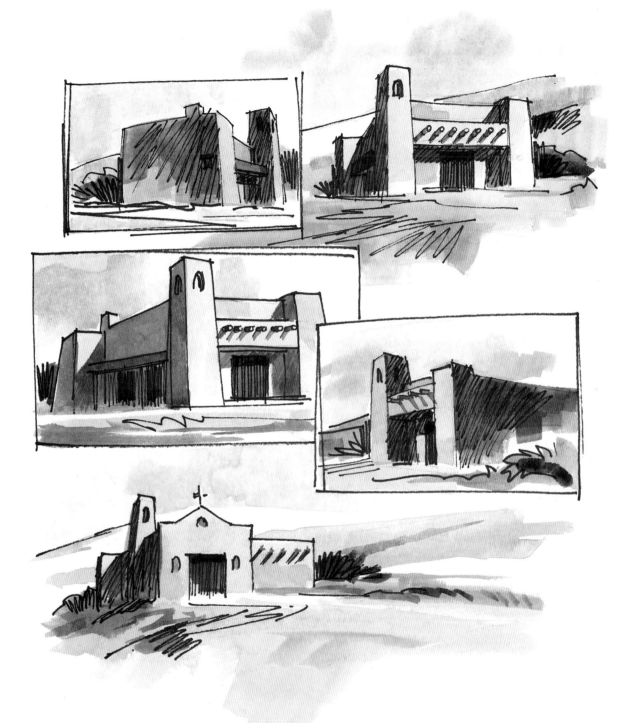

Light and shadow always play an important role in creating visual interest in the simple forms of an adobe building. Here, sketchbook studies help analyze the composition and determine the most effective point of view. They also show changes in light and shadow that will help emphasize the volume of the forms and how the masses of the building fit together. You can use sketches of different structures of the same type, since all have a common visual vocabulary you can rely on for your painting.

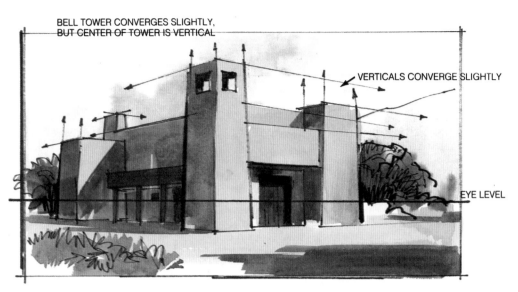

The perspective of this subject is fairly straightforward, but careful study is needed for the vertical edges. Adobe-style construction is often slightly tapered at the corners, and its verticals are not really true but move closer together as they rise above the ground. This converging, although not great, must be shown, but it must be handled subtly to avoid the appearance of a perspective effect. Note that the building mass itself does not tilt in; only the corner towers slope inward as they rise.

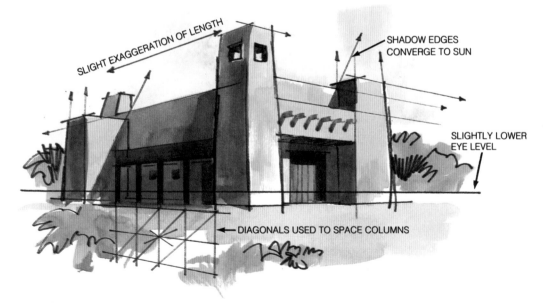

Here, the composition has been adjusted somewhat: The perspective angle has been exaggerated for dramatic effect, and the eye level/horizon line has been lowered to emphasize the upward thrust of the bell tower. The whole side of the building has been lengthened to avoid too squarish a massing of volumes.

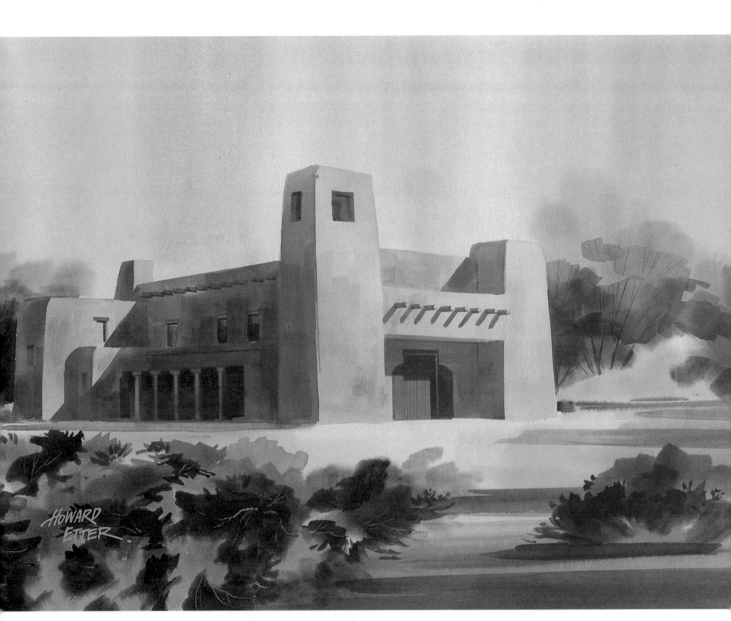

SANTA FE CHURCH
Watercolor, 20 × 26" (50.8 × 66.0 cm).

In the finished painting, you can see that the angle of sunlight has been changed to light the front of the church, leaving the side in shadow. This morning lighting effect strengthens the feeling of volume. The shadow side of the building and the dark shadows on the ground act as a foil for the bushes in the foreground.

Howard Etter & Margit Malmstrom

Combining Separate Elements in a Single Composition

These photographs show a number of different elements found at the site of an abandoned railway station in Leadville, Colorado. The buildings and train cars themselves would make interesting studies, but in this demonstration they're combined in an entirely new composition. When you are combining or rearranging separate elements, redraw the perspective of each one so that it fits into the unified point of view of the new composition.

DORMER MUST SIT OVER
ROOF CENTERLINE

NOTE THE DIFFERENT ANGLE
OF THE ROOF VALLEY

CENTERLINE OF HIP ROOF

When you're trying to work a number of different objects into a coherent whole rather than draw what you see in front of you, make preparatory sketches, in which you can arrange and rearrange your material, trying out different viewpoints and relationships. Experiment with your composition until you get something you like. Note, too, the light-and-shadow effects; try to come up with a play of light and shadow that will create interest in the final painting.

Since the caboose is much closer to the viewer than the station in this composition, it requires more study with regard to details and structure. The left-hand vanishing point is quite distant, which gives a "fast" perspective effect to the long side of the car. The vanishing points for the caboose are spaced approximately the same distance apart as those for the station, but they don't coincide.

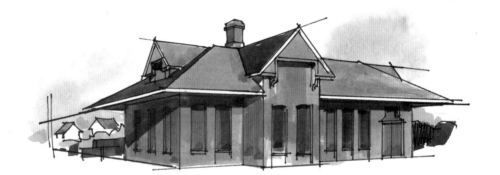

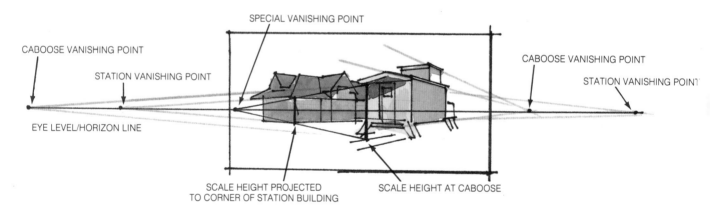

SPECIAL VANISHING POINT

CABOOSE VANISHING POINT

STATION VANISHING POINT

CABOOSE VANISHING POINT

STATION VANISHING POINT

EYE LEVEL/HORIZON LINE

SCALE HEIGHT PROJECTED
TO CORNER OF STATION BUILDING

SCALE HEIGHT AT CABOOSE

Because the station is more distant, it has a flatter perspective look, even though its vanishing points are the same distance apart as those for the caboose. The tricky parts of the station are the small dormer and where the sloping planes of the roof come together. The diagram shows the relationship between the two sets of vanishing points and illustrates how to use a "special" vanishing point to keep the heights more or less in scale.

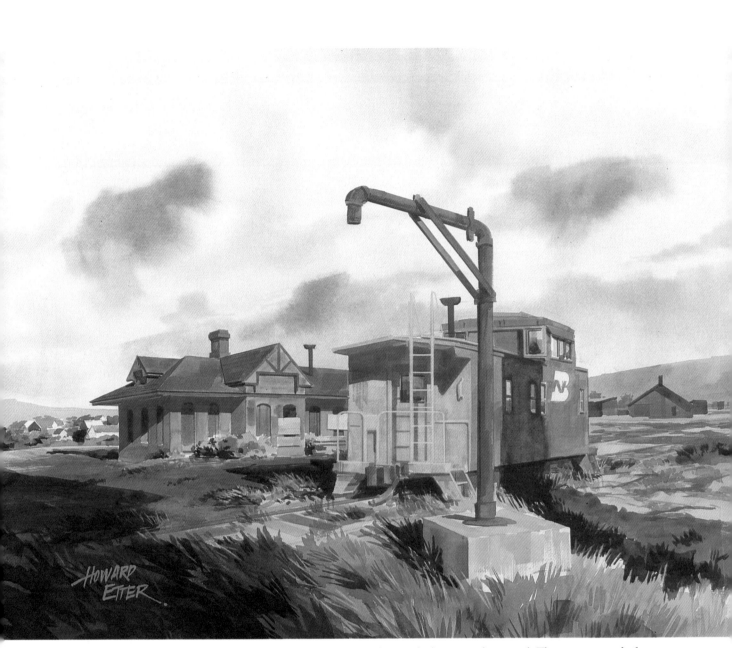

LEADVILLE STATION
Watercolor, 20 × 28" (50.8 × 71.1 cm).

You can see the liberties taken with the original material: The opposite end of the caboose was used, the station building was reversed to show its most interesting end, and the large dormer was moved to the left to give more rhythm to the roof line. The shapes and details were taken from the photographs, but they have been shifted and modified to such an extent than an entirely new reality has been created.

Howard Etter & Margit Malmstrom

A View in One-Point Perspective

Mackinac Island is a popular summer resort a short ferry ride off the northern tip of Michigan's Lower Peninsula. Tourist shops, narrow streets, and horse-drawn carriages (automobiles are prohibited) all add to the island's appeal. For the artist, much of Mackinac's charm lies in the random collection of buildings, in a great variety of styles, all crammed together to create a kaleidoscope of shapes, colors, and patterns in which the artist's imagination can have free reign. A view into a back courtyard offers possibilities worth developing into a composition and provides a good example of a simple yet interesting one-point perspective view.

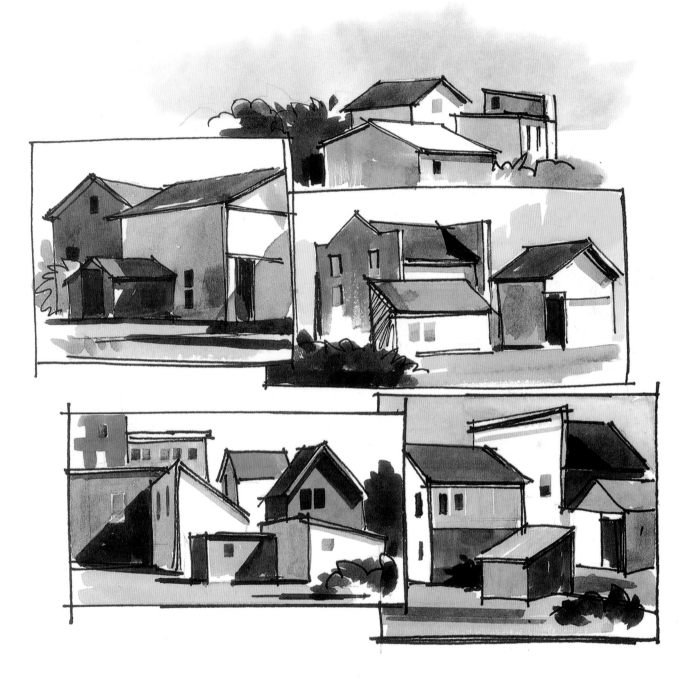

The illustrations above show a number of building shapes grouped together in different environments. These sketchbook studies of a vacation resort explore various combinations of buildings, sometimes to help isolate and identify the subject and sometimes to combine and recombine portions of the material in order to come up with a number of different ideas for a painting.

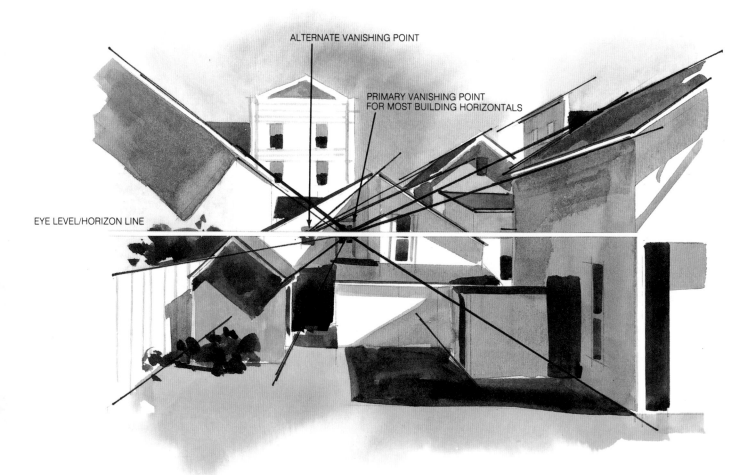

ALTERNATE VANISHING POINT

PRIMARY VANISHING POINT
FOR MOST BUILDING HORIZONTALS

EYE LEVEL/HORIZON LINE

The main perspective consideration in this subject is to locate the central
vanishing point. With a straightedge, you can visually extend the horizon lines of
the buildings to where they converge on the pane of glass in the door of the
central building. This locates the main vanishing point and also establishes the
position of the eye level/horizon line. Not all lines vanish here, but most do.
There is always the option of making some walls or roof lines vanish on the same
eye level/horizon line, even if they aren't parallel and even if they have different
vanishing points.

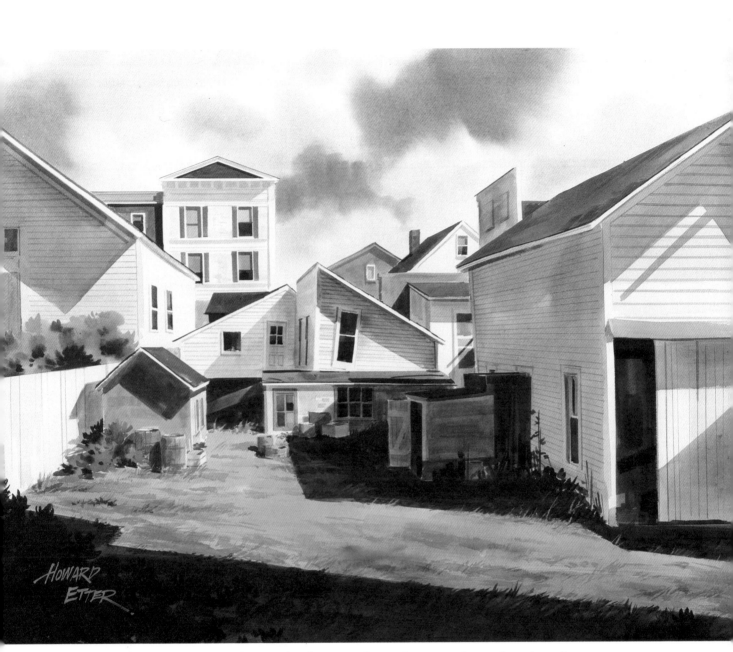

MACKINAC ISLAND
Watercolor, 20 × 26" (50.8 × 66.0 cm).

The completed painting shows a few minor changes from the preliminary photograph. The angle of view has been widened to include the end wall and door of the barn on the right and to allow more space in the foreground. The white fence has been added on the left, against the dark shrubs. A gable end added to a building breaks the skyline in the distance, and a chimney and a building false front have been eliminated to avoid visual confusion. Some dark cast shadows in the extreme foreground suggest other unseen buildings nearby.

Howard Etter & Margit Malmstrom

Depicting a Distant Subject

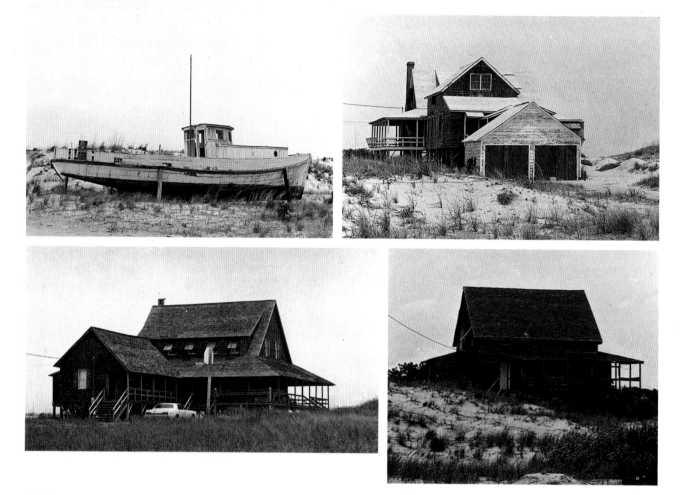

In this case, several separate photographs were used to incorporate a number of subjects—all typical of the sandy beach along the Outer Banks of North Carolina—into a single composition showing the perspective of a fairly distant scene. The final painting would include the large beach house with the boat in front and a few distant buildings at the crest of the dunes in the background.

In the sketches, various compositional ideas and perspective relationships were tried out among the different parts of the whole. The placement and angle of the buildings could be changed and redrawn to fit the overall perspective point of view of the painting.

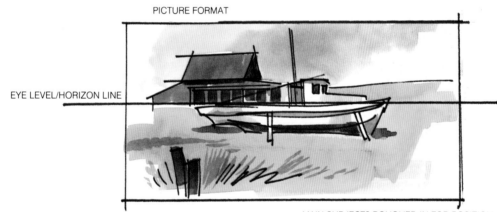

PICTURE FORMAT

EYE LEVEL/HORIZON LINE

MAIN SUBJECTS ROUGHED IN FOR POSITION

The first step in putting together this composition is to locate the placement and indicate the size of the two major elements—the house and the boat—and to rough them in on the picture surface. Since the thrust of the composition carries the eye to the middle distance and beyond, it's best to use fairly widely spaced vanishing points—at least three times the diagonal of the picture format. The wide vanishing points guarantee that the feeling of distance will not be lost if the viewer steps back a bit from the optimum viewing distance.

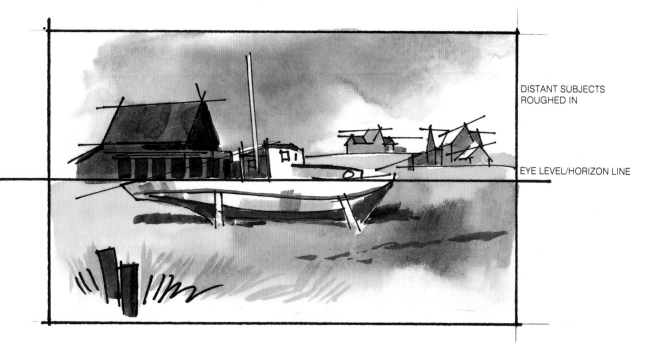

DISTANT SUBJECTS
ROUGHED IN

EYE LEVEL/HORIZON LINE

Here the most distant elements are roughed in, in the positions suggested by the sketchbook studies. Since the buildings are all quite far away from the picture plane, small changes in the placement of vanishing points for each may not adequately explain their nonparallel, or random, relationships to one another. But some effort must be made to convey the idea. Since the boat is also at a different angle from the main beach house, it should have its own set of vanishing points. To be consistent with the overall perspective, each building's set of vanishing points must be separated by a distance equal to at least three times the diagonal of the picture format.

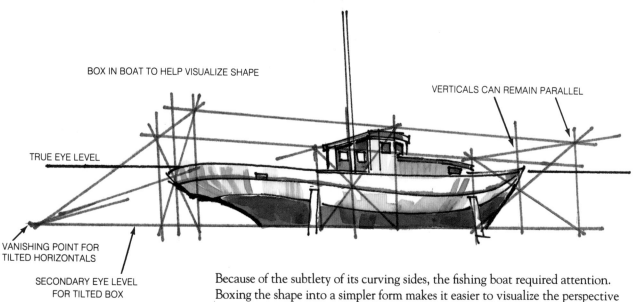

BOX IN BOAT TO HELP VISUALIZE SHAPE

VERTICALS CAN REMAIN PARALLEL

TRUE EYE LEVEL

VANISHING POINT FOR
TILTED HORIZONTALS

SECONDARY EYE LEVEL
FOR TILTED BOX

Because of the subtlety of its curving sides, the fishing boat required attention. Boxing the shape into a simpler form makes it easier to visualize the perspective of the curves. The cabin is more straightforward, with a few vertical edges and straight lines that lend themselves to linear perspective. The rounded stern, with its long overhang, is a subtle form that requires careful drawing.

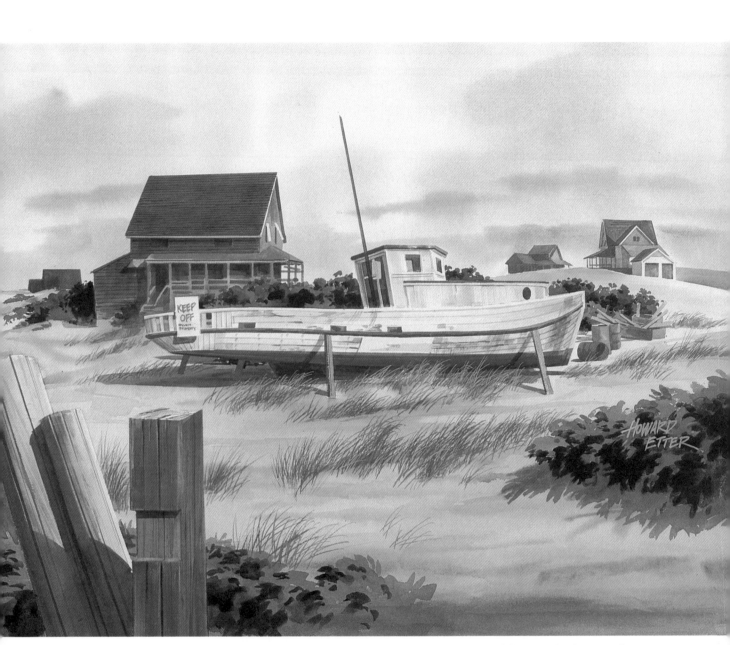

BEACH AT KITTY HAWK
Watercolor, 18 × 26" (45.7 × 66.0 cm).

The finished composition shows a combination of middle-ground subjects and distant subjects, with the foreground taken up by beach grass. The perspective effects employ both linear perspective and the depth implied by overlapping forms, which helps push the most distant beach houses well into the background. Their reduced sizes, the overlapping of closer objects, and the very flat perspective angle of the building horizontals all contribute to the feeling of depth, which is further accentuated by the addition of a little atmospheric perspective produced by slightly lowering the contrast range in the distant houses.

LANDSCAPE PAINTING

The landscape offers so much to the painter—
moody, stormy skies, luminous sunsets, rippling
mountain streams, rolling hills, magnificent trees.
In this chapter, ten different artists show you
ways to capture what nature has laid out for you.

Charles Reid
Sketching a Point of View

Sketches don't necessarily have to serve as the basis for future paintings. They can be valuable exercises to get you used to seeing painting possibilities in the material around you.

Sketch 1

Charles Reid did these three sketches over a two-hour period on a brisk autumn afternoon in upstate New York. He was attracted by the geometric shapes in the fields as opposed to the soft, feathery quality of the trees and distant hills. He was also intrigued by the strong yellow-orange of the fields on such a bleak day. Once he had decided what interested him, Reid was ready to begin. He made the sketch smaller than the paper itself and surrounded it with definite borders—note the pencil line he's drawn around all three sketches. (These lines define the picture frame, the borders of your composition; Reid recommends that you include them in your sketchbook.) Then he wandered off so he could return with a fresh and critical eye. In this case he came back to find the oranges harsh and the greens rather dreary. Reid liked the rather abstract feeling in the fields, though, and thus felt that all wasn't lost.

SKETCH 1

SKETCH 2

Dick painting ~Casanova~ 10·21·84

Sketch 2

Make a second sketch, trying to retain what you liked about the first but altering the few things that displeased you. Be specific in your mind about what you'd like to change. Don't just paint, hoping your second sketch will come out better. Here, Reid cooled the cadmium orange down a bit with alizarin crimson and cerulean blue. He mixed his tree greens on the paper instead of the palette, hoping they'd look less tired and dull. While he was working, one of his students came along and started painting, so Reid included him in the sketch.

Sketch 3

Again, Reid analyzed the result after a brief break from painting. The second sketch was an improvement over the first, particularly in its color feeling, but Reid still felt he didn't have a painting. Then he looked a bit to the right where another student was painting the same view, and was reminded of a figure from an Ingmar Bergman film. This changed Reid's initial painting idea, but it didn't matter. He was still painting with an idea and a purpose.

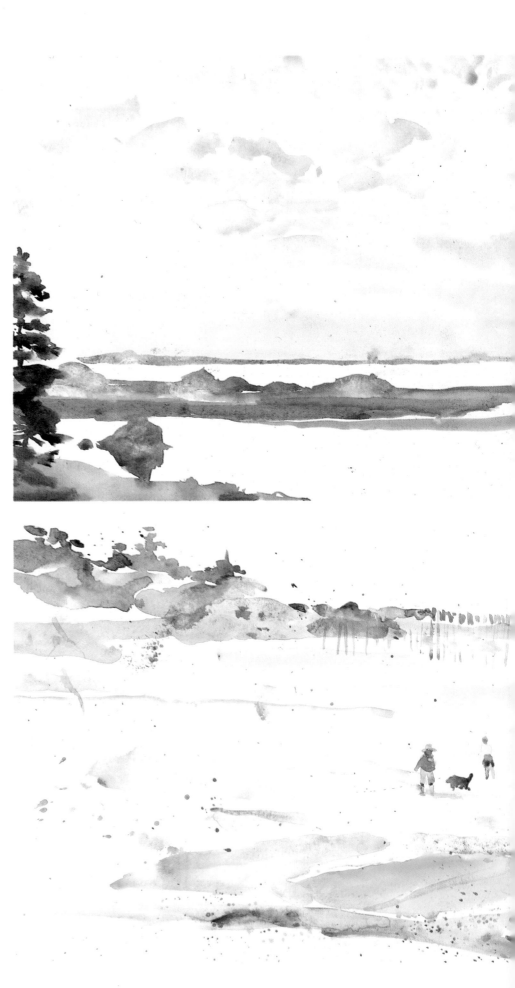

Charles Reid
Expressing the Quality of the Day

While Charles Reid believes you should make value and color changes that suit your paintings and not be a slave to what's actually in front of you, he finds that sometimes it's wonderful practice to catch a specific time of day or get the feeling of the weather at a particular moment. As he sketches, Reid thinks less about composition than about catching a specific cloud formation or getting a certain color and value relationship between the rocks, sea, and sky. In other words, he is primarily involved with what's in front of him, hoping it will look good on the paper. Here are the results of some of these study sessions, five small sketches Reid did in Nova Scotia. Try some quick sketches like these too.

Alfred's Blue Boat

With this sketch Charles Reid wanted to express the freshness and purity of a sunrise scene—the soft, clean colors and the stark contrast between the colorful sky and the dark land masses. To keep the soft effect, he diluted the sky colors with water. The pinks are cadmium orange and alizarin—sometimes mixed, sometimes used separately. The pale blue is cobalt and the gray clouds are ivory black. To get a clear, definite feeling in sky and land masses, Reid used hard edges throughout. Even though we're told that pictures need some soft edges as well, in this case it was hard edges that helped convey the effect he was after. He left the water as white paper because he wanted the rocks to stand out starkly.

78

ter I got up to get him off fishing with Gordon tDavid on alfred's boat- 5:45 - July asleep so Sam & I sit at front and watch for Alfreds blue boat - Great sky!

Sandy Cove, Nova Scotia

The day was crisp and warm, with no wind. Reid tried to keep his colors clean and did hardly any mixing on the palette. He didn't want grays; he wanted strong color. So he used the color right out of the tubes, adding only water to cut the intensity. Note the alizarin crimson on the sandbar at the lower left. Reid put the slightly diluted alizarin there, then allowed some cerulean blue to flow into it. He didn't paint them together but let the water and diluted pigment mix by themselves. The blue of the water is cerulean with only some water added. Reid tried to give each area—the sea, sand, and people—a color identity, even in very light, high-key areas.

Left to right - Ellnore, Sam, Peter, Sarah and Judith at Sandy cove N.S. - 7.26.78 -

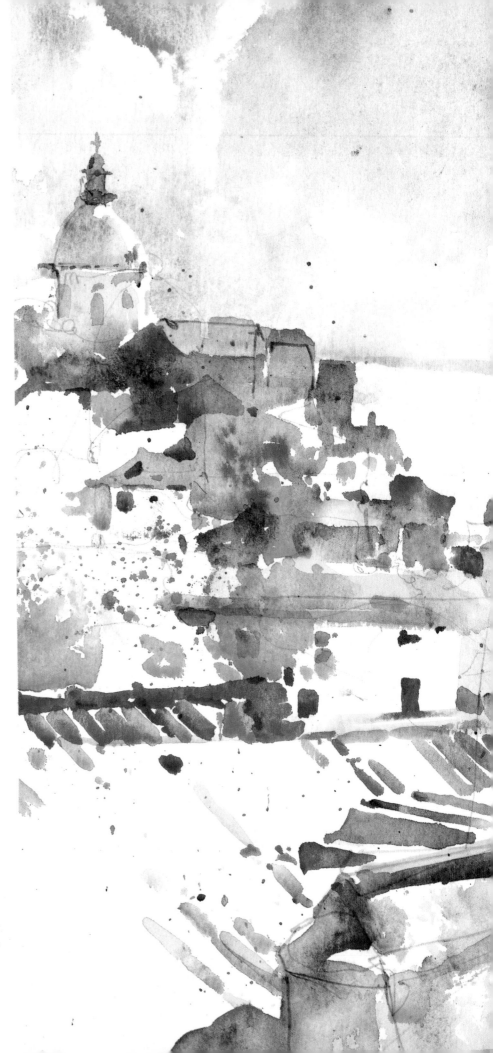

Charles Reid
Finding a Finish

The question of finish bothers
even experienced painters.
Charles Reid believes there is
no one answer to the question
of when a painting is finished,
just as there's no really good
answer to how to finish a
painting. For his part, Reid feels
he's finished when he can't
think of anything more to do.
He usually gets a wave of
weariness with the picture and
then he knows it's time to stop.
His advice is, if you can't think
of any more major statements to
make and find yourself merely
reworking areas you've already
painted, then you're finished.
You might not be happy with
the picture, but you'll probably
be a lot unhappier if you keep
punishing it.

Reid likes to leave paintings,
especially those done on the
spot, with potential for more
work. If after a second look at a
picture he feels that more is
needed, there should be places
on it still left to be painted.

Look at *View of the Alfama*.
There's quite a bit of white
paper left untouched. Should
Reid have filled it in? Certainly
that's open for judgment. Now
look at other things. Did he
catch a feeling of the rising sun,
off to the right, silhouetting the
buildings and ships? That's the
major question. Has he achieved
his "picture idea"—showing the
way the Alfama and the river
look at 10:00 A.M.? If so, the
picture is finished. If not, no
amount of small darks or details
will save it.

VIEW OF THE ALFAMA
AND THE TAGUS, LISBON
Watercolor, 11 × 15"
(27.9 × 38.1 cm).

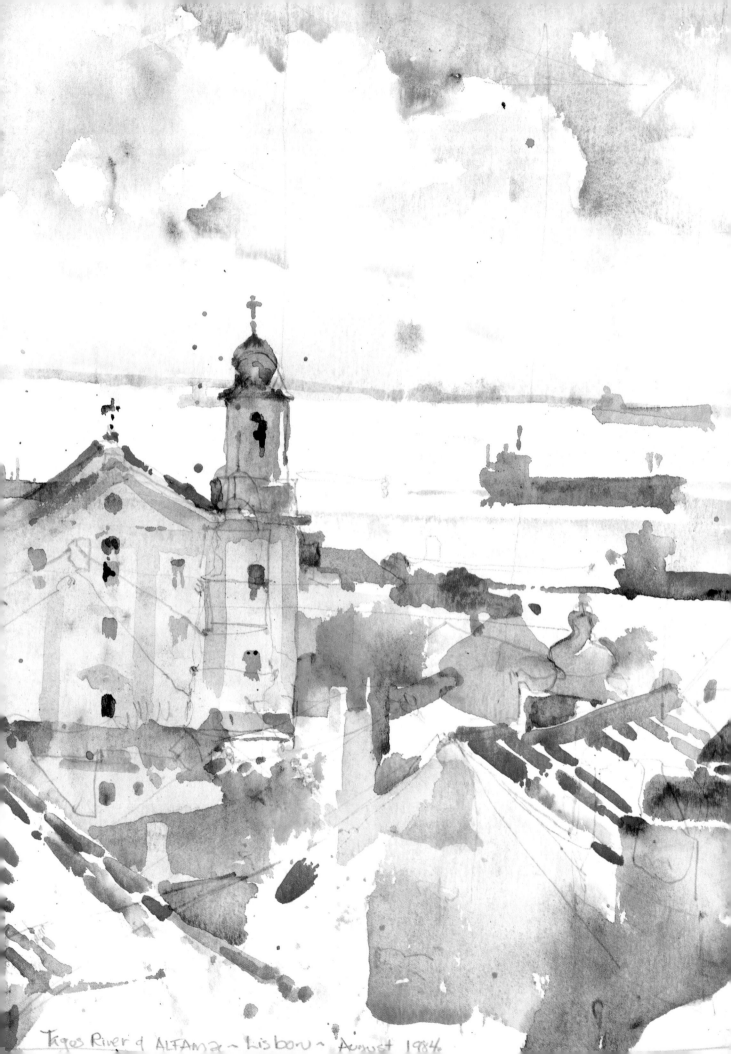

Tagus River & ALFAMA ~ Lisbon ~ August 1984

Philip Jamison
Composing with Abstract Design and Color

Abstract design and color are of equal interest to Philip Jamison as he starts this watercolor of a local farm. He takes special care in drawing the house as he lightly sketches in the scene with a pencil; he wants the shapes of the various snow-covered roofs to be the focal point of the painting. In a sense the composition is almost divided in half, with cool colors at the top and warm colors in the lower half. The placement of the colors also assists in creating a feeling of depth—the cools recede, and the warm colors come forward.

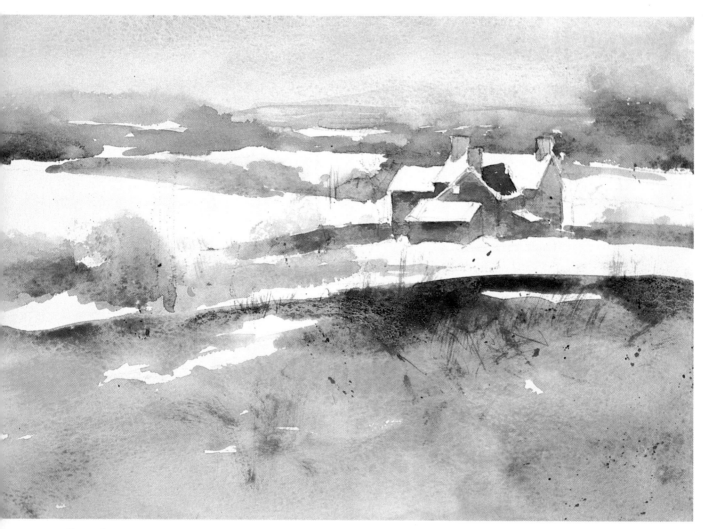

Step 1

His pencil drawing in place, Jamison initially covers the sky area with a warm underlay wash of yellow ochre. When this is dry, he paints a second, cooler wash of Davy's gray over the warm sky wash. From there he works right down the painting from top to bottom, almost without stopping, leaving the white of the paper for snow patches. Most large areas of paint are isolated from each other so they won't run together; however, within each individual area Jamison allows the colors to flow into each other freely. The distant hills are primarily Prussian blue and Payne's gray. The one spot of red denoting the tin roof is a mixture of alizarin crimson and Payne's gray. The foreground grasses are a mixture of most of the warm earth colors in his palette; the texture of the grasses is painted rapidly with a #4 sable brush.

This first step in painting the picture is unusually complete for Jamison's method of working. It goes very quickly, and details just seem to fall into place.

264

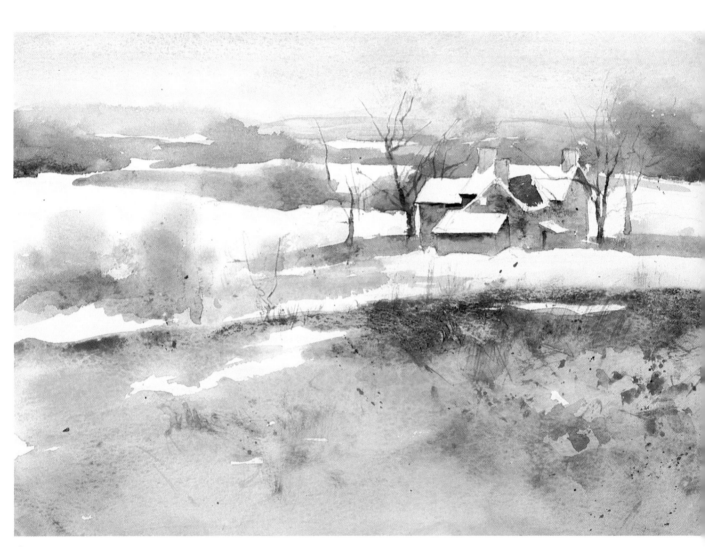

Step 2

A logical progression seems to develop easily through this step in the painting, which in Jamison's experience is certainly not always the case. He darkens sections of the house and some middle-distance trees with Davy's gray and Vandyke brown. In the tree line he dampens the area first with a 1" flat brush, drops in the paint, and allows it to spread out, forming soft edges. He does the same with the tree and brush forms at left center. Using a wet-in-wet technique, Jamison develops the large grass shape in the foreground with earth colors—yellow ochre, raw umber, raw sienna, burnt sienna, and Vandyke brown. After this underlying wash is dry, he casually drybrushes over the area with the same colors to create texture. Then he paints the trees, the darkest note in the painting, taking care to keep the limb forms smaller and lighter in value as they stretch out from the heavier trunks.

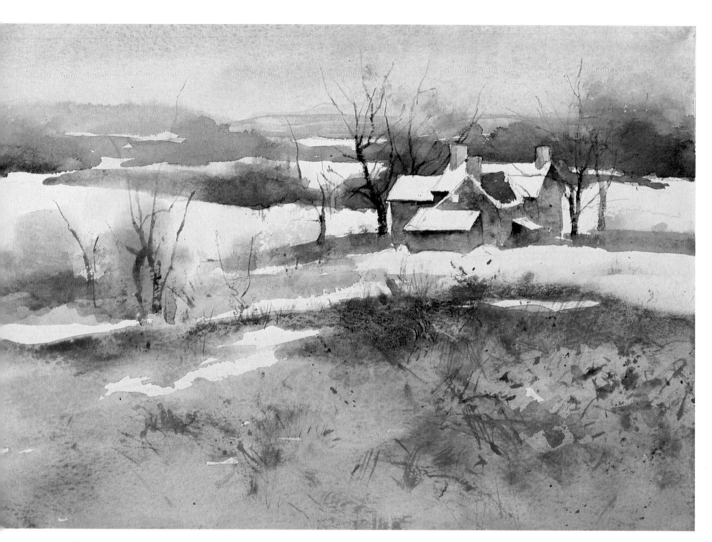

Step 3

This step is a simple continuation of step 2. Jamison adds the smaller trees at left and again works over the foreground, using the same method as before. He makes minute changes in the house, where he is especially concerned about bringing out the form of the building and the chimneys. Although the house is quite small in relation to the rest of the painting, it presents some fairly complicated perspective problems. Jamison wants it to be correctly drawn, but at the same time the actual painting of it must be as simple as possible. He tries to improve the shape of the horizontal strip of snow at right center by rubbing out a small section with a damp cosmetic sponge.

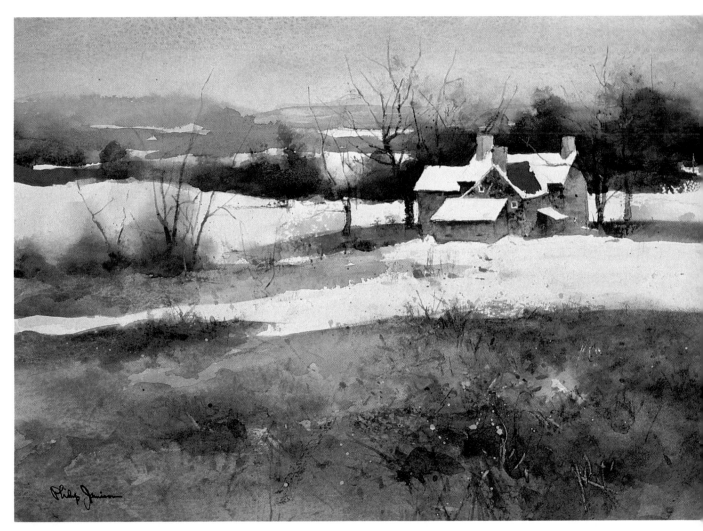

ABERNETHY'S FARM
Watercolor on Arches 140-lb. cold-pressed paper, 10 × 14⅝" (25.4 × 37.0 cm).

Step 4

At this point Jamison finds it necessary to put the painting aside for a few days so he can look at it with a fresh eye. When he comes back to it, he enriches the foreground for the fourth time with subtle washes of olive green, burnt sienna, raw umber, and raw sienna. He adds details to the left foreground trees as well as the windows of the house. Now that the watercolor is almost complete, Jamison's main concern is the abstract pattern of the light and dark shapes. He's not pleased with the shape of the horizontal strip of snow at right center, so he cuts some white paper into strips of various shapes and moves them around the painting until he arrives at a satisfying pattern. Then he scrubs this area out of the foreground grasses until he is down to the white of the paper. Finally, to strengthen the design, he lays in a darker, soft-edged wash over the middle-distance trees and the line of small shrubs at left center.

Don Rankin

Linking Basic Shapes to Build Your Painting

Successful paintings are most often built on the idea that various shapes and forms in the landscape must be linked together. Far too often, painters get so caught up in the "reality" and subject matter of the scene that they forget that a painting must possess its own level of reality. The mere fact that your subject matter is a compelling, interesting scene is of no consequence unless you are able to translate it into a viable painting language. While there is more to painting than linking shapes, if you get that part right you're off to a good start.

Bass Harbor Light

On a trip to Bass Harbor, Maine, Don Rankin arrived at the lighthouse just half an hour or so before sundown. The quality of the light was perfectly clear and golden. Prepared with a small sketchbook and a camera, Rankin began to work. Since he had seen beforehand several commercial photographs of the lighthouse, he knew immediately that he wanted to avoid duplicating any of these efforts. While a completely original statement may not always be entirely possible, Rankin believes it is the artist's duty to try. So in this context, his most important concern was to record his own reaction to the evening light. Each of the photographs shown here accomplishes that goal, and suggests a different painting.

Back in the Studio. Some weeks later, Rankin was back in his studio with some fine memories, a few good photos, and some sketches. When it was time to go to work, he began to examine his preparatory materials and make some final decisions about his approach. The sketches provided a good indication of the movement of shadow shapes up the cliff toward the house. They also told how the fairly clean lines and shapes of the house related to the jagged rock shapes below. After examining the photographs, Rankin found that he

PHOTO 1

PHOTO 2

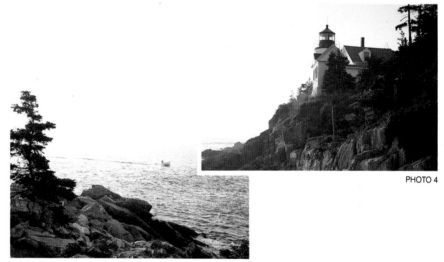

PHOTO 4

PHOTO 3

PHOTO 5

PHOTO 6

favored those that had the vantage point of looking up. He then began to develop the composition with quick sketches. On the surface, it appears that photo 5 influenced the final painting most. This is true as far as the angle of the building is concerned, but the truth is, Rankin liked several elements in all the photos that deal directly with the lighthouse. For the most part, the composition is pretty well spelled out by the photograph; the artist's alterations had to do primarily with the handling of the various shapes, the light quality, and development of detail areas. While planning the painting, Rankin borrowed the strong points that he liked from each of the photos. In photo 4, he liked the strong shadows off the side of the lighthouse, the strong silhouette of the pine trees against the sky, and the way all of the dark shapes angle down toward the left. In photo 5 he liked the vantage point of viewing both the lighthouse and the rock ledge from below. Of course, it's good to remember that decisions about what to use or omit are based largely upon personal taste.

This rough sketch was done as a way to begin thinking about the large shapes and how they made up the painting. At this stage subject matter is not as important as the movement and relationship of the masses.

Study this simple outline drawing. While there is no detail as such, you can almost imagine the finished painting based upon these flowing shapes. It is these interlocking shapes that will ultimately create the feeling of the work.

Finished Painting. Once all the preliminaries were completed, Rankin was ready to begin the actual work. One problem was that the photos and sketches did not really reflect the color he had seen that day, or at least, the color he "felt." Whatever the case, the camera just wasn't able to record the rich glow of the light that evening. It was this quality of light that had motivated Rankin to paint.

The photographs helped Rankin to recall the scene and the experiences he had had there. For him the experience itself is crucial to good painting. In this case, he was intent upon capturing the glowing quality of the light, but to do this he needed to build a foundation of interlocking shapes. The forms of the rocks and the way the house fits into the rocky cliff needed to be carefully drawn in first. The preliminary sketches were invaluable because they provided a framework for the painting.

Rankin began by applying diluted washes of new gamboge and manganese blue to the sky and the shadow areas of the rocks. Once this was completely dry, he changed to a mixture of new gamboge and Winsor red, using this mixture until he had a strong division between the sky and the highlighted side of the lighthouse. As he continued to develop the painting, Rankin was intent on maintaining the atmospheric effect of the light as it fell across the rocks and shadows. He managed to do this by keeping the washes transparent and allowing the edges to be somewhat indistinct. The shadow areas were the last to be clearly defined.

If you look at the shaded side of the house, you'll see that a tree and a window have been omitted. Rankin did this because when he applied the new gamboge and Winsor red mixture to that side of the building, the paint took on the exact glowing quality that he remembered. The effect also looked like reflected light. Rankin liked it so much that he decided to leave well enough alone.

A color study like this one is a helpful exercise in setting your energies in order. It not only lets you make decisions about the colors you want to use and how they will relate to one another, but also provides a means for testing ideas about shapes and how they relate. This sketch is also an attempt to study the lighting effects a bit more before committing to a final painting. As you compare this study to the final, you'll see how the shapes are still very basic and not fully defined. There are also some very definite changes from this stage to the final. Trying to duplicate a small study like this one for the final work would be like working in a straitjacket. The final work has to fly on its own merit or not at all.

BASS HARBOR
Watercolor, 24 x 14" (61.0 x 35.6 cm).

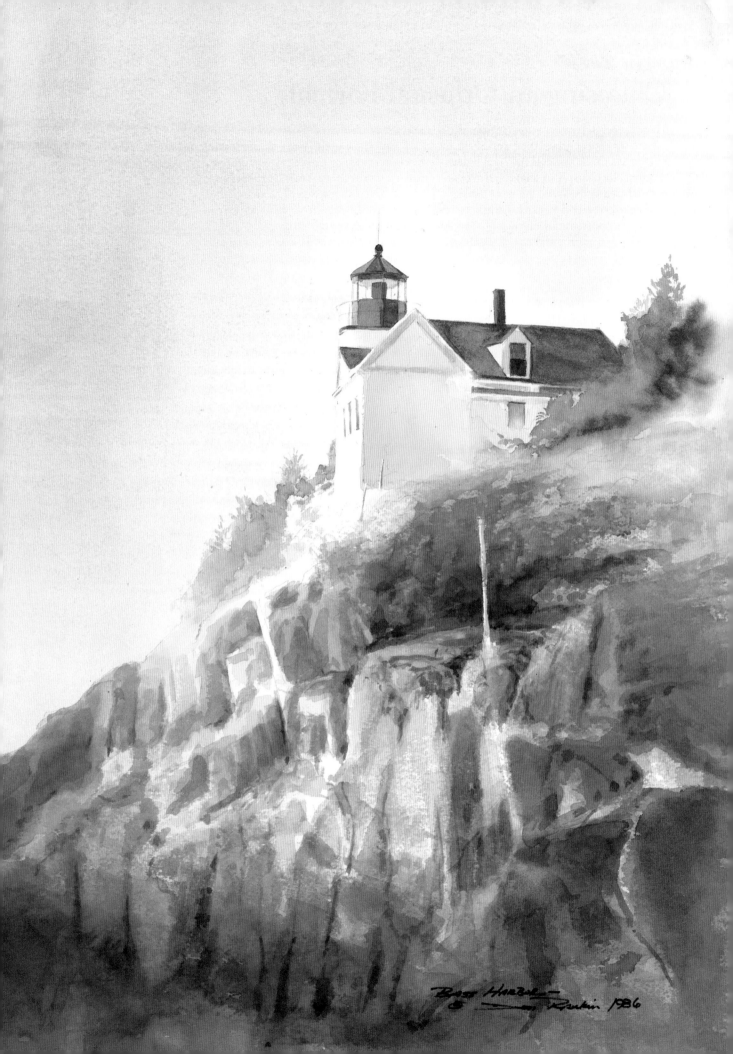

Bass Harbor
&bmp; Rankin 1986

Stephen Quiller

Choosing an Unusual Format

There are several reasons water media artists stick to traditional sizes in their work. First, it's economical to use a quarter, half, or full sheet of watercolor paper. Also, frames and mats are cut to these standard sizes. But by restricting yourself to certain proportions, you may cut out a lot of opportunities. Stephen Quiller has learned that there is always one, and only one, ideal format for expressing what he wants to say; this painting is an extreme example.

Even in his first sketch (study 1), he used two pages of his sketchbook, as he needed horizontal extension. He wanted to catch the stillness and restfulness of this warm, hazy scene. Quiller was particularly interested in the rock forms and the jetty projecting into the ocean. Notice the small cluster of buildings at the bottom of the sketch, which he repositioned in the final painting.

A year later, Quiller came back to this subject and did another quick sketch, adding a rock in the left foreground, some driftwood, and the shape of the dune on the right. He then did a compositional study, using a brown brush pen on two pieces of paper taped together to create the long, horizontal format he wanted (study 2). Notice how the rock on the left projects above the jetty to suggest depth and how the soft diagonals of the driftwood lead the eye through the composition.

For his value study (study 3), Quiller used black and sanguine Conté crayons, dragged flat across the paper to create halftones and suggest a hazy atmosphere. The ends of the crayons he used for intense darks, as you can see in the rock forms.

Quiller measured this value study to calculate the proportions of his larger painting, and then cut his paper to size. He chose a beige-toned paper because its warm undertone would shine through the watercolor and gouache, lending a feeling of unity and helping to create a warm, hazy atmosphere.

After rewetting the paper, Quiller washed on a transparent watercolor mixture of burnt sienna, cadmium red light, and cerulean blue for the sky area, leaving lots of paper untouched. When this had dried, he penciled in the rock, jetty, and building forms. Then, for the jetty, he used a wash of the same colors as the sky—slightly warmer but still very transparent to suggest the haze. With a somewhat deeper mixture of these colors, Quiller painted the shadow side of the buildings, roofs, and telephone poles. He let this dry before using a translucent application of permanent white gouache (opaque watercolor) for the sunlit side of the buildings.

STUDY 1

STUDY 2

STUDY 3

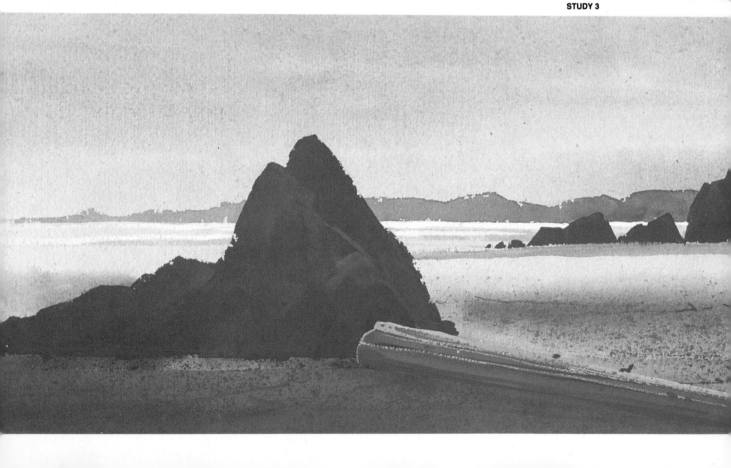

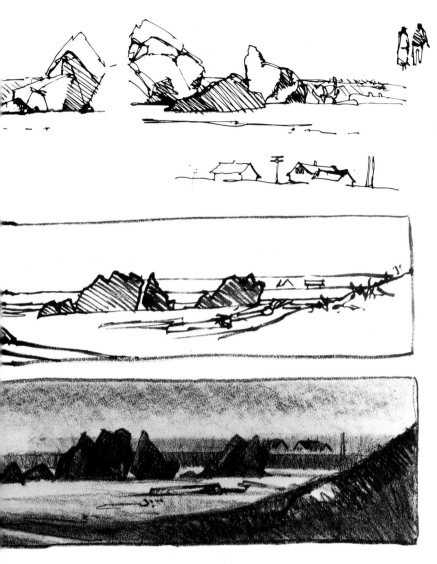

He also painted around the windows for architectural definition, but he kept the treatment soft, so it did not come forward too much.

When this was dry, Quiller used an opaque mixture of burnt sienna and ultramarine blue gouache to paint the rocks to the left of the buildings. Making these forms more solid, as well as warmer and darker, pushed the buildings into the distance. For the beach area in the middle and the driftwood, he used transparent watercolor. The light reflected from the water was painted with opaque white gouache. It added a sparkle to the subdued scene and, because it was lighter and brighter than the houses, served to push them back.

Finally, working wet-in-wet, Quiller painted the rock form on the left with opaque gouache, with more detail than the rocks in the middle distance. The right bank and the foreground log were then simply stated in opaque gouache. For finishing touches, he used a series of light watercolor washes and a light spatter for texture.

The result is a scene of peaceful serenity; the long, horizontal format is the key to this effect.

COASTAL HAZE
Watercolor and gouache on de Wint 72-lb. beige-toned paper, 7 ³/₄ × 29" (19.7 × 73.7 cm), collection of the artist.

Stephen Quiller
Evoking the Feel of Aspen in Autumn

Instead of working from preliminary sketches and value studies, Stephen Quiller developed this transparent watercolor in a looser, more spontaneous manner, based on his feelings about aspen, their fall colors, and the relationship of their forms to the mountains. These feelings, rather than a photographic representation of the scene, were what he was interested in conveying. Before beginning, he gave some thought to the composition— deciding where to place the main group of aspen, for instance. But he really did not want to be rigid. He wanted the paint to flow freely and to play a part in locating the elements of the composition.

Quiller began by wetting the paper with clear water, using a 2" squirrel-hair brush. While dampening the paper, he was constantly visualizing the clumps of aspen on the distant mountainside and how he wanted the color to flow. Using the same big brush, he applied a warm mixture of cadmium yellow medium, cadmium orange, and a bit of sap green, and let this wash of color flow down the paper in an irregular manner, leaving the lower middle area nearly white. He then washed in the foreground with pale sap green.

While the first wash was still wet, Quiller used a pocket knife to scrape out the shapes of trunks in the upper left. Using a #5 sable brush and darker shades of red and green, he painted some of the trunks positively. Then he created more tree trunks by painting negatively, that is, by painting around them, using red over green and green over red. When the wash was totally dry, he painted the very dark area at the top, thereby creating the tops of the most distant trees.

To determine the placement of the aspen trees on the right, Quiller developed a sketch on a separate piece of paper and placed it nearby on his worktable. He didn't draw the aspen trees on the painting; nor did he use Maskoid (liquid mask, or frisket), which would have spoiled the painterly quality he wanted. Instead, using transparent sap green in a pale wash, he created the aspen forms by painting negatively. This pale green provided the undertone for the dark spruce trees, which were painted later. Quiller also added touches

of cadmium red light to some of the negative pockets made by the branches. When the pale green dried, he gave it another wash of deeper color, adding Prussian blue to the sap green.

While developing the tops of the spruces, Quiller took care to space them in an irregular fashion and to make each a different height. To create the sparkle of light on the top of the foliage, he used a drybrush technique; then he developed the remainder of the spruces with a brush loaded with rich, dark pigment.

Next, Quiller washed in horizontal strokes of sap green to suggest a shadowed area under the spruces and to add stability to the foreground. After this had dried, he cut a stencil from masking tape and, with an old toothbrush, lifted off the green color where he wanted to extend the tree trunks into the foreground and where the figure was to be. When this scrubbed area was completely dry, he washed burnt sienna and alizarin over the trunks and, with great care, used a drybrush technique to develop scarred and textured areas in the trunks. This had to be done carefully to keep the passage very subtle so it would complement, rather than distract from, the essence of the painting.

Finally, Quiller painted in the figure and the trees at left. The trees were necessary not only to enhance the feeling of depth but also to balance the composition.

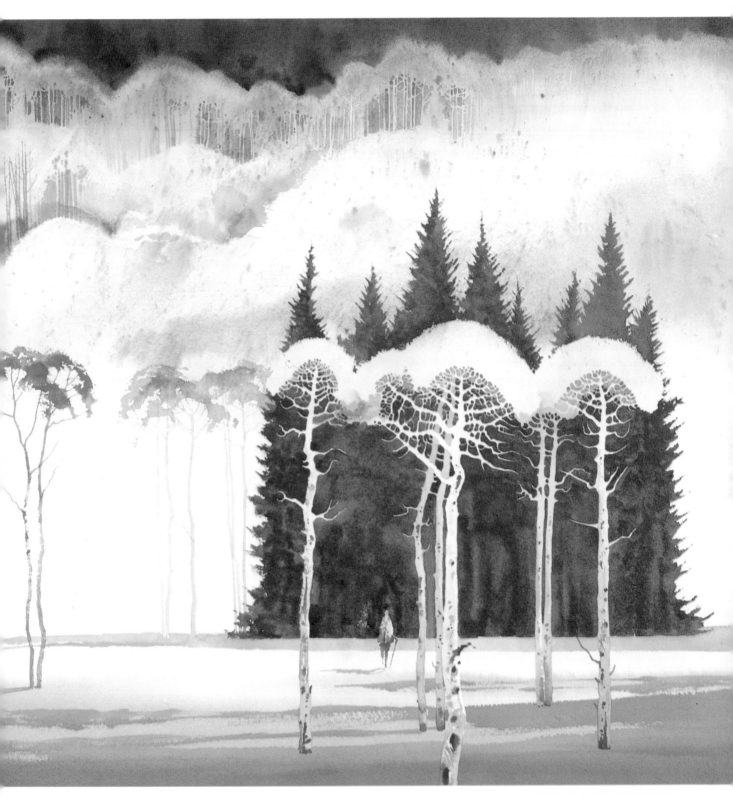

AUTUMN ASPEN IMPRESSIONS
Watercolor on Arches 300-lb. cold-pressed paper,
21 × 29" (53.3 × 73.7 cm), collection of the artist.

Richard Karwoski
Exercise: Dealing with Foreground and Background

Choose a landscape that has an obvious background (hills, mountains, sky), a definite middle ground (a row of trees or a house), and an interesting foreground (a single tree, flowers, a bird, or even a manufactured object). Decide which area of the foreground will be your primary center of interest and which will be your secondary interest. Then set up your paper either horizontally or vertically, depending on the direction of your subject.

The first step in this exercise is a preliminary drawing with an HB pencil. Keep a kneaded eraser handy to remove unwanted lines. Don't become self-conscious because you have to do a drawing; it can be very loose, perhaps just a sketch. It doesn't have to be a tight or complex rendering—the HB pencil wasn't designed for that kind of drawing anyway—but it is important to block in the basic shapes before beginning to paint.

Look closely at your subject matter, analyzing it in terms of a foreground, a middle ground, and a background, then draw what interests you. Don't worry about capturing a photographic likeness. When the painting is finished, and is shown publicly, only you will know where it was done. No one is going to say, "I saw ten leaves on that branch and you have only eight." You do the editing, the interpretation; you can take liberties with what you see. Allow the pencil to flow freely on the paper. If you are tempted to spend time perfecting small details, force yourself to keep the pencil moving and don't raise it from the paper. This will help you to create broader shapes.

Keep the point of your pencil sharp for a cleaner drawing. The drawing should take anywhere from five minutes to half an hour.

Once you're pleased with the composition, it's time to think about painting. In preparation, moisten any colors you plan to use with a drop or two of clean water.

Use a #10 or #12 round brush with a good point to block in some of the larger masses, such as the background sky. Work around the details—behind the leaves, behind the foliage. Save your center of interest until later. After the background or middle ground is dry, come back with a smaller brush, a #3 or #6, and paint the foreground and other details. When that is dry, you can go back to the larger areas, provided you've painted them light enough.

Mix your colors directly on the paper, not on the palette or a test sheet. If you feel timid about working with a lot of color or mixing color this way, then limit your palette. Using only shades of green or blue for an entire landscape might be easier than working with a full color spectrum, especially if you're just beginning. In fact, you might prefer to do your first painting in black and white, then introduce one color in your next painting, two colors in the third, and so on, continuing to add colors until you are ready to graduate to a full watercolor palette.

Keep the color fresh by changing the water regularly and rinsing your brushes frequently. If you want a color that is not on your palette, say a special green, dip your brush in the yellow and apply it to your paper. Then do the same with a blue, mixing the green just where you want it.

Another thing to keep in mind is that you can draw as you are painting, even after you have been painting a while, if you decide you need more detail. You can add to the painted or unpainted surface.

In his own work Richard Karwoski often leaves areas of unpainted paper to create positive white shapes or represent specific subject matter such as snow or small highlights. You can suggest an object by silhouetting a positive white area with color rather than by defining it with color.

Richard Karwoski used an HB pencil to do a preliminary drawing with a definite foreground, middle ground, and background.

He painted the larger areas first, including some of the background, with #10 and #12 brushes.

THROUGH THE TREES
Watercolor on Arches 140-lb. cold-pressed paper,
11 × 15" (27.9 × 38.1 cm), private collection.

In the last stage, Karwoski painted in the rest of the composition. He used ultramarine blue in the sky area to define the silhouettes of the branches but left the branches themselves and the trunks of the trees unpainted.

Richard Karwoski

Painting a Seasonal Series

Breeze Hill Summer was one of the first watercolors Richard Karwoski painted after he moved to his home in East Hampton, New York, in the summer of 1978. It was one of a series inspired by the natural environment surrounding his home and studio. Notice that he left areas of white paper unpainted, including the lower right-hand corner.

In *Breeze Hill Winter*, Karwoski has created still another view of the seasons, based on what he saw when he looked out the window of his home on a snowy day. Note how the shapes and color washes between the branches almost become the visual interest in the composition, rather than

the trees themselves. Karwoski introduced a lemon y[...] near the top of the watercolor sheet to contrast with [...] general cool look and feeling of the painting.

As a way of exploring your own environment, cr[...] series of paintings based on a particular site that int[...] you. Paint the same scene at different times of the y[...] even at different times of the day, aiming to capture [...] changing mood. Find ways to express the warmth a[...] greenery of summer, the crisp air and vivid contrast[...] autumn, the icy-cold beauty of winter, spring's soft g[...] and delicate new life.

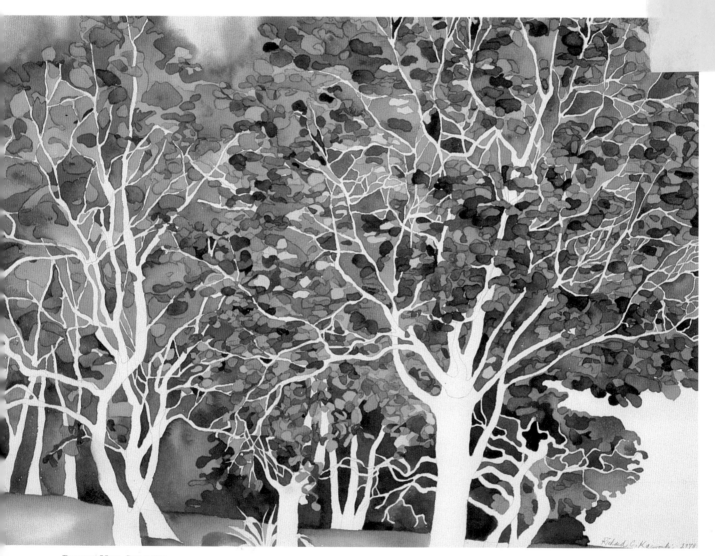

BREEZE HILL SUMMER
*Watercolor on Arches 140-lb. cold-pressed paper, 22 × 30"
(55.9 × 76.2 cm), collection of Mr. and Mrs. Plitt, East
Hampton, New York.*

BREEZE HILL WINTER
*Watercolor on Arches 140-lb. cold-pressed paper,
22 × 30" (55.9 × 76.2 cm), private collection.*

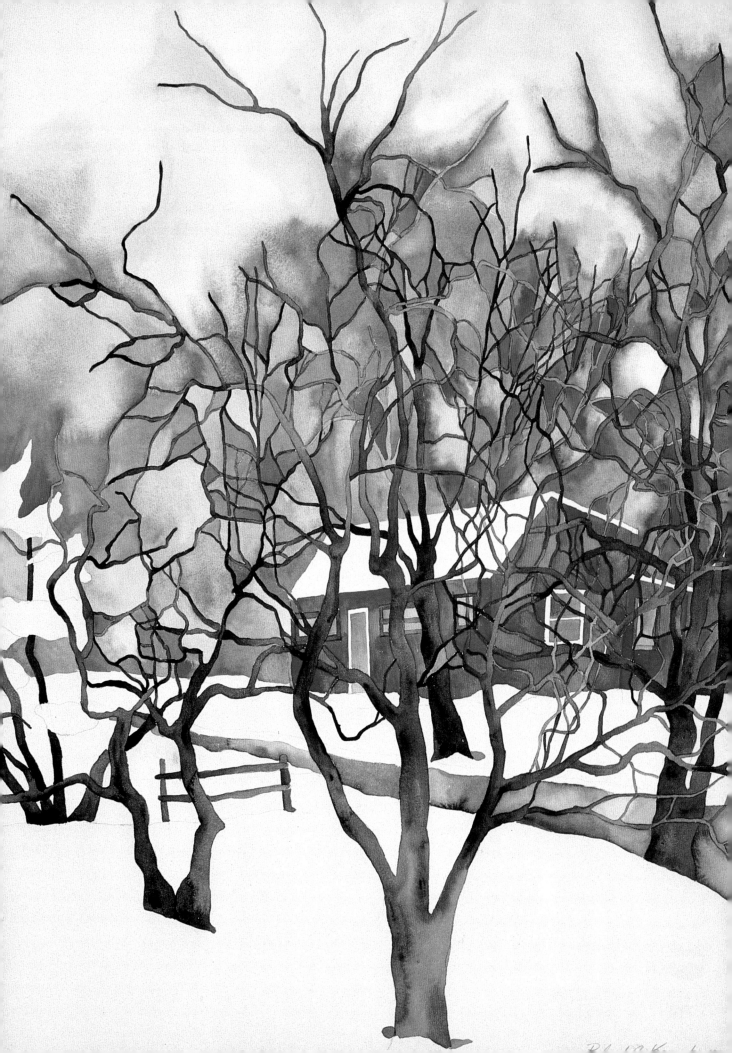

Richard Karwoski

Exercise: Painting a Sunset Wet-in-Wet

Richard Karwoski has been painting sunset watercolors for over a decade, ever since he saw J. M. W. Turner's watercolors at London's Tate Gallery Although he may average but one or two sunset paintings a year, Karwoski finds that they play an important role in his work. He enjoys doing them because they represent a departure from the way he usually approaches a watercolor painting, and that in itself can be a challenge.

In the exercise he presents here, you will paint the sun setting over the ocean (or other large body of water). When Karwoski works with this subject matter, he generally refers to a slide or photograph, because the sunset changes constantly. He usually works on a big watercolor sheet—22 × 30" or larger, up to 38 × 44". If the paper is larger than 22 × 30", he tapes it down to his working surface with some masking tape so it's less cumbersome. The large format gives him more freedom to experiment with washes of different colors.

Wet-in-Wet Method

Begin this exercise by just indicating the large areas of the composition; don't do a preliminary line drawing this time. The only pencil line on the watercolor sheet might be the horizon line separating land, sea, and sky.

Wet the entire sky area with a #24 brush or a sponge; then, working quickly, add the appropriate colors with a smaller brush, such as a #12. Start at the top of the sheet with a dark ultramarine blue or Winsor blue. As you work downward, slowly lighten the values and make color transitions to violet, red, orange, yellow, or whatever hues you see. Concentrate on mixing a variety of colors directly on the paper. Keep the paper moist so the colors will blend smoothly. The paint behaves less predictably when you're mixing colors over a large area than when you are filling in a small, defined shape. (When working on a large scale, you'll find you have more control over the painting surface if you paint standing up.) Be careful not to overwork this area.

Stop painting when you reach the line where the sky meets the land or sea. If you have indicated a narrow land mass near the center of the paper, leave it unpainted for now; it acts as a division between sea and land and prevents the color washes created in the sky from merging with the color washes in the sea.

Wet the other large area, representing the water, and proceed to paint in the colors that would be reflected by the sky. Begin with your lightest color just below the horizon line or land mass, and gradually add more colors and values as you work downward toward the bottom of the watercolor sheet. Remember that the colors that exist in the sky will be reflected in the body of water below. Adding yellow, orange, red, violet, and blue, in that order, to the sea would be one method of establishing a proper spectrum for a sunset painting. While the body of water is still moist, use the tip of a smaller brush and some fresh blue or Payne's gray to highlight ripples or waves on the surface of the water. Be careful not to overwork this area.

When the large areas have dried, the last step is to paint in the strip of land separating sky and sea. Do not begin by moistening the paper this time; instead, paint this area with a wet-on-dry technique, using a small brush. You might use Payne's gray, sap green, or even violet for this area, depending on the subject matter and the overall effect and mood you've decided to establish in the painting.

Right: Karwoski did no preliminary pencil drawing on the watercolor sheet except to indicate the strip of land separating the sky from the sea. He moistened the sky area with a #24 brush, then painted it with a #12 round brush, starting at the top of the watercolor sheet with cool colors that got warmer as he continued down to the hills on the horizon. When the sky was complete, Karwoski painted the body of water, using the same warm and cool combination but beginning with the warm tones and slowly adding the cool tones.

Below: Karwoski used a #6 brush and a combination of Payne's gray, sap green, and violet to represent the land at the horizon. Using a #3 brush, he suggested the reeds in the foreground with a combination of sap green and Payne's gray. He painted these directly over the body of water with quick brushstrokes that began at the bottom of the watercolor sheet and tapered about midway up to where the water meets the body of land.

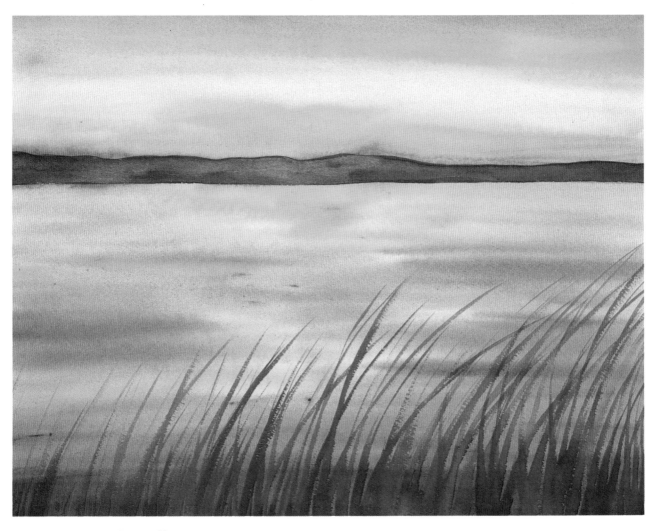

THREE MILE HARBOR SUNSET NO. 11
Watercolor on Arches 140-lb. cold-pressed paper, 11 × 15" (27.9 × 38.1 cm), private collection.

Valfred Thëlin

Placing a Silhouette Against a Colorful Sky

The next time you see a setting sun, look at the foreground as well as at the sky itself; the silhouettes formed are made of not just black, but of many different colors, as seen in Valfred Thëlin's painting *Fisherman's Wharf*.

The secret of painting a successful sunset, according to Thëlin, is to blend alizarin crimson with the blues, reds, oranges, and yellows you use. As the crimson blends into the blues, beautiful purples and mauves develop, and as it blends with yellows and oranges, beautiful reds develop.

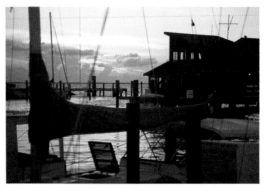

Here is a photo of the sun setting behind the fishing wharf that inspired the painting for this demonstration. When working with this type of very colorful sky, Thëlin likes to use it as the background and paint a silhouette against it.

Thëlin began by using his 1½" flat brush to paint the top of the paper with Winsor blue.

Then, working downward, he added alizarin crimson, blending to Winsor red and placing cadmium orange along the horizon line. Taking a damp brush, he encouraged the pigment to move in a specific direction, softening the cloud formations.

Thëlin suggested the main cloud shapes with a gray made of Winsor blue and warm sepia. Wherever he needed a straight line he used a ruler, holding it at an angle and placing the ferrule of his #5 round brush against it. You may prefer to draw lightly with pencil here instead of using just the gray watercolor.

With his 1½" flat brush Thëlin painted in the main wharf structures, using a mixture of Winsor blue, alizarin crimson, and warm sepia.

He then scraped out the highlights with a razor blade, using a squeegee motion, and finished the details with his #5 round brush.

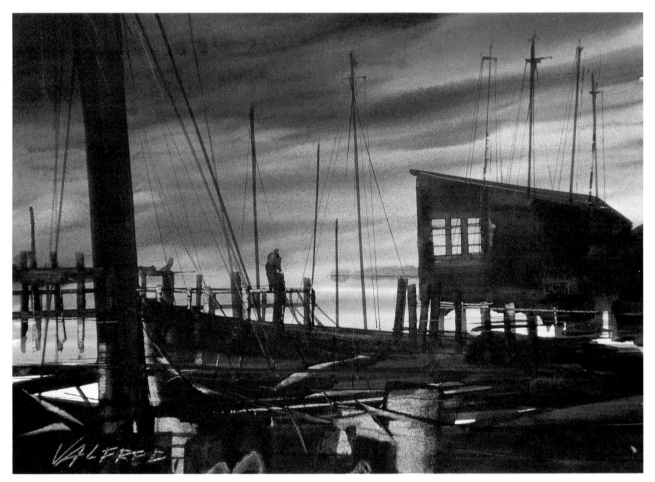

FISHERMAN'S WHARF
Watercolor on Arches 140-lb. cold-pressed paper,
16 × 20" (40.6 × 50.8 cm), collection of the artist.

Valfred Thëlin

Overcast and Stormy Skies

The simplest sky is an overcast one that's just plain white; however, even when this is the case, Valfred Thëlin prefers to put in some gradation. Whenever you are working with a plain, bright blue or gray sky, it is important to have an interesting, strong foreground to offset it.

Start with a dark wash at the top of the paper and lighten it by adding more water as you move toward the bottom, blending the sky over the entire painting surface. This makes it possible for reflections of sky to show through later in other parts of the painting. If you want to accent the angle of light, you can add just a touch of color in the top corner of the paper.

Quite often Thëlin paints his skies only after he has an idea of what the foreground is going to look like. However, if the sky is dramatic like the stormy one shown here, he paints it first.

As you look at a stormy sky, study the changing colors and values in it as the clouds move along and block out the sun. Ask yourself what colors it is—a turmoil of violet and earth tones, perhaps, or a multihued gray?

Thëlin began this painting by putting down a very wet wash with cobalt blue, being sure to leave a lot of the white paper surface showing through.

He came back into the wet wash with cadmium orange and warm sepia, and placed shadows on what would become the dominant cloud formation. He then added the foreground.

To set his middle value, Thëlin added the horizon line. Holding an atomizer 18" from the surface, he sprayed his semidry painting lightly with water to create white spotting. You can use an empty atomizer left over from some household product as long as you wash it thoroughly first. To get larger white spots, he spattered water with his brush. This works best on a surface of Winsor blue or cobalt blue.

With a #5 round brush Thëlin added trees to the horizon.

To turn the summer sky into a stormy one and make it look as if it was going to rain, Thëlin wet the painting surface one more time, working very evenly so as not to disturb the underpainting. He then added a mixture of Winsor blue, cadmium orange, and warm sepia to get a nice gray.

Aiming for the full dramatic look of an impending thunderstorm or tornado, he added a touch of Hooker's green dark and alizarin crimson. While the painting was still wet, he took a semidry 1½" flat brush and pulled it down through the stormy area to suggest streaks of rain in the distance.

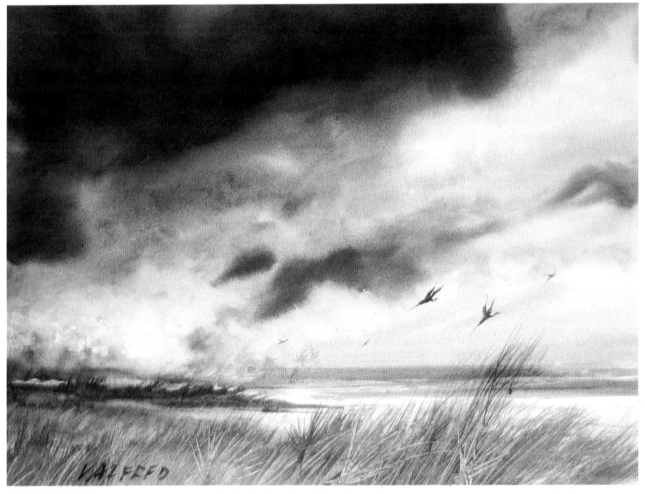

SWAMP FIRE
Watercolor on Arches 140-lb. cold-pressed paper, 16 × 20" (40.6 × 50.8 cm), collection of the artist.

Thëlin finished the painting by adding some grasses in the foreground and a few seagulls flying overhead; their natural patterns among the clouds make a design that helps carry your eye through the composition.

Stephen Quiller

Using Gouache in a Snowstorm Scene

This is one of the first paintings Stephen Quiller did after returning from Oregon to live in the mountains. Working with the theme of man and nature, the artist wanted to express his feelings about isolation and winter storms in the mountains. This is also one of his first paintings to combine gouache with transparent watercolor.

The subtle colors of this painting result from mixing two intense complementary colors: alizarin crimson and phthalo green. It's interesting that these rather garish colors, when combined, can produce such soft tones. The entire painting was done with a variety of single-stroke sable brushes.

Quiller began by saturating the paper with clear water; he then tilted it and applied wet-in-wet washes of alizarin crimson and phthalo green. While the paper was still wet, he loaded white gouache heavily onto a toothbrush and dragged his thumb over the bristles, spattering the opaque white. The white gouache flowed as it willed, blurring into the areas of transparent color. While this surface was still wet, Quiller made a deeper mixture of the two transparents and developed the left-hand ridge of trees. Another spatter of opaque white gouache was applied. Then he let the entire painting dry.

Later on, Quiller mixed the two watercolors and, with controlled brushstrokes, formed the foreground thicket and the somewhat paler tree to the right. This tree might not seem important, but it's necessary to prevent the composition from "falling off" on that side. It also suggests that the soft, diffuse background is really made up of tree and mountain forms. White gouache was brushed on to give solidity to the snow in front of the thicket. The figure was painted with the two watercolors, using a bit more alizarin crimson in the mixture.

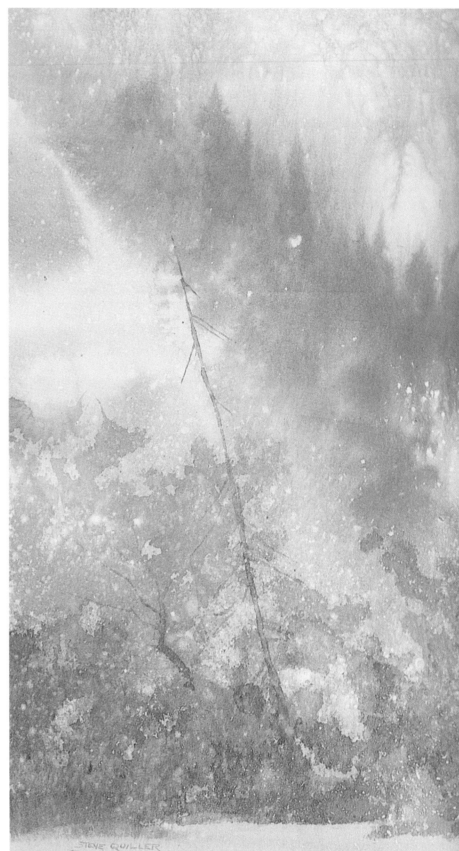

WINTER STORM
Watercolor and gouache on Arches 300-lb. paper, 19 × 24" (48.3 × 61.0 cm), collection of the artist.

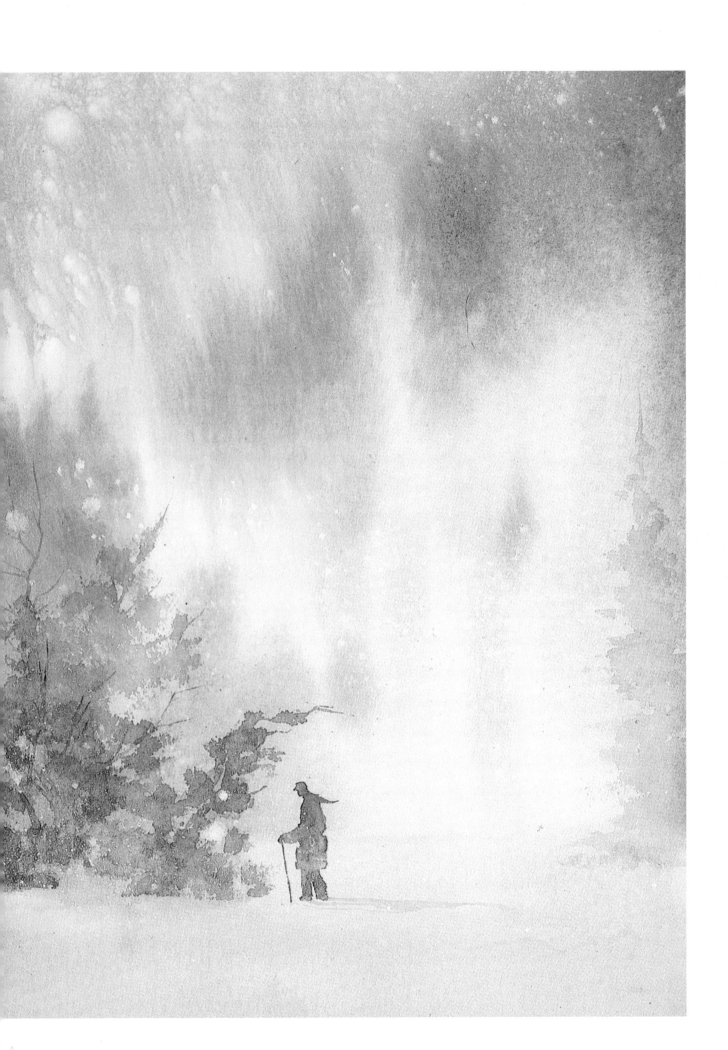

Graham Scholes

Conveying the Crispness of a Winter Sky

The day Graham Scholes photographed the building that became his subject, the temperature was -25°F and the air seemed to crackle. It wasn't only the house that he felt demanded a painting but also the sky, whose coldness exuded a textural feeling that inspired him to try an interesting technique for capturing it.

Masking simply means covering parts of a composition to keep paint off; masking tape, paper, wax, and liquid latex (frisket) are all possible materials to use. The latter two work especially well on rough or cold-pressed paper; and liquid latex applied in the drybrush method can have particularly interesting textural results.

The palette for this painting consists of cerulean blue, cobalt blue, Winsor blue, raw sienna, Indian yellow, and alizarin crimson.

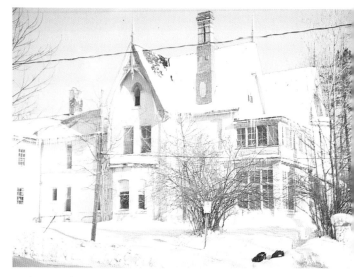

In planning the painting this photograph inspired, Graham Scholes found that all he needed to do was eliminate a few elements like the truck and the telephone pole and lines, as well as reduce the size of the bush in front of the house; then he was able to start his pencil drawing.

To protect the building while painting the sky, Scholes attaches kraft paper to the watercolor paper with masking tape and covers the chimneys with tape, gently removing the excess with a utility knife. To create the texture of the sky, he dabs on color with a tissue, first applying Winsor blue, then cerulean blue. After allowing this to dry, he loads a slanted bristle brush first with alizarin crimson, then Indian yellow, and then Winsor blue and spatters the pigment on the sky area by dragging his index finger across the brush. Next he draws in some of the tree trunks and branches with a wax stick as a resist, then dabs on Winsor blue, alizarin crimson, and raw sienna with a tissue.

Detail of sky texture.

After removing the tape and paper mask, Scholes is ready to start painting the building, laying down in sequence first light, then medium, then dark values.

Before applying his first light-value washes, Scholes draws in shrub branches along the side of the house with a wax stick to maintain whites. He then lays down a light, warm value of raw sienna and a touch of alizarin crimson for the yellow brick, dodging around the areas he needs to keep white and using more alizarin crimson for the warmer color of the chimneys. The cast shadows in the foreground are cobalt blue, the only color necessary to establish a path of vision and subtle detail. Any more colors could conflict with the sky and building detail.

With the medium value Scholes adds a little more color on the chimneys and some architectural details, and establishes the cast shadows on the building using cobalt blue, grayed slightly with alizarin crimson and the yellow from the first wash. Note the negative branches in shadow—the ones he drew with a wax stick prior to the first light yellowish wash.

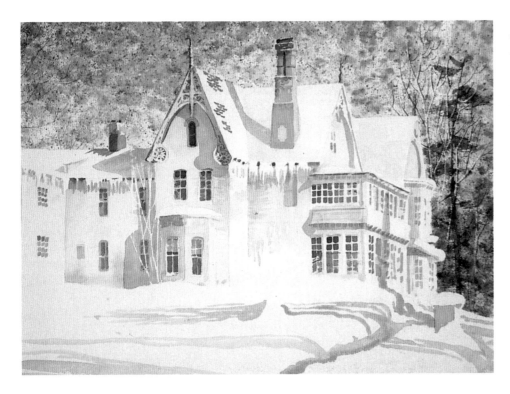

For the darks Scholes mixes Winsor blue and alizarin crimson, adding raw sienna to prevent the first two hues from going purple. He uses this combination for the windowpanes, eaves troughs, and gingerbread detail on the peak of the building.

Below, Scholes applies the final dark details with a palette knife, defining the bushes and small tree in the foreground, and branches against the sky at left.

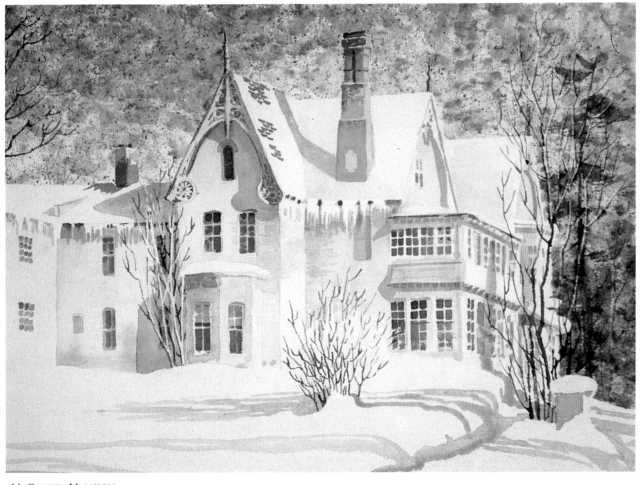

MCCONKEY MANSION
Watercolor on Arches 300-lb. cold-pressed paper, 11 × 15" (27.9 × 38.1 cm).

Don Rankin

Underpainting to Capture a Certain Time of Day

Any time of day or any weather condition can be created using the glazing technique, from a warm-colored afternoon to a cool, shadowy twilight. To depict a particular time of day, you must know what characteristics will convey that condition visually. Therefore, you must sharpen your powers of observation. You need to ask yourself: What is the difference between the light at sunrise and the light at midday? How does it change toward sunset? Are the changes predictable, or do they change with the setting, the season, and the day's weather?

If you have any power of observation at all, you know that many of the lighting changes are subject to a whole host of conditions. Once you understand some of these conditions, you will be better able to create a convincing visual portrayal. For example, sunrise and sunset have one thing in common: They are both low-light situations. The range between lights and darks is shortened so that you will have a very contrasty painting. These times of day can create some very dramatic color and contrast effects. As a general rule, early morning light is cleaner or clearer than afternoon light. Afternoon light will usually be bathed in warmer yellow or yellow-red tones. However, even though the evening light may appear at times to be warm, many objects will be bathed in cooler shadows in the evening than in the morning. As the season approaches autumn and winter, the yellows and reds give rise to warm crimson and golden tones, depending on your local latitude. For example, sunset in February in Alabama, Don Rankin's home state, is very similar in coloration to sunset in Nova Scotia in early June. The latitude makes the difference in the angle at which the sunlight strikes the surface of the earth.

Here the light is the beginning of dawn; many shadow areas are ill-defined and seem to blend into one another. Look at the shooting stand, occupied by two men, and at the shape of the boat with its reflection. Since the lighting is low key, the subtle distinctions in these areas are momentarily blurred. Don Rankin chose to utilize a warm color in the underpainting because the rising sun would permeate everything with a warm glow. He made the horizon washes a little misty to suggest wisps of morning mist that will quickly burn off as the sun continues to rise. The cool blue-green wash helps add contrast to the warm oranges of the underpainting. This color combination and the atmospheric effect of the lights and darks seem to suggest sunrise. The feeling and the time of day are clearly outlined in these first few simple washes.

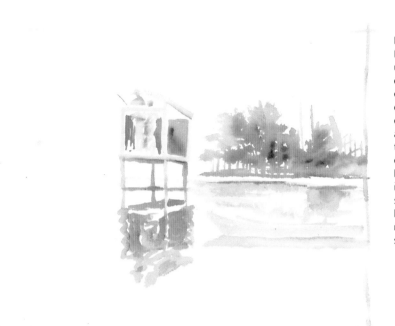

It is midday, and the sun has risen. Early morning mists have burned away under the sunlight, and the lights and darks are clearly defined and established. You can see a definite division between the lights and the darks in the underpainting. There is also a wider range of tonal values in this underpainting than in the previous example. The reason for this is that the light is stronger and more values are revealed. There are definite hints of shadow and depth in the distant tree line, the shooting stand, and the reflections. Also, the clarity of the scene suggests a later time of day.

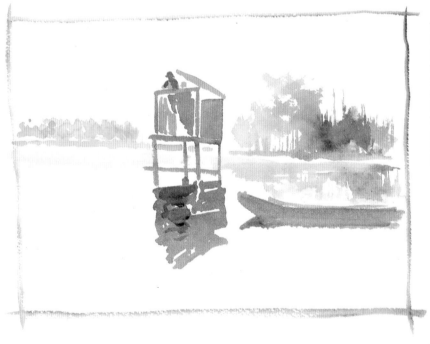

The sun has passed over and is now beginning to set. The distant tree line reflects the warm rays of a setting sun while the other objects take on a cool silhouette against the evening sky. The colors in this underpainting are Thalo blue, Winsor violet, and pale vermilion. This combination of colors suggests a setting sun with the coming of night. In just a short while everything will fade into black.

Stephen Quiller

Using Color for Mood

This painting is an example of how a subject can grow on you and how your surroundings can influence your painting. This building was a familiar local landmark for Stephen Quiller. He found himself noticing how it looked after sunset, when the streetlight was turned on and the right side of the building was sharply lit, contrasting with the dark, leafless trees in the background. He also enjoyed the way the tops of the mountains would catch the light of the setting sun and seemingly reflect it into the sky.

To capture the feeling of a late fall evening, Quiller selected a very limited palette of warm and cool colors, subjective choices influenced as much by the emotional response to a subject as to visual acuity. Consider which colors will best convey the mood you want to suggest. The palette you select can intensify the impact of your painting.

To understand the darks and lights of the main shapes, Quiller did a pencil drawing. He found that the spiky, rough textures of the tree forms offered an important contrast to the smooth, quiet areas of building and sky. Using his drawing for reference, Quiller lightly drew the building forms and indicated the road's placement on his paper. He wanted to have lots of activity in the branches, but leave plenty of quiet areas in the sky to convey the sense of solitude he wanted to express.

Turning his paper upside down, Quiller wet the area from about the horizon line to the edge of the paper and washed in a mixture of cadmium orange and cadmium red light, letting it bleed and grow lighter as it moved across the paper. When this was dry, he turned the paper right side up and washed on a mixture of ultramarine blue and ultramarine violet, taking care to leave plenty of the warm sky untouched. Then, after this had dried, he scumbled in the background ridge and the tree forms and also defined some of the branches.

For the lit-up side of the building, Quiller first washed on cadmium red light, diluting it with lots of water and applying it very lightly so the paper would sparkle through. When this had dried, he painted the shadowed sides with a mid-value ultramarine blue. The darkest value was used for doors and windows.

The foreground was a mixture of ultramarine blue, ultramarine violet, and brown madder alizarin, scarred while wet with a pocket knife. As the pigment slid into these crevices, it suggested a tangle of grass and weeds. Once this had dried, Quiller painted the foreground trees using ultramarine blue and brown madder alizarin. As a final touch, he mixed some gouache colors and picked out the light on the ridge, glimpsed here and there through the trees.

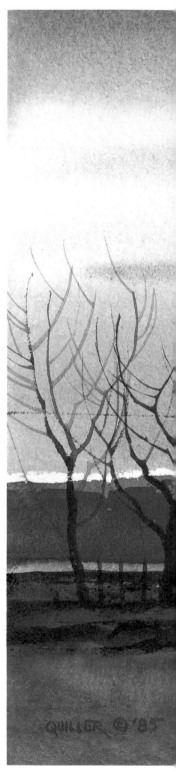

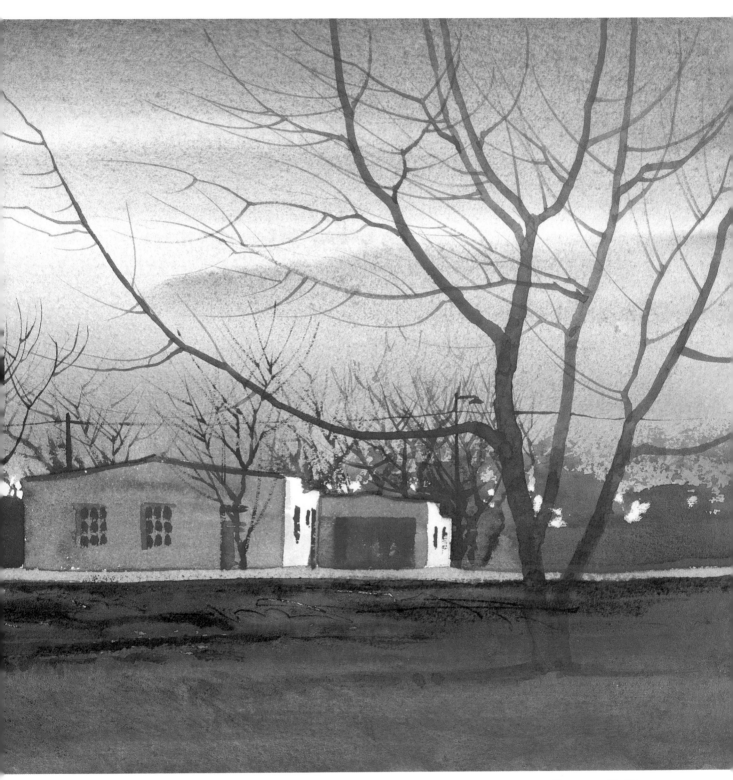

VIEW FROM MY WINDOW
Watercolor and gouache on Fabriano 300-lb. rough paper,
8½ × 12" (21.6 × 30.5 cm), collection of Philip and Lori Williamson.

David Millard
Building a Picture with Flat Blocks of Color

In a color woodblock print, or woodcut, a different block of wood is carved (in relief) for each color required in the overall image. The blocks are numbered to follow a sequence of printings that are done in register. The painting *Harbor Foliage* was conceived with the idea of approximating the appearance of a Japanese block print. By working step-by-step in this so-called color-block technique, even a novice can accomplish a rather complex composition.

In a woodblock print, the colors are self-contained; the areas are of flat color; the edges, for the most part, are hard. Look at a small section of the finished painting—the rigging of the ship in front of the shed—and see how it would be made had this been an actual woodcut. In the printing process, each block is dipped into a color and stamped onto the paper. So if you were to print the red shed, you would have to gouge out everything else from the woodblock except the areas that would print red. This means that the white rigging would have to be cut out first, before the block is dipped in red and stamped in the spot where the red shed is. Wherever the wood has been gouged out, the white of the paper remains unprinted, creating the rigging.

At the left, there is a black piece above the bridge of the ship, the result of our next hypothetical block, cut to print the black areas of the design. Again the white rigging and ship's details would have to be gouged out. Next, as you move up the mast and rigging, you have blue, olive, and tan color blocks, each of which would also have to be cut out and printed separately, in perfect register, so that all the ship's lines appear as uninterrupted white and so each color is self-contained.

Painting Stages

To imitate the effect of woodblock printing in a watercolor painting, David Millard made a preliminary drawing of an imaginary harbor village, a composite of buildings in Gloucester, Massachusetts. He wanted the drawing to have a handmade quality, so no T-square or ruler was used; he drew it freehand. A good deal of thought went into planning the stage setting: the levels of the roofs and their shapes, the sizes and positions of the skiffs, boats, and ships, with their rigging patterns.

As the title suggests, the foliage is the key to this watercolor, and all the colors have been selected to harmonize with the trees in shades that relate to orange. If you look carefully, you will see that even the trees are made up of individual blocks of color. Here Millard describes the steps he took in making this painting:

1. Put the two strips of sky in as a crown or top to establish a color that is unexpected (or unusual as a combination with orange) and will also serve to accent the foliage colors.

2. Put in the block that makes up the hills and trees. This block will be warmer as it comes toward you, and richer in pigment. It rests on top of the trees and roof, leaving an exciting pattern of white as the lower skyline.

3. Now put in the buildings, ships, and skiffs along the waterfront. Work your way along carefully, taking the time to get the colors and values right. Novices should use masking fluid on the rigging and masts; otherwise, cut around these spots, leaving the white bits and blocks of white roofs. Look at the detail of the finished painting for reference.

4. Move on to the water. Study it and duplicate the patterns there with care.

5. Put in the base wash of the tree foliage and, when it dries, paint the darker and brighter colors over it, as though they were being printed rather than painted. Work them, one at a time, over the previous, dry layer. This is also the way the darker red siding was painted on the red shed.

6. Millard placed two blacks earlier—the horizontal dark below the trees on the right and the black square behind the rigging. These blacks (and the white paper) suggest the extremes of the value range, and he can relate the buildings and ships on the waterfront to these darks as he fills in the other colors. Experiment with the remaining unpainted roofs. Where would you have placed the accents?

Notice the motion to the right: the sweep of the sky, the swirl of the water, the angle of the roofs. Because of it, Millard chose to lead the eye back into the painting with the ascending, ladderlike quality of the three black roofs on the extreme right, moving up and to the left.

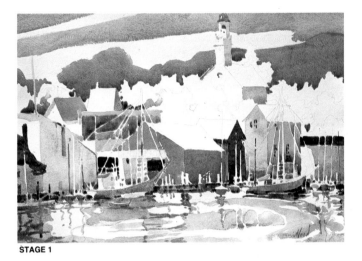

STAGE 1

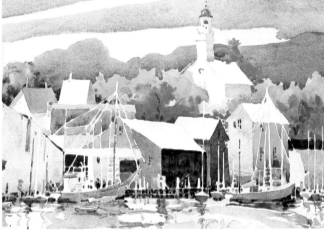

STAGE 2

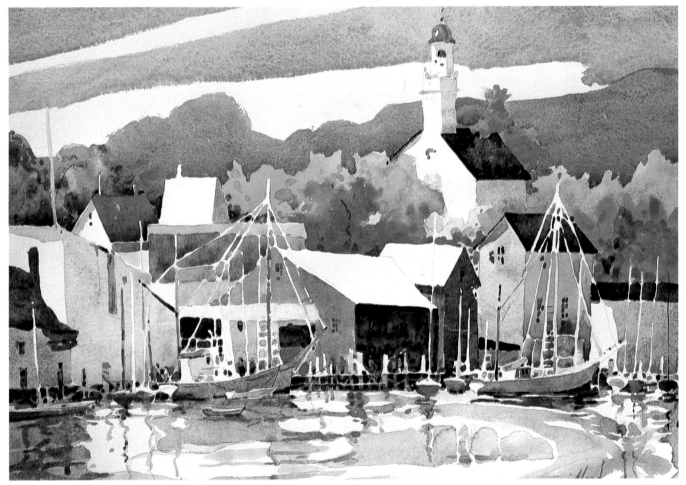

HARBOR FOLIAGE
Watercolor, 22 × 30" (56 × 76 cm), collection of the artist.

Edward Norton Ward

Simplifying Shapes

Although things in nature appear as complicated shapes with random edges, you should look for ways to reduce them to more graceful, simple geometric forms. When you first observe a tree, for example, it seems to be made up of hundreds of lines. Squint your eyes at the tree's mass, though, and you will see that most of these unorganized lines merge into a few major ones defining no more than a five- or six-sided irregular shape. The cottonwood trees in *Early Snowfall near Trampas*, right, had hundreds of branches of leaves. When Edward Ward put down the watercolor wash, he simplified their irregular edges to a minimum of lines. In the thumbnail sketch the trees have been drawn as a few overlapping five-sided shapes, their trunks suggested with two or three lines at most.

Morning at Noyo Harbor, opposite, shows how this principle also applies to man-made objects, in this case, boats. Notice that the bow of the nearest boat is drawn with only seven lines—two that define the top left and right edges of the hull, two that describe the waterline on each side, one vertical to describe the bow, and two small angled lines that suggest the rear. The other boats were drawn in the same way. Since the docks and buildings were of less importance in this painting, their shapes are barely suggested—just simple rectangles. The sketch of boat hulls below shows how with just a few strokes of a large flat brush, you can quickly and simply suggest fishing vessels.

When you paint outdoors, what counts is your ability to quickly select from a plethora of shapes just those few lines that define the essence of the subject and lead to a strong, simplified composition. Squint at your subject to see the important shapes, paint them in quickly with a few strokes, and then ruthlessly leave the image alone.

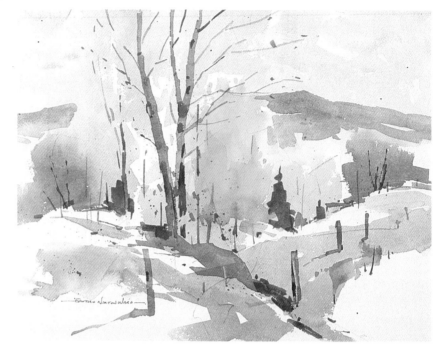

EARLY SNOWFALL NEAR TRAMPAS
Watercolor on 140-lb. cold-pressed paper, 11 x 15" (27.9 x 38.1 cm).

Most complicated or busy shapes can be reduced to simpler forms. When the edges of shapes are too busy, they are distracting and the resulting sketch begins to look overworked.

298

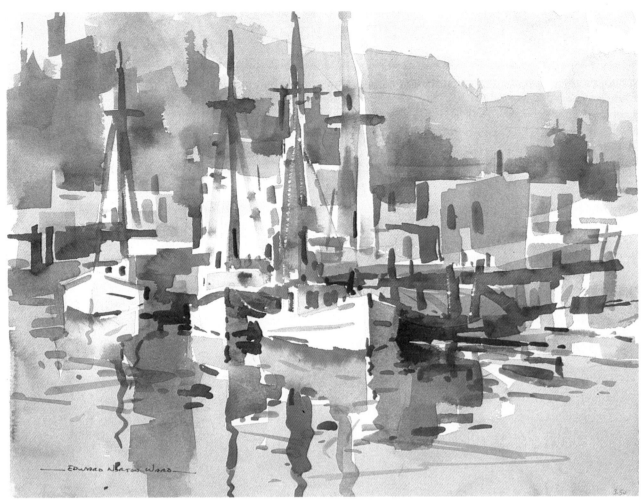

MORNING AT NOYO HARBOR
Watercolor on 140-lb. cold-pressed paper, 11 x 15" (27.9 x 38.1 cm).

The shapes and values of the hulls are more important in this composition
than the individual planks from which the boats were made.

Edward Norton Ward

Sketching Open Seas and Rocky Shores

When the open sea is your subject, you have to bring into play all you know about the planes that constitute the water's long, unbroken waves, and about how passages of floating foam from whitecaps can be used to knit these planes together. Though wave after wave stretches off toward the horizon, you have to find a way to design them so that you emphasize just one or two that are nearby.

Open Sea is a record of an experience Edward Norton Ward had while aboard the *Seacomber*. The ship had just cleared the entrance of the Lisianski Straits and headed out into the North Pacific off the Alaskan coast. There you will find some of the roughest seas in the Pacific Ocean, and that day was no exception. During transit, the surface of the rough seas kept attracting Ward's attention. Since he couldn't paint at the time, he tried to memorize everything he saw and felt, hoping to paint upon arriving in quieter waters. From the wheelhouse Ward tried to record in his mind the feel and motion of the sea, imagining how early

Russian explorers must have felt in their small sailing craft, without the benefit of twin 600-horsepower diesel engines.

An hour later, with the ship safely back in the shelter of Porcupine Bay, Ward painted this sketch from memory at the sink of the *Seacomber*'s galley. Had he waited any longer, another experience might have clouded his memory, and he might have lost the feeling of the heavy open seas.

Ward took full advantage of the white combers at the crest of the swells. In his first attempt at this sketch, he was left with one white shape dead center in the picture. In *Open Sea*, his second attempt, Ward placed three white shapes in a triangle to keep the eye moving over the surface of the water. He eliminated the horizon and suggested breakers in the distance to indicate a dangerous reef. By placing a pattern of grays and greens where previous combers had passed, he introduced color into the sea. Looking at his completed sketch, Ward was able to recall the feeling of the weight of those big waves.

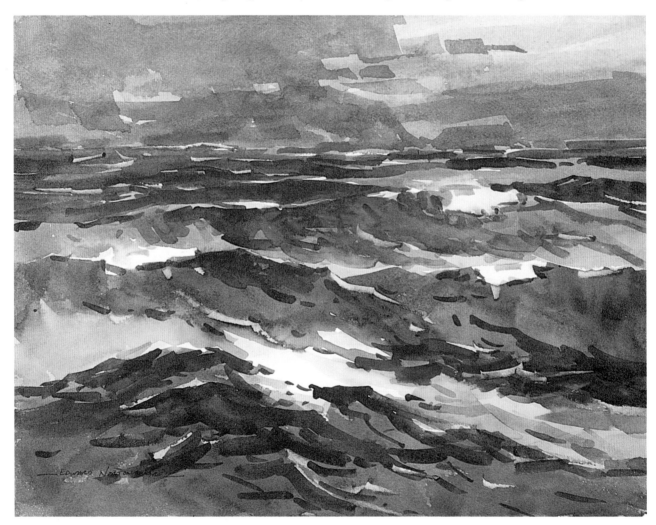

OPEN SEA
Watercolor on 140-lb. cold-pressed paper,
11 × 15" (27.9 × 38.1 cm).

Ward placed three white shapes of cresting waves in a triangle to keep the eye moving over the surface of the water and introduced some color into the sea by placing a pattern of grays and greens where previous combers had broken and gone by.

Since light plays such an important part in painting—especially in marine painting—let's look at some ways of using it interestingly. Naturally, the sky reflects off the surface of the water, and whatever bright colors are in the sky will show there. In *Light on the Sea*, notice how the offshore rocks break up the water's surface as they trail off toward the point in the background. This half-light of the sky eliminated almost all details in the rocks.

To emphasize the reflective surface of the water, Edward Ward drew it as a major negative shape. The irregular path of the protruding rocks gives the viewer a little adventure in getting to the distant headland and creates diversion from the placidity of the sea. The foreground bluff and offshore rocks give scale to the overall scene, again emphasizing the distance to the far point.

With the exception of a few carefully placed whites at the base of some of the offshore rocks, Ward used one large wash of light yellow-gray over the sky, background headland, water surface, and rocks. He then painted a second warm wash over the foreground bluff; this was his only variation of color and value.

When the initial washes were dry, he painted the headlands and offshore rocks in a cooler, darker value than the sky, with a slight hint of blue-violet to contrast with the yellow-gray of the sky and water. To suggest the disturbance the offshore rocks created in the water, he added a few strokes of cooler blue of the same value. Finally, he painted in warmer and darker washes over the foreground blue and the nearest offshore rock. Using dark accents, Ward was able to suggest coastal pines. This final touch of color completed his sketch.

On a clear day there is little atmosphere to break up the light. Sharp contrasts appear where shadows are cast on the white water. These shadows, which are actually darker than they appear, can be exaggerated to make the light seem brighter.

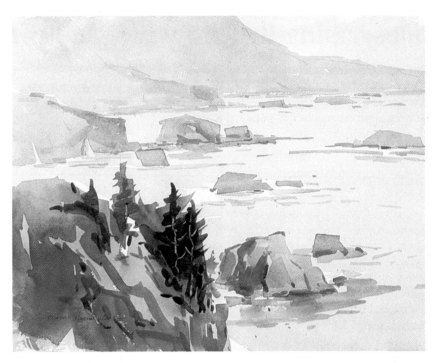

LIGHT ON THE SEA
Watercolor on 140-lb. cold-pressed paper, 11 × 15" (27.9 × 38.1 cm).

An aerial view reveals the surface of the sea in all of its variations. Ward drew the surface as a major negative shape, with rocks forming a path into the distance.

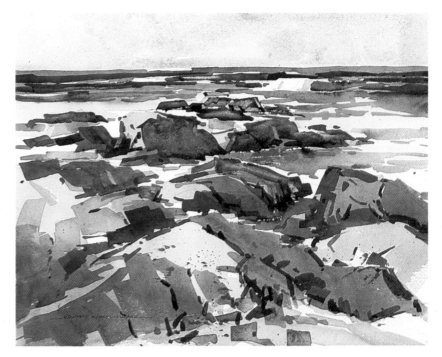

ASILOMAR COAST
Watercolor on 140-lb. cold-pressed paper, 11 × 15" (27.9 × 38.1 cm).

The rocky points going out into the white water characterize the coastal area near Ward's California studio. In low, bright sunlight, the rocks stand out as dark shapes massed together with their cast shadows.

Irving Shapiro

Describing the Flow of a Mountain Stream

Standing by a mountain stream in Colorado, Irving Shapiro was entranced by the movement of the water against the immovable granite. The lacy filigree of the water struck a note of whimsy, as if nature were frolicking amid the stoicism of the boulders. The elusive and the forthright: Shapiro wondered how he could translate all of this into a visual language. His view of the subject began to blend with considerations of pattern, color, and composition. He wanted to evoke sensory responses by enriching the light, exaggerating textures, and tuning up the rhythms.

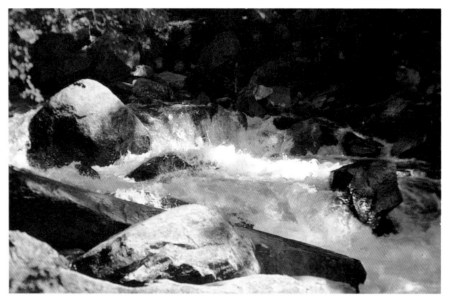

He began the painting by working into the water with a range of colors that includes cerulean blue, olive green, burnt sienna, and raw sienna. He dilutes the colors somewhat in his mixing tray, but doesn't mix them there—instead, he lets them mingle on the paper. Encouraging color to mix on the paper often gives it a radiance and clarity, which can be lost in the common tendency to overmix color on the palette. Notice that Shapiro's pencil drawing is minimal, simply establishing the placement of the main shapes. The brush he uses here is a 1" ox-hair flat that is excellent for broad, sweeping statements.

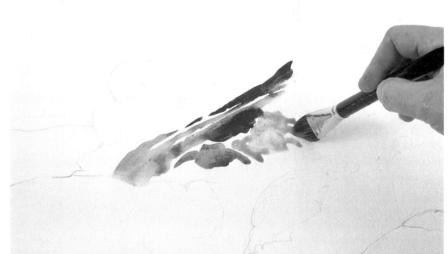

Color continues to be added—lots of it. Remember that the dynamic qualities of painting can be smothered by timid approaches. Note that Shapiro doesn't keep the water and the large rock to the left separate at this stage. He tries to determine how inclusive the handling can be as the painting is blocked in. His value sketch is tacked to the top edge of his drawing table. His paper surface— Crescent cold-pressed watercolor board—is secured to the drawing table by letting the heads of tacks grip its edges; the tacks aren't driven through the surface of the board.

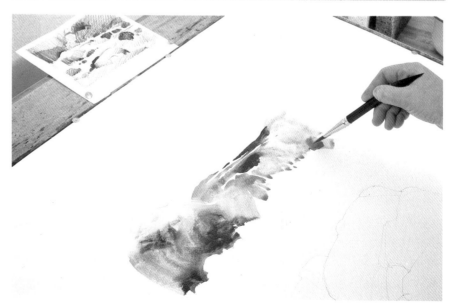

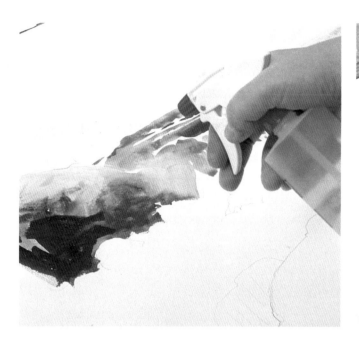

After introducing Thalo blue and burnt
sienna in an almost undiluted state within
the rock, Shapiro dilutes the rich, dark color
by spraying water into it. Splashing water
into color in this way creates fascinating
textures as the droplets of water run and
merge on the paper. It's an excellent way to
capture textured surfaces like rock. Then he
uses a facial tissue to blot the water sprayed
into the rock. In the closeup at right, you can
see the mottling that the spraying and
blotting technique has created in the rock's
surface. Shapiro continues, now with the
churning water, using cerulean blue, cobalt
blue, cobalt violet, and olive green.

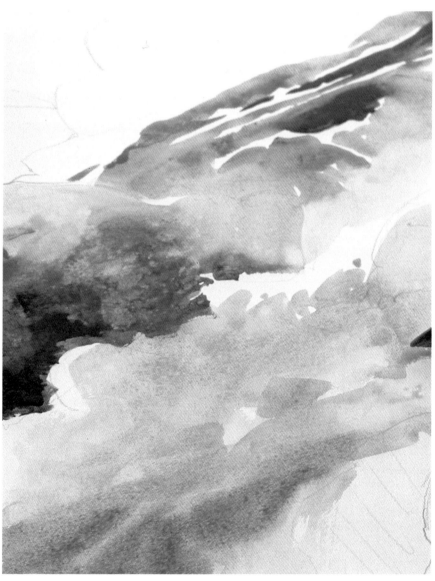

Leaving the water for the moment, Shapiro brushes liberal amounts of potent color and value into what will become the background plane and the far shore of the stream. The colors include Thalo green, Thalo blue, olive green, burnt sienna, raw sienna, raw umber, and burnt umber. He doesn't use much water because he plans once again to dilute the colors by spraying water into them. Spraying not only will texture the background but also will allow the various colors to fuse and mingle—avoiding the feeling of partitioned colors (colors that are too removed from other colors within the overall plane).

In this closeup you can again see the mottling created by spraying and blotting. The surface has dried, and Shapiro now defines some of the individual forms within the mass with a #12 round brush.

While the surface is still moist, you can scratch it to bring out delicate light shapes. Shapiro does this here with the back of the handle tip of his brush, which is beveled expressly for this purpose.

The large light shape you see here, representing a fallen tree, was wiped out with a damp brush. With a relatively smooth surface like the Crescent cold-pressed watercolor board, you can wipe out lights more readily than on more textured, "toothier" surfaces. Shapiro continues to scratch out more delicate lights with the handle tip of the brush.

Another trusty tool for scratching color when the surface is still damp is your fingernail.

Leaving everything that's been done so far, Shapiro lays in the mass of the foreground rocks, using warmer colors to reinforce the projection of these elements. Notice how the direction of his brushstroke follows the contour of the rock. There are many times in painting when you can think of your brush as a sculpting tool as you "carve" the forms.

Now he adds glazes of color to develop the color interest and dimension of the various forms.

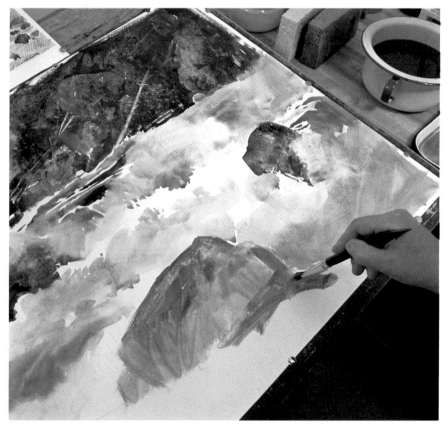

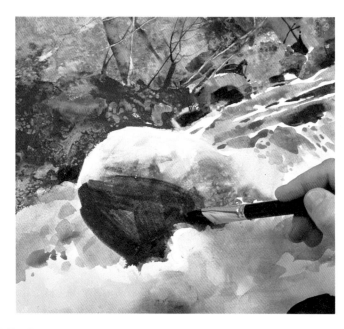

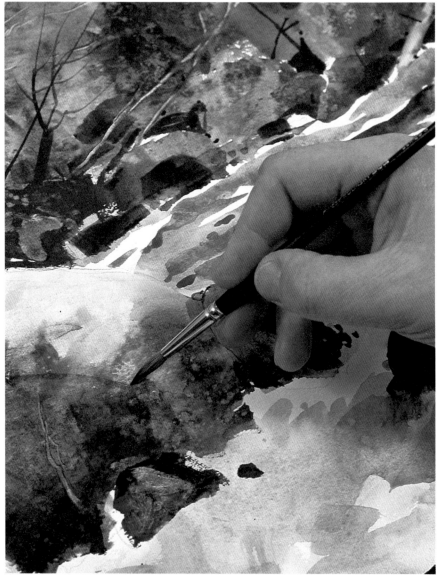

Pausing to survey the overall painting so far, Shapiro decides that the rock is not dark enough, so he deepens it with Thalo blue, alizarin crimson, and burnt sienna. After spraying the dark with water, he again blots it. While the surface is still damp, he scratches out a bit of light reflecting from the water with the handle tip of his brush. Then he indicates crevices and cracks with darker color and a smaller brush.

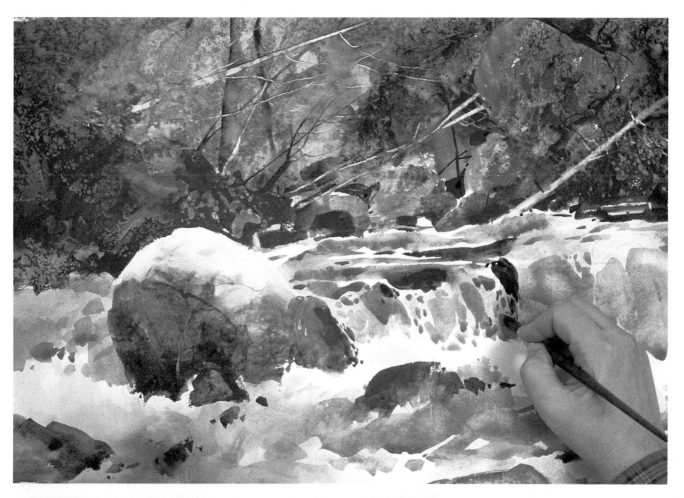

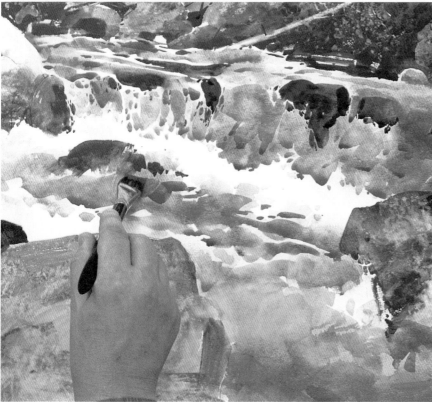

This is the area of the composition Shapiro wants to be the most commanding, so it gets special attention. He concentrates on the character of the rushing water. The play of dappled light, the faceted shapes in both the water and the rock, the transparency of the water, the swirl and dash of the water's movement—these are the qualities and feelings he hopes to capture. As you can see, the paper itself plays an important role in the painting; the white paper is part of the artist's palette.

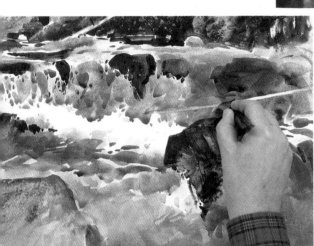

Here Shapiro wipes out a light with a damp brush. Lifting lights in this way gives them a soft edge, so that they seem somewhat diffuse.

At right you can see how Shapiro paints behind and around parts, identifying them by their negative shapes. The forms emerge here not by his painting them directly, but by his painting in the space outside them.

In this closeup you can see how the calligraphic use of the brush suggests fractures and patterns within the masses of the rock.

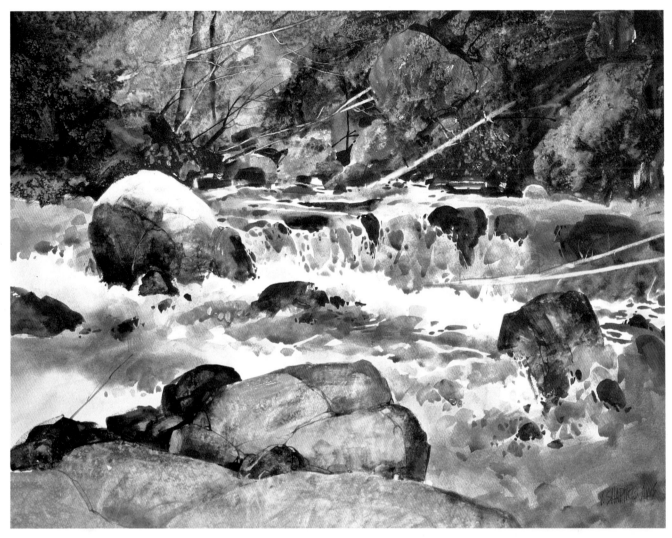

WHITE WATER

*Watercolor on Crescent cold-pressed watercolor board, 24 × 32"
(61.0 × 81.3 cm), collection of Mr. and Mrs. Clinton E. Frank.*

Here you can see some changes the artist made to translate his
feelings for the subject. The shift in the boulder's contour (1)
makes it less of a clumsy lump. Simplifying the background mass
(2), while enriching its color, lends animation to the more distant
elements. The altered rock shapes in the lower left (3) avoid the
slablike appearance of the real thing. The design of the water
surface (4) also provides a sense of pattern and heightened
movement. To capture the subject's radiance, the lights (5) are
developed as abstract shapes and made more contrasty. Areas of
secondary interest (6) are reduced in contrast, color, and definition,
thus strengthening the center of interest. In all, the composition is
deliberately arranged to encourage the eye to flow (7). Even the
fractures in the boulders elaborate on the sinuous rhythm.

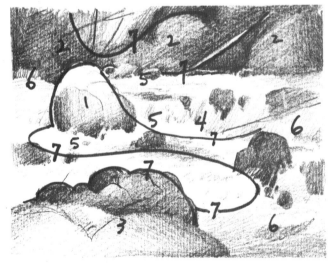

Don Rankin
Looking for a Fresh Angle

The subject of a well-known old mill has been a challenge for Don Rankin for more than twenty years, when he was first taken to the site by a teacher. For six months Rankin made drawings of the mill. He loved its textures and angles, but hated his attempts at solving the problem of conveying the mill's elusive quality.

Years later he returned to this familiar landmark, setting about to find a fresh angle from which to paint it. He took a series of photos of the site. The valley in which the old mill stands is thick with trees, and its dark, foreboding lighting creates some interesting visual effects. In late winter and early spring the afternoon sunlight barrels down through the valley, at times like a search-light. After the foliage comes out, the light becomes diffused and much of the mill falls into shadow.

You will see that there is no one photograph that corresponds to the view of the mill Rankin chose to paint. That is because from this angle a photograph would only reveal limbs and undergrowth. So he took artistic license and made some major modifications.

Because of his familiarity with the location, Rankin decided to review a few vantage points. Armed with a camera and a sketchbook, he began to gather material that would help him decide on an approach. Most of the decisions were actually made on the spot. Back in the studio, he began to refine the rough drawings he had made on the site. He had taken almost three dozen black-and-white photos to record placement, shape, form, and time of

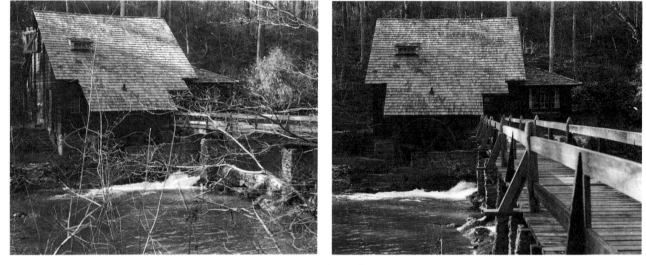

Most people see the old mill from a very restricted vantage point on the road.

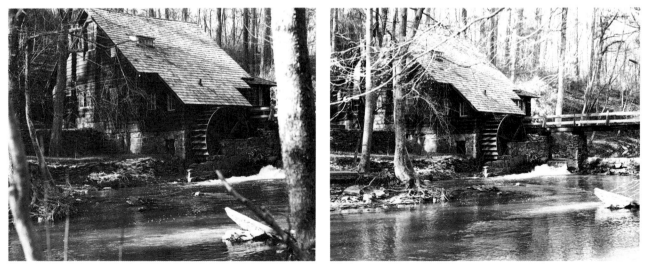

A few hardy souls climb down a bank to get a different perspective on things.

day, in many cases composing shots from the same angle as his sketches to help him recall the situation back in the studio. Very rarely does Rankin use color in his sketching shots, preferring instead to compose his own color renditions on the spot. In some cases the color is so vivid in his mind that no reference is needed.

Study the sketches and compare them with the photographs as they progress toward the steps to begin painting. The amount of time spent on each sketch varied; some were quite involved, while others were unrealized and somewhat crude. But each line served a purpose: to communicate to the artist and to help spark his memory. Rankin thinks sketches should be like shorthand notes. As long as he knows what they say, nothing else really matters.

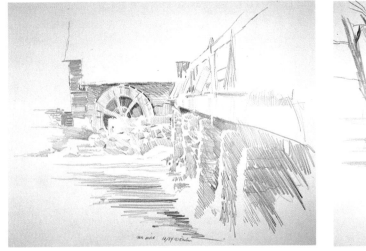 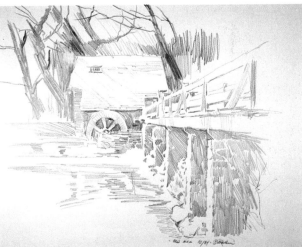

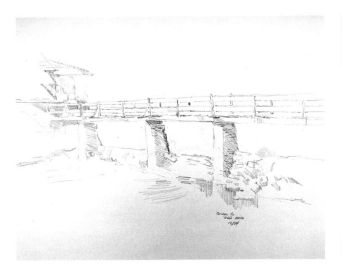 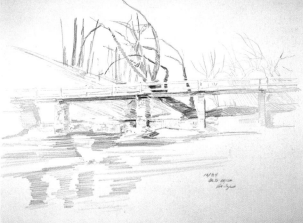

Preliminary pencil sketches for *The Old Mill.*

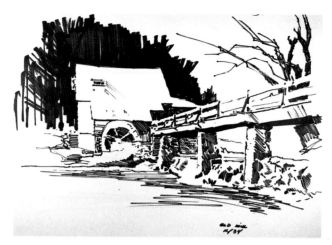

Executed in felt-tip pen, this sketch takes another look at the mill from a different vantage point.

Preliminary for the final reference sketch.

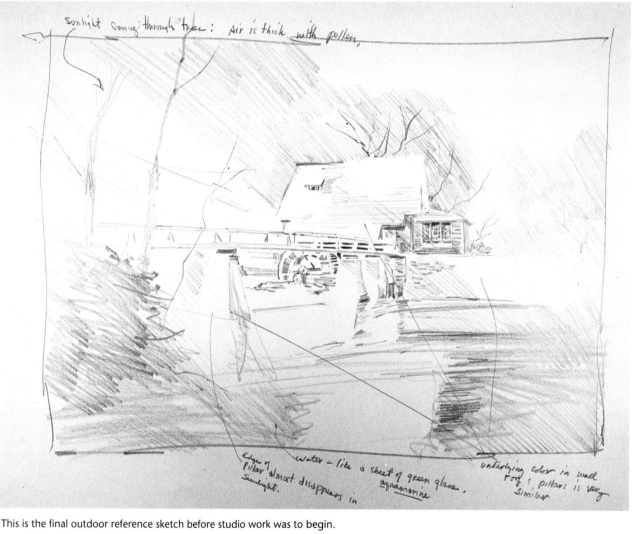

Sunlight coming through trees: Air is thick with pollen,

Edge of
Pillar almost disappears in
Sunlight.

water - like a sheet of green glass, aquamarine

underlying color in wall
roof + pillars is very
similar

This is the final outdoor reference sketch before studio work was to begin.

After considering alternatives, Rankin chose to develop the old mill as you see it in these sketches. Much of the painting was left to be worked out in the actual painting sequence. His palette consisted of new gamboge, Winsor blue, manganese blue, Winsor red, and Thalo yellow green.

Step 1. The final sketch was transferred to watercolor paper. Note that certain parts are very finished, but others have been left vague. In a painting like this where a lot of soft color is going to be established, Rankin avoids the distraction of too many pencil lines.

As soon as the major elements had been sketched in place, it was time to paint. Rankin began with a Winsor blue underpainting, using three values of blue. Here, note what is painted and what is not. Much of the character of the finished work will be set with a few pale blue washes. Consider the part of the underpainting that indicates the water. The character of this wash reflects the smooth, flowing quality of water. The reflections, some of the ripples, and the shadows were all suggested by this first wash. The major shadow areas, the direction of the light, and the reflections of various items in the water have all been established. Note that some of the major darks are set from the very beginning. These areas grew even darker as the work progressed. But even more important, the placement of these darks helps to suggest the mood of bouncing light.

Step 2. As soon as the blue underpainting was completed and dry, Rankin put the entire sheet of paper into a basin of water and allowed it to soak until thoroughly wet (about five minutes). He then stapled the wet sheet to a wooden board. While the paper was still very wet, he applied a dilute wash of new gamboge, but avoided those areas where he didn't want the highlights to contain any yellow. He also avoided the sky. The yellow wash helped to establish a mood of sunny warmth.

Step 3. After the new gamboge wash was dry, Rankin merely brushed in a mixture of Winsor blue and manganese blue, being careful to dampen a large portion of the sky as well as the tree area. In this manner the blue wash could bleed out to a feathered edge if necessary, so there would be no harsh, abrupt edge to disturb the flow of the washes that would make up the foliage.

Step 4. After the previous wash had dried, Rankin was ready to proceed with another layer of color. Since he was intent on portraying an early spring day, with soft yet direct sunlight filtering through the pollen-laden air, he wanted to keep his washes very soft instead of hard-edged. The best way to accomplish this was to paint wet-in-wet. The wash applied here was flowed over damp paper. The upper portion of the watercolor was dampened with clear water. Care was taken to avoid the mill area. Also note the indication of light coming in a diagonal sweep from the left corner. In this area the wash was diluted. Depending on how intense such a wash appears after it dries, in a situation like this you might need to apply more than one layer of this color. Do not hesitate to modify color if the need arises.

Step 5. This wash is a mixture of new gamboge, manganese blue, and Winsor red. As the color dries it separates, creating several shades of orange and yellow. This wash was confined to the upper portion of the painting and was allowed to seep down the rock wall into the water on the right side of the picture plane.

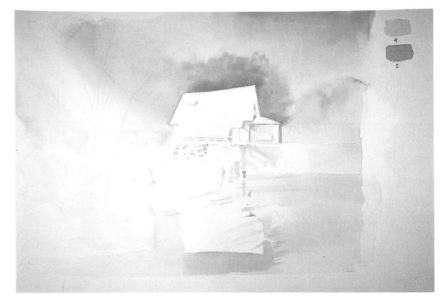

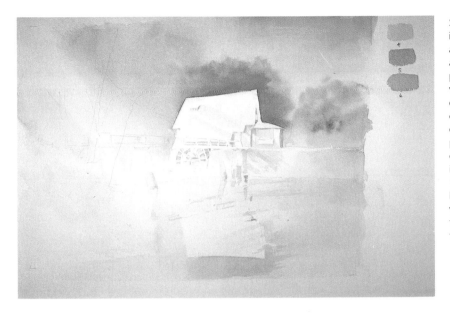

Step 6. Several washes were applied in a wet-in-wet sequence. One of the applications was a mixture of Winsor blue and Winsor red. In this step as well as the previous one, all washes were applied to very damp paper. While these washes are difficult to control, Rankin was able to contain them to some degree by wetting only the sky and the upper portion of the painting. He applied the washes with the edge of a square sable brush while imitating the general shape of trees. Naturally, the washes spread out and became feathery soft on the edges, which worked to Rankin's advantage in creating the effect of fresh spring growth on the trees.

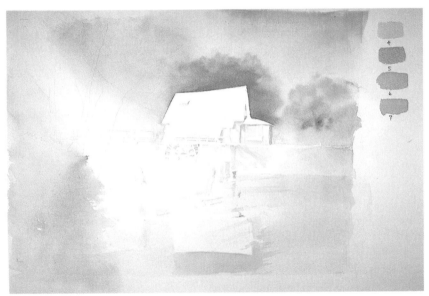

Step 7. While the upper portion was drying, Rankin decided to apply a mixture of Thalo yellow green and new gamboge to the underbrush in the lower left corner—a very simple operation. Later, this color would be modified with cooler washes to create shadow in this area.

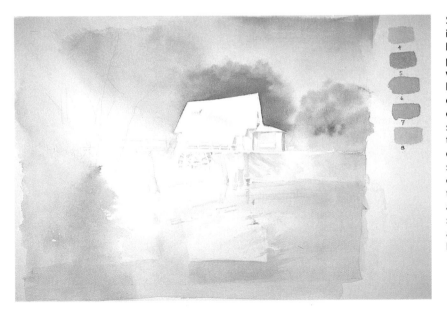

Step 8. To bring the rest of the painting into balance, Rankin applied the first full layer of color to the water and to select portions of the roof and masonry. The wash was a combination of manganese blue and new gamboge. On rare occasions, the water flowing down out of the hills in this area will be clear and sparkling like aquamarine; this was one of those days. As a result Rankin took a great deal of care to get the color right. As you study the example you will see that this color was also used as an underwash on the shadows of the rock walls and pillars, as well as the roof. When sketching the scene, Rankin had made note that these areas were closely related in color harmony.

Step 9. After the wash had dried, Rankin decided to further strengthen the foreground of the painting. He did this by applying a slightly bluer mixture of the previous color combination. Before applying the wash, he wet the water area with clear water. While it was damp, he washed the color in with a sweeping diagonal motion. He was extra careful to avoid placing any additional color in the section under the bridge at this time. If a color correction was needed in this area it could be done at a later date. Rankin's purpose here was to create a form of graduated wash. The strength of the color was in the foreground; it gradually diminished as it moved toward the horizon.

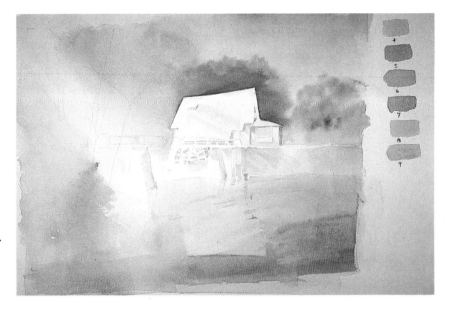

Step 10. A neutral wash consisting of manganese blue, new gamboge, and Winsor red was mixed on the palette and washed into several areas. Examine the trees at left, the bridge, the waterwheel, the roof, and the rock wall. This wash helps to develop the overall balance. In this step the color on the rock wall was applied as individual brushstrokes, imitating rough-hewn rock. As more color was applied, this texture became more prominent.

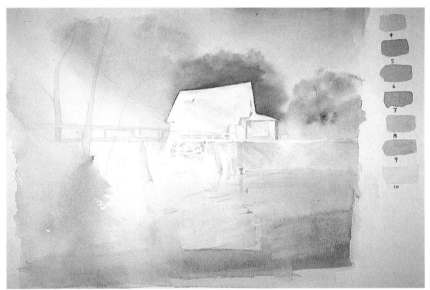

Step 11. The neutral wash that was applied next is very close in color and value to the preceding layer. Although it was mixed from the same formulation, it is just a bit darker. This wash was used to begin texture in the roof and to continue building texture on the rock wall to the side of the mill. These are critical steps that will not be readily apparent to the untrained eye when viewing the finished work. These seemingly bland neutrals will lend support to the darker washes that cover them. All in all, they contribute to the patina of age that shows through in the finished piece. This neutral wash was also applied to the shadows in the reflections.

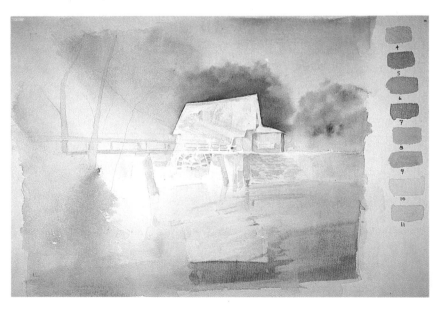

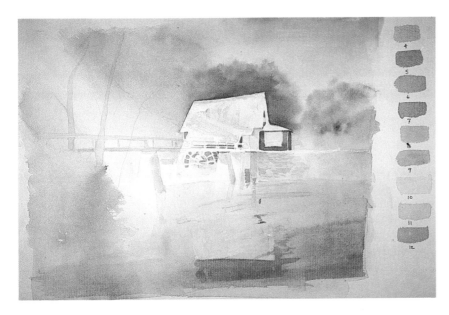

Step 12. At this point Rankin was finally reaching the stage where he could concentrate on strengthening color values and shadows. In many ways this watercolor has been built upon the traditional method of establishing middle values and then adjusting highlights and shadows to bring the piece together as a working unit. Since this is transparent watercolor, there is one modification to this approach. In this case the highlights have already been established. The rest of the painting fell into a near-middle value. The only thing left to do was to introduce the shadow passages.

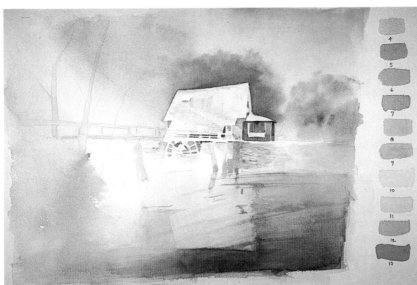

Step 13. Rankin began to develop the darker tones with a series of washes using Winsor blue mixed with Winsor red. Some of the specific areas include the water in the foreground, some of the areas in the trees directly behind the old mill, and naturally the windows and doors. In some cases, he applied two coats of wash.

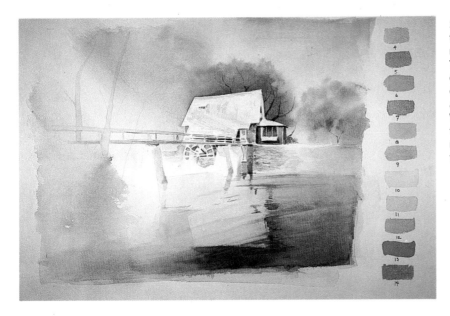

Step 14. In an effort to continue refining this painting, Rankin applied another mixture of Winsor red and Winsor blue. This time the color is almost blue-violet, a color used to strengthen the shadow areas on the mill, the waterwheel, the bridge, and in the foreground around the mill. With this step, all color mixtures used in the painting have been introduced. The remaining work is merely a continuation of the previous steps.

Finishing Touches

Once the foundation of color had been carefully laid, the final applications followed with little difficulty.

The character of the water had already been established. However, it was not yet dark enough to work in relation to the overall painting. At this stage it required no more than one or possibly two washes to firmly establish the darker value; this was accomplished with a mixture of Winsor blue and a little manganese blue. The area of highlight under the bridge did not require any modification. Observe that the color is darkest in the lower right side of the foreground. Also notice that a mixture of Winsor red and Winsor blue has been used in the shadow area around the reflection of the mill. After these washes had dried, Rankin examined the ripples and darker shadows in the water to determine whether they needed strengthening.

Using a mixture of Winsor blue and Thalo yellow green with Winsor red, Rankin began to darken the value of the underbrush in the left foreground. When aiming to mix a satisfying green shade like this one, always test your color on a separate piece of paper and continue to adjust the proportions until you get a nice, strong dark green that's not too bright.

Using a #5 round red sable brush, Rankin refined the detail in the rock wall underneath the waterwheel and on the other side of the bridge. A number of previous washes have been diluted and used on the walls. The final, darkest shadows were a mixture of Winsor red and Winsor blue applied carefully with a sensitive line.

Next it was time to put the finishing touches on the mill. Starting with the roof, Rankin used a red sable round to work in the shingle lines, in some cases using the side of the brush to create texture on the shingles. The colors used on the roof were combinations of manganese blue, faint amounts of new gamboge, and Winsor red. Note that the roof and the rock walls have a similar color quality. The roof was critical to the overall success of the painting. To convey the effect of weathered cedar shingles, the color and contrast had to be in proper relationship to everything else in the watercolor. In the waterwheel area passages needing attention were darkened. Aside from sharpening a few shadows and scribing the lines in the window, the mill was all but complete.

At this stage there were a few final touches that still needed to be made. For example, the trees at left needed a little extra attention. Rankin carefully dampened the trees individually and allowed a little dark neutral wash to create some variation in the color. He also painted in the rest of the trees in the general area, and made a few adjustments to the trees on the other side of the creek behind the mill. The highlights were scribed with the point of an X-Acto knife. After these tasks were accomplished, Rankin carefully examined his painting to make sure that all relationships were pleasing and to make any adjustments necessary to make the painting work as a total unit.

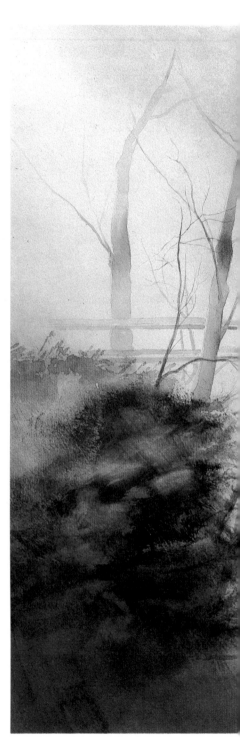

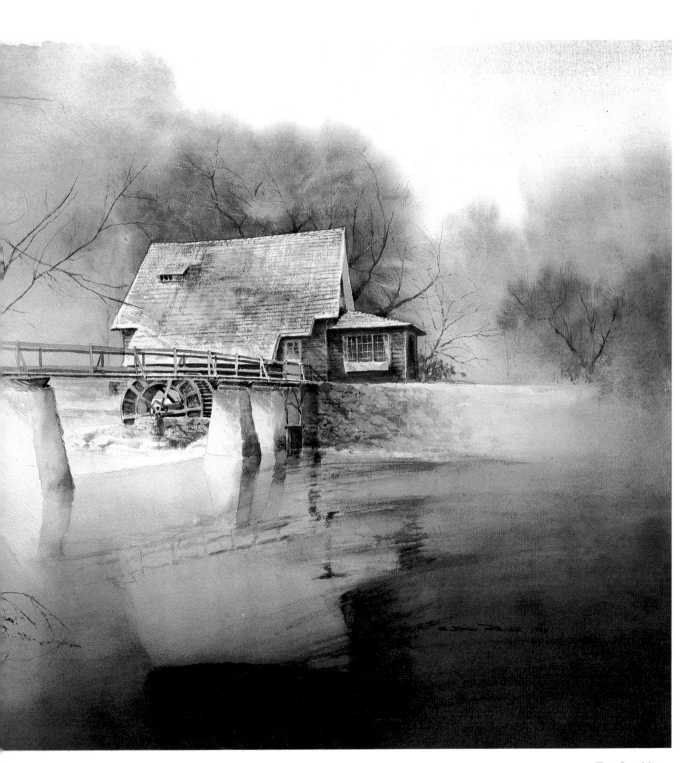

THE OLD MILL
*Watercolor, 18 × 27" (45.7 × 68.6 cm),
collection of Mrs. Nancy Lewis.*

FIGURE
PAINTING

If you are a beginner, painting the human figure may seem intimidating; perhaps you are concerned about getting anatomy and gesture right, or getting a good likeness of your subject. But if you can ignore those concerns and learn to look upon the figure as you would any other subject—as a set of shapes, values, colors, lights, and shadows—you will discover that, viewed as a design problem, painting a human being becomes much simpler. Keen observation is the key. Three masters of figure painting—Charles Reid, Don Andrews, and Alex Powers—show you how to render the figure beautifully in terms of gesture, color, and design.

Charles Reid

Learning to Render the Figure

Using Wash Without Line

When painting the human figure, try to see your subject in terms of large, simple shapes. You might find it helpful to start with flat silhouettes just to get a sense of the body's forms and gestures. Some people find it easier to paint without the restrictions of line. Here are some silhouettes Charles Reid copied from works by Degas. He hasn't made compositions. Reid recommends that you practice the method and see if it works for you. Here he has used only two colors for the flesh tone—cadmium red and yellow ochre—to keep things simple.

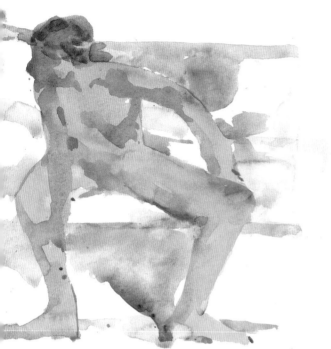

Adding Shadow Shapes

Here Reid has added shadows to his silhouette, this time using a combination of raw sienna and cadmium red for the basic flesh tone. He's made the shadows warm by using cadmium red in them. Compare this figure with the two below, where Reid has overlapped his two single Degas dancers and added shadows, this time cool ones, in cerulean blue. Experiment with colors to find the ones that work best for you—perhaps you prefer cooler to warmer flesh tones. It's your choice.

Reid describes these pictures as rough and not "suitable for framing," but they do make an important point. You'll notice that in the single figure especially he didn't attempt to soften edges; try to see that clarity of shape is preferable to a fussy, overworked, overly softened rendering. Articulating light shapes, both positive and negative ones, should be your main concern.

Charles Reid
Sketch Class

Charles Reid generally begins a figure sketch class by asking the model to take three- to five-minute poses, working up to longer, ten- to fifteen-minute poses. You don't need much to start with—a #2 office pencil, a block of watercolor paper, and just a few colors. Try working with cadmium red, cadmium yellow pale, and raw sienna, with cerulean blue as a cooling color. You'll notice that in Reid's sketches the flesh tones are mostly cool. Working this quickly doesn't allow for fine tuning, and cooler color is generally preferable to a poorly mixed hot red-orange flesh tone. Actually, it's not color itself that's so important here, it's honing your ability to mix color and value instinctively that counts. You have to get the value right with the first wash, since short poses don't allow for drying time and overwashes.

Instead of doing single-figure studies, try to compose a picture by combining the model's various poses on the same sheet of paper, as if there were actually two or three different models posing at the same time. When drawing the figure from life, use the basic contour method but with a little more flow to the line. Don't make a lot of little sketchy marks with your pencil; this wastes time. Practice using a single line. Be decisive. Accuracy of proportion isn't as important as accuracy of gesture.

Use a chair or the floor as a reference point to establish the relative positions of your model as he or she takes different poses. Concentrate on seeing and rendering large, articulate shapes—simple shapes with hard, definite edges where you want accurate and descriptive forms, and softer edges when you want the eye to slide around and over a soft part of an arm or back. Edit out the many small details, value gradations, and colors that appear in reality. Think of the figure in terms of only one light and one shadow, along with a darker value for your negative shapes. Let the white paper stand for your lights. That means you'll just be painting shadow shapes and negative darks adjacent to the figures—but they must be accurate and descriptive if you're hoping for a human-looking figure. Negative shapes are critical in bringing the light side of the figure into focus. Render them at the same time as shadow shapes; negatives must never be afterthoughts. Crowd your picture space with people. Make some overlap, using negative shapes to bridge gaps between figures.

The figure second from the left was Charles Reid's first sketch of the session, a three-minute pose. He got the drawing done—you can see the model's boundaries, since he didn't erase anything when he superimposed the figure on the far left. There was only enough time to add a wash to the face. The next three poses lasted five minutes each; Reid placed the figures at whim but kept the height of the chair in mind to create the sense of four models on the podium instead of one.

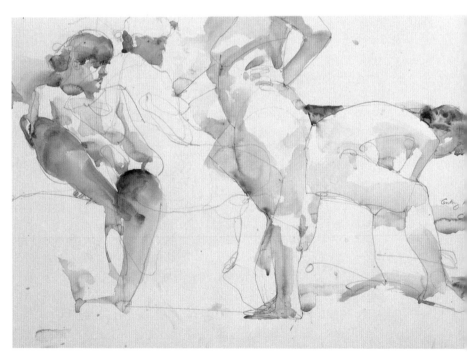

Ten-Minute Poses

Ten minutes can be enough for an adequate drawing and well-considered shadow and negative shapes, but this sort of sketching takes a lot of practice and drawing skill. Do as much as you can in ten minutes, but follow the rules: single lines that suggest varied, incisive shapes and contours. And when you're drawing, don't erase; it's like getting lost in a snowstorm. You need the old tracks to guide you to a better new path.

Charles Reid

A Lesson in Softening Edges

Every form has some hard edges and some soft ones; no form is made up of just one or the other. Edges that face the light source tend to be hard, while those away from the light tend to be soft; edges in shadow are softer than those out in the light. In terms of the human figure, edges are generally harder on bony parts of the body and softer on fleshy parts. But perhaps above all, edges are harder in places you want to emphasize, and softer in whichever areas you want to lose.

You must remember that in any situation, some of the guidelines just mentioned might be at odds with one another. For example, you might see a hard edge out in the light but decide you want to emphasize a shape on the shadow side; in that case, you should promptly forget the "rules" and go with harder edges in the shadow.

Softening edges lets you show rounded, less defined forms, and lets you merge adjacent forms when you need to for compositional purposes. By skillfully manipulating values, however, you can still maintain distinct *shapes*; it's a matter of lessening contrasts in tone.

To soften an edge in watercolor, basically all you have to do is dampen the paper next to a wash that's still wet, allowing the wash to escape. Mix your wash, lay it down, then rinse your brush in clear water and give it one vigorous shake. Your brush must be absolutely clean. If you're worried about splattering, cover your painting area with a drop cloth or newspaper. The sketches below illustrate two possible approaches.

Here's one way to soften just a small section of a wash. After laying down color, rinse your brush, then shake it and, starting about ¾" away from the painted area, make a stroke toward and just to the edge of the section you wish to soften. *Don't let the brush actually go into the wash or it will ruin everything.* You're simply making an escape path—the part of the paper you dampened with clear water will draw out some of the wash. Mopping your brush with tissue takes too much moisture out of it, but if the brush is too wet after you rinse it, the water will attack and destroy the painted area with a "backwash"—you can see this happening here in the forehead.

Here's a variation. Make a curving stroke with your damp brush toward the section you want to soften, barely touch it, and continue to move the brush out and away.

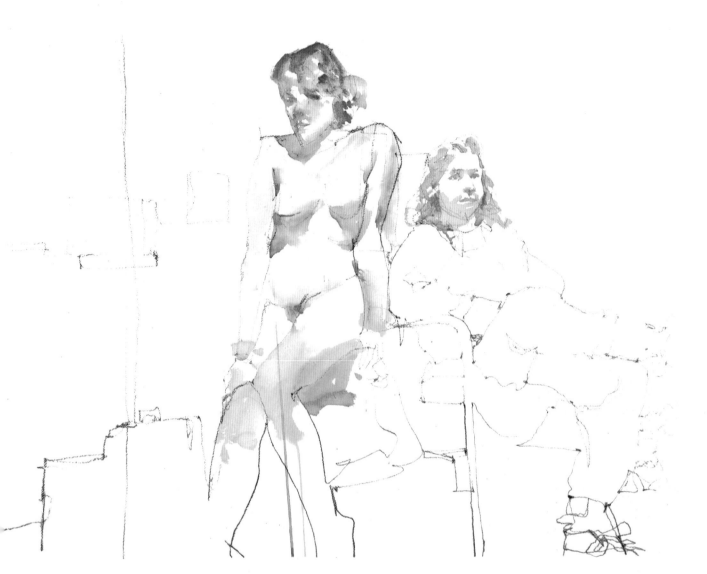

The picture above was a class demonstration Charles Reid did to show how he softens small sections of a form. The torso of the standing model gives you an idea of what he means by selective softening using the methods discussed on the facing page.

Notice the head of the standing figure where the edges have been overly softened and the structure of the face has been lost. Reid was more careful with the face of the seated figure; he kept some definition by leaving certain edges hard and precise.

Practice softening edges of wet washes. Make small color squares like the ones you see here and try to soften two sides while leaving the other two fairly crisp. Remember, in almost any form, you'd see both hard and soft edges.

Charles Reid
Editing for Effective Design

Compare the darker negative background shapes with the lighter and darker values in the figure. Look for contrast and separation. Notice especially how Charles Reid has sculpted the model's raised shoulder, which is out in the light, against the darker background; note, too, how he has managed to define the knee and shin of the extended leg.

Now look for blurs, losses of definition—the places where your eyes seem to go out of focus. Squint at the picture and you'll see where the harder edges stand out, defining contrast between adjacent forms. Wherever it's hard to see a contrast, you have a blur, a merging of one form into another.

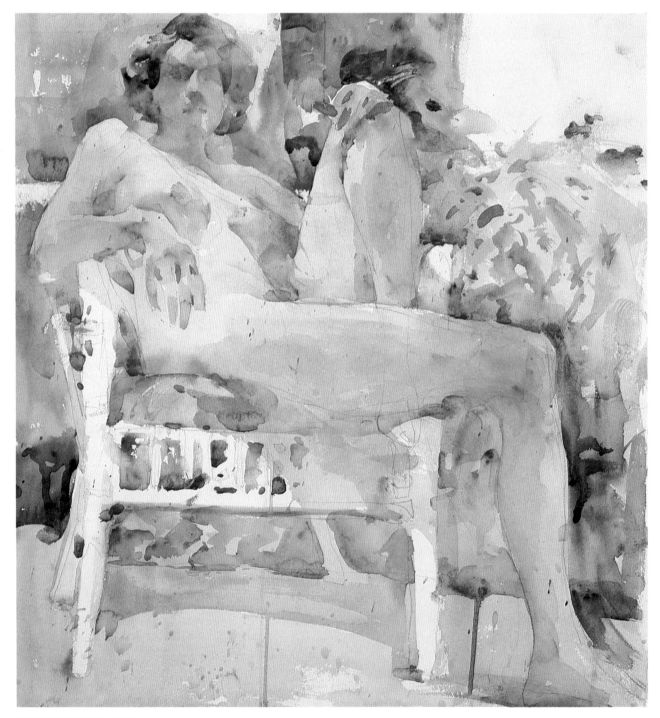

KAREN IN WICKER CHAIR
Watercolor on Fabriano 140-lb. cold-pressed paper, 15 × 15" (38.1 × 38.1 cm).

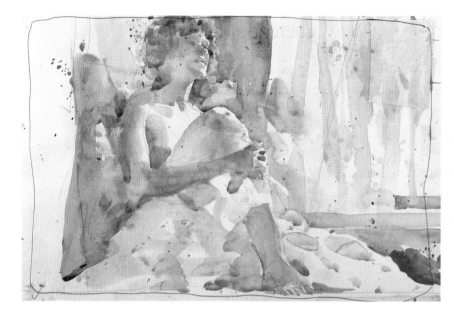

REDHEAD
Watercolor on Fabriano
140-lb. cold-pressed paper,
12 × 18" (30.5 × 45.7 cm).

In this picture there is a lot of reflected light in the shadow side of the face, but compare this reflected, or "bounced," light with the white cloth the model is draped in. When you're in doubt about a lighter value within a shadow, compare it with a white that is out in the light.

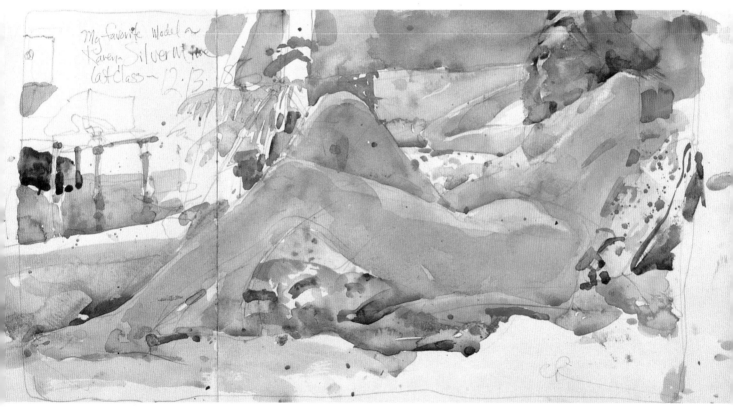

KAREN
Watercolor on Fabriano 140-lb. cold-pressed paper, 12 × 24" (30.5 × 61.0 cm).

As you paint you must constantly edit, leave things out, simplify. Look at how Charles Reid has managed to simplify the figure in this painting. Because they are both in shadow, the foreground arm and the rest of the body cease to exist visually and compositionally as two separate forms. Separation is lost. The shadow of the arm passes right over the hip into cast shadow, and the arm and back are united into a single shape.

Charles Reid
A Workshop Session

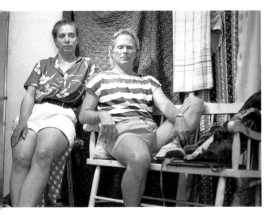

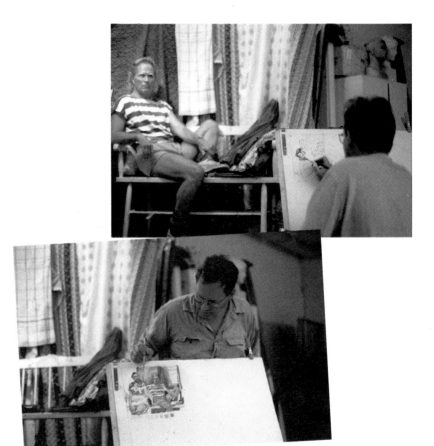

This two-hour figure-painting session was photographed during one of Charles Reid's workshops. One of his students took the step-by-step snapshots over his shoulder as he worked, and although they're not technically perfect, they perhaps offer a better sense of how Reid puts a painting together than you might get from an artificial reconstruction of the process.

Reid recommends that you think of the model as your partner in painting. In a class that's going to last for six hours, he has the model pose for twenty minutes at a time, with five-minute breaks in between, shortening the sessions as the day moves on.

Have your model simply sit. If Reid has two models, as here, he asks them to look in different directions. Always have a single, fairly strong light source. Flat or diffused lighting makes for difficult painting—there's no drama, no simple shapes; everything is a sea of detail.

Once you've set up the models, you must decide *before* you begin painting what your focus will be. Ask yourself what you really want to paint. Don't get involved with a lot of boring background.

To get started, Charles Reid has his students do a contour drawing to make a local value study. These two snapshots show him in the process of developing a value study from his contour drawing; the completed study appears on the facing page. For Reid, the value study is not a final plan for the larger painting; he likes the unexpected too much to map everything out. It's simply a way for him to hone his eye and help him understand what's happening with his subject.

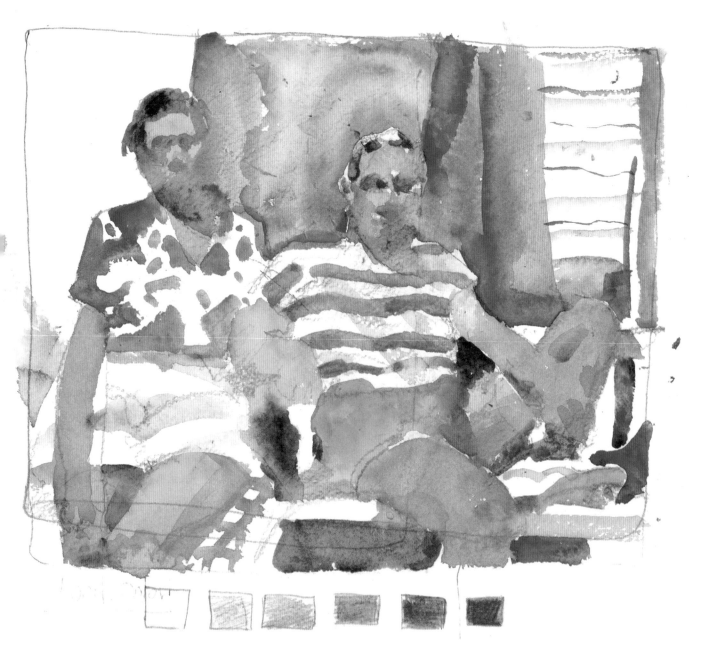

When you make a contour drawing, remember to travel across the page with your pencil, weaving the background, picture border, and figures together right from the beginning; never fill in a figure and then add a background as two separate, isolated thoughts. If a boundary is lost in shadow, leave it out in the drawing as a reminder to do the same in the painting stage. Make sure your figures don't float; connect each of them to at least three of the picture borders, and try to have half the shapes negative and half positive. Don't use a lot of background unless it interests you. And don't alter proportions just to get a whole figure in; instead, let part of the figure go off the page.

Reid made a six-value scale in pencil along the bottom margin of the drawing as a reference for the color-values he paints in the figures and surroundings. In the photograph of the two models, seen on the facing page, light and shadow are most apparent in the faces—the light-value areas—while local color-value dominates in the shirts, background, and lower parts of the composition—the darker areas.

Reid asked the class to try to get the specific color-value of each area correct with the first wash. The second wash is only for adding shadow shapes. In strong color spots he used unmixed color—pure cadmium orange and yellow for the man's shorts, and various blues for both models' shirts. (The blues look all the same here, so Reid plans to aim for more variety next time.)

Charles Reid begins his painting with a contour drawing that fills the whole sheet of paper, eliminating much of the background and crowding the figures. As the photo at near right shows, he starts the painting with the man's eyes, finishing the one on the lighter side of his face first. He works his way down the center of the face, aiming to get his final colors and values on the first try. He softens and connects, leaving areas of white paper and harder edges where he finds light hitting the lower lip, the bridge of the nose, and the cleft above the upper lip. The nostrils are darker and done wet-in-wet. The photo at far right shows the completed head.

 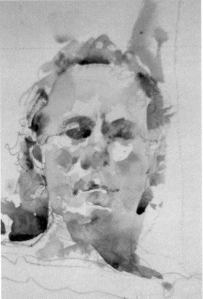

The photo at near right shows how Reid works his way down the arm with a negative dark to make it pop out, connecting this negative shape with the cast shadow under the sleeve. He does the same with the shadow side of the arm, running into shadow on the shirt and chair. In the photo at far right, he adds stripes to the shirt and paints the shorts, socks, and shoes, keeping things varied but still definite without making them look cut out and pasted down. He lets some adjacent areas work together wet-in-wet.

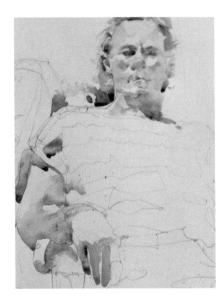

For the skin tones Reid uses cadmium red light, raw sienna, and cerulean blue. He likes to concentrate on one person at a time, solving major areas that help him feel confident as he moves on. The male figure seemed to come out all right, giving Reid the spirit to continue. In the photo at far right he has moved on to the female figure, again starting with the eye shape on the illuminated side of her face. The light sculpts the structure of the head. That's what he paints: the pattern of light and shadow shapes. Accuracy and understanding the planes of the face are the whole ballgame.

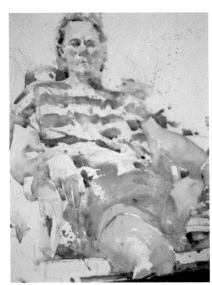 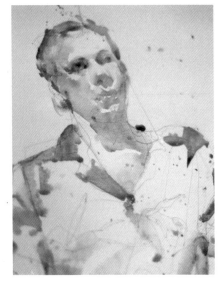

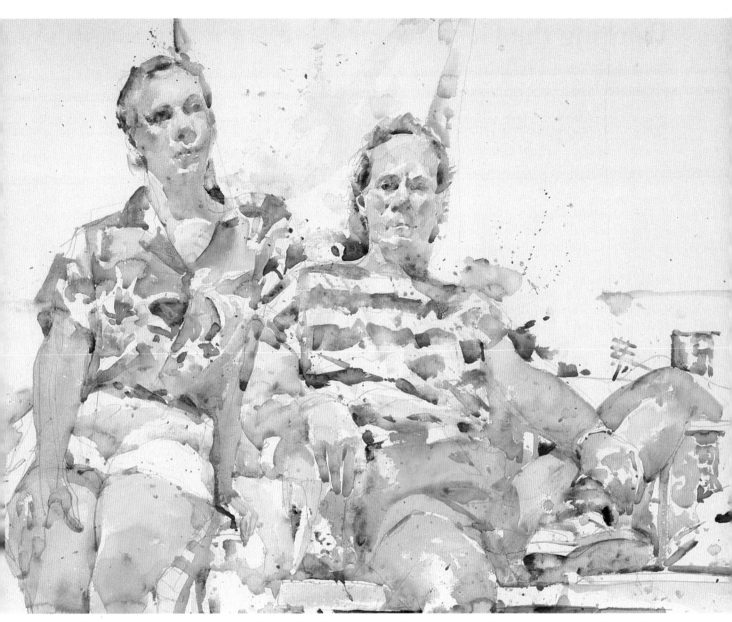

SUE AND JON
Watercolor, 22 × 30" (55.9 × 76.2 cm),
courtesy of Munson Gallery.

Charles Reid likes to create the sense that his figures are woven together, with easy transitions and connections in some places, saving his separations for the play of light around lovely form. He painted *Sue and Jon* with the assumption that he had only one chance to get it right. There is no corrective overpainting here.

Reid used an oil-painting method in most of this picture. The heads, for example, were painted darks first—the features and hair. He left the light areas as white paper. The shadows weren't important, so he painted the blue in the shirts first, stating the patterns as precisely as he could with the first pass of the brush. (If Reid had had dominating shadow shapes in these areas, he would have painted them first and then added the stripes.) Remember: Articulate dark shapes first, then correct color (as in alla prima oil painting), winding up with the softening of whatever edges call for it.

Don Andrews
Painting the Gesture

One of the best ways to learn to simplify the details and busy shapes in the figure is by doing a series of quick gesture paintings. The idea is to turn your attention away from reporting the details and to begin focusing on the essential overall shapes of the figure and their relationships to one another—in essence, to begin looking at the figure as one form. Gesture paintings are, by nature, abbreviated interpretations of the figure rather than attempts at finished renderings.

Don Andrews recommends doing a series of quick gesture silhouettes rather than spending a great deal of time on one particular pose. This is not the time to do a finished painting but a time to explore—to explore not just the form of the figure but also your feelings about shape, color, and brushstrokes. In this way, you will develop a new sense of freedom and looseness in your brushwork, which will be a rewarding addition to your more finished works. Also, by doing these quick gesture drawings, you will begin to teach yourself to see more clearly how the entire figure is involved in every movement or action the model makes. Notice how the weight shifts from one leg to the other when the model raises one arm over his or her head, or how the left shoulder drops when the head is turned to the right. Many people assume that figure painting consists of explaining tiny details of the anatomy. But it is when you begin searching for a better understanding of how the overall shapes of the figure interact and affect each other that you give life to a fluid figure statement.

When describing the figure in gesture painting, Don Andrews suggests that you use your largest round brush (#24 or larger) or a 1" or wider flat brush. This will help you avoid busying up areas within the form and will also help you begin to abbreviate and interpret shapes into a more personal statement.

Make your paintings on large, inexpensive sheets of student-grade drawing paper, 18 × 24" or larger. Any grade of paper will work as long as water runs or puddles on the surface rather than soaks through to the other side. Student-grade drawing paper can be purchased at most art supply stores in pads of fifty to one hundred sheets. By using inexpensive paper, you are less likely to worry about taking chances or experimenting.

Tilt your painting board up to an angle of about seventy-five degrees so the paint runs down the paper rather than forms puddles. This will allow the paper to dry faster and wrinkle less. Though some buckling will occur on the paper, don't be concerned at this point. You are looking more to broaden your understanding than to do finished paintings.

As far as color is concerned, at this point anything goes. Try using as many varieties of color as possible for the gesture painting session. Using an obvious color such as a pinkish-tan mixture for flesh isn't wrong, but realize that it is just one possibility for these experiments.

Rather than drawing or painting an outline of the figure in advance and then just filling in the lines, begin by looking at and painting the mass of the form in silhouette gestures. Strive for the overall shapes that describe the pose rather than the details that fill up each separate part.

For the first gesture painting session, have the model change poses every two minutes, just as in a gesture drawing session. Remember to take a few moments first to gain a visual understanding of the overall pose, then concentrate more on your painting and less on the model as you begin to paint. Don't be concerned with painting the hair differently from the face or explaining the changes that occur within the outside boundaries of the figure. The goal here is a fresh, interpretational silhouette of the figure. Work quickly and keep your brushstrokes large and fresh, not labored.

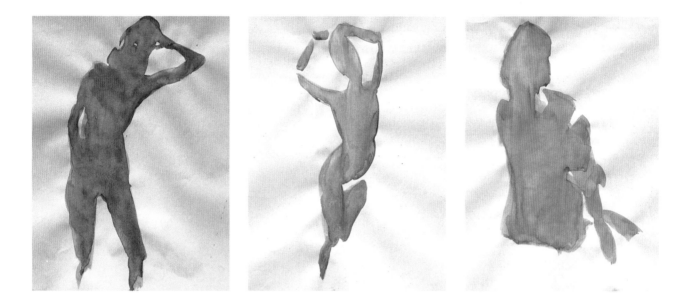

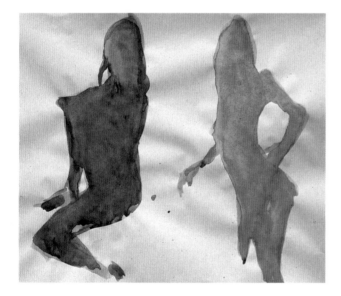

By doing a continuing series of quick gesture silhouettes, you gain a better understanding of how the human form is totally involved in every action the body makes. For every action that takes a part of the body out of balance, there is a reaction by other parts of the body to bring it back into balance. Gesture paintings sensitize the artist to these automatic redistributions of weight and will translate into a more knowledgeable interpretation of the figure.

Don Andrews

Introducing Linkage of Light and Shadow

You can begin to better organize and simplify the various parts of the figure through the use of linkage. Linkage can be created by having the model pose under a strong spotlight (a minimum of 100 watts) so that part of his or her body is in the light and part is in the shadows. With the spotlight placed on the right side, squint your eyes and look at the model in terms of what shapes are in the light and what shapes are in the shadow. Notice how the light hitting the model on the right side links the face to the shoulders and arms. Also, note that the left side of the model is brought together by the linkage of the shadow on the left side of the hair, face, shoulder, and arm.

Rather than thinking in terms of anatomical parts, think in terms of the simple linkage of shapes created by the light and shadow. For example, instead of looking at the hair, eyes, nose, mouth, and chin, look at the shapes created by the linkage of light and shadow that flow across the face.

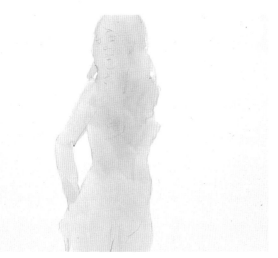

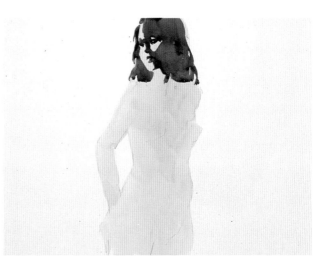

To gain a better working knowledge of the concept of linkage, first construct a simple silhouette of the entire form. Allow a good amount to be shown so that you are able to see how linkage connects the different anatomical parts. Any color will work at this point. After the figure is painted in silhouette form, allow the paint to dry.

Now mix an obviously darker value of the same or another color. Make enough of this mixture to complete the entire painting. Begin the second phase of the exercise by painting in not the face but the shadow pattern that flows across the face. The idea here is to allow the pigment to flow across the separate parts, such as hair, cheek, and nose, without stopping at the edges of these individual parts.

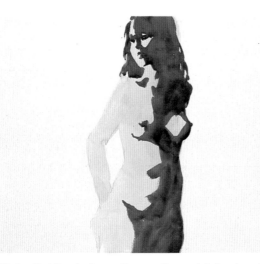

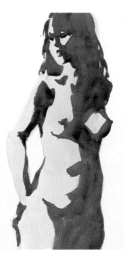

Notice that the shadow pattern on the model's head continues down into the shoulder and torso, in effect linking these various parts together. As you continue to paint the simple pattern into the legs, be aware that though you haven't painted individual parts, a good deal of information is being explained by the division of light and shadow.

Now quickly add some linkage of shadow into the arm and hip on the left side of the figure. Step back and take a look at the pattern of light and shadow. You have constructed an image of the figure by pulling the many separate parts together, a simplified foundation on which the finish will rest. Information about the structure is given without sacrificing the unity of the entire form.

Organizing the Patterns of Light and Shadow

When you are establishing the linkage, it's usually a good idea to find a balance of light and shadow, but generally an even division of these elements looks a little predictable and usually isn't exciting (A).

As an artist, you have the ability to move the light around until you find a more interesting display of light and shadow. Usually when the model poses under the spotlight, there will be some areas of light in the shadow and some areas of shadow in the light. As an artist, you should develop the patterns of light and shadow not only where they really exist but where you would like them to be. Push them around until you find a more striking arrangement (B).

When looking at and painting the linkage of light and shadow, consider that these patterns alternate as they travel across the figure. In some areas on the model, the pattern of light will be large and simple; in other areas, the pattern of light will be small and interesting. The same can be said for the shadow pattern. Light may be found just on the edge of one shape, while another shape or area of the figure may be bathed in light. Look for and paint as much variety in these patterns of light and shadow as possible. The more variety you are able to express in the linkage of light and shadow patterns, the more visually interesting the patterns will become.

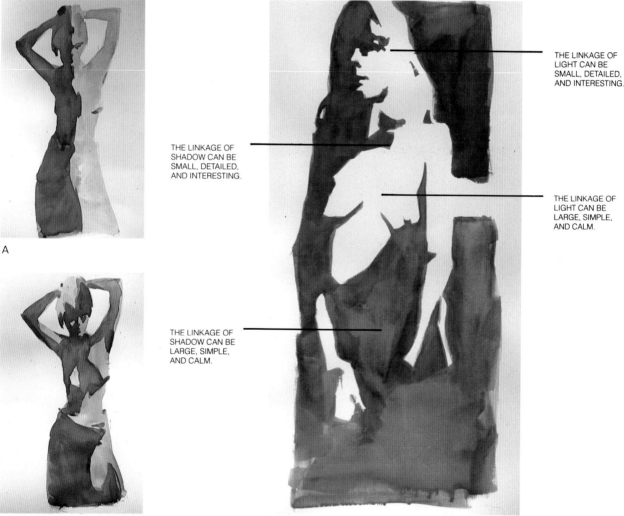

A

B

THE LINKAGE OF LIGHT CAN BE SMALL, DETAILED, AND INTERESTING.

THE LINKAGE OF SHADOW CAN BE SMALL, DETAILED, AND INTERESTING.

THE LINKAGE OF LIGHT CAN BE LARGE, SIMPLE, AND CALM.

THE LINKAGE OF SHADOW CAN BE LARGE, SIMPLE, AND CALM.

Don Andrews
What Color Is Flesh?

Whenever Don Andrews has explained flesh colors by mixing variations of yellows and reds, such as raw sienna and alizarin crimson, he has found that his painted flesh tones are "technically" correct and visually boring.

If you were going out in landscape class to paint a group of trees, you wouldn't bring along just a few tubes of green paint. As artists, we feel the need to create and add variety to the local colors of nature. This artistic license applies to figure painting as well.

Technically, it's true that the stronger the light that warms an object, the cooler its shadow becomes. So, technically, if the flesh tones of a model posing under a spotlight are warm where the light hits, then the shadows, or absence of light, on the model will be cooler by contrast. To an artist, however, these technical facts don't seem to be valid reasons to mix only certain colors. Don Andrews demands the freedom to be creative in his color choices rather than simply observing and reporting facts. Instead of

MANGANESE
BLUE, LEMON
YELLOW, OPERA

HOOKER'S GREEN,
RAW SIENNA,
OPERA

MANGANESE
BLUE, OPERA,
RAW SIENNA

PEACOCK BLUE,
ALIZARIN
CRIMSON,
AUREOLIN

MANGANESE
BLUE, RAW
SIENNA, OPERA

CERULEAN BLUE,
COBALT VIOLET,
CADMIUM RED
MEDIUM, AUREOLIN

TURQUOISE, LEMON
YELLOW, ALIZARIN
CRIMSON, RAW
SIENNA

COBALT VIOLET,
MANGANESE
BLUE, LEMON
YELLOW, OPERA

painting all of the lights on the model warm and all the shadows cool, he feels the need to place these colors throughout the figure as his taste dictates. With wet-into-wet color mixing directly on the paper—a technique he calls granulation—Andrews can easily add endless variety to the flesh tones and still indicate that the colors represent flesh.

You can begin painting flesh with blues, greens, violets. You can go miles away from the reality of flesh with creative color mixtures, and then, by touching back into these "dishonest" colors with some hints of warm flesh tones, you can usually make these creative colors read as flesh. Not only are you able to accept these created colors as flesh, but the flesh seems to come alive on the watercolor paper.

The examples given are just representative of the possibilities; they are not formulas to remember. Allow your search for creative flesh tones to grow out of these few examples.

ULTRAMARINE BLUE, COBALT VIOLET, CADMIUM YELLOW MEDIUM, ALIZARIN CRIMSON

AUREOLIN, OPERA

RAW SIENNA, MANGANESE BLUE, ALIZARIN CRIMSON

CADMIUM RED MEDIUM, CERULEAN BLUE, LEMON YELLOW, ALIZARIN CRIMSON

CADMIUM YELLOW MEDIUM, TURQUOISE, ALIZARIN CRIMSON, RAW SIENNA

SAP GREEN, TURQUOISE, ALIZARIN CRIMSON, RAW SIENNA

To develop visual contrast, in most of these examples Don Andrews has either started the color swatches with cool pigment or introduced it at some point. The concept to remember here is that any color or combination of colors or temperatures can be introduced, and as long as a warm mixture is then applied on top, the warmth will dominate, giving the impression of flesh.

Don Andrews

Using Color Temperature Expressively

To visually express the feeling of living flesh, we usually reach for the warm
pigments in our palette. However, it's just as acceptable to develop the
impression of living flesh by using the cool side of the palette and employing the
warm colors as a relief. In this painting, Don Andrews first developed areas
within the figure and background using warm pigments. Then he quickly
overpowered the warm statement with a variety of contrasting cool colors. Care
was taken to allow some of the beginning hints of warmth to be saved to provide
visual relief from the mostly cool arrangement of color.

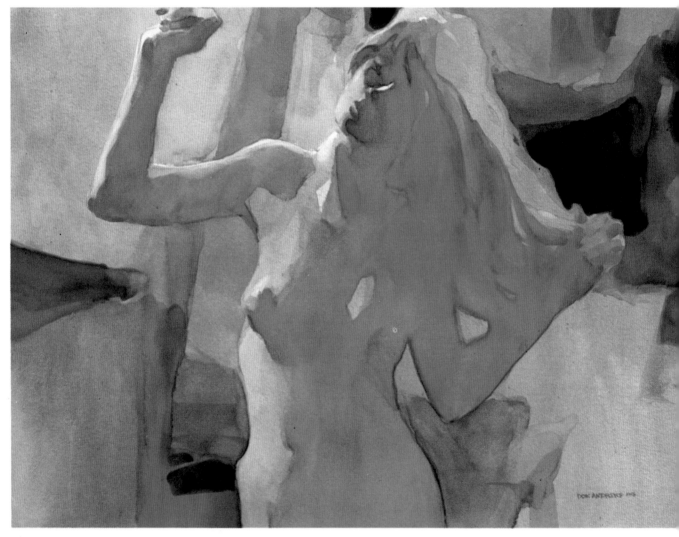

ANGELA
Watercolor on Arches 140-lb. cold-pressed paper, 22 × 30" (55.9 × 76.2 cm).

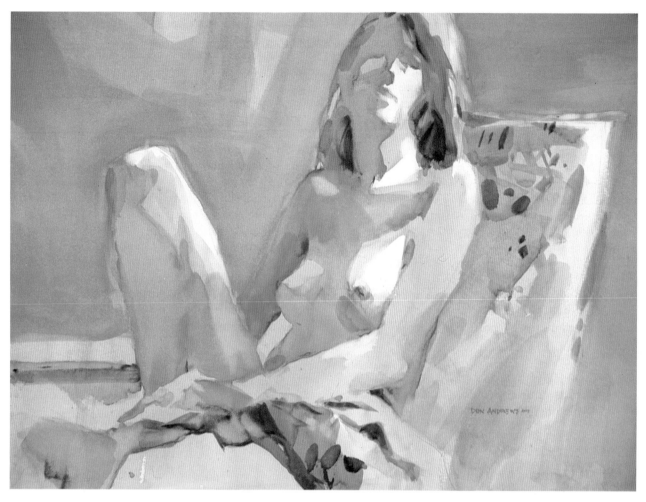

JACKIE
*Watercolor on Arches 140-lb. cold-pressed
paper, 22 × 30" (55.9 × 76.2 cm).*

In this painting, Don Andrews wanted to create a dramatic statement about warm colors. In order to more vividly suggest the blast of warmth that the yellows, oranges, and reds on his palette can describe, he began the painting with contrasting cool colors. Once they were in place, he overpowered them with stronger warm pigment. Care was taken to occasionally save balanced areas of cool color. This gives the viewer some visual reference to what warm color is by showing a little about what it isn't.

Don Andrews
Eliminating Distracting Detail

In figure class, one of the most common problems Don Andrews sees in other artists' work, as well as in his own, is painting in too much information about the subject. We must first realize that the human form is filled with information from head to toe. Every square inch has some change in shape, some interest or detail. In aiming toward the goal he desires to achieve in his paintings, Don Andrews often asks himself, "How can I tell LESS about the subject?", not "How can I explain more?" Less *is* more.

When the model poses under a spotlight, there will be many interesting areas of shapes and light across the face and body. Every detail will compete for your attention. And you must decide which is the most important or exciting shape or light to accentuate, then push back or eliminate the other competitors. You must become aware of how much detail is visually necessary to make the painting work—not how much is actually there, but how much is needed. Generally, a good part of the figure will need to be calmed down or left a little unexplained so you can more clearly show off the few balanced exciting areas of form or light you feel are worth accentuating.

In a particular pose, there may well be a wonderful pattern of light flowing across the form of the figure. This light accents the bridge of the nose, the side of the face, and the hair but is just as dramatically found on the arms and chest, as well as the hands, legs, and feet. It is your job as an artist to choose where the excitement will be enhanced in your painting, and just as important, where it will be subdued.

Develop your painting in much the same way a writer develops the characters in a book or play. There are usually just a few main characters around whom the story revolves. Then there are a few secondary characters who have some interest but support the main characters; and finally, there might be several minor characters who have only a line or two of dialogue.

Step back and evaluate your paintings in these terms. Don't say, "Did I record every detail of the figure correctly?" Instead say, "Can I easily recognize a few dominant focal points or main characters? Are there a few areas of secondary interest and some noncompetitive subordinate areas in the painting that don't steal the interest from the main characters?"

An artist develops detail or interest in a watercolor painting by creating small, active shapes, or calligraphy. The inexperienced painter might therefore assume that the more detail or interest a painting contains the more exciting it will become. Unfortunately, most of the time just the opposite result is produced. Small, active shapes are interesting in themselves, but they can also be very demanding. In effect, each detail calls for the viewer to "look at me." In this example, Don Andrews created interest in the painting by developing small, linear lights on the model where the spotlight hit. Rather than being selective, he simply reported the light where it was found on the form. When you examine each part of the figure separately, the light is interesting; however, when you step back and look at the figure as a unit, you are somewhat overwhelmed by the activity of the light, which seems equally important throughout. In effect, each special character of light calls for attention.

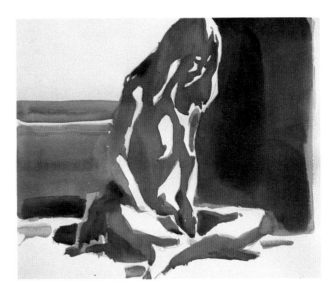

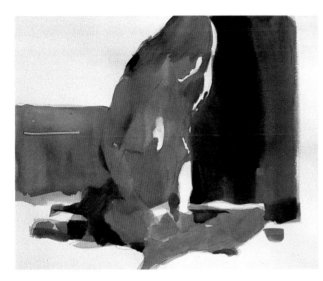

In this positive example, Andrews painted the pose again as closely as possible to his first version, except here he was selective as to what characters of interest (the lights) would be shown off, and he eliminated the competitive light. One of the hardest things an artist must learn is to paint out exciting details that are beautiful in themselves, for the sake of the overall balance of interest in the painting. As hard as this was for him to do, Andrews realized that it was necessary here, so he cut away most of the activity of linear light to create a more unified balance of interest.

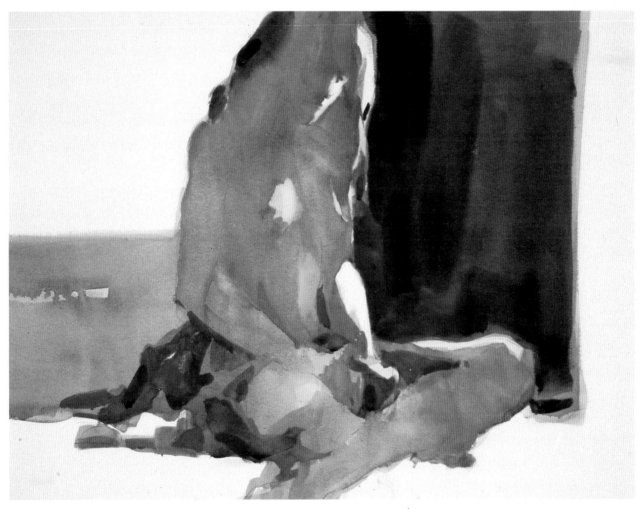

CAROLYN
Watercolor on Arches 140-lb. cold-pressed paper, 22 × 30" (55.9 × 76.2 cm).

Andrews enjoyed the special qualities of light, color, and simple balance of shapes in the demonstration, and he felt compelled to get out a full sheet and see if these qualities might again be captured in a finished painting. He tried to work quickly and not be enticed into saving more details on the full-sheet painting than were absolutely necessary to excite the page. The goal continues to be "How can I tell less, not more?"

Don Andrews
Balancing Background Shapes

Since there is a good deal of interest and detail within the framework of the figure in this particular pose, artist Don Andrews decided to keep the background shapes fairly large and undemanding. The large warm mass just behind and to the left of the seated figure is balanced by a smaller, somewhat similar version of this color and shape on the right. The three negative white shapes are balanced in zigzag fashion by being placed at the top right, middle left, and bottom right. Though they are the same value, each negative white space has a different weight and shape.

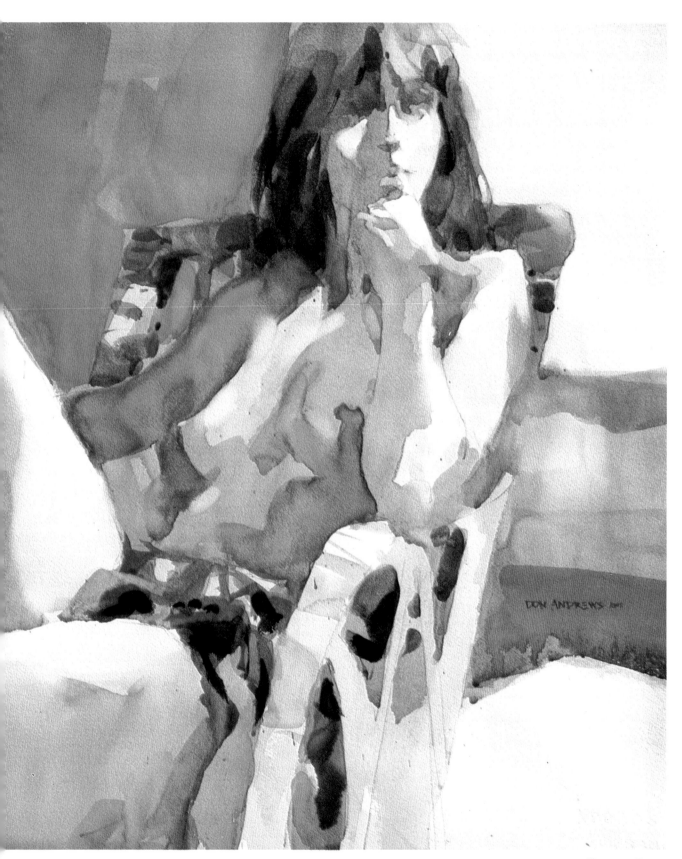

BETWEEN POSES
Watercolor on Arches 140-lb. cold-pressed paper, 22 x 30" (55.9 x 76.2 cm).

Don Andrews

Turning On the Light

The medium of watercolor is unique in that the highest value, or white, in a watercolor painting is actually the white of the paper. The white paper can take on a special quality of light when the artist saves a small amount of it and reduces the values of colors around the white to contrasting middle and dark values.

A repeated theme in many of Don Andrews's paintings, and a real goal to strive for in watercolor, is to capture a small amount of white paper so that it appears to be bathed in glowing light.

Obviously, in order to make white paper special, you have to limit the amount of it you save in the painting. The idea employed is contrast. The more emphatically you drop the value around saved whites, the more the white will be enhanced.

You can see this theory in action with headlights on a car. They are dramatically light at night, when contrast is high, and unnoticeable in daylight, when contrast is low. Simply put, the key to turning on the luminous quality of light that white paper can take on in a watercolor is to drop the value in the majority of the painting to a range of middle and dark values.

To gain a better understanding of how the white paper can be enhanced to indicate light, Don Andrews first makes a drawing on his paper, and, using a photograph as a reference, he decides where the light might best be displayed. Once this decision is made, he makes a puddle of a light middle-value color (he uses neutral colors here to make it easier to think in terms of value). Andrews begins by reducing all of the form to a single light wash, except for the areas of white paper he wants to enhance. In effect, he begins by eliminating all competition of the saved white.

Once the first wash has had a chance to dry, Andrews cuts back into the planes of the face with a middle-value wash to create more value contrast between the majority of the shapes on the face and the saved white shapes.

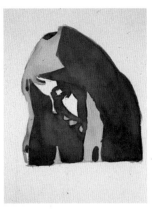

Once the majority of the face has been established with a middle-value wash, Andrews develops some areas of dark value. He places some darks next to the saved white on the model's face to emphasize the value contrast between the saved white and all other values on the page. Now compare the light on the model's face in this stage to the white on the model's face in the first stage.

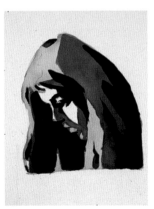

Saving the Whites

For this demonstration on light, Don Andrews first decides on the pose and then adjusts the spotlight so that most of the figure is in shadow and the light hits it in only a few places.

After making a drawing on the watercolor paper, Andrews decides to push the color temperature of this painting to the warm side of his palette. He begins his first wash with a light value of cerulean blue and follows with cobalt violet, knowing that he is about to overpower these cool washes with a stronger mixture of contrasting warm colors. He is saving a few more whites in this beginning stage than he knows he will need at the completion of the painting, but he his not sure yet exactly which whites will be saved. It's much easier to eliminate the white paper gradually than to try to recapture it once it has been painted over.

Rather than wait for the cool wash to dry, Andrews jumps in immediately with an overpowering value of warm pigment. He is still using light values, but he is adding more pigment to the light washes so that there will be an obvious value drop from the untouched white paper he has saved. He cuts away a few more remaining whites until the only white paper left is that on the top of the model's head, her shoulder, and two or three areas in the background. At this point, he feels that one or two of the background whites might work well along with the whites on the figure, but he isn't sure which ones should be saved and which should be eliminated. Andrews will save them all until he gets a better idea of which ones work best. At this point, he lets the painting dry.

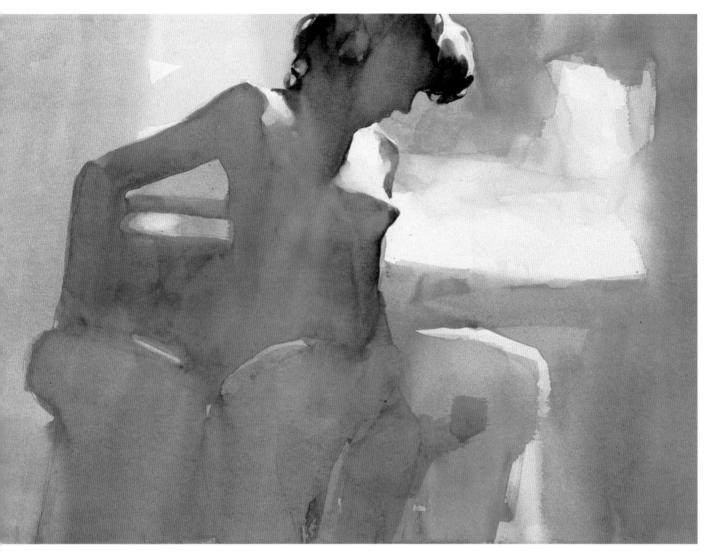

After much looking, Andrews has decided to cut away most of the white paper in the lower middle section of the painting, and to begin dropping down the value of some of the surrounding shapes as well. He feels the figure can now benefit from more definition, and he starts by strongly darkening the value in the model's hair. This will be useful as a contrasting dark next to the saved whites on the top of her hair and on her shoulder. Immediately, these two saved whites become more emphatic. The urge now is to jump in and start throwing darks down everywhere. But Andrews fights the urge and stops here to let the painting dry again.

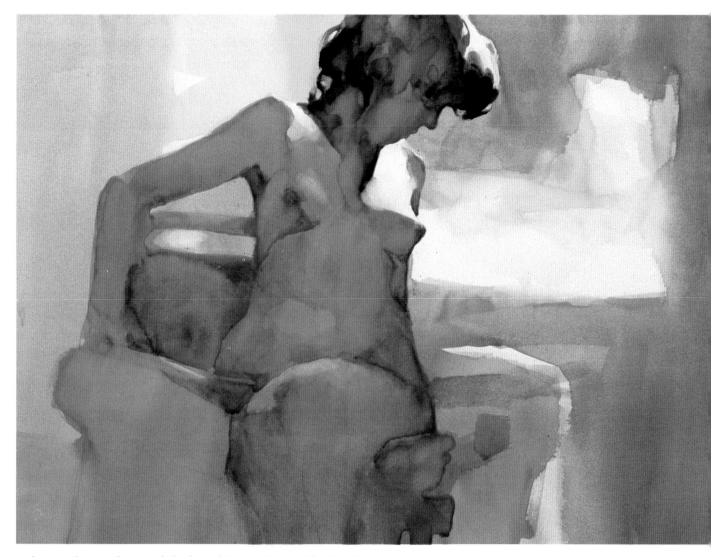

In the next phase, Andrews works back into his main character (the figure), as he feels more anatomical explanation is needed. However, he is careful not to start explaining every square inch equally. He is trying to visually explain the necessities that make the figure believable, but equally important, he tries to leave some of the figure lost as well as found. For instance, he just hints at the knee and leg in the bottom left and allows the shape to be mostly washed out rather than well defined. As he adds more strength to a range of middle values in both the figure and the background, Andrews begins to be aware of the white paper that now becomes glowing light on the model's shoulder and hair, and also of the saved background whites. He perceives what seems to be a problem with the shapes and light in the background area in the lower middle portion of the painting, just beside the model's hip. The shapes are poorly structured, and the glowing light of white paper seems to call for more attention than the area needs. Again Andrews stops to allow the painting to dry, and he makes a mental plan of action that will enable him to bring the painting to a successful completion.

Don Andrews eliminates the problems of both the competitive light and the busy shapes in the bottom middle of the composition by painting them out with a simple dark middle value. Again, each time some of the light of the white paper is eliminated, the remaining saved whites become that much more emphatic. He now adds a few dark middle values and dark shapes in the background, as he feels it needs a few hints of form; more importantly, he wants to continue to develop contrast in value between his saved lights and all other areas. Once again, the more he drops down the value in the majority of the painting, the more the few areas of saved light are turned on. Andrews is now satisfied with the impact of the glowing lights on the figure's shoulder and hair, and of the reflected light in the middle background. At this point, he calls the painting finished. To gain a better idea of how much importance the white paper has taken on without being touched, compare the white paper on the figure's shoulder and hair in the finished painting to the same area of white paper in phase one of the demonstration.

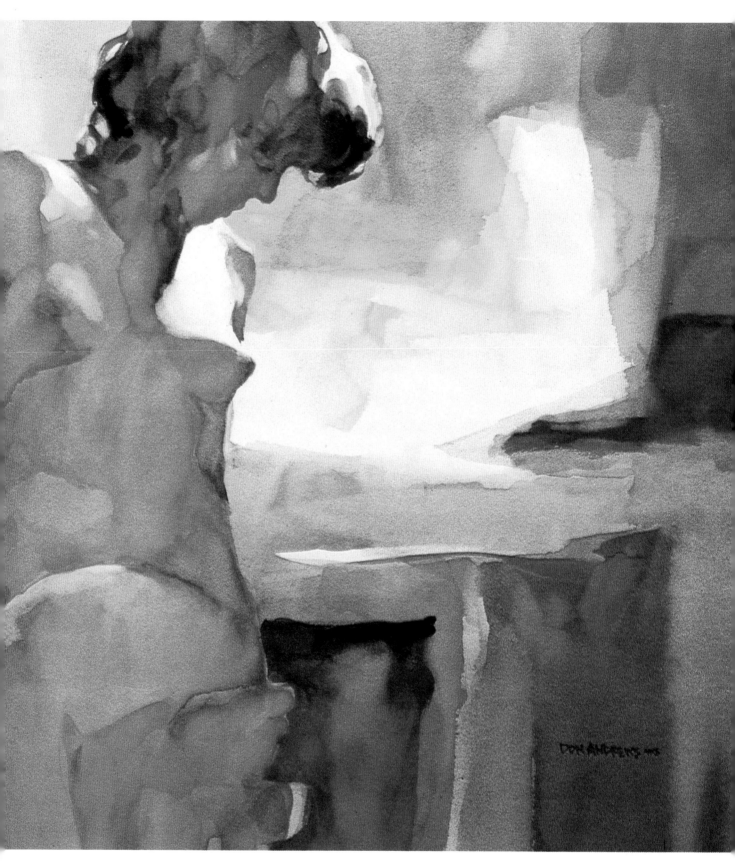

MORNING LIGHT
Watercolor on Arches 140-lb. cold-pressed paper, 22 × 30" (55.9 × 76.2 cm).

Alex Powers
Letting Value Dominate in Design

Value is Alex Powers's choice of a dominant design element. He gets excited about mysterious darks, transparent middle values, and contrasting whites. His persistent interest in drawing and his preference for graphic images on paper reinforce his fascination with lights and darks.

Value is the core of Powers's vision. Leaving light shapes white and being bold enough to paint rich darks maximizes the boundaries of contrast. Traditional realists, colorists, and abstract artists all generally agree that value is the primary visual shape-maker. Humans identify objects in nature primarily by whether they are light, middle, or dark values.

Color, texture, and most of the other design elements are characteristics usually seen secondarily.

This value-oriented vision does not have to be the case. Shapes can also be distinguished by color, for example. However, most art students are trained to see shapes in relation to values, and this is the method Powers advocates. Master value before emphasizing color. Use color to enrich shapes defined by value. From the light and dark poles of the color sphere, travel the equator of color's perimeter, never forgetting the value of value.

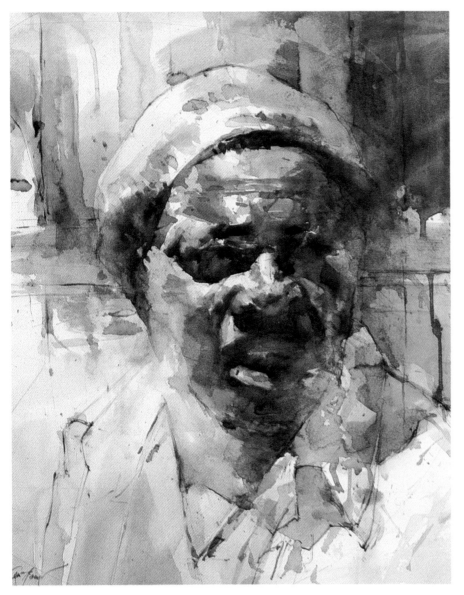

Most artists who paint in watercolor do so because they love the transparency of the medium. They tend to worry when they lose the white of the paper. Dark areas of watercolor can be painted in such a way that they retain their transparency, but those areas are often not dark enough for the value painter. Be willing to paint opaque darks as you see here. They will contrast nicely with the transparent middle and light values. Be sure to repeat them in other places in your composition as well as set them up with strong middle values.

PLANTATION MAN VIII
Watercolor, 22 × 17" (55.9 × 43.2 cm), 1982,
collection of Nancy and Max Rogers, New Bern, N.C.

The "Paper-Doll" Relationship

Cutting out white paper dolls with scissors and gluing them on a black paper background is a common activity for many children. The white paper-doll shapes stand out from the black background. The paper-doll value relationship is the core of the vision of all watercolorists. An interesting light shape, or the possibility of one, is often the single inspiration needed for painting. Beginning watercolorists quickly learn to give special visual attention to the light shapes that come forward in space. Creating the paper-doll relationship is one of the ways of handling these areas of light.

Most of Alex Powers's paintings were initiated upon seeing an exciting foreground light shape. *Jacksonville Demo* is an example. In this painting, the light on the side of the face is the "paper doll" coming forward in space in front of the dark background.

It is often critical to resist the local color, in this case the light flesh tones. Sufficient value contrast can be achieved only by leaving this light shape very light. Often it is necessary to paint around it, leaving the white of the paper. Value contrast, being the dominant element and, thus, the focal point of the entire painting, must be kept far from a middle-value range. If the pure white of the paper-doll relationship seems too stark after the painting is otherwise completed, it might be appropriate to use a very pale wash over certain portions of it.

Powers loves this foreground light focal point so much that he will often change a middle or dark value in his subject to a white paper-doll value relationship. The light plane of the black man's face in *Ned* is an example. The characteristics of the black man's face are not lost when using a paper-doll value relationship, for they are portrayed in the shadowy shapes of the face and in the contours of the white value against the background. This ability to change any middle or dark value to a white value gives the painter great latitude in handling subject matter.

The paper-doll relationship has the white shape coming forward in space as the dark shape recedes. The only way to make a light shape come forward in space in a painting is to surround it on three or four sides with dark.

JACKSONVILLE DEMO
Watercolor, 15 × 22"
(38.1 × 55.9 cm), 1985,
collection of the artist.

The paper-doll light value that comes forward in space in this painting is the light on the side of the face. It is surrounded on three sides (left, top, and right) by darker areas to make it come forward. The background dark on the left is the most contrasting value relationship with the light face, insuring a foreground-to-background relationship.

NED
Watercolor, 17 × 23"
(43.2 × 58.4 cm),
1984, collection of Bobbie
Cheetum, Aiken, S.C.

The right side of this black man's face remained white without changing the character of the black face. It may be necessary to change middle or dark values to light values in order to express your unique vision. Artistically, for the value painter, black skin ranges from rich darks to shimmering lights.

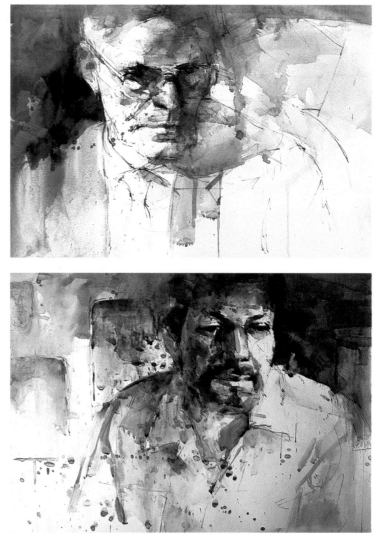

Alex Powers
The Silhouette Relationship

In the silhouette, the spatial positions of the light and dark shapes are reversed from those of the paper-doll relationship. The dark shape comes forward and the light shape recedes. You can visualize the silhouette as a figure in front of a window or as any shape made shadowy by backlighting. *Classic Golf* is a painting that has a complete silhouette, a silhouette with no secondary paper-doll relationship. It is rare to find an image that works as a continuous silhouette without being monotonous.

The silhouette can be the focal point and the paper doll the secondary relationship. In this case, the foreground shape of the silhouette (A) in *Junior Leaguer*, opposite, should be a rich dark and the background very light. Because the paper doll (B) in the same painting is not the focal point, it should be closer in value to the background shape.

Try to gain facility in painting the silhouette in a flexible range of values, deepening middle-value shapes to darks and changing light shapes to dark silhouettes. The photograph of the model on the facing page shows the upper portion of the figure to be a light shape and the lower portion darker. When transformed with paint, the figure became a dark silhouette at the top and a secondary paper doll at the bottom.

The key to creating a silhouette is not the silhouette itself but the light background portion of the silhouette relationship. Hold out one of your hands. The lamp by which you are reading makes your hand light. Now move the same hand in front of the reading lamp or in front of the daylight from a window. Squinting your eyes will help you see that your hand has become silhouetted.

The silhouette is the opposite of the paper-doll relationship of values in space. The dark is in front, and the light is behind.

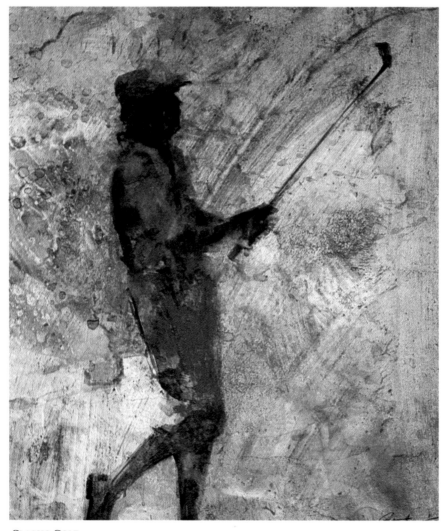

CLASSIC GOLF
Watercolor on watercolor-toned paper, 19 × 17" (48.3 × 43.2 cm), 1988, collection of Mr. and Mrs. Hal McHarris.

Alex Powers emphasizes that you use both the silhouette (dark foreground shape against a light background) and the paper-doll relationship (light foreground shape in front of a dark background). He believes that in most value paintings, it is necessary to use both. However, this painting uses only the silhouette. Nowhere in this painting does a light shape come forward in front of a dark shape. The monotony of the continuous silhouette is alleviated by the interesting textures in the dark figure and the light background.

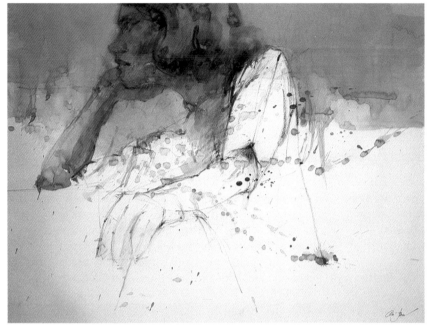

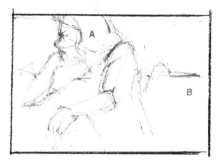

The silhouetted focal point here is the dark face (A) against the light yellow background. The paper-doll value is a secondary relationship. It is the light shoulder against the yellow, and the white paper (B) against the yellow.

JUNIOR LEAGUER
Watercolor, 17 × 23" (43.2 × 58.4 cm), 1986, collection of the artist.

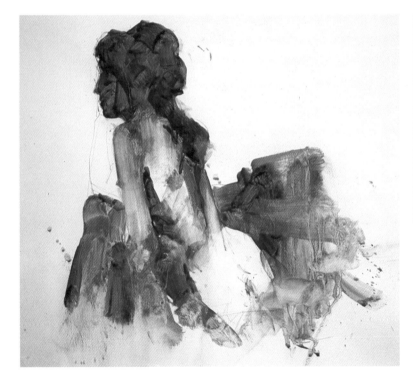

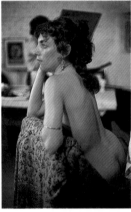

In this photograph the upper part of the figure is light and the lower part dark. See how the values can be adjusted to suit the artist's purpose in the painted diagram.

The light upper part of the figure is changed to a silhouette. The shadowy lower part of the figure is left lighter than it really appears, and the lightness is enhanced by the lower background darks.

Alex Powers
Space in Design

Many artists today combine the traditional artistic illusion of three-dimensional space with the flatness of modern imagery, creating an exciting combination that acknowledges the past while paying heed to the discoveries of modern aesthetics. The French postimpressionist Paul Cézanne may be seen as the art-historical bridge between these two approaches to dealing with space.

Alex Powers's interest in both traditional and contemporary art clearly shows itself in his use of space. He loves to model three-dimensional shapes—such as a portrait head—with value, color, and a variety of edges. However, he finds that when the entire rectangle is handled with three-dimensional use of space, the overall impression is mannered and unexciting.

What intrigues Powers much more is combining flatness with the illusion of depth in the same painting. He enjoys the emphasis of the patterned divisions of two-dimensional flat space in the rectangle. But the artist has to beware of carrying this to the extreme and painting flat shapes that look cartoony or unsophisticated.

Space and the Focal Point

The paper-doll and the silhouette value relationships in space are simplified flattened shapes, but their contrasts of value separate them in space, creating the illusion of depth. The white shape of the paper doll comes forward as the dark shape pushes back. The dark shape of the silhouette comes forward in front of its light background. The flat shapes combined with the push-pull between them create a focal point that uses both two- and three-dimensional space.

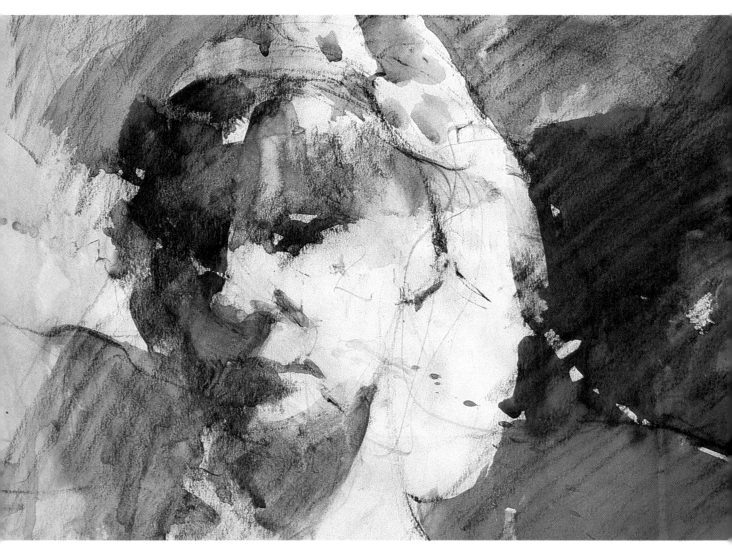

The illusion of depth here is strong even though most of the shapes are flat. The large white shape—which includes the hair and the light side of the model's face—appears to be flat. In the background the dark shape is seen as flat also. But because of their value contrast, the two shapes separate in space and create a three-dimensional space between them. Notice that the details of the face all occur at the left edge of the flat white shape.

Contrasting Two- and Three-Dimensional Space

The primary impetus for this painting was the special light on the hand and the cheek. To emphasize the special lights, Alex Powers exaggerated the lights and darks of the hand and the dark of the adjacent neck (A) and intensified the extreme dark of the eye sockets. The front of the face and hat are blurred middle values so that they will not compete with the focal point.

This focal point and the use of the background at B and C establish a clear three-dimensional horizontal band (D). Powers created a contrasting two-dimensional use of space at the bottom of the painting (E) as a complement to his focus. A transitional horizontal band of space (F) unified the spatial transition from D to E. Horizontal band D has the look of being complete, whereas E is mostly vignetted white paper. Notice how line is used as the unifying element between contrasting horizontal bands D and E. At the upper portion of band F, line is a continuation of shape. In the vignetted white paper (E), the charcoal lines are more abbreviated.

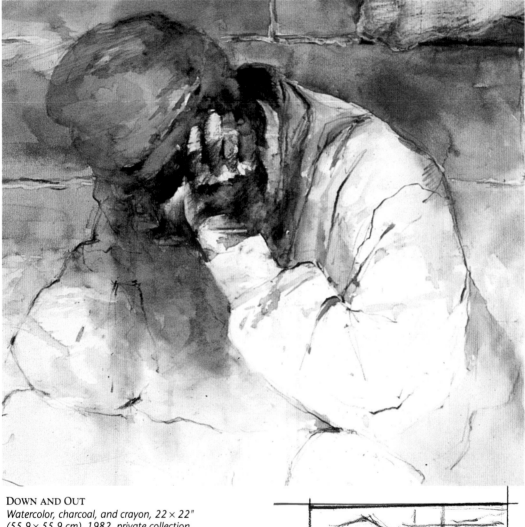

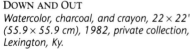

DOWN AND OUT
Watercolor, charcoal, and crayon, 22 × 22"
(55.9 × 55.9 cm), 1982, private collection,
Lexington, Ky.

Alex Powers
Handling Edges for Dramatic Effect

Children's early years in art classes are sometimes dominated by well-meaning teachers who instruct the students to color within the lines. The results are often dull as compared to what they might have produced without strictures, following their own imaginations.

Unpredictable groupings of shapes can occur by painting across edges. See, for example, *Sideline Soccer—Henry II*, in which the edges of the dark head are lost into the dark background. As a result, the small highlights on the face and the light shoulder become more interesting. Since the lower part of the figure was not needed, the edges dissolved, light shape into light shape. To lead the eye along a certain path, Alex Powers maximized the sharp edges from the head to the soccer ball.

Notice how the use of edges drastically changes this figure. Edges are lost dark into dark at the head and edges are lost light into light lower in the figure.

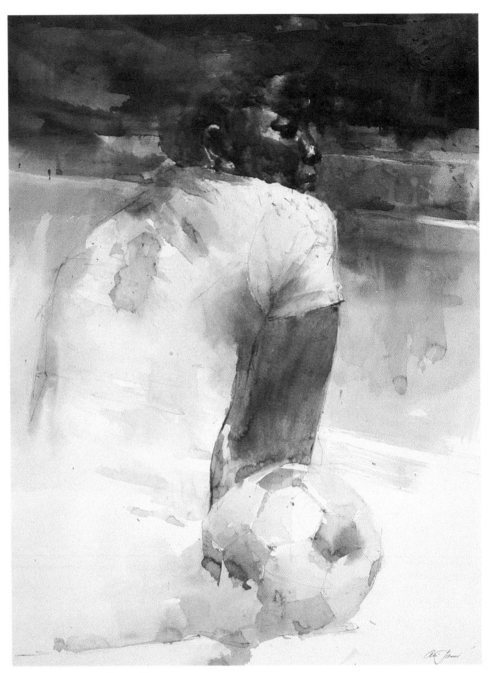

SIDELINE SOCCER—HENRY II
Watercolor, 30 × 20" (76.2 × 55.9 cm), 1982, collection of Paula and Sam Parker, Mars Hill, N.C.

Edges and Movement

If a shape has four sharp edges, the eye is boxed in, or "put into jail." One or more blurred edges will alleviate this problem by beginning a movement beyond the shape through the remainder of the rectangle. In *Portrait in Blue and Yellow* the blurred edge of the head at A contrasts with the sharp edge at B, luring the eye from the hair toward the background. Similarly, the lack of a sharp edge at C allows the connecting white paper to move in the direction of D.

If you prefer imagery to be lively but serene rather than busy and jumpy, watch out for too many sharp edges. Almost any shape you paint will appear to have sharp edges when the eye is forced to focus on it. The decision about which edges to lose and which to keep is best resolved by taking the entire rectangle into consideration, since the choice of edges should be consistent with the overall design plan.

As you will see, it is edges, to a large extent, that determine the movement of the viewer's eye through the rectangle of your picture surface.

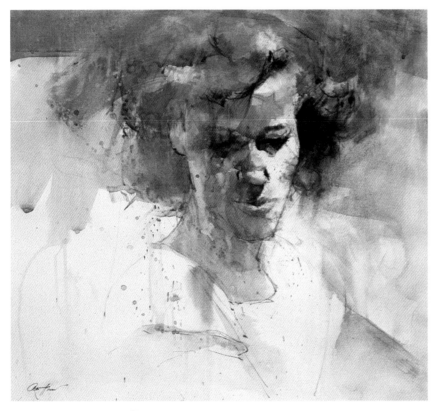

PORTRAIT IN BLUE AND YELLOW
Watercolor, 21 × 21" (53.3 × 53.3 cm), 1984, collection of the artist.

One of the most significant problems with paintings by beginning and intermediate art students is the inclusion of far too many sharp edges. Allow lost and found edges to dance the viewer's eye along the contours of form.

Alex Powers
Establishing Movement

Often overlooked by inexperienced painters, movement is the heartbeat of design. The rhythm of the rectangle is to visual art what tempo is to music.

Alex Powers says that when he began taking art classes, he gave no thought to the rhythm of the rectangle. He painted as if he were working on a jigsaw puzzle, one piece at a time. He did not consider placing shapes in the entire rectangle before finishing individual shapes. Without movement, there is no transition from shape to shape. Without movement, there is no order or rhythm to the design.

The focal point of a painting is where the viewer's eyes look first, and should be seen as the relationship between two shapes, a relationship created by using value contrast. The edge between the two shapes is the center of the focal point. Generally, this edge should be placed in one of the so-called sweet spots of the rectangle—not centered horizontally or vertically, and not placed around the edges of the rectangle. Powers believes that the viewer's eye enters a painting from the bottom; therefore, it is appropriate to place the climaxing focal point toward the top of the rectangle, in the upper horizontal band of space. It is from this point that the movement through the rectangle begins.

Beginning the Movement

In handling edges there is the problem of boxing in, or putting the eye into jail, by using all sharp edges. But at least one sharp edge of the paper-doll white shape (A) in *Melba* is necessary against the dark background to create the focal point. A connecting light shape (B) is required to begin the light movement through the rectangle.

In *The Dishwasher*, the focal point is the light on the left side of the face (A), which is located in quadrant 1. Rather than forcing light shapes across the face to quadrant 2, Powers used the shoulder and chest (B) to continue the light movement. The light in these shapes are the obvious links to the light on the face. The movement of light shapes travels from quadrant 1 at A to quadrant 3 at B. The S movement, which basic design finds desirable, becomes an S turned on its side or, more often, a simplified U.

An important part of this painting is the light shape on the side of the face. As Powers's subject posed, there was a strong shadow under her jawline (C) just below the light on the face. After he painted this shadow, he realized that he had trapped the light on the face. To provide an outlet, he lifted off the shadow. This allowed the light to move downward and circulate through the remainder of the painting.

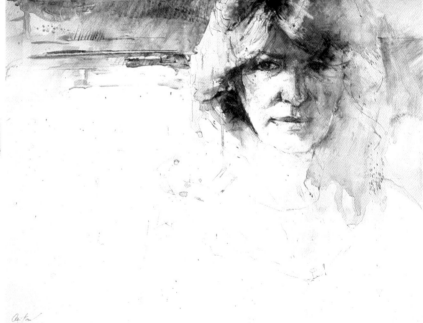

MELBA
Watercolor and charcoal, 23 × 29" (58.4 × 73.7 cm), 1984, collection of Melba Hayden, Myrtle Beach, S.C.

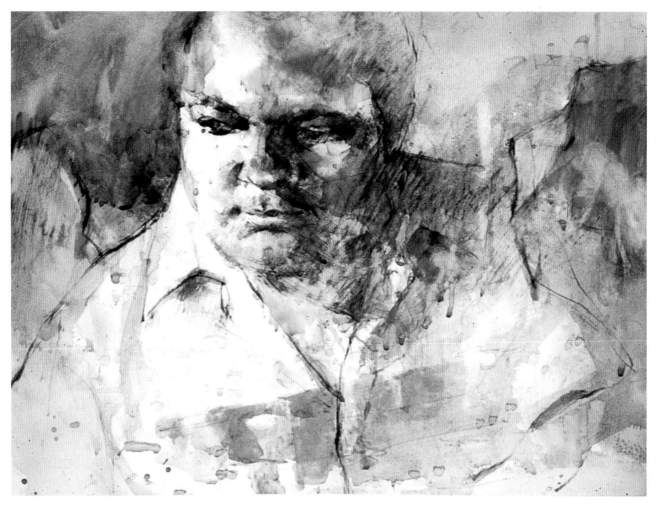

THE DISHWASHER
Watercolor and charcoal, 18 × 24" (45.7 × 61.0 cm), 1986, private collection, Columbia, S.C.

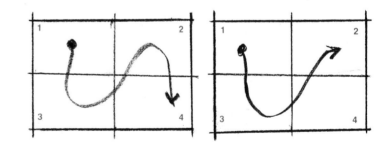

Here the movement of light is from the face to the shoulder, across
the chest, continuing toward the background light in the upper right.
This movement makes a sideways S- or a U-shaped movement.

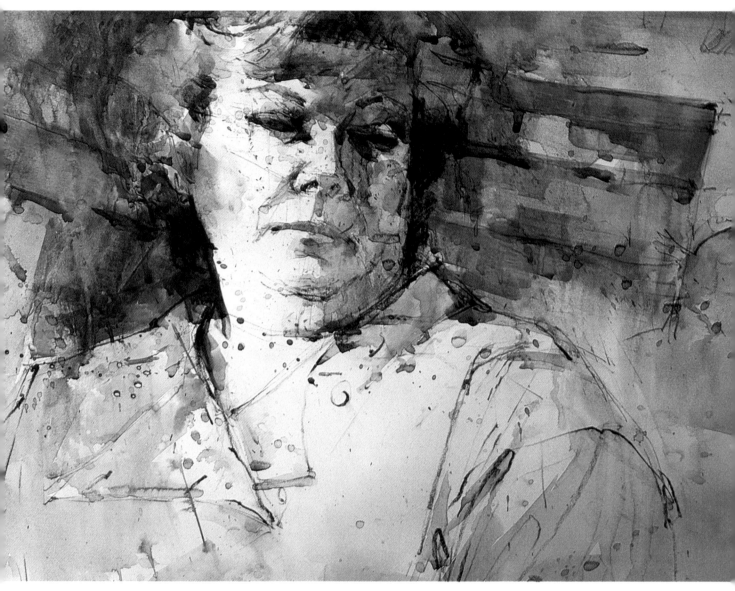

GLENDA
Watercolor, 17 × 23" (43.2 × 58.4 cm), 1985, collection of Helen Bixler, Anderson, Ind.

This painting is an example of movement in a U shape. The focal-point light shapes in quadrant 1 move to quadrant 3, then to 4 and finally to the background light shapes in quadrant 2, completing the U shape.

Alex Powers

Movement from Foreground to Background

The use of space is integrated into movement through the rectangle by connecting the foreground light of the paper doll to the background light of the silhouette. If the paper doll is in quadrant 1 and the silhouette is placed in quadrant 4, the movement makes the shape of an S turned on its side. A vignette is created by placing the silhouette in quadrant 2 rather than quadrant 4. Study the passage of light in *Southport Model*. Also, notice the rest area created by the background light of the silhouette.

Have you observed Alex Powers's inclination to turn the watercolor sheet horizontally rather than vertically, even when the model is in a vertical pose? This prevents the vertical pose from being echoed too loudly by the vertical format of the paper. A diagonal and horizontal movement counteracts the vertical format and brings the background space into play, offering the possibility of movement into the background. Otherwise, situating a vertical figure in a vertical rectangle can result in a thoughtless rendering of the figure, since the background space is marginal and makes no artistic demands.

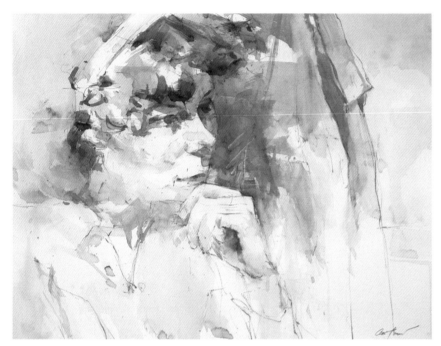

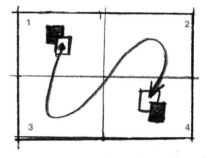

If the silhouette relationship of values is placed in quadrant 4, a sideways S movement is traveled when the white shape of the paper doll is connected to the background light of the silhouette.

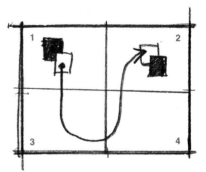

SOUTHPORT MODEL
Watercolor, 18 × 24"
(45.7 × 61.0 cm),
1983, private collection.

Again, the focal-point light shape is the side of the face. The outlet for this light shape is the hand. The light movement connects to the vignette at the bottom of the painting and moves up to the background light behind the vague image of the silhouetted hanging jacket.

When the silhouette is moved up to quadrant 2, a U-shaped movement is made, leaving quadrants 3 and 4 as vignettes.

Alex Powers

Demonstration:
Coordinating the Head with the Background

As a teacher, Alex Powers does not have a technique-oriented approach to instruction, but he does find value in using painting demonstrations as a program for an art meeting or as part of an art class. The process of making a painting is revealed as well as the finished product. There are as many different processes, or painting procedures, as

there are varieties of completed paintings.

When Powers uses demonstrations, he schedules them toward the end of the workshop week. Also, during demonstrations he explores with the class how technique relates to design and aesthetics.

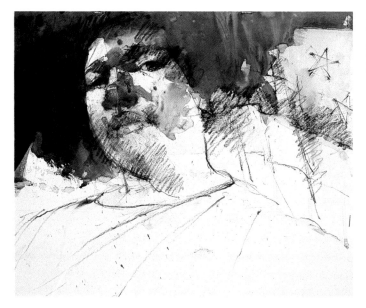

Step 1. Before he painted the dark blue background, Powers defined and modeled the upper part of the face. Even though this model, one of Powers's favorites, is a black woman, he left some of the light areas of the face as white paper. This creates sufficient value contrast with the dark background.

The focal point of the painting is established in the upper left quadrant with the white face against the dark blue background. The sharp edges of this strong value contrast draw the eye to the focal point. A middle-value version of the dark blue background is carried behind the head and toward the upper right.

Step 2. With a 6B charcoal pencil, Powers drew back into the painting, after it had dried, to reestablish the drawing and to allow himself to think about the next step in the painting. He also strengthened some of the darks of the face with the charcoal pencil.

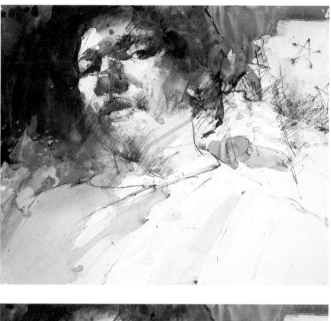

Step 3. The browns and tans of the face were repeated in the lower half of the painting. Powers indicated the beginning of the feeling of the stripes of the flag at middle right.

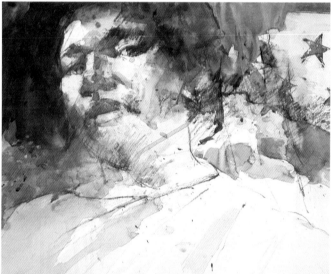

Step 4. The reddish tones added here had already been set up by the browns, which are in the same color family. Powers painted the stars red in the background flag to contrast with the off-white beside them. He did not want to continue the blue all the way across the top of the painting. This left the off-white to play against the stars. He added some reds to the face to bring the reds into the foreground space.

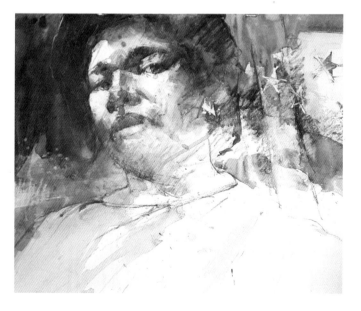

Step 5. Although this step is one of clarifying detail, it is a step that worries the artist. He tries to confine any detail to the transition from one shape to another. He tries to stay out of the center of light, middle-value, and dark shapes.

At this point, Powers added a white star or two to suggest the feeling that the stars are becoming lighter in value as they move to the left, while the blue background grows darker moving toward the left.

Notice that one side of the face has a much sharper edge than the other, making clear which is the focal point. Similarly, the upper part of the face is much more defined than the lower part. This prevents the rectangle from being divided in half. Also, it sets up a transition from the clarity of the face in the upper left to the vagueness of the shoulder in the lower right. The entire central area of the painting serves to unify this contrast.

BLACK AMERICA II
Watercolor, charcoal, and chalk,
12 × 16" (30.5 × 40.6 cm), 1987,
collection of Elaine West, Lakeside Park, Ky.

FLOWERS

What could be more inspiring than the sight of a hillside covered with beautiful flowers, a bower of roses, or the scent of lilacs on a spring day? Many an artist has succumbed to the delights of painting flowers in all their variety and glorious color; here, five experts share their approaches.

Edward Norton Ward

Learning from Variations in Light and Shadow

No matter what the light of the day—sunny, overcast, rainy—flower gardens are beautiful. The varying outdoor light inspires Edward Ward to return to the same scene again and again to discover there yet another, different painting. Knowing how colors respond to light and how different atmospheric conditions create unique effects, he may find strong, bright highlights on blossoms one day and return on a gray day to find flowers displaying their colors at full intensity against the cool background light.

The poppies in *Iceland Poppies* were mostly in shade when Ward first saw them. When the sun moved out from behind a cloud, suddenly several blossoms stood out in sunlight, while many of the flowers remained in the background shade. Ward was interested in the contrast between the flowers in the light and those in the shade.

The artist's preference was for the sunlit blossoms. He decided to show only a few shaded flowers in the distance; these form a diagonal outline behind the tops of the sunlit flowers. Ward chose the green foliage as his dark shapes, using it to frame the main group of poppies. Notice that he painted the poppies primarily against a white background, which sets them off dramatically. To further emphasize the feeling of light, Ward painted a few leaves and buds in a warm yellow-green as a contrast to the cool blue and gray-green of the darker foliage.

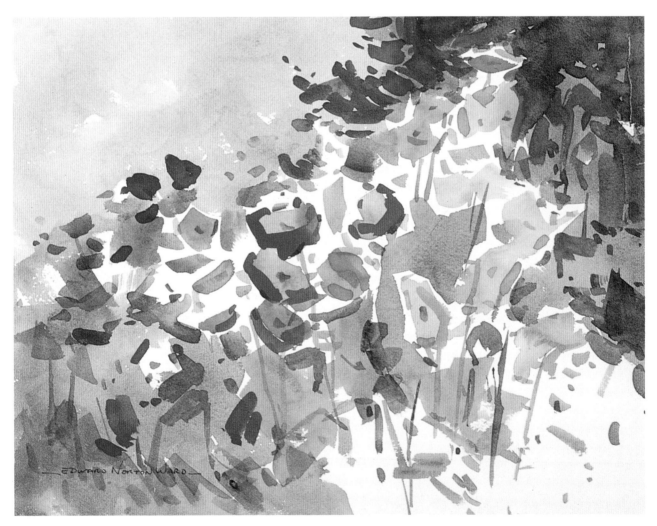

ICELAND POPPIES
Watercolor on 140-lb. cold-pressed paper, 11 × 15" (27.9 × 38.1 cm).

Edward Ward painted the individual blossoms in two or three strokes, emphasizing the red poppies over the yellow. When these first small washes were dry, he added darker red strokes to some of the poppies to further define them.

Seeing Flowers As Masses of Color

When Edward Ward paints a flower garden, it is the colors that first attract his eye. Once he's featured a dominant color, he can use several variations to perk up the initial flat washes. *Ivy Geraniums* was a quick sketch of a plant the artist's wife was growing in a pot on their deck. It was in full bloom, almost a solid mass of cool pinks and reds, with hardly any of the yellow-green leaves showing. Ward decided to feature one large shape of cool pinkish red as an underpainting. Before the initial wash of light permanent rose could dry, he put in some strokes of the richer pigment scarlet lake to add both interest and dimension. He made

no attempt to paint the individual blossoms as botanically correct specimens, because he wanted to show them massed together. The touches of scarlet lake introduced a second variation of red and gave texture to the large wash of pink.

In this sketch, Ward left several accidental spots of white paper when he put down the first wash. These "accidents" create sparkle and highlights, adding yet another dimension and texture to the initial wash. Actually, these whites only appear to be accidents; they are the result of the artist's skill and conscious effort to preserve them.

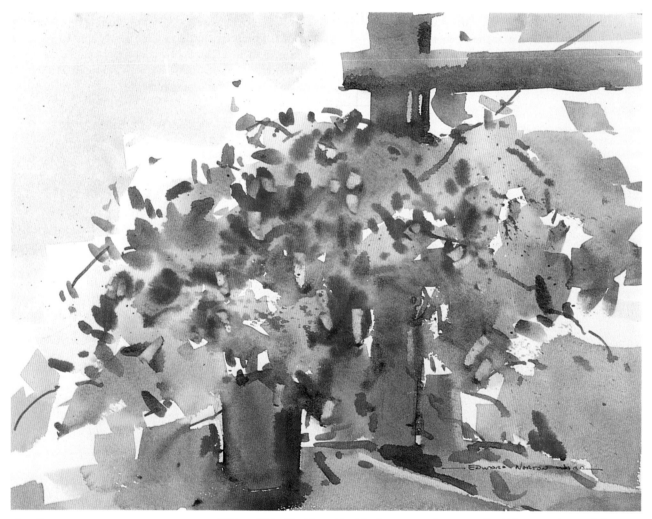

IVY GERANIUMS
Watercolor on 140-lb. cold-pressed paper,
11 × 15" (27.9 × 38.1 cm).

If Edward Ward had found in this plant an equal amount of red blooms and green foliage, he would have made the color red dominate by eliminating the green foliage from his sketch. When painting masses of flowers, it's better to let the flower color dominate.

Edward Norton Ward

Finding Different Shades of White in an Overall Shape

One of the most striking contrasts in the garden is that of white flowers against a dark background. When you feature white as a dominant color in your painting, you have to be aware that white has much the same visual properties as real colors. Nearby colors can reflect into the white in shadow. Knowing this gives the painter opportunities to find different shades of white within the overall white shape.

Shasta Daisies and Coreopsis is a sketch of some flowers that were growing in the artist's wife's garden. Edward Ward wanted to suggest the ragged edges of the daisies by cutting brushwork of dark background color into their white shape. A few yellow spots at the centers of the blossoms, and the shape looked like a cluster of daisies. Ward let a little of the yellow creep into the lower edge of the white daisies to show that the light was reflecting off the coreopsis.

When Ward painted *Apple Blossoms in the Sierra Foothills*, he had been scouting the Sierra Nevada foothills for other reasons and was pleasantly surprised to find the orchard in full bloom. It had been raining on and off all day, and he wanted to try to capture the feeling of that time of day when the sun goes below heavy rain clouds and casts a strong, low-angled light across the landscape.

Usually Ward visits the apple farm just after the harvest, when there is fresh apple cider and the tang of fall in the air. The color is warm then and rich against dark violet blue hills. The atmospheric feeling he was seeing this time, in spring, was lost in the first sketch, which he felt came off too strong. With his second attempt, Ward decided to let up on the strong contrast of light and dark and work the gentle color contrasts in the white blossoms instead. The dark ultramarine blue in the background hills would be replaced by cobalt blue. Where he had left the flowering trees almost all white before, he decided to wash a gentle blue-violet over most of them. Light, cool shadows replaced the darker ones. Ward reserved rich color for the warm russet reds he painted as symbols of the bare, wet earth.

Here, the strong diagonal line of the shasta daisies, identified by their subtly rendered yellow centers, continues over the top edge of the yellow coreopsis. The artist used a few reserved white spots in the dark background wash to suggest distant daisies and to complete the design.

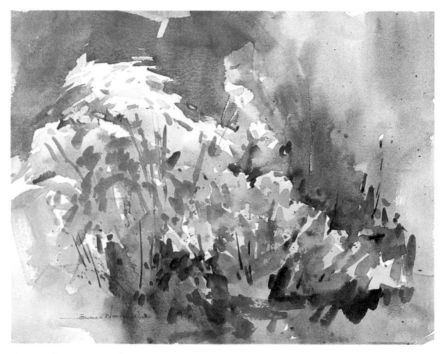

SHASTA DAISIES AND COREOPSIS
Watercolor on 140-lb. cold-pressed paper, 11 × 15" (27.9 × 38.1 cm).

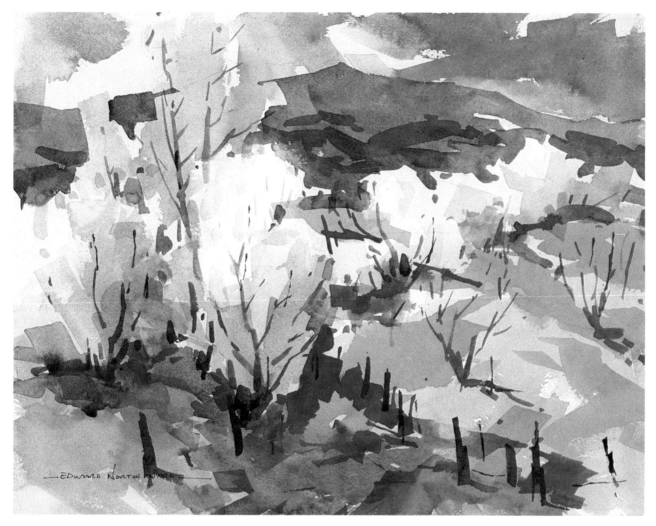

APPLE BLOSSOMS IN THE SIERRA FOOTHILLS
Watercolor on 140-lb. cold-pressed paper, 11 × 15" (27.9 × 38.1 cm).

While the main color of the flowering trees is white, Edward Ward could see several pastel shades of the surrounding colors reflected up into the cool shadow sides of the trees. Only enough white was left at the tops of the trees to show that the sun was shining behind the dark rain clouds.

Philip Jamison
Two Vases of Daisies

Philip Jamison sees this as a "fun" painting, meaning that he is starting out in a very loose, free manner without a particularly strong preconceived plan. Although he usually paints flowers from life, this watercolor is done from memory, and his intention is simply to give an impression of two vases of daisies.

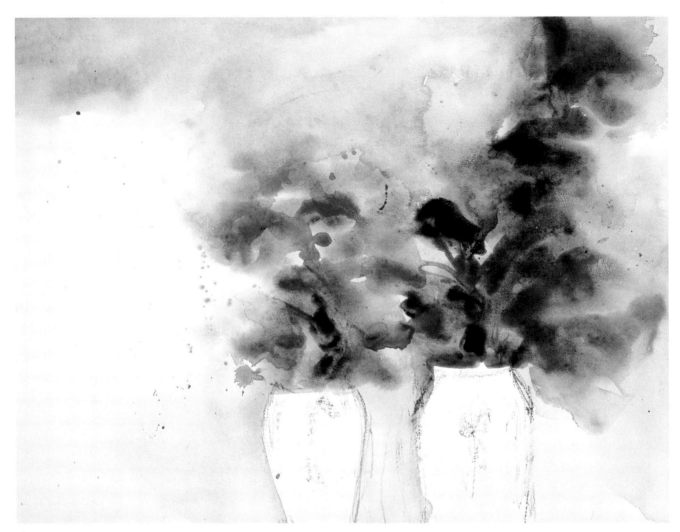

Step 1

Jamison does very little preliminary drawing—just roughly suggests a few shapes with soft charcoal on his paper. He knows that he will eventually want the daisies, and perhaps one of the vases, to be the whitest areas of the painting; so he first applies a cool wash of Davy's gray mixed with Payne's gray over the entire paper except for the area where the vases will be. While the paper is still wet, he drops in some spots of yellow ochre and raw sienna. When this dries, he remoistens the area that will eventually be flowers, and flows in light and dark olive greens to suggest the foundation colors for the bouquets.

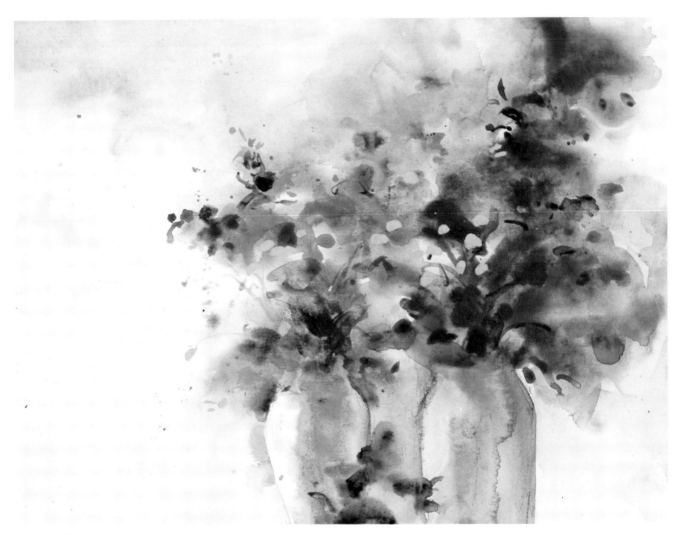

Step 2

In order to cover as much of the paper as possible right away, Jamison paints the two vases using a mixture of Davy's gray, Payne's gray, and cerulean blue, allowing the colors to flow together freely. At the same time he wets a few areas of the background and drops in a touch of these same colors, along with some raw umber. He does this to create a feeling of air and space surrounding the flowers, and to eliminate the flat white background. Notice that Jamison also tones down the area between the two vases so that it won't be so prominent. He begins to define the leaves just a bit, using olive green with traces of Vandyke brown. Because the vases seem very harsh at the bottom of the painting, he softens their lines and importance by suggesting a few leaves coming up from below. He also denotes a number of yellow daisy centers here and there among the greens, using cadmium yellow mixed with a trace of permanent white.

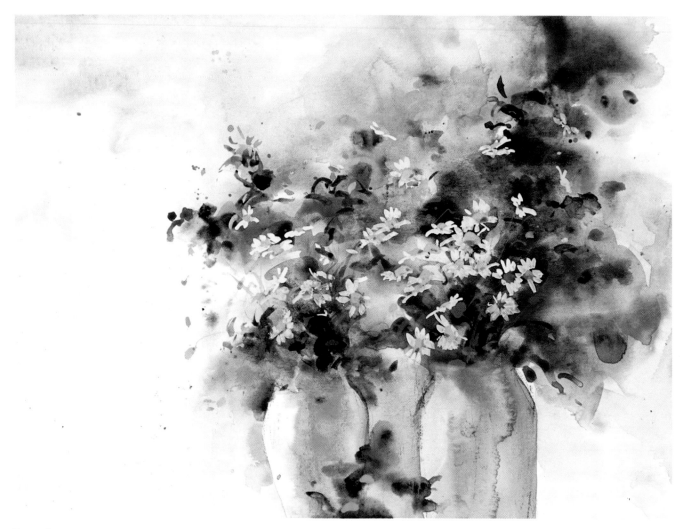

Step 3

At this stage, all of the large areas are established and Jamison is anxious to put in some suggestion of daisies in order to give the painting a feeling of life. Because not all flowers or petals will be in full light, he uses a mixture of permanent white and Davy's gray to portray the flowers that he wants to be in partial shadow. Although he wants to create the impression that the flowers have been very casually placed in the vase, their arrangement in the painting is of paramount importance to him, since these whites will form an integral part of the overall design.

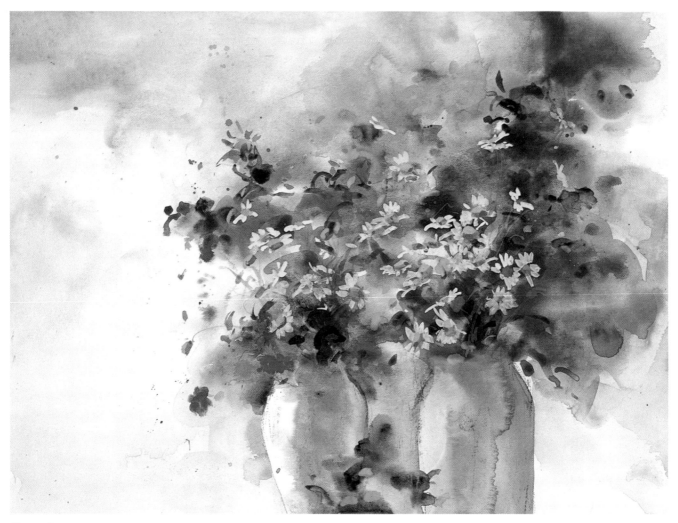

Step 4

Jamison's chief concern now is to develop the flowers further and to give them a feeling of mass existing in space. To do this, he adds a few more flowers and begins to mold their centers by adding shadows of burnt sienna and olive green. He paints in suggestions of stems and leaves, using a semiopaque mixture of olive green and permanent white. At this point, the artist feels the painting is somewhat lacking in color, so he adds touches of Prussian and cerulean blue to represent bachelor's buttons. These are applied with both a #8 sable brush and his finger.

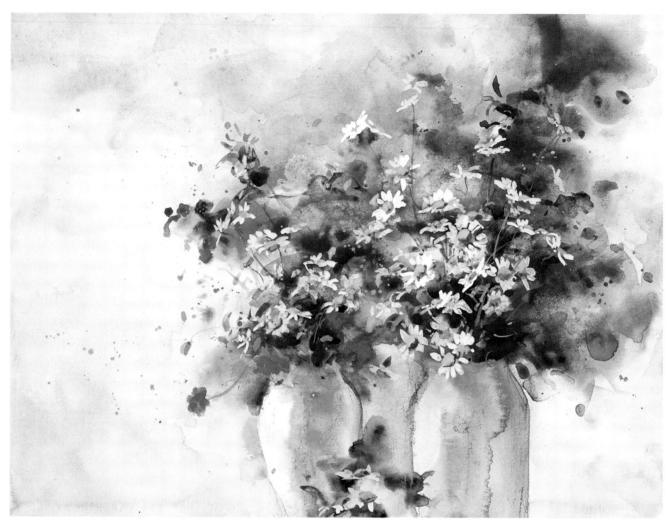

Step 5

Jamison adds more flowers to the composition, including several at the bottom of the paper. Continuously attempting to think in terms of light and form, he now concentrates on the flowers that will not be in shadow. He paints some daisy petals with pure permanent white, and others with permanent white tinted with cadmium yellow light, thereby giving a feeling of depth to the bouquets. Using a 2" flat brush, Jamison wets the background and puts in a few tones of Davy's gray—especially in the lower left-hand corner, which he feels is overly white.

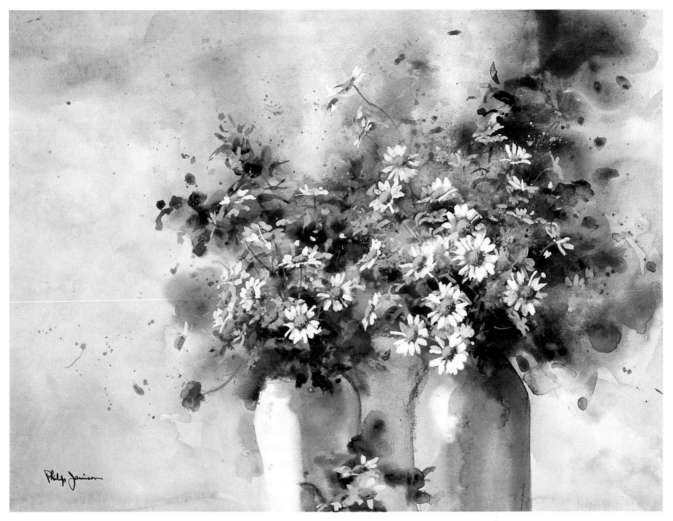

TWO VASES OF DAISIES
*Watercolor on cold-pressed rag paper,
14½ × 19¼" (36.8 × 48.9 cm).*

Step 6

In this final step, Jamison considers the overall painting and begins to refine the larger areas, adding some detail as well. He wets a small natural sponge and removes several patches from the background, such as the warm area at top center, which he considers too prominent and not exactly the shape he prefers. He blends some of the greens and daisies together in a similar manner and subtly overpaints them with a semiopaque mixture of cadmium yellow, olive green, and a touch of permanent white. He applies the paint with a natural sponge as well as a #8 sable brush, in order to give the greens a textural feeling and to add warmth to the center of interest. Jamison wipes out part of the right-hand vase with a moist brush and also darkens its right edge with a cool mixture of primarily Payne's gray.

The artist adds more flowers and refines others further by introducing a bit more detail—all the while thinking of the watercolor as a *painting* rather than a literal picture of two vases of daisies.

David Millard

Making a Good Painting with Only Two Colors

One way to learn about what your colors can do is to work with a limited palette. Challenge yourself. Pick one or two colors at random and see what you can do with them. Here is a two-color floral of some spring lilacs that were just begging to be painted. Using just a bit of mauve and green, how would you paint them?

Tone the paper with a big, soupy wash of mauve, except where you want little white touches and the white paper to separate your wet colors and prevent them from running into each other. This wash diminishes the quality of light so you now have a soft, foggy morning effect. The bits of white paper tend to sparkle in the fog and give the feeling of a third color, white—as though you were actually using a tube of white paint.

After the first wash is dry, begin to design and color your way down through the bouquet of lilacs and leaves, working down from the top. Get the most out of your green: heavily pigmented leaves, tinted-water leaves, or green and mauve mixed for stems and a few dark accents. Then design the stems with great care. Good stems can make a floral!

Turn the painting upside down and study the negative shapes around the outside of the bouquet. Note the near-parallel horizontals of the water level in the vase compared to the tabletop, and the vitreous quality of the shape of the light reflection at the base of the glass. Even on a two-color, "make-do" watercolor, good design is always important.

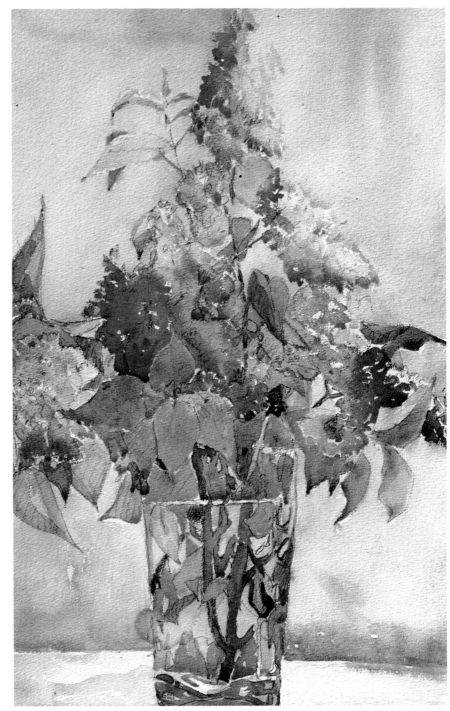

Capturing the Impression of Dew-Laden Tulips

At times you may wish to create a very deep-toned watercolor, one with a quiet mood but not a somber or murky one. Let's say you're out in a field very early to start your painting day and run across a delicate trio of tulips in the early light of dawn. How can you manage to get these deep tones and still not come up with mud?

First, fix this fleeting impression, the image of the light of dawn on these dew-laden tulips, in your artist's eye, your memory. Your desire is to express this piece of poetry in paint.

Right away, picture in your head how the entire vision will look as a painting. Get a fix on how the colors relate to each other. How are you going to rapidly grade these colors for the tulips, grasses, sky, and leaves on your value scale of one (white) to ten (black)? How will you get those values of tone, grayness, brilliance of edges, and wetness catching the first sun? By remembering what you've seen. You have only a few moments to stare at this scene, to think it out in color before you even wet your brush. Remember the first rays of light and the emotion of this sudden discovery. That's what you'll have to get into the watercolor. Your goal is easy; just remember this first impression. But look quickly—the light changes constantly.

Now let's analyze how this gets translated into paint. That rim of dew catching the sun has to be done by leaving a tiny separation of white paper between the edges of the blossoms and leaves. The sky is still quite gray, since the sun is so low. The grasses are dull grayish greens and earth tones mixed with blues. Some areas are intensely deep, such as where ultramarine blue and alizarin crimson are mixed on the extreme left-hand side.

The yellows start out quite light, but are then grayed off with raw umber and run down into a fusion of umber-oranges and quite deep yellow-browns. The center blossom moves into mauve and burnt sienna at its base. This is really deep color, but it will remain clear and clean if you apply your wash quickly and keep your paper slanted at all times, even while drying. Use cool greens for the stems and leaves. After all, it's early morning and the sun isn't adding any warmth to speak of, as yet.

The trick is to catch this first glimpse. Lock it into your memory, and then, in a burst of emotion, paint it to match your first impression, even though the light and colors have changed as the clock ticks on.

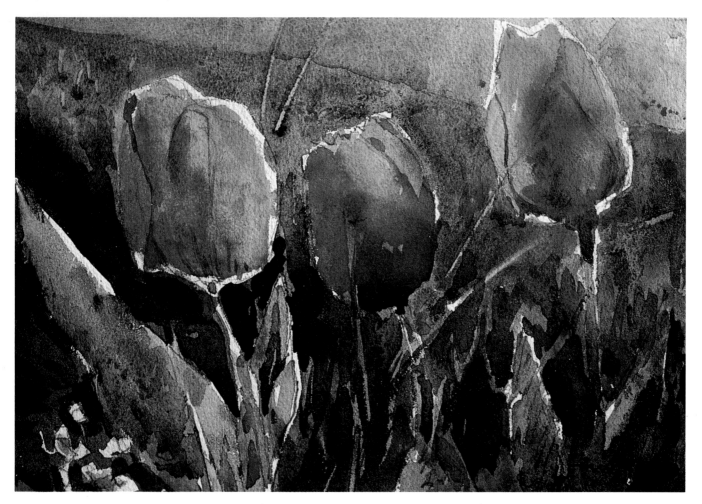

David Millard
Creating a Series of Floral Tone Poems

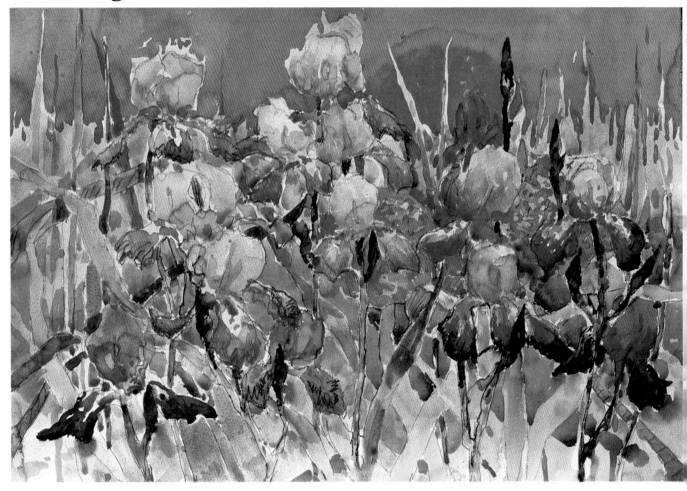

The three floral paintings shown on these two pages form a series of what David Millard calls "tone poems." Each painting is an attempt to create a different type of mood, another sensation, with varied colors and designs.

The first of these paintings has high-key oranges, lavenders, pinks, and greens. It makes Millard think of Rimsky-Korsakov's *Scheherazade*, an exotic Oriental musical fantasy. The second painting is deep and sonorous, with dark earths, purple-browns, and blues. Looking at it, Millard thinks of Beethoven. The third painting is strident in its strong, contrasting tones, both very high and very low. It has an abstract quality that makes him think of modern jazz.

Now look at the basic design themes. The first painting has vertical spears, spikes in puffy circles, phallic qualities. The second painting also contains many V shapes originating from the tree trunk, but these shapes are less vertical and closer in quality to those in the third painting. The third example, on the other hand, has a rounded effect, with its emphasis on circles and ovals formed by the swirling stems.

Notice the importance and volume of the darks. In the first example, the pattern of V shapes is continued in the dark bottom petals and their tips. In the second painting, an enormous volume of darks is interwoven between the delicate branches. The third painting has a more varied treatment of darks, which appear as negative shapes in the stripes and positive forms in the shadows.

Now look at the picture plane. How deeply does the eye move into the distance, or does it stay on the surface of the paper? In the first painting, the green leaves are modest in their penetration, but the sun and sky are deep behind the iris. In the second example, you look deep into the forest in the upper half, but slabs of granite in the middle distance block the lower areas. Looking at the third painting from all four sides, you move from shallow to moderate penetration of the surface.

Looking at other features in common, notice the use of threadlike whites in each painting, to separate the colors and emphasize directional movement. Also, note the nonclassical treatments here, the use of asymmetrical shapes and nonformal arrangements. Your eye is constantly drawn from positive shapes to negative ones and back again, creating a great deal of surface tension throughout the paintings. Finally, notice how the problems of landscape and still life are interchangeable. If you're having a tough time with a landscape, just pretend it's a still life—and vice versa.

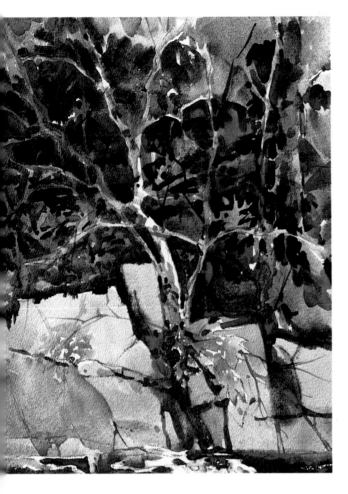 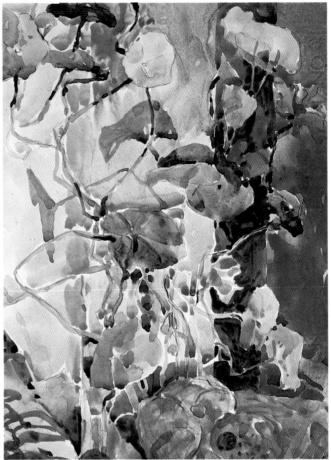

Richard Karwoski

Composing a Flower Portrait

This exercise focuses on a single flower. The purpose is to learn how to draw and paint directly from flowers and to practice simplifying a composition or subject by editing and painting in a more fragmented way. Work may proceed from the center of the flower outward or from the outside inward.

This type of composition works best on a large scale, 22 x 30" or larger. Start your drawing in the middle and expand outward. Position the smallest petals somewhere near the center of the sheet. Draw with an HB pencil, using a light hand; as your pencil moves closer to the edge of the sheet, the petals should increase in size and proportion.

When you complete the drawing, begin to paint by building up your color washes in small shapes that are scattered all over the surface. Don't begin by painting from the center outward; you may get bogged down in details. Vary the washes and color values from petal to petal. Try not to be repetitive, treating all the petals the same way and using the same colors and values. This type of composition does not call for much of a background. In fact, in some instances, Karwoski leaves the white of the paper as the background, instead of a colored or gray wash. Consider which is best for your particular situation.

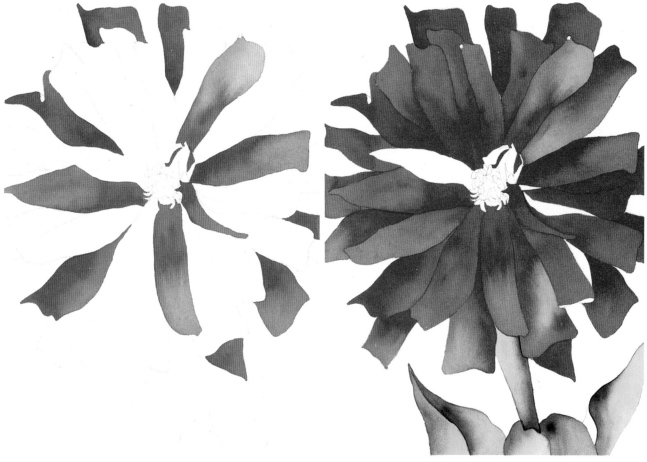

Zinnias make wonderful subjects because of their bold shapes and vivid colors. Karwoski held the zinnia in his hand and drew the individual petals, starting with the center of the flower. He began painting with several reds—alizarin crimson, cadmium red light, and rose madder—working all over the paper with a #6 brush.

Karwoski continued to paint most of the flower, including the stem and leaves near the lower part of the watercolor sheet. Notice that the petals reach to all the edges in the composition. The colors and values vary along with the washes within each petal.

ZINNIA
*Watercolor on Arches 140-lb. cold-pressed paper,
11 x 15" (27.9 x 38.1 cm), 1987, private collection.*

In the last stage, the artist painted the remainder of the petals, as well as the center of the flower and the background. He chose ultramarine blue for the background color and used a #12 brush to create the value variations in the wash. The lower portion of the background is darker in value to give a sense of blue sky and a natural setting.

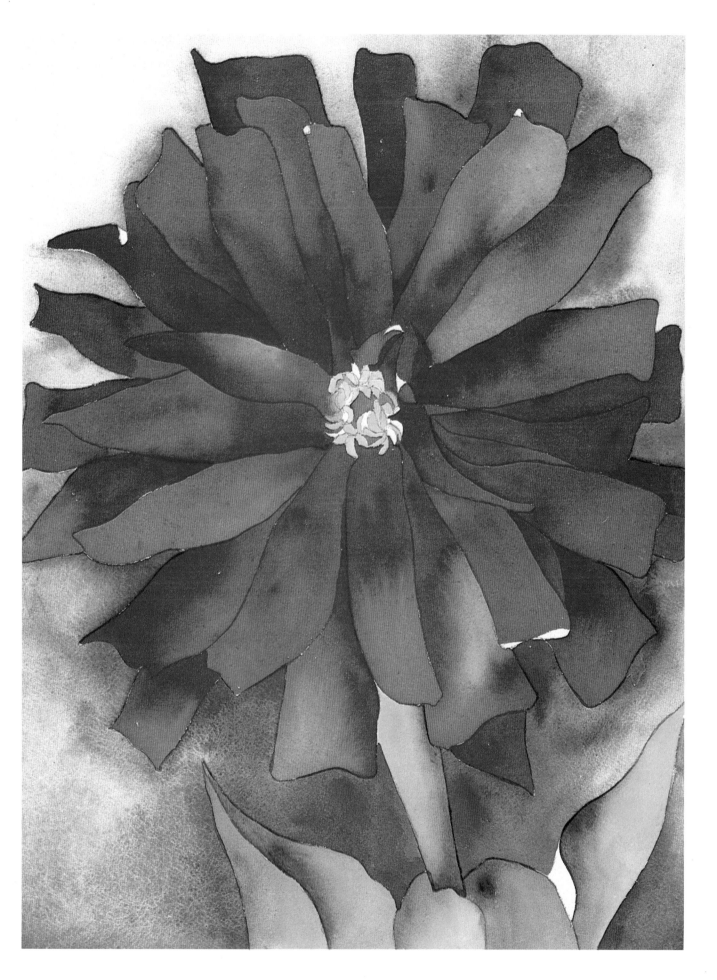

383

Richard Karwoski

Painting Bouquet Close-ups As Abstract Designs

The bouquet close-up makes an interesting composition, for it can hug all the edges of your watercolor sheet and look quite abstract.

Choose several kinds of flowers, place them in a container, and arrange them in a cluster so the petals and colors mesh and intertwine. Move as close to them as possible without distorting their proportions and shapes.

Use a rather large vertical or horizontal format for this painting. Richard Karwoski works on a scale of 22 × 30" or larger when he does this kind of composition.

Create a free-flowing pencil drawing that reaches all the edges of your watercolor sheet.

This particular approach to painting flowers becomes fairly abstract. Begin to paint by isolating each petal with value and color; keep the edges crisp and the inner areas loose and flowing. There is no background to consider.

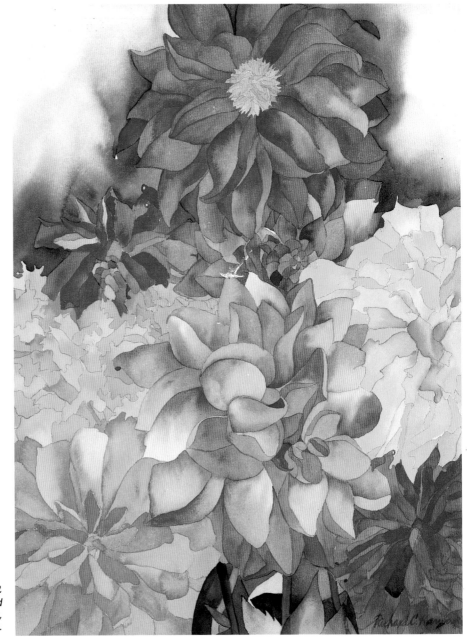

BOUQUET NO. 2
Watercolor on Arches 140-lb. cold-pressed paper, 22 × 30" (55.0 × 76.2 cm), 1980, private collection.

This watercolor painting is one in a series Richard Karwoski has done depicting bouquets of flowers. He arranged the flowers (dahlias, zinnias, and marigolds) as a close-up study and allowed the image to run off all the edges; note the two petals of the red dahlia at the top. As you can see, he incorporated a wide range of colors and values to make this bouquet convincing. The background color was left for the last step; there, Karwoski chose cerulean blue to suggest the color of the sky. Note how the deeper values in the background wash trace the overall outline shapes of the flowers.

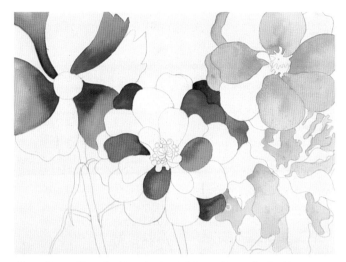 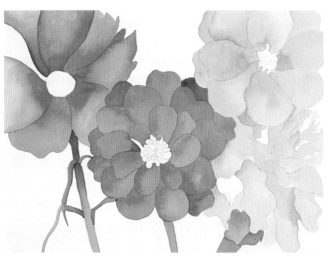

Here, Karwoski worked in a horizontal format to make the flowers appear to be growing in a row from below the bottom edge of the paper. He overlapped the flowers to give a sense of the meshing and interlocking of the petals and made sure that they all touched the edges of the paper.

Karwoski continued to paint all of the flowers in the composition with a variety of colors including cadmium yellow light, magenta, carmine, permanent orange, and permanent green light. He chose to leave the centers of the flowers unpainted until he applied the gray wash to the background.

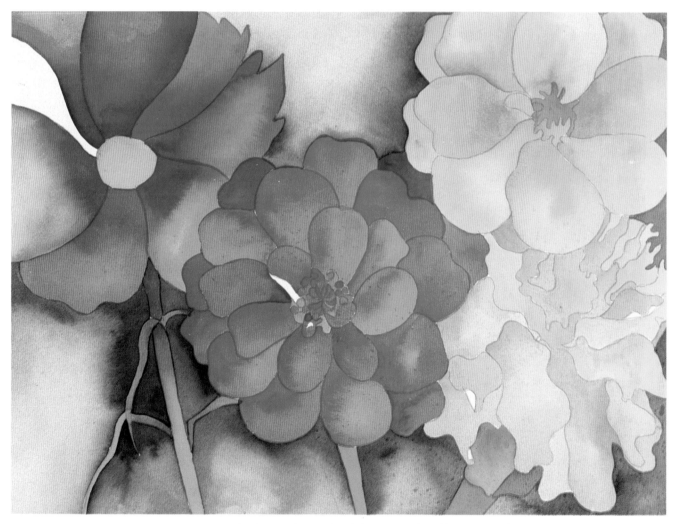

MIXED FLOWERS
Watercolor on Arches 140-lb. cold-pressed paper, 11 × 15" (27.9 × 38.1 cm), private collection.

Richard Karwoski completed this painting by adding an overall wash of Payne's gray to the background, with the deeper values surrounding the edges of the flowers. Notice that he left one petal of the cosmos flower unpainted. He wanted to lead the eye off the watercolor sheet so sharply that the viewer might even be startled at first glance. Several smaller white areas were also left unpainted for accent and highlight purposes.

Richard Karwoski

Editing the Garden Landscape

A specific detail in a garden setting can make an interesting watercolor composition. Several leaves, branches on a tree, or a few flowers can be considered appropriate subject matter for this exercise.

Begin by doing a fairly casual pencil drawing on a sheet of cold-pressed paper. Don't attempt to draw an exact likeness of each leaf, branch, or petal, but draw an overall impression of the subject matter. Richard Karwoski tends to improvise as he draws by working all over the watercolor sheet. When drawing a tree, for instance, most people would begin by drawing the trunk, but he usually begins with the branches.

As you do the drawing, remember: Begin with the composition and work all over the paper, blocking in your primary areas first in pencil. Don't get bogged down with detail, but draw in large sections of subject matter and then rework them by adding detail. Remember to be free with the pencil, as if the right side of the brain is doing the work for you.

Once you have created a pencil composition that pleases you, it's time to begin painting. The first step is to apply pigment washes with a large brush to the most prominent areas in the foreground, middle ground, or background. Next, use a smaller brush to isolate specific details such as branches and leaves. When Karwoski paints this type of subject matter, he tends to see what's behind the branches. For instance, he sees shadows and other branches that isolate the shapes of the leaves; these are not necessarily drawn but may be suggested with a color like burnt umber. In describing the branches you may choose to do what Karwoski does: leave them unpainted to create positive white areas on the paper. Remember to paint the secondary areas, such as the background, the branches, or the areas behind the leaves, before the primary areas. It may be tempting to paint the flower before the leaves that surround it, but you'll find it's easier to work around an important shape and then come back to it.

As Karwoski continues to paint, he mixes and dilutes the pigment on the watercolor sheet rather than on the palette. He has fun with the leaves by suggesting their shapes with the tip of the brush. He's also painting clusters of leaves, not necessarily each individual leaf. By reducing complex forms to an overall shape or shapes, leaving some of the paper unpainted, and mixing his colors on the paper, Karwoski builds up the forms as he goes along. If you're painting trees or a cluster of leaves, you should work with a variety of greens such as viridian, emerald green, and yellow-green, to mention a few. You may add some yellow or blue for greater variation.

Always make sure you work in such a way that most of your shapes go off the edges of the paper. Work quickly with the brush so the pigment doesn't dry too fast on the watercolor sheet. Feel free to mix the pigment as you go along. Try not to wash out the color; you can avoid this by mixing directly on the paper rather than diluting the paints on your palette.

If you prefer to suggest the subject matter with a more impressionistic technique, especially when suggesting leaves, that is also valid. It's possible to block in all the major areas with simple shapes filled in with washes of various light and dark values, then go back with a smaller brush to suggest texture.

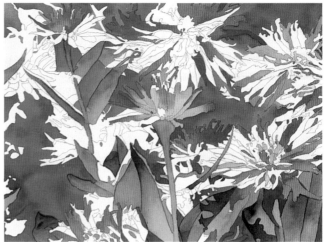

Richard Karwoski focused on a cluster of zinnias in the flower garden and drew his subject in pencil. He singled out one flower in particular to represent the center of interest and began to paint some of the petals on the zinnias.

He painted in the areas around the flowers, using greens, blues, and violets to suggest the leaves, stems, shadows, and sky. He also painted more petals on the zinnias. Notice how the color and value vary on each petal.

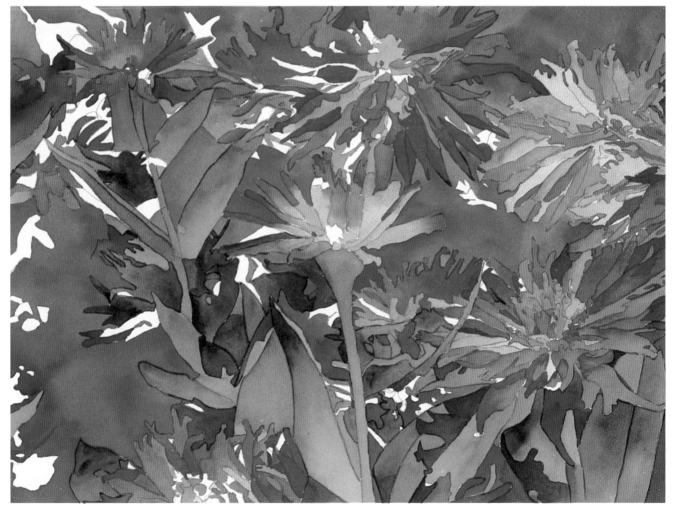

A MINI MEXICAN GARDEN
Watercolor on Arches 140-lb. cold-pressed paper, 11 × 15" (27.9 × 38.1 cm), 1987, private collection.

Karwoski continued to alternate between painting the subject and painting the background, developing them both simultaneously until he reached a pleasing composition. He retained several areas of white to represent highlights on the zinnias; white areas in the background create further interest there as well.

Richard Karwoski
Finding Inspiration in Tropical Plants

Richard Karwoski made a trip to the Hawaiian Islands several years ago that inspired a series of watercolor paintings depicting tropical plants. He did most of the paintings in the solitude of his studio after he returned home, however; he had taken hundreds of slides and photographs that he later used as references and sources of information for this particular series. You don't have to book a flight to Hawaii in order to create such a series of paintings; simply go to your nearest florist, greenhouse, or public botanical garden and either draw and paint on location or photograph your subject matter to capture an image for future use.

The Close-up Composition

Whether you work on location or from a photograph, the approach to the close-up painting is the same. Block in the line drawing with an HB pencil, making certain that it touches all the edges of the paper. Tropical plants usually offer a definite center of interest. Place it somewhere near the middle of the sheet for the best results. The only background to consider when doing the drawing may be other leaves from other plants; integrate them into the composition along with the primary subject matter. If you work in the studio, refer to slides or photographs but aim for an individualistic interpretation, not a photographic likeness.

Begin by painting the leaves, stems, and flowers in the foreground using a large brush, such as a #10 or #12. When most of the primary areas have been painted, begin adding details with smaller brushes. Don't do them all at once; alternate between the details and the large areas. If the subject matter you have chosen has a strong light source, include an additional element of shadows as a last stage after the primary image has been painted. Karwoski has used a violet or a blue to indicate the shadow effects by painting over the existing imagery to convey atmosphere and depth. A background consisting of other plants or just space could also be handled by adding blue or violet to create shadows for greater depth or by leaving the white of the paper unpainted. The latter approach would suggest bright sun and daylight; the former would convey dawn or nightfall.

The Panoramic Composition

The panoramic approach to tropical plants, whether painted on location or from slides and photographs, may be done on any size paper; the format can be either horizontal or vertical. Consider the center of interest before you begin to draw the composition; if the plants that you have chosen to paint have no flowers, isolate several leaves in the foreground, somewhere near the center of the sheet, to serve as a focus. The middle ground and background could consist of other plants, perhaps with a suggestion of space or sky near the top of the watercolor sheet. When you have completed a preliminary drawing that seems pleasing to the eye, begin to paint. Whether this exercise is done on location or from reference material, the pencil line may be added or taken away at any point in the painting process.

Beginning somewhere near the middle of the pencil composition, use a #10 or #12 brush to paint in the lightest values in the background, middle ground, and foreground. Work from light to dark values throughout the painting, mixing colors and washes directly on the watercolor sheet. Change to a smaller brush as the painting nears completion and save all details and color accents, except the unpainted white areas, for the last stage. Any shadows that are to be indicated can be painted in; again, they are usually done in a blue or a violet after the rest of the painting has been completed.

Step 1. For this close-up composition of tropical plants, Richard Karwoski referred to a slide he had taken while visiting the Hawaiian Islands several years ago. He selected a flower as the center of interest and incorporated the leaves of the plant in the background. After completing the preliminary line drawing, he began to paint the flower and several of the leaves, making sure to touch the edges of the watercolor sheet.

Step 2. Karwoski continued painting, using several greens, including Hooker's green, sap green, and viridian for the leaves and stems of the plant. He also retained several linear unpainted areas as visual highlights.

Step 3. He finished the leaves on the plant and painted in several small flower buds with cadmium yellow medium. For the background, he chose violet to suggest the fragments of sky appearing through the leaves at upper right and for the shadows in the other areas.

1

2

TROPICAL NO. 12
Watercolor on Arches 140-lb. cold-pressed paper, 15 × 11" (38.1 × 27.9 cm), 1987, private collection.

3

Don Rankin

Incorporating Opaque Techniques

Don Rankin found the inspiration for this painting in a small, untouched strip of land on the top of a local mountain where it is possible to believe that you are in the deepest wilderness, far from civilization. From season to season there are delights of wild violets, native orchids, jacks-in-the-pulpit, trilliums, a wide variety of ferns, and all manner of growing things. *The Edge of the Cliff* was painted in the studio, but it was born out of actual experience. The time was early morning in early spring, when the greens seemed to be unusually vibrant and intense. Rankin was excited by the light, and some of the colors were incredibly vivid against black shadows.

As you study the progress of this painting, you can readily see the wide range of color value. This was a case where the use of some color in an opaque manner was an ideal solution.

The glow of the white flowers against their background was Rankin's most important concern. Here he chose to reserve the white of the paper to maintain the quality of light that transparent colors allow. He did this both by carefully painting around some of the flowers and by using masking fluid in the areas where several flowers touch or overlap one another.

After Rankin had worked out his sketch, he transferred it to his watercolor paper using a light box. Next he soaked his paper in cold water for a short time, then stapled it to a plywood board, smoothing it to remove air bubbles. As the paper dries it contracts naturally and forms a tight surface.

Remember that when paper is damp it is vulnerable to abrasion and pressure, so be careful while you handle it. Damage to the surface will show up in a dried wash as a spot several degrees darker than the surrounding wash.

Step 1. Rankin executed his sketch on the paper, then, before immersing it in water, placed small amounts of masking fluid in areas he wanted to keep white. Although he really doesn't like using a masking agent, he did use it on a few of the flowers that were so closely clustered together that he would not have been able to reserve the white of the paper otherwise.

The first wash was applied wet into wet. When Rankin began to dampen the paper he was careful to paint with clear water around the individual flowers. As he dampened the paper, he would have to add more water to keep the paper from drying out before he could finish the tedious task of outlining each flower.

The first wash to be laid into the wet paper was new gamboge. Since the paper was stapled flat and contained no ripples, the color oozed into place around most of the flowers without much coaxing. In this wash, Rankin didn't attempt to be deadly accurate, except with the shape and placement of the flowers. After all, the flowers were the reason for the painting. In the rest of the piece he let the wash flow without a great deal of manipulation. His primary objective was to reserve the whites of the flowers; the secondary objective was to develop the middle-tone and shadow values.

Step 2. Once the sheet was completely dry, Rankin was ready to apply the second wash, a mixture of Thalo yellow green and Indian yellow. Note that the Thalo yellow green is predominant. Although this wash caused the watercolor to look too "hot" in value, later washes would modify that condition, but at this stage Rankin needed the strength of the color to set the stage for the rich, vibrant effect he wanted. This wash was applied to the entire paper, which once again he premoistened, especially around the flowers, to make coverage easier. This wash was especially critical for developing the intense, fresh spring greens that the artist had encountered on the edge of the cliff. As you examine this step, compare it to the final work. Notice how these early washes show through and influence the finished painting. Examine the direction of the washes. It is important to understand that every wash, every stroke is executed with a definite purpose. All of these strokes and washes come together to create a finished statement.

Step 3. In this step the character of the painting begins to assert itself. Some of the color-value relationships are almost set and others are strongly suggested. The application of Thalo blue begins to bring the color closer to the final statement. If you examine the flowers closely, you will see that they were not completely defined. As the washes continued to develop, greater care was taken with their finished appearance. Each application of wash was utilized to refine any mistakes or omissions made in previous layers.

Step 4. This layer of wash, a mixture of Winsor red and Winsor blue, was introduced to help neutralize some of the predominant yellow-green in a few areas. In fact, this wash was applied only to the upper right half of the piece and to the bottom half below the flowers.

Step 5. Rankin applied another wash of Winsor blue to further tone down the green. At this point some of the areas around the flowers were rather ill-defined. While the color was being corrected, most of the detail in the painting was still very nebulous. He had kept it that way so that he'd be able to take advantage of any abrupt changes in the work. Since no shadows or details were definitely set, changes wouldn't be as difficult to accomplish.

Step 6. Rankin felt that at this point the painting wasn't very attractive. In fact, a stage like this in the painting process often requires the artist to have a great deal of faith to continue. But in spite of its appearance, many important things were established with this dark wash, a mixture of equal parts Winsor red and Winsor blue. (The color bars to the right of the painting indicate the average value of each wash.) Some of the major shadow values are now in place; Rankin also continued to refine the white flowers. Note the value of some of the leaves; you will see that they are quite green. This is a part of the original washes that were applied for the background. The artist merely reserved some of this color by painting the darker washes around the basic leaf shape.

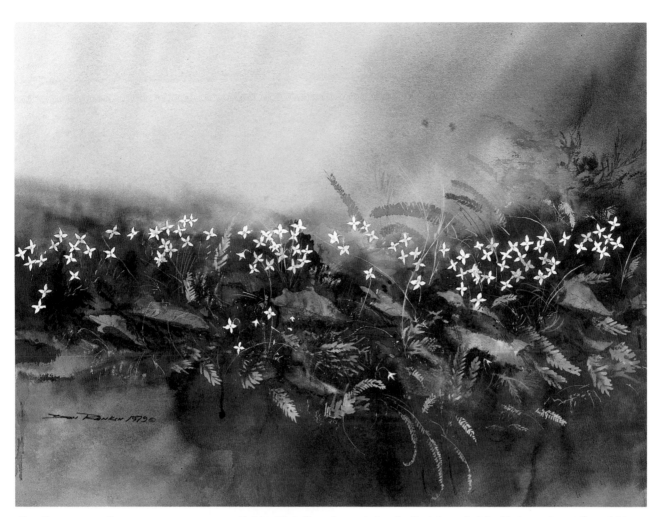

THE EDGE OF THE CLIFF
Watercolor, 17 × 23 ¾" (43.2 × 60.3 cm),
collection of the artist.

Finished Painting. It was during the final stages that Rankin began to use the paint in an opaque manner. Examine the shadows and note how they vary in value. These opaque washes are nothing more than Thalo yellow green painted over much of the shadow area at the base of the composition. Even though yellow-green is an opaque color, it is still transparent enough to be affected by the variation in shadow values over which it was painted, a fact that caused all of the fern fronds to automatically fall into proper color relationship with the surrounding color. The same holds true for all of the vines and stems that were painted in with the same color. The ferns were rendered with the edge of a #5 round sable brush.

To create the effect of dancing light, Rankin varied the strength of the white flowers. Some of the flowers on the right side of the painting were cast into light shadow. This was accomplished with a mixture of cerulean and Winsor blue. The centers of the flowers were painted with a mixture of vermilion and Indian yellow.

At this stage most of the painting had been completed. However, there were a few finishing touches to be made. Some of the flowers were highlighted with the tip of an X-Acto knife and one or two flowers were scraped out with a knife. Several of the leaves were modeled with vermilion to impart texture and to help regulate their color value.

Step 1. Creating the illusion of white flowers on a dark background can be easily accomplished without using masking fluid. To begin, carefully dampen the paper, making sure that none of the flowers are dampened. Then wash a layer of new gamboge over the wet sheet of paper. With a little coaxing, the wash will seep into every damp crevice around each flower. Since watercolor is inherently transparent, these flowers will be harder to obscure with each succeeding wash application.

Step 2. After the new gamboge has thoroughly dried, dampen the paper again. Once more, make sure to avoid wetting the flowers. Once the paper is damp, apply a wash of Thalo yellow green mixed with new gamboge.

Step 3. This step is critical; here you must be very careful in your application of a layer of Thalo blue around the flowers. You may even find you need to clean up the edges around each flower as this wash dries. If you want darker shadow areas, add a little Winsor red or indigo to the next wash of Thalo blue.

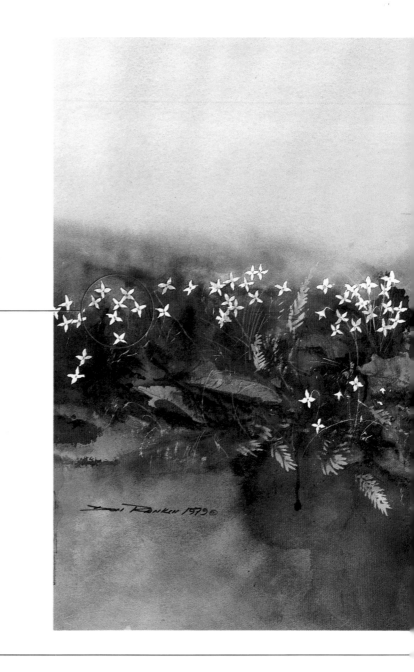

Step 1. Establish a warm green background, using new gamboge and Thalo yellow green.

Step 2. Apply a dark mixture composed of Thalo blue and Winsor red.

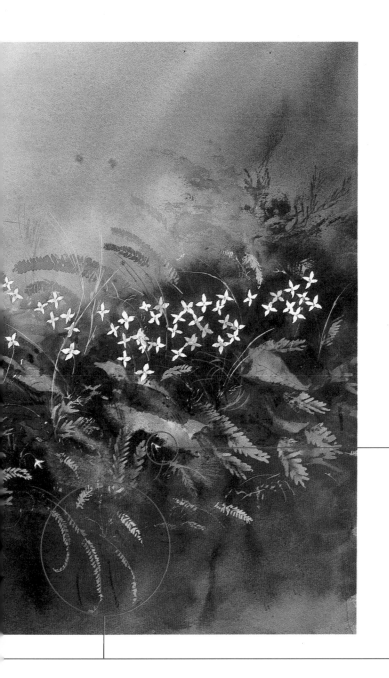

Step 1. Create a warm green background using new gamboge and Thalo yellow green.

Step 2. Add a wash composed of Thalo blue and Winsor red to establish the color of the shadow values.

Step 3. Once this dark area is completely dry, carefully scrape out the white flowers with the point of an X-Acto knife.

Step 3. Upon this dark background, allow the brush to create the fern fronds. If you are not familiar with these brushstrokes, closely examine the shape of the fern leaves. They are really nothing more than the shape that a Winsor & Newton Series 7 brush makes as it is laid lengthwise on the paper.

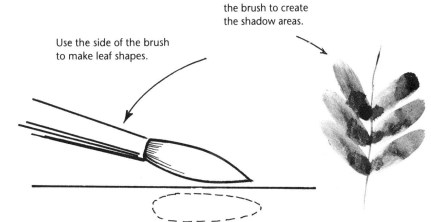

Use the side of the brush to make leaf shapes.

Use the heel of the brush to create the shadow areas.

INDEX